PROFESSIONAL
PORTRAIT RETOUCHING
TECHNIQUES
FOR PHOTOGRAPHERS *using* Photoshop

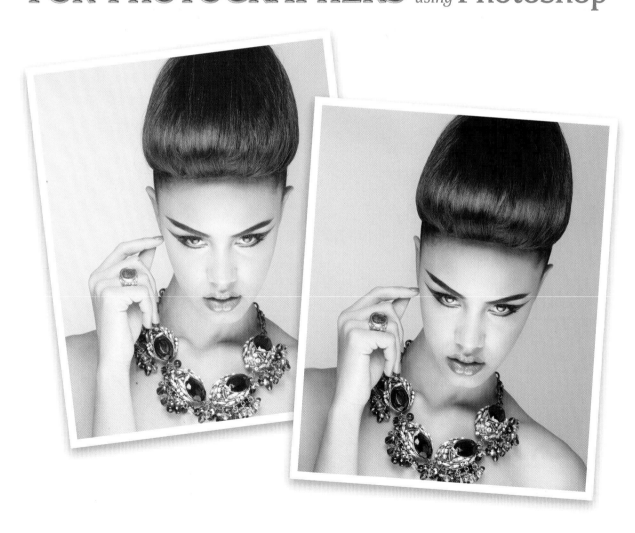

Scott Kelby

The *Professional Portrait Retouching Techniques for Photographers Using Photoshop* Team

CREATIVE DIRECTOR
Felix Nelson

TECHNICAL EDITORS
Cindy Snyder
Kim Doty
David Cuerdon

ASSOCIATE ART DIRECTOR
Jessica Maldonado

TRAFFIC DIRECTOR
Kim Gabriel

PRODUCTION MANAGER
Dave Damstra

PHOTOGRAPHY BY
Scott Kelby

Published by New Riders

Copyright ©2011 by Scott Kelby

Composed in Avenir, Museo, Sling, and FG Grayson by Kelby Media Group, Inc.

Trademarks

All terms mentioned in this book that are known to be trademarks or service marks have been appropriately capitalized. New Riders cannot attest to the accuracy of this information. Use of a term in the book should not be regarded as affecting the validity of any trademark or service mark.

Photoshop is a registered trademark of Adobe Systems, Inc.

Macintosh and Mac are registered trademarks of Apple Inc.

Windows is a registered trademark of Microsoft Corporation.

Warning and Disclaimer

This book is designed to provide information for photographers about retouching in Adobe Photoshop. Every effort has been made to make this book as complete and as accurate as possible, but no warranty of fitness is implied.

The information is provided on an as-is basis. The author and New Riders shall have neither liability nor responsibility to any person or entity with respect to any loss or damages arising from the information contained in this book or from the use of the discs or programs that may accompany it.

THIS PRODUCT IS NOT ENDORSED OR SPONSORED BY ADOBE SYSTEMS INCORPORATED, PUBLISHER OF ADOBE PHOTOSHOP.

ISBN 13: 978-0-321-72554-7

ISBN 10: 0-321-72554-9

9 8 7 6 5 4

www.kelbytraining.com
www.newriders.com

To my daughter Kira:
You've been blessed with
so many of your mom's gifts—
I can't wait to see the amazing
woman you, too, will become.

Acknowledgments

After writing books for 13 years now, I still find that the thing that's the hardest for me to write in any book is the acknowledgments. It also, hands down, takes me longer than any other pages in the book. For me, I think the reason I take these acknowledgments so seriously is because it's when I get to put down on paper how truly grateful I am to be surrounded by such great friends, an incredible book team, and a family that truly makes my life a joy. That's why it's so hard. I also know why it takes so long—you type a lot slower with tears in your eyes.

To my remarkable wife, Kalebra: We've been married 21 years now, and you still continue to amaze me, and everyone around you. I've never met anyone more compassionate, more loving, more hilarious, and more genuinely beautiful, and I'm so blessed to be going through life with you, to have you as the mother of my children, my business partner, my private pilot, Chinese translator, and best friend. You truly are the type of woman love songs are written for, and as anyone who knows me will tell you, I am, without a doubt, the luckiest man alive to have you for my wife.

To my son, Jordan: It's every dad's dream to have a relationship with his son like I have with you, and I'm so proud of the bright, caring, creative young man you've become. I can't wait to see the amazing things life has in store for you, and I just want you to know that watching you grow into the person you are is one of my life's greatest joys.

To my precious little girl, Kira: You have been blessed in a very special way, because you are a little clone of your mom, which is the most wonderful thing I could have possibly wished for you. I see all her gifts reflected in your eyes, and though you're still too young to have any idea how blessed you are to have Kalebra as your mom, one day—just like Jordan—you will.

To my big brother Jeff, who has always been, and will always be, a hero to me. So much of who I am, and where I am, is because of your influence, guidance, caring, and love as I was growing up. Thank you for teaching me to always take the high road, for always knowing the right thing to say at the right time, and for having so much of our dad in you.

I'm incredibly fortunate to have part of the production of my books handled in-house by my own book team at Kelby Media Group, which is led by my friend and longtime Creative Director, Felix Nelson, who is hands down the most creative person I've ever met. He's surrounded by some of the most talented, amazing, ambitious, gifted, and downright brilliant people I've ever had the honor of working with.

Thank God for Kim Doty, my Editor. She is amazing, and single-handedly keeps me from visiting a nearby tower, and climbing to the top to throw myself off (anyone catch that vague Gilbert O'Sullivan reference there? Anybody? No?). Kim is just an incredibly organized, upbeat, focused person who keeps me calm and on track, and no matter how tough the task ahead is, she always says the same thing, "Ah, piece of cake," and she convinces you that you can do it, and then you do it. I cannot begin to tell you how grateful I am to her for being my Editor.

Working with Kim is Cindy Snyder, who relentlessly tests all the stuff I write to make sure I didn't leave anything out, so you'll all be able to do the things I'm teaching (which with a Photoshop book is an absolute necessity). She's like a steel trap that nothing can get through if it doesn't work just like I said it would.

The look of the book comes from an amazing designer, a creative powerhouse, and someone whom I feel very, very lucky to have designing my books—Jessica Maldonado. She always adds that little something that just takes it up a notch, and I've built up such a trust for her ideas and intuition, which is why I just let her do her thing. Thanks Jess!

I owe a huge debt of gratitude to my Executive Assistant and Chief Wonder Woman, Kathy Siler. She runs a whole side of my business life, and a big chunk of our conferences, and she does it so I have time to write books, spend time with my family, and have a life outside of work. She's such an important part of what I do that I don't know how I did anything without her. Thank you, thank you, thank you. It means more than you know.

Thanks to my best buddy, our Chief Operating Officer and father of twin little girls, Dave Moser, first for handling the business end of our book projects, but mostly for always looking out for me.

Thanks to everyone at New Riders and Peachpit, in particular, my way cool Editor Ted Waitt, my wonderful Publisher Nancy Aldrich-Ruenzel, marketing maven Scott Cowlin, and marketing diva Sara Jane Todd, and the entire team at Pearson Education who go out of their way to make sure that we're always working in the best interests of my readers, and who work tirelessly to make sure my work gets in as many people's hands as possible.

Thanks to my friends at Adobe: John Nack, Mala Sharma, John Loiacono, Terry White, Cari Gushiken, Julieanne Kost, Tom Hogarty, Dave Story, Bryan O'Neil Hughes, Thomas Nielsen, Russell Preston Brown, and the amazing engineering team at Adobe (I don't know how you all do it). Gone but not forgotten: Barbara Rice, Jill Nakashima, Rye Livingston, Addy Roff, Bryan Lamkin, Jennifer Stern, Kevin Connor, Deb Whitman, and Karen Gauthier.

Thanks to Matt Kloskowski for letting me bounce ideas off of him for this book and for his input and suggestions. A big high-five and thanks to Corey Barker, who developed the cool set of eyelash brushes you guys get with the book. And thanks to professional makeup artist Shelley Giard for all her help and insights.

I was very fortunate to have professional retoucher and instructor David Cuerdon as Technical Editor for the book. The entire book is much better because of his input, and I'm very grateful for his advice and his friendship.

I want to thank all the talented retouchers who I've learned so much from over the years: Katrin Eismann, Jane Conner-ziser, Felix Nelson, Natalia Taffarel, Corey Barker, Christy Schuler, Mary DuPrie, Kevin Ames, Dave Cuerdon, Calvin Hollywood, and the community at RetouchPRO.com.

Thanks to my mentors, whose wisdom and whip-cracking have helped me immeasurably, including John Graden, Jack Lee, Dave Gales, Judy Farmer, and Douglas Poole.

Most importantly, I want to thank God, and His son Jesus Christ, for leading me to the woman of my dreams, for blessing us with two amazing children, for allowing me to make a living doing something I truly love, for always being there when I need Him, for blessing me with a wonderful, fulfilling, and happy life, and such a warm, loving family to share it with.

Other Books by Scott Kelby

The Adobe Photoshop Lightroom 3 Book for Digital Photographers

The Digital Photography Book, volumes 1, 2 & 3

The Photoshop CS5 Book for Digital Photographers

The Photoshop Channels Book

Photo Recipes Live: Behind the Scenes, parts 1 & 2

Scott Kelby's 7-Point System for Adobe Photoshop

Photoshop Down & Dirty Tricks

The iPhone Book

The Mac OS X Leopard Book

The Photoshop Elements Book for Digital Photographers

About the Author

Scott is Editor, Publisher, and co-founder of *Photoshop User* magazine, host of the top-rated weekly videocast *Photoshop User TV*, and co-host of *D-Town TV* (the weekly videocast for DSLR shooters).

He is President of the National Association of Photoshop Professionals (NAPP), the trade association for Adobe® Photoshop® users, and he's President of the training, education, and publishing firm, Kelby Media Group, Inc.

Scott is a photographer, designer, and award-winning author of more than 50 books, including *The Adobe Photoshop Lightroom 3 Book for Digital Photographers*, *The Adobe Photoshop CS5 Book for Digital Photographers*, *Photoshop Down & Dirty Tricks*, *The Photoshop Channels Book*, *The iPhone Book*, *The iPod Book*, and *The Digital Photography Book*, vols. 1, 2 & 3.

Scott's book, *The Digital Photography Book*, vol. 1, is the best-selling book ever on digital photography. In 2010, Scott became the #1 best-selling author across all photography book categories. From 2004–2009, he held the honor of being the world's #1 best-selling author of all computer and technology books, across all categories.

His books have been translated into dozens of different languages, including Chinese, Russian, Spanish, Korean, Polish, Taiwanese, French, German, Italian, Japanese, Dutch, Swedish, Turkish, and Portuguese, among others, and he is a recipient of the prestigious Benjamin Franklin Award.

Scott is Training Director for the Adobe Photoshop Seminar Tour and Conference Technical Chair for the Photoshop World Conference & Expo. He's featured in a series of Adobe Photoshop online courses and DVDs at KelbyTraining.com and has been training Adobe Photoshop users since 1993.

For more information on Scott, visit his daily blog, *Photoshop Insider*, at www.scottkelby.com.

Scott Kelby

Contents

Contents

Seven Things You'll Wish You Had Known Before Reading This Book

It's really important to me that you get a lot out of reading this book, and one way I can help is to get you to read these seven quick things about the book that you'll wish later you knew now. For example, it's here that I tell you about where to download something important, and if you skip over this, eventually you'll send me an email asking where it is, but by then you'll be really aggravated, and well…it's gonna get ugly. We can skip all that (and more) if you take two minutes now and read these seven quick things. I promise to make it worth your while.

©ISTOCKPHOTO/GCHUTKA

#1 This book was written for photographers—not photo retouchers.

Most photographers aren't able to send their images out to a full-time, high-end retoucher, so we wind up doing our own portrait retouching in Photoshop. That's exactly who I wrote this book to help— photographers who want better, faster, more realistic results from their own portrait retouching. The key word here is "photographers." This isn't a book to learn how to become a high-end portrait retoucher (which is a very hard job, done by highly skilled, and very patient, professionals who take whatever time and steps are necessary to create absolutely perfect images. I have immense respect for these folks, who spend an average of four hours on a retouch, and as much as two to three days on a single cover image). However, as photographers, we usually don't get paid for the retouching part of our jobs, so we need to get back to shooting as quickly as possible. That's why I only focus on teaching you the fastest, easiest techniques to get your retouching done in as little time as possible. That means doing things that some high-end retouchers would definitely wrinkle their brow over, but when you make your living from shooting, you need to get back to shooting. That's what this book is about—quick, efficient techniques for great-looking, natural retouches that make you, and your subject, look great.

#2 Download the practice images, so you can follow right along with me.

I've made all of the photos I used here in the book available for you to download, so you can follow right along with me as we work. For this book, though, I added something extra—a second practice file, so you can try the same technique you just learned on a totally different image. With retouching, it's the repetition that builds your speed, so this is another way for you to take what you've just learned and apply it somewhere else. You can download the images at **www.kelbytraining.com/books /retouching** (see, this is one of those things I was talking about that you'd miss if you skipped this and went right to Chapter 1).

#3 You don't have to read this book in order.

I designed this book so you can turn right to the retouching technique you want to learn and start there. I explain everything as I go, step by step, so if you want to learn how to sharpen your subject's eyes, just turn to page 81, and in a couple of minutes, you'll know how.

#4 The intro pages at the beginning of each chapter are not what they seem.

The chapter introductions are designed to give you a quick mental break between chapters, and honestly, they have little to do with what's in the chapter. In fact, they have little to do with anything, but writing these quirky chapter intros has become kind of a tradition of mine (I do this in all my books), so if you're one of those really "serious" types, I'm begging you—skip them and just go right into the chapter, because they'll just get on your nerves. However, the short intros at the beginning of each individual technique, up at the top of the page, are usually pretty important. If you skip over them, you might wind up missing stuff that isn't mentioned in the technique itself. So, if you find yourself working on a technique, and you're thinking to yourself, "Why are we doing this?" it's probably because you skipped over that short intro.

#5 I included a chapter on my own start-to-finish retouching workflows, but don't read it yet.

At the end of the book, I included a special chapter detailing my retouching workflows for a 5-minute, 15-minute, and 30-minute retouch, but please don't read it until you've read the rest of the book first, because it assumes that you've read the book already, and understand the basic concepts. So, it doesn't spell everything out (or they would be really, really long, drawn-out workflows). In this chapter, I refer back to things you've already learned, and if you haven't learned them…well…you'll get kinda stuck there. So, do yourself a favor—read the first six chapters first, then do the workflows.

#6 Do I need to do all this stuff?

Absolutely not. In fact, the goal is to do as little as possible, and be as subtle as possible, so if you can finish off an image with just two or three techniques from the book, that's fantastic. If you find yourself using 20 or more techniques, maybe it's time to find some better looking subjects (kidding, just a joke). I just don't want you to think that you have to apply everything in this book to every photo. Start by evaluating the image and what needs to be done. I always start by looking at the image and asking myself, "What do I wish here was different?" (For example, I wish his teeth weren't yellow, and that he didn't have that big mole on his neck, and all those stray hairs across his face.) Then you turn to the pages with those techniques and apply just the ones you need. Retouching is one of those "less is more" things.

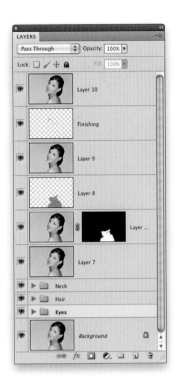

#7 I made you a Retouching Checklist.

One of the things photographers ask me the most is, "How do you know what to retouch?" So, I made you a checklist of things to look for. Now, you don't have to do all the things on the checklist (in fact, if you do, perhaps retouching shouldn't be your biggest concern), but at least you'll have a list to make sure that nothing that needs to be retouched slips by you. I put this checklist right before the workflow chapter that's at the end of the book (you'll find it on page 294). Also, I took it a step further by creating a custom Photoshop panel, so you won't even have to pull out the book—the panel will be right inside Photoshop. You can download it at www .kelbytraining.com/books/retouching. See, I told ya I'd make reading this worth your while.

Why We Retouch

Before you dive into the book, I hope you'll invest two minutes in reading my philosophy on why we retouch. I think that, not only will this help you understand where I'm coming from with these retouches, but it also will make you a better, more aware, retoucher. The ability to make people look their best, or better than their best, is amazingly powerful and, as someone retouching photos, you have a responsibility to your subject, your client, and yourself to do this right.

A couple of years ago, my wonderful wife surprised me with a trip to the Tuscany region of Italy. It was an amazingly beautiful place (and the food was...well, the food was insane!), and one afternoon I grabbed my camera gear and drove up into the Asciano hills (I couldn't get anyone in my family to go with me— I think I had already burned them out with all my photography outings that trip).

At one point, I pulled to the side of the road when I saw this beautiful little villa, sitting up on a hill, sur- rounded by tall olive trees, and this amazingly green, rolling grass—it was just stunning. I set up my tripod, got out my remote cable release, and really took my time to capture the scene that I wish my family had been there to see. After I was done shooting, I stood there for a moment, took a deep breath of the fresh air, and just gazed upon that perfect little "villa in Tuscany" scene. I couldn't wait to show my family the pictures.

When I got back to our hotel room, I immediately found the image and opened it in Photoshop, so I could rush out and show everybody the image full-screen. But as soon as the image opened, I was stunned to see something that totally ruined the picture for me—power lines and telephone poles. Not just one or two. About two dozen. There were lines and cables and 20-foot poles all over the place. I never saw them while I was standing there right in front of the scene in Tuscany, but the moment I opened the image in Photoshop, it was the very first thing that jumped out at me. I sighed, and then I spent the next two hours carefully removing every line, every wire, and every pole, because I wanted the scene to look like what I saw while I was right there, standing in front of it.

Well, photos of people are exactly the same. You can have a one-on-one conversation with someone for a solid hour, take a quick portrait of them, and when you open their image, every flaw, every blemish, and every little imperfection you totally missed during your conversation may as well have a big red circle around it and a large arrow pointing right to it. I know it's the truth, because it's happened to me, and count- less other photographers, again and again over the years.

So, our job, when we're retouching people, is to take that flat, unflattering, two-dimensional still image of them, where every flaw doesn't just stand out, but gets magnified, and make them look as good as they did when they were standing right in front of us.

If you go too far, they will know it has been highly retouched and they won't feel good about it. Worse than that, their friends and family will know it has been highly retouched. But, if you're careful to make them look as good in the photo, or perhaps just slightly better, than they do in real life, their friends and family will love the photo, and so will your subject.

Lastly, here's one thing I learned the hard way: You're about to learn some amazing techniques and no doubt you'll want to brag to your subject about what an amazing retouch you did for them in Photoshop, and how great you made them look. But, here's my advice: don't do it. Never show them the before/after, and don't show their friends or family, either. This is about making them look their best, not making them feel their worst. Keep this between you and Photoshop, and I promise you, you'll be glad you did.

12 Things You Need to Know Now to Make Your Retouching Easier

I know you want to get to retouching, but I promise you—if you take just a few minutes to read these 12 things, you'll better understand what you'll be doing, why you're doing it, and you'll get better results faster from your retouching. Really. I promise.

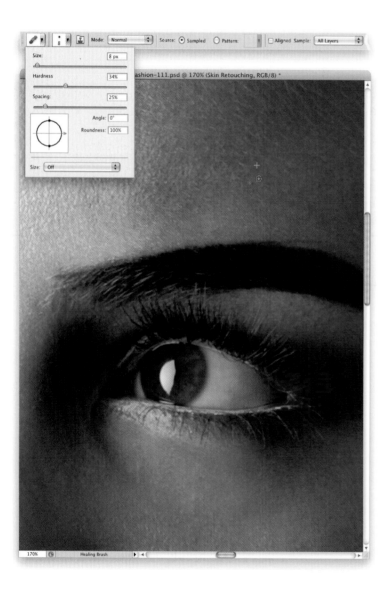

#1 Think Small

If I could only give you one piece of advice, one secret about successful retouching, it would be to work with a small brush as much as possible. Of course, as photographers, most of us just want to get the job done as quickly as possible, so we use a large brush, which does get things done faster, but often picks up a repeating pattern (repeats a speck, or hair, or blemish from the area where you sampled), or it smudges an area when you've brushed over it a few times, and generally it's one of the big causes for a retouch looking shabby. Stick with small- or medium-sized brushes as much as possible, and I promise you, your retouching will look more professional. Also, to get more control, work at low Opacity settings with your brushes (between 10% and 30%), and gradually build up your strokes, one on top of another. You can't do this every time you use a brush, but when you can, it makes a big difference.

#2 Use a Pen and Tablet

If you decided to become a professional house painter, one of the first things you'd buy is a roller brush, because it makes your work easier, and you'd get more done in less time. Then, you'd probably buy a small edge brush to get the corner details. These are the tools of the trade, and about any pro you meet would have these. Well, it's kind of the same with retouching. I don't know a single professional retoucher that doesn't use a Wacom pen and tablet. It's the retoucher's tool-of-the-trade, because it makes your retouching tasks so much easier, and you'll get more work done in less time. Plus, it will let you do the detail work (like an edge brush for painters) that makes all the difference in the final image. I don't get a kickback or payout whether you buy a tablet or not, but this is the tool we all use (I use the Intuos4 medium-sized tablet myself). That being said, you do not need a tablet to do any of the techniques in this book—you can tough it out with a mouse. ;-)

COURTESY OF WACOM: IMAGE WITHIN MONITOR © SCOTT KELBY

#3 Save Time with Tool Presets

You'll wind up using the same tools, with the same custom settings, pretty often, and you can save yourself a lot of time by using tool presets, which remember all those settings. For example, let's say you use the Clone Stamp tool for removing stubble, and you have the tool's Mode set to Lighten, the Sample pop-up menu set to All Layers, the Opacity at 40%, and you use a medium-sized, soft-edged brush. Once all that's in place, click on the Clone Stamp tool icon up at the left end of the Options Bar (shown circled here in red), and then in the Tool Preset Picker, click on the right-facing arrow in the top-right corner and, from that menu, choose New Tool Preset. Give your tool preset a descriptive name (like the ones I've already added to the Picker here) and click OK. Now, anytime you need to remove stubble, you don't have to enter (or remember) all those settings, just click on that icon, then click on your tool preset, and it's all set up and ready to go.

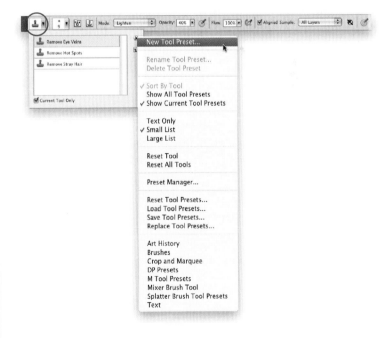

(Continued)

#4 Walk Away After a While

If you've been retouching for a while, you start seeing everything as a problem to be retouched, and after about an hour, most folks start to over-retouch and not realize it. That's why, after an hour of retouching, you need to take a break, do something else for five or ten minutes, and then return to retouching with a fresh view. I know this one might sound silly as you're reading this right up front, but an hour from now, it will make total sense. This is a more important point than it sounds right now.

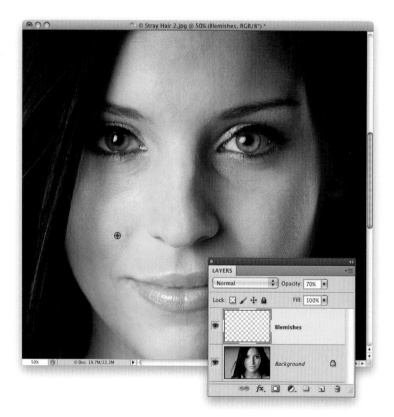

#5 Why We Work on a Layer

We do most of our retouching on a separate layer (or a copy of the Background layer, if necessary) for a few reasons: (1) We can lower the intensity of any retouch by lowering the opacity of the layer we did our retouching on, and we do this a lot throughout the book. (2) It lets us have a quick before/after anytime by just hiding the layer from view, and then turning it back on (just click the Eye icon to the left of the layer's name in the Layers panel). And, (3) it protects the original background image, so we can always go back to it if we need to (so, basically, our edits are non-destructive). This is a guideline, but it isn't a rule, because when you've got five minutes to do a retouch, you can't be working with 10 layers, but for the most part, we always try to keep our retouches on one or more separate layers.

#6 Learn This Keyboard Shortcut

Command-Option-Shift-E (PC: Ctrl-Alt-Shift-E) is the shortcut for creating a merged layer, and what this does is it creates a brand new layer with a flattened version of your multi-layered document (as seen at the top of the layer stack here). That way, you can keep lots of your earlier retouching layers intact while you work on a flattened version of the file. Then, if you need to go back and fix something, you still have the original layers. If this sounds confusing, it will totally make sense in just a few minutes. Another handy keyboard shortcut to know is Command-H (PC: Ctrl-H). If you have a selection around something, pressing that shortcut hides the "marching ants" selection border, so you can more easily see what you're working on. Just don't forget to press it again when you're done retouching that area.

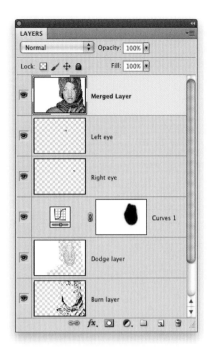

#7 Don't Retouch Zoomed Out

If you work with your image zoomed out at 66.7%, or 50%, or 33.3%, or smaller, you're gonna get burned by some little area you missed. It might be a small piece of skin that you didn't brush over when smoothing, or a tiny part of the image you missed when you changed its hue, but unless you do most of your retouching at 100% size or larger, I guarantee you something is going to slip by and embarrass you—or worse yet, your client. In the book, you'll see me use different zoom sizes to make things fit better for you, the reader, but when I'm retouching, I'm always working at 100%. It's important to zoom out every so often, because it's easy to do too much to a small area, and you'll only realize it has been over-retouched when you zoom out, but when I'm working, I zoom in to 100% if at all possible.

(Continued)

#8 The Direction of Your Strokes Matters

Whenever you can make out a direction of the texture of something (like skin), or the angle of something (like hair), try to make your brush strokes go in that same direction. I know you're probably thinking, "Well, duh!" but I see people cloning up and down on a forehead area all the time. If you look at the direction of the skin texture there, it goes from left to right (well, it goes horizontal anyway), and if you want your retouches to look more natural, just be aware of which direction to make your strokes so they blend in with what you're brushing on—it makes a difference.

#9 Applying These Retouches to Men

As much as I hate to admit it, retouching men is pretty easy (well, compared to retouching women, anyway), because you don't have to make their skin silky smooth, or make the eyelashes long and lustrous, or adjust their makeup, or lipstick, and so on. Because of that, you don't see a lot of guys in this book, but many of the retouches on women here in the book also apply to men (like removing blemishes, or stray hairs, or making their eyes symmetrical), so don't worry—you're covered.

#10 Use a B&W or Curves Adjustment Layer to See If You Missed Anything

When you're removing dust or specks from a background or sky, or removing blemishes or spots on clothing, because you're working on a color image, it's easy to miss a spot here or there. It happens to all of us, but it can really be a mess when a big one sneaks by us and we get a call from the client. That's why a lot of professional retouchers use a couple of temporary layers that they toggle on/off, just to help them see the spots, stray hairs, and blemishes much more clearly. One is a simple Black & White adjustment layer. This works great on skin, and you can keep it hidden until you're about to finish up an area—then you make it visible and see if you missed anything. The second one is a two-hill Curves adjustment layer (like the one shown here. To add points to the curve, just click anywhere along the line and then drag the point where you want it). This one does an amazing job of finding specks, spots, and stray hairs (try it on a solid studio background, like you see here— it's amazing!). Again, you'll only use it to check your work, but it can really save your butt by catching those things you might have missed. And if you get something crazy in your cloning or healing cursor while fixing those things you missed, make sure you're working on the image layer and your brush is set to sample only the current layer.

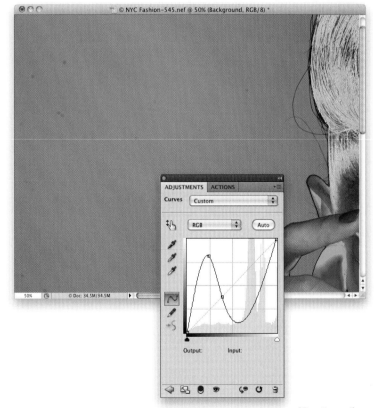

(Continued)

#11 Use Actions to Work Even Faster

When retouching, you'll wind up doing the same thing again and again, which is why you need actions (Photoshop's built-in recorder, which remembers your steps, and plays them back by hitting just one key—no matter how many steps it took—faster than you could ever do it). For example, in Chapter 3, we learn how to create a special new layer for dodging and burning, where you have to choose New Layer from the Layers panel's flyout menu, then set the layer's blend mode to Soft Light, and then turn on the checkbox for Fill with Soft-Light-Neutral Color (50% Gray). You can have it do all this in just one click of an F-key on your keyboard. Open the Actions panel (go under the Window menu and choose Actions), and click the Create New Action icon at the bottom of the panel (it looks like the Create a New Layer icon). Give your action a name (New D&B layer), choose which function key you want to use for playback, then hit the Record button. Now, go make your Soft Light layer. When you're done, hit the red Stop button at the bottom of the panel. To play it back, at super-speed, just press that F-key.

#12 How Long You Should Spend Retouching a Particular Image

I hate to give you, "Well, that depends," but, "Well, that depends." When you do the shoot, you probably know how the image you're creating is going to be used (it's for a website, for a print ad, for a model's online portfolio, etc.), and because of that, you need to make a realistic decision about how much time you, as a photographer, can commit to the retouch. If this image is going to be used on the cover of the local bridal magazine, you'd better invest 30 or more minutes (a long retouch for a photographer). If it's going to be a 2x4" image in the clients' wedding book, on a page with six other photos, this image gets five minutes max! Another consideration is how tight the image is cropped. Is the image a close-up? Then you need to consider every little detail, from stray hair to red eye veins. However, if your subject is farther away, like a ¾-length view or full-length shot, you probably won't need to be nearly as detailed (if their eyes wind up only being 1/32 of an inch high in the image, how much time do you really need to spend retouching their eyes)? In short, you have to make realistic decisions about how much time to spend retouching.

Chapter 1
NAKED EYES
Retouching Eyes

If you came to this chapter intro page expecting to read something insightful about retouching eyes—stop right now, turn back a few pages, and read "Seven Things You'll Wish You Had Known Before Reading This Book" first. Then you'll either: (a) be in the right state of mind for this chapter intro, or (b) you'll skip it, because you're the really serious type, and reading it will just make you irritated (more than you normally are, which is plenty). Now, if you're still reading, I'm assuming that you've either: (a) read the "Seven Things…" and you're cool with reading these chapter intros, or (b) you actually are that serious no-nonsense type, yet you didn't stop and go back to read the "Seven Things…" section, which means you're not good at taking simple directions, in which case, I wouldn't just skip the chapter intros, I'd skip the whole rest of this book, because it's all about taking direction. But for everybody else (the cool people), I'm

going to sneak in an actual nugget of semi-useful information here—please don't expect this in any future chapter intro, because it goes against everything I believe in (including unicorns and The Force). The nugget is this: This is the biggest chapter in the book, and I cover all sorts of different retouches for the eyes because the eyes are so incredibly important. Don't worry, you're not going to use them all on any one image, but the closer cropped your subject is, and the larger their eyes appear in the image, the more retouches you might want to consider. However, if you do wind up retouching a cyclops, you will probably use them all, but the good news is: you only have to retouch one eyebrow. One last thing: this chapter, "Naked Eyes," is named after the UK-based band that did the song "(There's) Always Something There to Remind Me" back in 1982. Worse yet: I knew that without looking it up. Sad, I know.

Increasing Contrast in the Iris

One of the secrets to really making eyes look captivating is to add contrast to the iris. It really brings out the color and depth of the eyes, without adding artificial color, and although it's really easy to do, it delivers pretty amazing results.

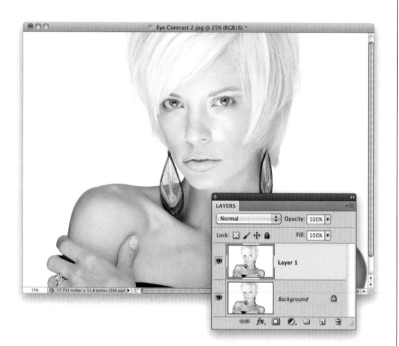

Step One:

Here, our subject's eyes look kind of flat, and almost hazy, because they're really lacking contrast. So, to start off, we need to duplicate the Background layer by pressing **Command-J** (**PC: Ctrl-J**; or just drag the Background layer in the Layers panel onto the Create a New Layer icon at the bottom of the panel). Next, zoom in tight on the eyes. You're going to be zooming in tight quite a bit when you're retouching, so learning this quick way to zoom in can be a real timesaver: If you press-and-hold **Command-Spacebar** (**PC: Ctrl-Spacebar**), your cursor temporarily switches to the Zoom tool (the one that looks like a magnifying glass). Just click-and-drag this tool on the area you want to zoom in on (in this case, the eye on the right) and it zooms right into that spot. (*Note:* On a Mac, you'll probably need to go to your Keyboard Shortcuts System Preferences and turn this system shortcut off first for it to work this way in Photoshop.)

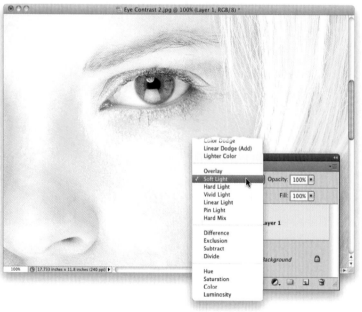

Step Two:

Although there are a number of different ways to add contrast to a photo in Photoshop, this is probably the fastest and most efficient. At the top of the Layers panel, just change the blend mode of this duplicate layer from Normal to **Soft Light** (as shown here). This makes the entire image much more contrasty, but of course we don't want all that—we just want her iris more contrasty. Don't worry; we're going to fix that in a moment.

Step Three:

Press-and-hold the Option (PC: Alt) key and click on the Add Layer Mask icon at the bottom of the Layers panel (it's shown circled here in red). What this does is hides that really contrasty version of your image behind a black mask (so, it's still there—you just can't see it). The image now looks like it did when we first opened it (notice that her skin looks back to normal now?). Next, we'll use the Brush tool to paint over the iris (and pupil) to reveal the super-contrasty version of it. So, start by getting the Brush tool from the Toolbox (you actually might as well get used to using the keyboard shortcut for the Brush tool—just press the **B key**).

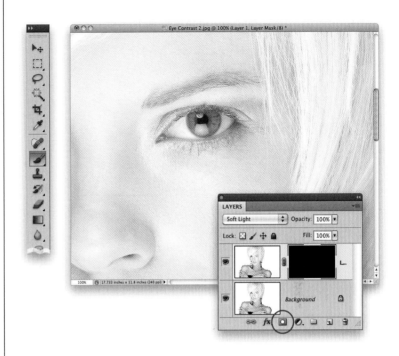

Step Four:

Make sure that your Foreground color is set to white (since your layer mask is black, you'll want to paint in the opposite color—white) and choose a small, soft-edged brush from the Brush Picker in the Options Bar. Begin painting over the iris (and pupil, as shown here), and as you paint, the much more contrasty version of it is revealed, yet the rest of the photo remains untouched. If you make a mistake, just press the **X key** to switch your Foreground color to black, and paint over the area where you messed up to hide it again. When you've fixed your mistake, press X again to toggle the Foreground color back to white and continue painting over the iris (and pupil) to complete your contrast retouch.

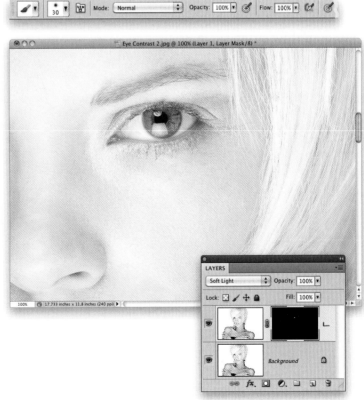

(Continued)

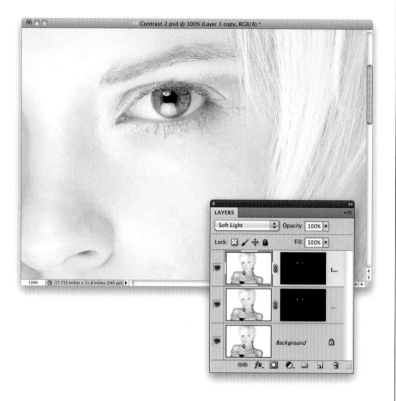

TIP: Adding More Contrast

If, after painting in the iris, you think you need even more contrast, just duplicate the top layer. Since the eye is already masked, you'll see just the iris and pupil become even more contrasty.

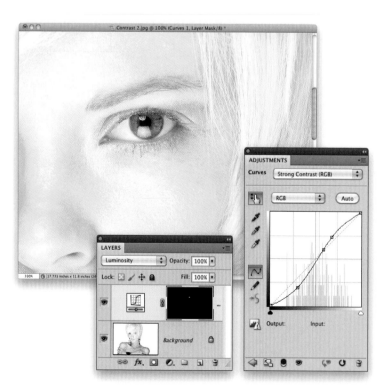

ANOTHER TIP: Using Curves

Instead of using a Soft Light layer to add more contrast to the iris, try an adjustment layer. Just click on the Create New Adjustment Layer icon at the bottom of the Layers panel and choose **Curves** from pop-up menu. Then, from the Curves pop-up menu at the top of the Adjustments panel, choose **Strong Contrast (RGB)**. Press **Command-I (PC: Ctrl-I)** to Invert the layer mask and hide the contrasty version of your image behind a black mask. With your Foreground color set to white, get the Brush tool, choose a medium, soft-edged brush at 100% Opacity, and paint over the eyes to add lots of contrast (as seen here). Tweaking the contrast like this can tend to actually change the color of the eyes, so since we just want more contrast, change the layer's blend mode from Normal to **Luminosity**, so you get the contrast, but not the color shift.

Try this technique on another image!

Download this practice image. See pg. xi.

Darkening the Outer Rim of the Iris

If you look closely at a person's iris, there's a slightly dark ring that goes around the outside edge of it, and making this ring darker helps enhance the overall look of the eye. This is one of those subtle little things you do that, by itself, may not seem like it makes a big difference, but add this in with the other things in this chapter, and it becomes one of those little things that helps take your retouch of the eyes to another level.

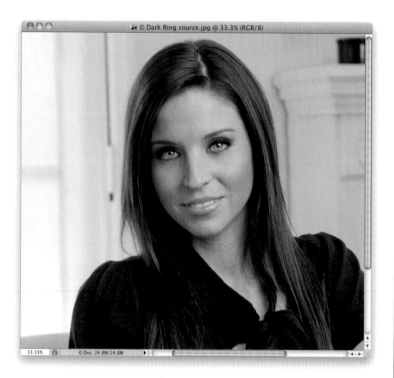

Step One:
Here's the image we're going to be working on (you can download it from the companion website mentioned in the book's introduction and follow right along).

Step Two:
Zoom in on the eyes, then get the Elliptical Marquee tool (press **Shift-M** until you have it) and make a circular selection around the entire iris of one eye. It's okay if it extends over the top or bottom of the iris, just get as close as you can in making a selection that completely covers it. (*Note:* If you have a problem getting the iris selected right on the money, try this trick: while you're dragging out the selection, press-and-hold the Spacebar. This lets you reposition the selection as you're dragging it out over the iris, and now selecting it should be a cinch. Also, if your subject's head is turned and the iris isn't perfectly round, go under the Select menu and choose **Transform Selection**. Then, Command-click [PC: Ctrl-click] on any one of the handles of the bounding box to distort the selection and fit it to the iris.) Then, press-and-hold the Shift key and select the other iris (holding the Shift key lets you create another selection, while keeping your first one).

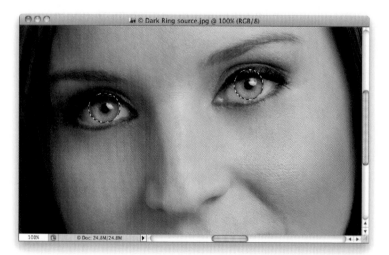

Step Three:

Go under the Select menu, under Modify, and choose **Feather** (as shown here). When the Feather Selection dialog appears, enter 5 pixels and click OK to soften the edges of the selection, so the retouch blends smoothly with the rest of the iris.

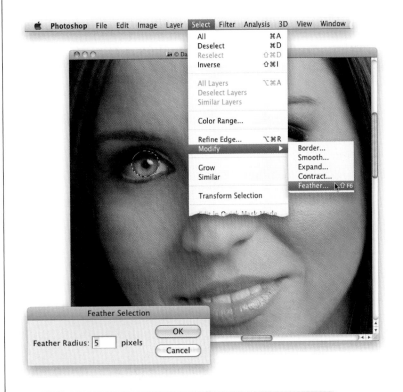

Step Four:

Click on the Create New Adjustment Layer icon at the bottom of the Layers panel and choose **Levels** from the pop-up menu. Since you had selections already in place, this automatically creates a mask for you, so you'll see the adjustment layer has a black mask to the right of it with both eyes already masked (sweet!).

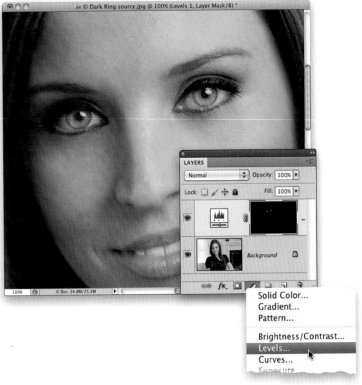

(Continued)

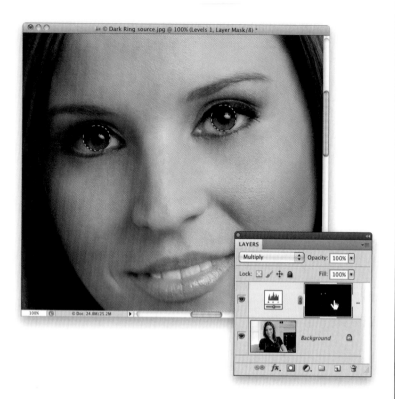

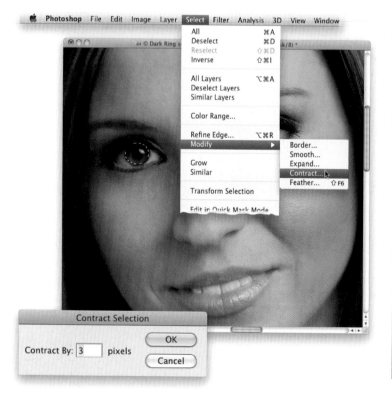

Step Five:

At the top of the Layers panel, change the blend mode of this adjustment layer to **Multiply**, which gives you a much darker version of the iris. The problem is, though, her entire iris is now darker (well, both are actually) and we just want the outside rings to be darker, so we'll need to fix that. Start by pressing-and-holding the Command (PC: Ctrl) key and, in the Layers panel, click directly on the black layer mask thumbnail to reload your original selection on both eyes (as seen here).

Step Six:

Now, we need to shrink the selection around each iris just a little bit, so go under the Select menu, under Modify, and choose **Contract** (as shown here). When the Contract Selection dialog appears, enter 3 pixels and click OK. This shrinks your selection by 3 pixels (giving you a slightly smaller circular selection).

Step Seven:

Make sure your Foreground color is set to white, then press the **Delete (PC: Backspace) key** to knock a hole out of the center of your darker iris adjustment layer. What you're left with is a darker enhanced edge ring around each iris that blends in perfectly with the rest of them. Now, you can Deselect by pressing **Command-D (PC: Ctrl-D)**.

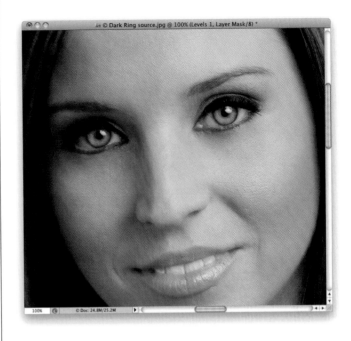

Step Eight:

To get rid of those extra areas that were selected above each iris, first press **X** to switch your Foreground color to black (so when you paint, it hides the darker areas), press **B** to get the Brush tool, choose a small, soft-edged brush from the Brush Picker, and paint around the outside of each iris, being careful not to actually paint over edge of the iris, or you'll erase the darkening we just added. A good trick to see if you've erased everything outside the iris is to simply toggle this adjustment layer on/off a few times (click on the Eye icon to the left of the layer's thumbnail; it's circled here in red) and you'll instantly see if anything's left over outside the dark area. If you see something, just paint over it in black to hide it.

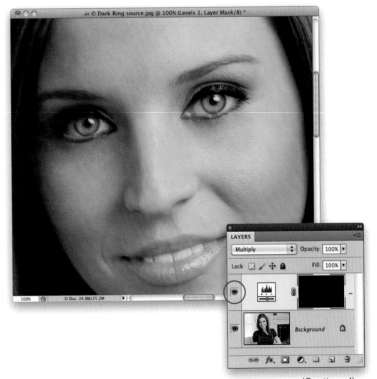

(Continued)

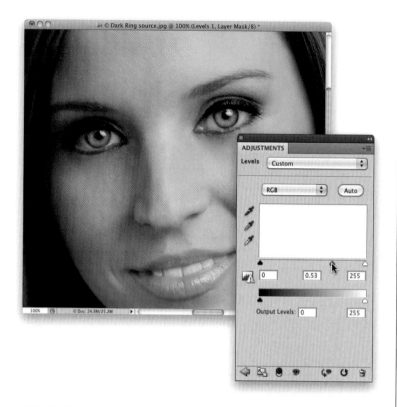

Step Nine:

If you want to adjust how dark this outer ring is, since you've already got a mask in place (thanks to the adjustment layer), it's really simple. All you have to do is go to the Adjustments panel and drag the midtones Input Levels slider (the gray triangle in middle) to the right (as shown here) to make the outer ring even darker, or to the left to lighten it a bit.

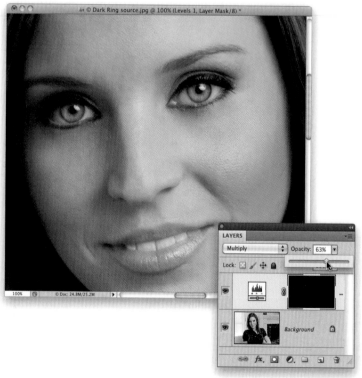

Step 10:

Another way to control the amount of your retouch is to lower the overall Opacity of your adjustment layer (as shown here, where I'm lowering it to 63%, because I felt the outer ring was too dark). You won't necessarily need to do this if you just darkened the midtones in the ring in Step Nine. You're more likely to lower the Opacity if you felt the ring was too dark when you first applied it, with nothing but the Multiply adjustment layer (in other words, before you applied the Levels tweak in Step Nine).

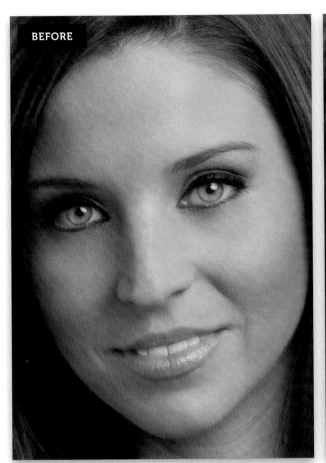
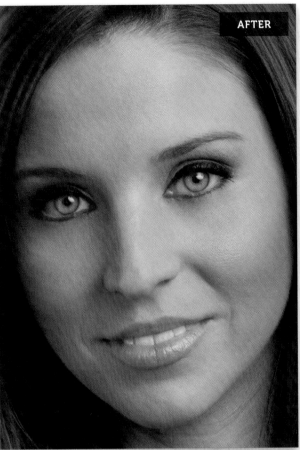

Try this technique on another image!

Adding More Life to the Eyes

This is another quick trick you can use to add more sparkle and life to the irises. Although it's a really simple retouch, you'll be surprised at how much it adds, and I do this to nearly every eye retouch I do.

Step One:
Zoom in on an eye where you want to add more sparkle to the iris. Click on the Create a New Layer icon at the bottom of the Layers panel to create a new blank layer. Then get the Elliptical Marquee tool (press **Shift-M** until you have it), press-and-hold the Shift key, and draw a circular selection that's just inside the iris (as shown here; holding the Shift key keeps your selection round).

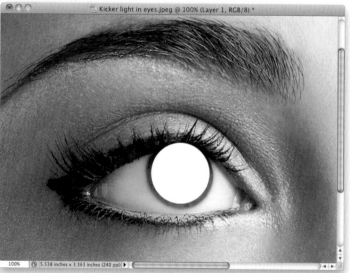

Step Two:
Press **D**, then **X** to set your Foreground color to white, then press **Option-Delete (PC: Alt-Backspace)** to fill this circular selection with white. Press **Command-D (PC: Ctrl-D)** to Deselect.

Step Three:

Now, get the Rectangular Marquee tool (press **Shift-M** until you have it) and draw a large rectangular selection over the top half of your white circle (like the one shown here). Press the **Delete (PC: Backspace) key** to knock a rectangular hole out of your white circle (basically, slicing it in half) and then deselect.

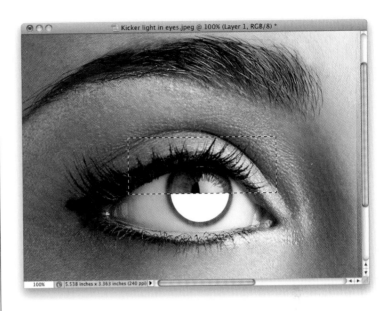

Step Four:

Go to the Layers panel, press-and-hold the Command (PC: Ctrl) key and click once on the white half-circle's layer thumbnail to put a selection around it. Now, move your cursor inside the selected area in your image (you should still have the Rectangular Marquee tool active) and drag that half-circle selection up a bit (like you see here), so the white area beneath the selection is the shape of a melon slice. Press Delete to knock a hole out of that half circle, leaving just that melon shape. Now, go ahead and deselect.

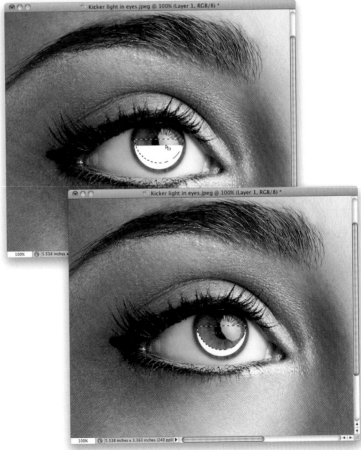

(Continued)

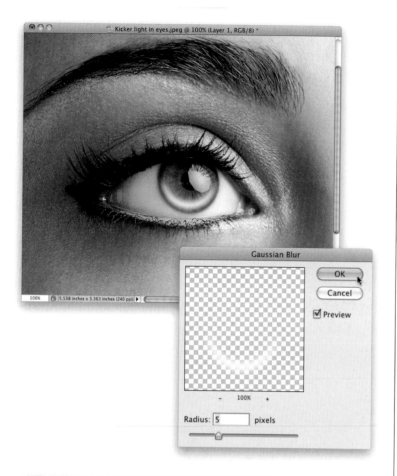

Step Five:

Go under the Filter menu, under Blur, and choose **Gaussian Blur**. When the dialog appears, enter 5 pixels, and then click OK to make the melon shape blurred with nice soft edges (as seen here). By the way, depending on the image, you may have to choose a higher, or possibly even a lower, number. Your goal is to make it look reasonably soft around the edges, like what you see here.

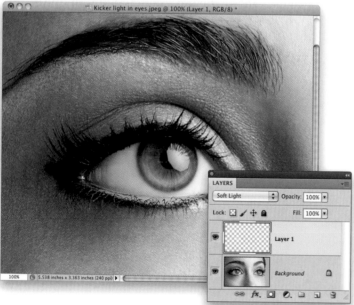

Step Six:

Now, to get this white, soft, melon shape to blend in with the iris beneath it, go to the top of the Layers panel and change the blend mode for this layer from Normal to **Soft Light** (as shown here). You can see how this adds a bright kicker on the bottom half of the iris.

Step Seven:

If you think this kicker looks a bit too bright, you can lower the layer's Opacity to tone down the effect (here I lowered it to 80%).

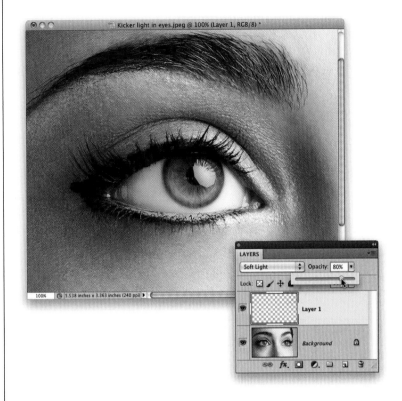

Tip: Blend Mode or Adjustment Layer?

You'll probably notice that sometimes I brighten things using a layer blend mode (like we did here), and sometimes I use a Levels adjustment layer instead. So, why do I choose one over the other? Generally, if I know that the effect is going to be too bright, and I'm most likely going to wind up toning it down,
I just go with a Soft Light layer because it's faster. However, if I'm not sure what my adjustment is going to be, or if I think I might need to make it lighter after I've applied it (rather than toning it down), then I use a Levels adjustment layer. That way, if I need to tweak it, I can double-click on the Levels adjustment layer and adjust the settings. A before and after is shown on the next page.

(Continued)

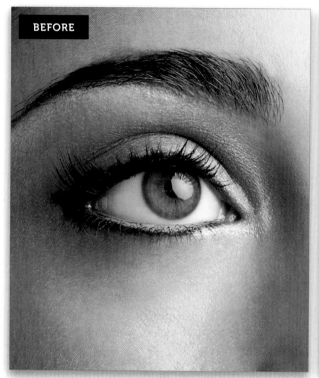

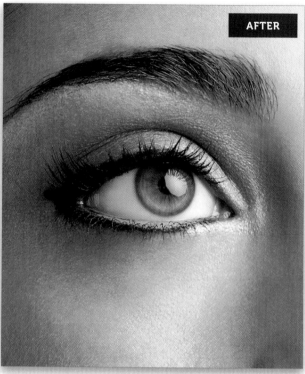

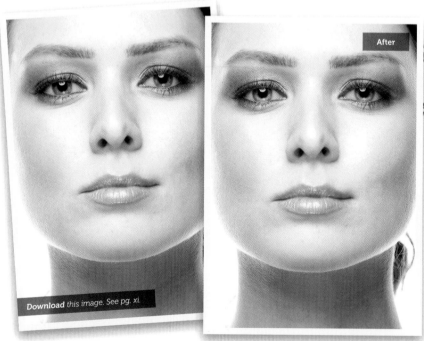

Download *this image. See pg. xi.*

Try this technique on another image!

Enhancing and/or Creating Catch Lights

Catch lights are those white dots that appear in the eyes in images and are reflections of the light source that's lighting the subject. Those white dots actually add sparkle to the eyes and keep them from looking kinda flat and dead (like round pools of black nothingness). If you're outdoors, the catch light will usually be a round dot (a reflection of the sun). But in a studio shot, not only will the catch light be created by your studio lights, you'll be able to see the shape and position of your softbox or umbrella in that catch light. Here's how to enhance existing catch lights, or add some if there aren't any.

Step One:
Here's the first image we're going to retouch (this one is for enhancing catch lights that are already there). Although her eyes are fairly well lit, the catch lights in them are pretty dim, and that really makes her eyes lack that sparkle that makes a portrait come alive. This first technique is pretty straightforward; you're going to brighten the overall highlights, and a little bit of the midtones, and then hide that brighter version and paint over just the highlights to make them really apparent.

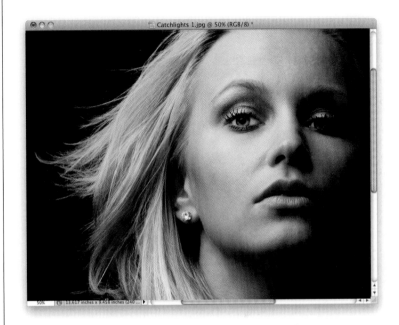

Step Two:
Start by zooming in tight on the eye on the left (here, we're at 200%), and then click on the Create New Adjustment Layer icon at the bottom of the Layers panel and choose **Levels** from the pop-up menu. In the Adjustments panel, grab the highlights Input Levels slider (the white triangle on the right beneath the histogram) and drag it quite a bit over to the left to brighten the highlights (you'll notice that the midtones Input Levels slider [the gray triangle in the middle] moves along with it, though not nearly as far). Keep dragging until the catch light reflection of your light source is nice and bright (as seen here at the top of the iris). Of course, this totally blows out your subject's skin, hair, and everything else, but don't sweat that—we'll fix this in the next step.

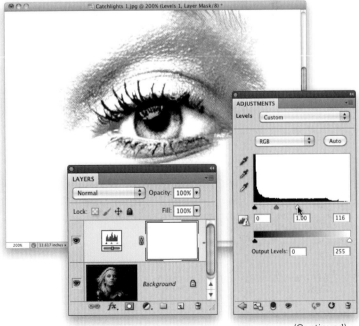

(Continued)

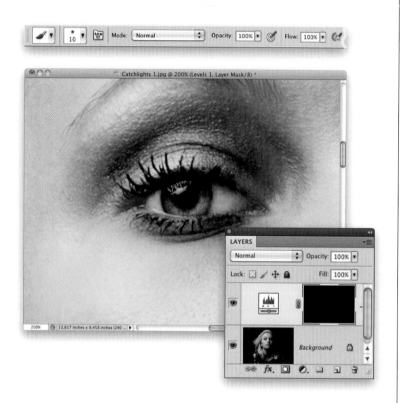

Step Three:

Press **Command-I (PC: Ctrl-I)** to Invert your adjustment layer's layer mask. This makes the mask black, which hides the brighter version of your image. Now, press **B** to get the Brush tool, make sure your Foreground color is set to white, choose a small, soft-edged brush from the Brush Picker up in the Options Bar, and paint over just the catch light (as shown here, where you can see my brush-tip cursor right over the catch light). As you paint, the much brighter version of the catch light appears. Once you're done with the eye on the left, go ahead and paint over the catch light in the eye on the right.

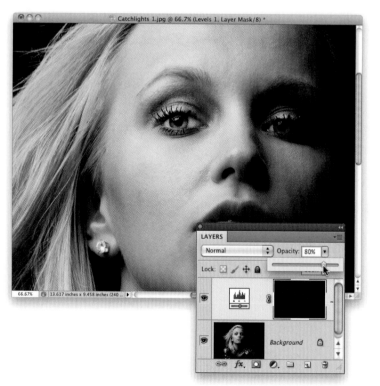

Step Four:

One of the great advantages of using adjustment layers (besides the whole masking thing you just did) is that they are layers in the first place, which means you can lower the Opacity if the brightening seems too much (here, I've lowered it to 80% for a more natural look). You could also just go back to the Adjustments panel and drag the highlights Input Levels slider back to the right a bit. The catch lights will already be masked because of what you did back in Step Three, so making this adjustment will only affect them. As you can see, the enhancing part is pretty simple, so let's move on to what to do if your subject doesn't have any catch lights at all.

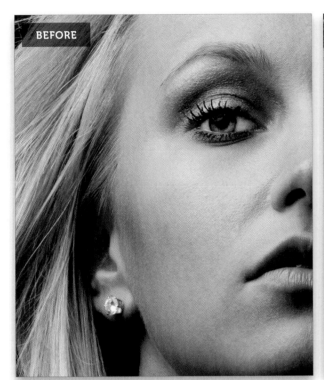

BEFORE

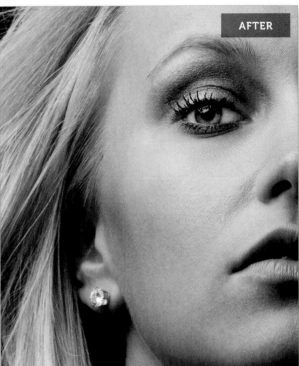

AFTER

Try this technique on another image!

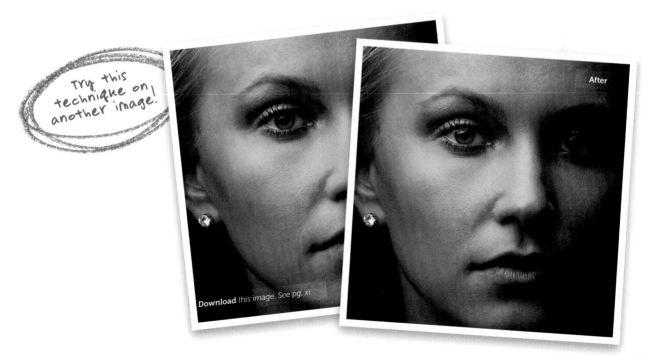

After

Download this image. See pg. xi.

(Continued)

Step Five:

Here's our second image and, if you look at her eyes, you'll see they have no reflection in them at all—they look kind of "dead." So, we're going to create our own light source catch lights, and add them to the eyes to bring them back to life, and add lots of sparkle. By the way, it's not our subject's fault that she doesn't have catch lights. In this case, the lack of them was caused by where I positioned my lights— at the tall height and angle they were at, they weren't able to cast a reflection in her eyes. So, basically it's my mistake (and so I have to fix it, right?).

Step Six:

Start by zooming in on the eyes (I'm at 100% here), then go to the Layers panel, and click on the Create a New Layer icon at the bottom of the panel (circled here in red) to create a new blank layer. Now, you have to choose which shape softbox or umbrella you want to reflect in her eyes. If you want a standard square or rectangular softbox reflection, you'll need to grab the Rectangular Marquee tool **(M)**. If you used a beauty dish for the shot (or you want to make it look like it was shot in sunlight), then grab the Elliptical Marquee tool (press **Shift-M** until you have it) and, to make a round selection for your catch light, just press-and-hold the Shift key. If you want to have your reflection look like an umbrella or an octagon-shaped large softbox (very popular for portraits), then grab the Polygon tool from the Toolbox (as shown here), and then in the Options Bar, enter 8 in the Sides field (also shown here).

Step Seven:

If you're using the Polygon tool, first make sure that the Fill Pixels icon is selected in the Options Bar (it's circled here in red). This sets the tool so it draws just regular pixels, and doesn't create a Path or a Shape layer. Now, press **D**, then **X** to set your Foreground color to white, then take the tool and drag out a small polygonal shape over the portion of the pupil where you want the catch light to appear (as seen here, where I dragged a polygon over the left side of the pupil on the eye on the left. Oh, and I also zoomed in more, to 200%). If you're using the Rectangular Marquee tool or the Elliptical Marquee tool instead, also set your Foreground color to white, and then drag out your selection. Now, fill your selection with white by pressing **Option-Delete (PC: Alt-Backspace)**, then Deselect by pressing **Command-D (PC: Ctrl-D)**. *Note:* As you're dragging out your shape, you can press-and-hold the Spacebar to reposition your selection as you're dragging (this works with any of the tools mentioned in this step).

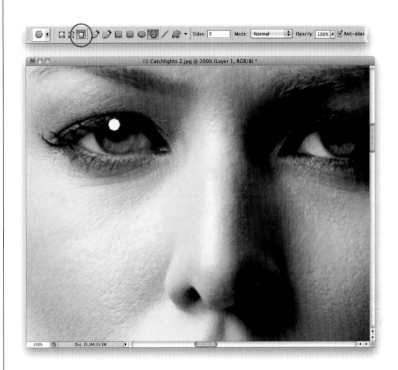

Step Eight:

If part of your catch light overlaps any other part of the eye area (like mine does here, where the top of the catch light extends over onto her top eyelid), then click on the Add Layer Mask icon at the bottom of the Layers panel (shown circled here in red) to add a layer mask. Now, at the top of the Layers panel, lower the Opacity of your catch light layer enough to make your catch light shape transparent, so you can see the eyelid behind it. Press **X** to set your Foreground color to black, then get the Brush tool **(B)**, choose a small, soft-edged brush from the Brush Picker, and just paint right over the part that overlaps the eyelid (as seen here) to erase it. We're not done yet, but we're almost there.

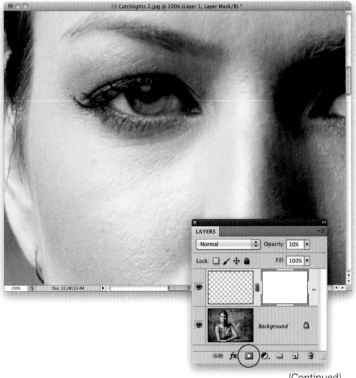

(Continued)

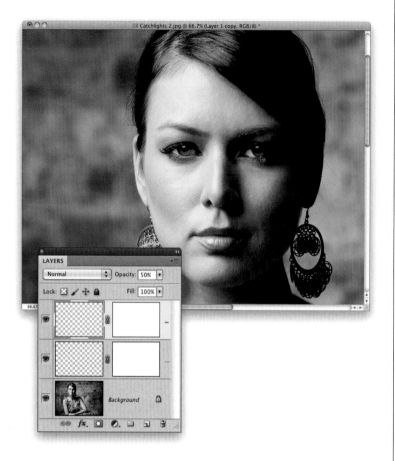

Step Nine:

You'll need to raise your layer Opacity back up a bit, so the catch light looks natural (here I raised mine from 30%, which was low enough for me to easily see through so I could erase the overlap, to 50%, where it looks natural). Of course, at this point, we've only done one eye, so press **Command-J (PC: Ctrl-J)** to duplicate the catch light layer, and with the Move tool **(V)**, drag this duplicate catch light layer over to the eye on the right, so it gets a similar catch light, too (as seen here). Now, when a real catch light goes over part of the pupil (and part of the iris), usually you will see a gradation from light to dark as it goes over the pupil. The pupil absorbs light, so the catch light is usually darker over it. To make your catch light look more natural, lower the Opacity setting on your brush and paint in black on the layer mask over the pupil to darken the catch light. A before and after is shown on the next page, and you can see what a difference adding a catch light can make.

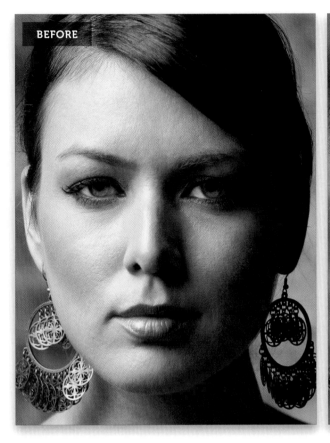

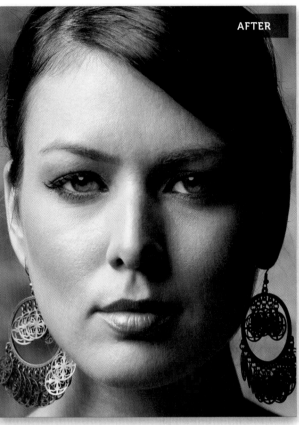

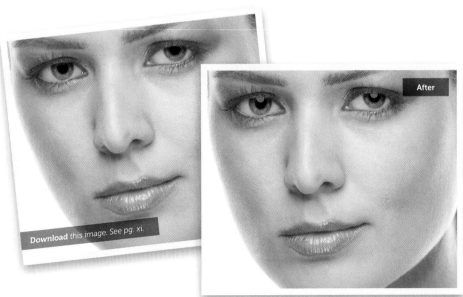

Download this image. See pg. xi.

Try this technique on another image!

Brightening the Whites of the Eyes

This is a retouch I do to every single photo where my subject's eyes are open. It seems like no matter how much light you get into the eyes during the shoot, the whites of the eyes end up off-white at best, but usually a light gray. This is one of those retouches that you just have to do once or twice—even if you think the eyes look white enough—because once you see the difference, you'll do this every single time. It makes that big a difference.

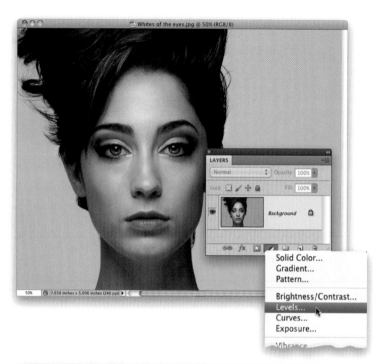

Step One:

I'm going to show you two different methods for brightening the whites of the eyes. Here's the first image we're going to work on. It's pretty well lit, but as is often the case, the whites of her eyes look almost gray (or off-white at the very least). So, start by clicking on the Create New Adjustment Layer's icon at the bottom of the Layers panel and choosing **Levels** (as shown here). By the way, it doesn't really matter which adjustment you add at this point—we just need some adjustment layer, any adjustment layer, so we can change its blend mode. Why not just duplicate the Background layer? Because doing it this way doesn't add any size to your Photoshop document, which keeps Photoshop running faster. Hey, it all adds up. (Again, you can download this image from the website mentioned in "Seven Things You'll Wish You Had Known Before Reading This Book." While you're there, why not read the six other things? ;-)

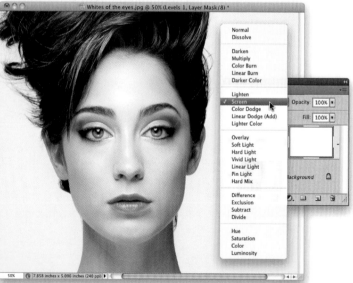

Step Two:

At the top of the Layers panel, change your blend mode for this adjustment layer from Normal to **Screen**. The Screen blend mode makes your image much brighter (compare the brighter image shown here with the one in Step One and you'll see what I mean).

Step Three:

The problem with our image at this point is we only want the whites of her eyes brighter (and maybe her irises), but not her skin or anything else. So, we'll have to do some simple masking. Start by pressing **Command-I (PC: Ctrl-I)**, which inverts the layer mask, making it black and hiding the brightening brought on by changing the blend mode to Screen.

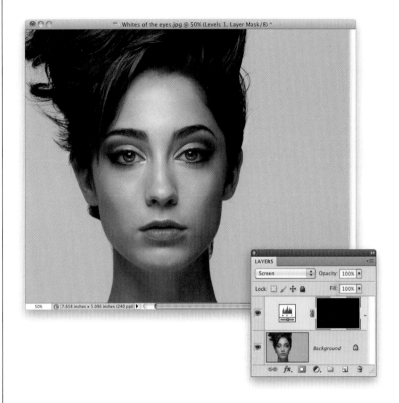

Step Four:

Zoom in on one of the eyes, press **X** to switch your Foreground color to white, then press **B** to get the Brush tool. Choose a very small, soft-edged brush from the Brush Picker in the Options Bar, and begin painting over the whites of the eyes (as shown here, where I'm painting over the left side of the eye on the left). As you paint, this area becomes much brighter, because you're revealing the Screen layer you applied earlier.

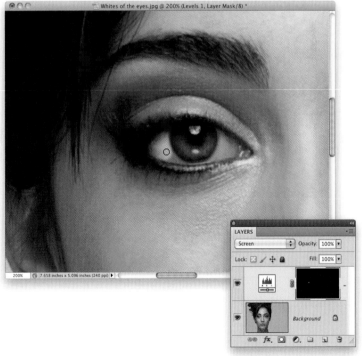

(Continued)

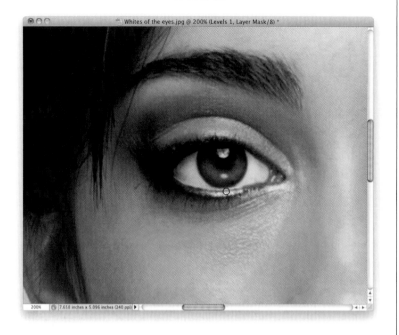

Step Five:

The tricky part of this technique comes when you try to paint that little bit of white that appears right below the iris. It's just so tiny that getting in there and doing it without spilling over onto the edge of the iris, or the bottom eyelid, is really a pain. So, what's the solution? Don't worry about it—just paint right over the whites, and if your brush extends over onto the iris or the bottom eyelid (like you see here), it's okay. The reason it's okay is I've found it's much easier to erase the spillover than it is to try to paint it just right with a super-small brush. After all, you've already got a layer mask applied; to clean this up will be a five-second fix (as you'll see in the next step).

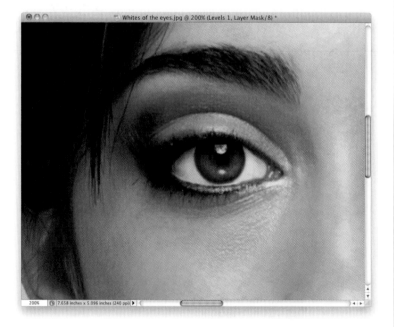

Step Six:

To get rid of the spillover (brightening of the iris or lower eyelid), just press the letter **X** to set your Foreground color to black, then paint over the spillover to remove it (as shown here). It couldn't be easier or faster. When you're done, just press X again to swap your Foreground and Background colors, making white your Foreground color again. Now, move over to the other eye and do the same thing.

Step Seven:

When you're done painting over both eyes, they'll probably look too white (giving your subject a freaky, possessed look), so in most cases, leaving the Opacity of this layer at 100% is unlikely. The best way to judge how white the whites of the eyes should be is to zoom out (like you see here), then lower the Opacity of this layer to around 50% and see how that looks. If it's still too bright, lower it a little bit more. The Opacity slider becomes your "whiteness amount slider," so just adjust it to where it looks natural, but brighter than it was before. A before/after is shown on the next page (I painted over the irises a little bit, too. They looked a little dark). Then, I'll show you an alternative that offers a little more control (because you don't have much control over how bright Screen mode is). This alternative method lets you make things brighter in either the midtones, highlights, or both.

TIP: Brightening the Entire Eye Socket

If you need to lighten the entire eye socket area, you can use the Screen blend mode, but in a slightly different way. Press **Command-J (PC: Ctrl-J)** to duplicate the Background layer, then change the blend mode to **Screen** to make the whole image brighter. Option-click (PC: Alt-click) on the Add Layer Mask icon in the Layers panel to hide this brighter version behind a black mask. With your Foreground color set to white, get the Brush tool **(B)**, and choose a medium-sized, soft-edged brush set to 100% Opacity. Now, paint over her eyes and the surrounding eye socket areas. I know she looks like she's been lying in the sun with sunglasses on, but we'll fix that by lowering the layer's Opacity until the brightening matches the rest of her face. If any edges look brighter, switch your Foreground color to black and paint right over them.

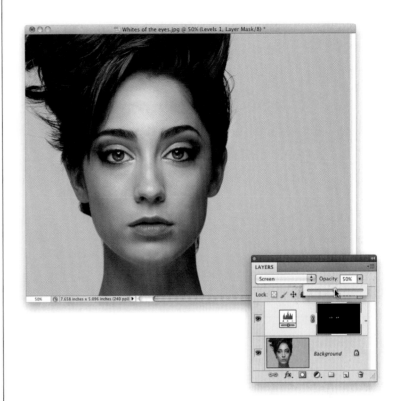

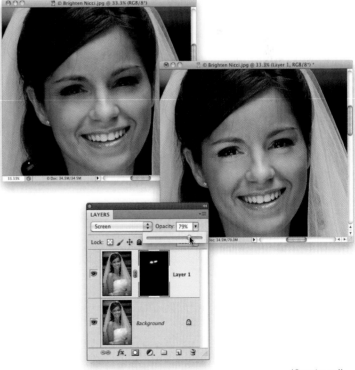

(Continued)

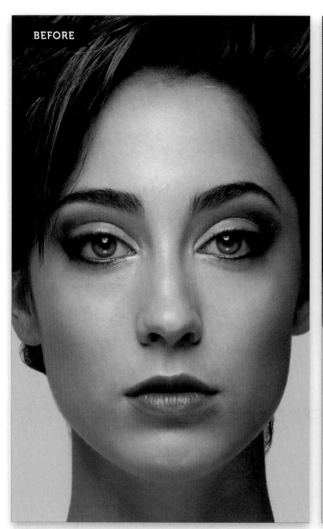

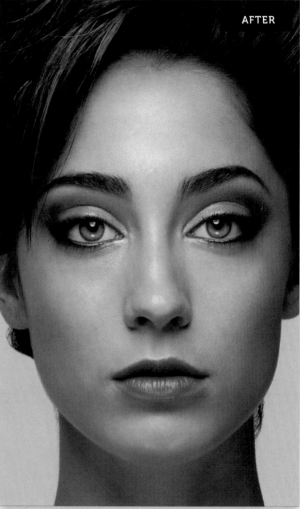

Step Eight:

The alternative technique actually uses the options in the Levels adjustment layer (but we leave the blend mode set to Normal). Doing it this way, you can really adjust the whites just the way you want them—adjusting the highlights and midtones, either together or separately. Here's the image we'll use for this technique.

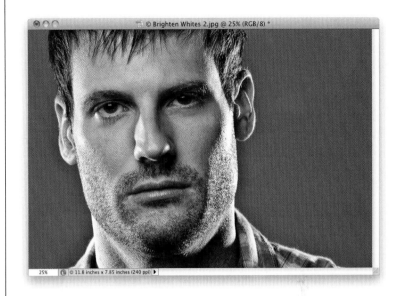

Step Nine:

Choose **Levels** from the Layers panel's Create New Adjustment Layer icon's pop-up menu and then, in the Adjustments panel, drag the highlights Input Levels slider (the white triangle under the right side of the histogram) to the left quite a bit. If you want to make the whites of the eyes really bright (like this photo needs), drag the center midtones Input Levels slider to the left, as well (as shown here). You can see the whole photo is really bright now and that it's a different, edgier kind of bright than Screen mode brings. (By the way, which method is "right?" That's easy—the one that looks the best to you. If you try the Screen method and don't like the results, then try this Levels method, or vice versa.)

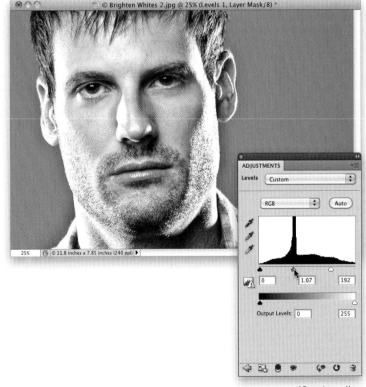

(Continued)

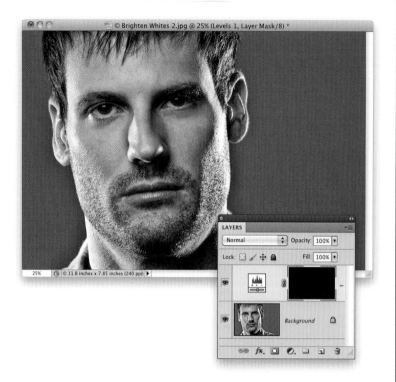

Step 10:
Press **Command-I (PC: Ctrl-I)**, which inverts the layer mask, making it black and hiding the Levels brightening behind that mask.

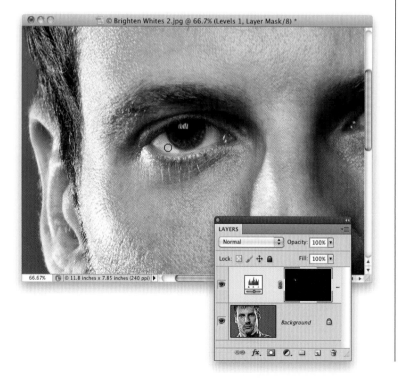

Step 11:
Zoom in on one of the eyes, make sure your Foreground color is set to white, then press **B** to get the Brush tool. Choose a very small, soft-edged brush from the Brush Picker, and begin painting over the whites of the eyes (as shown here, where I'm painting over the left side of the eye on the left). Basically, you're going to follow the same steps as before—including painting over the bottom eyelid, so you can get the whites under the iris, and then painting the spillover away, then painting the other eye, and then zooming back out and lowering the opacity. So, the rest of the technique is pretty much the same, but the actual whitening uses Levels instead of Screen. The good news is that now you have two techniques for whitening eyes in your bag of tricks, rather than just one.

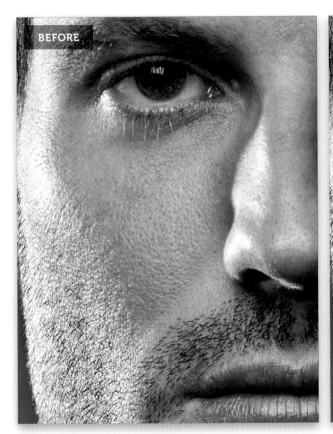

Try this technique on another image!

Download this image. See pg. xi.

Removing Eye Veins

Over the years, I've tried just about every trick for "getting the red out" and removing red eye veins—everything from the Healing Brush, to the Patch tool, to the Clone Stamp—but I don't think any of them work nearly as well as this simple, fast technique that removes all the veins, yet leaves the eyes looking clean and clear. This is also a great technique for removing contact lenses visible in your subject's eyes.

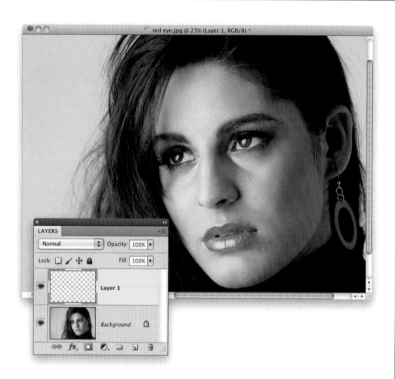

Step One:

Here's the image we're going to retouch, and if you look at the eye on the right, you can see some red veins that need to be removed. We're at a 25% magnification here, but you're going to need to zoom in to at least 100% to really see what you're working on, so grab the Zoom tool **(Z)** and zoom in on the eye on the right. Then, click on the Create a New Layer icon at the bottom of the Layers panel to create a new blank layer.

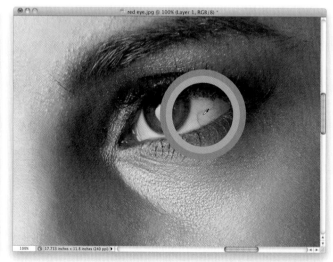

Step Two:

You're going to remove these red veins using two tools: the Brush tool and the Eyedropper tool. So, get the Brush tool **(B)**, then press-and-hold the Option (PC: Alt) key and your cursor will temporarily switch to the Eyedropper tool, so you can sample any color in your image to instantly make it your Foreground color. You're going to want to click the Eyedropper tool right near the red vein you want to remove (as shown here, where I'm clicking the Eyedropper tool right below the vein I want to remove). A large circular ring appears around your Eyedropper tool when you click—the inside of the ring shows the exact color you just sampled and the outside of it is a neutral gray to help you see the color without being influenced by surrounding color (but just for the record, I don't think that idea actually works—at least not with that small a ring, but hey, that's just me).

Step Three:

Let go of the Option key to return to the Brush tool, set your brush Opacity (up in the Options Bar) to 20%, and choose a small, soft-edged brush that's just a little bit larger than the vein you want to remove. Now, just start painting a few strokes right over the vein, and in just moments—it's gone! Remember, at 20% opacity, the paint builds up, so you have a lot of control as you build up your paint over the vein, so don't be afraid to go over the same stroke more than once. Since the eye itself is a sphere, the shading changes as you move across the eye, so be sure to sample again near what you're painting over as you're removing these veins, so the color and tone stay right on the money (I resampled about 10 or 12 times during this retouch).

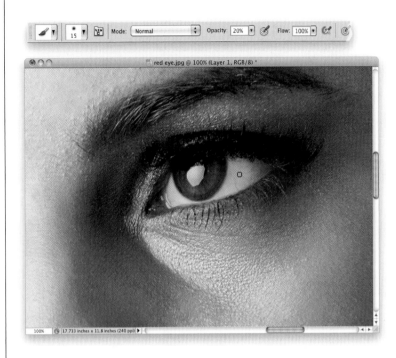

Step Four:

Lastly, to keep the whites of the eyes from looking pasty after your retouch, we're going to add a tiny bit of noise to your retouch layer. Go under the Filter menu, under Noise and choose **Add Noise**. When the filter dialog appears, choose 1%, click on the Uniform radio button, and turn on the Monochromatic checkbox. Click OK to add this texture to your retouch. Although it's subtle, it does make a difference. A before/after is shown on the next page.

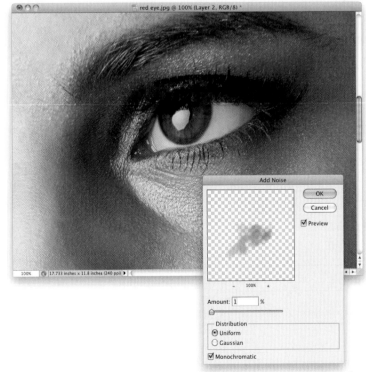

(Continued)

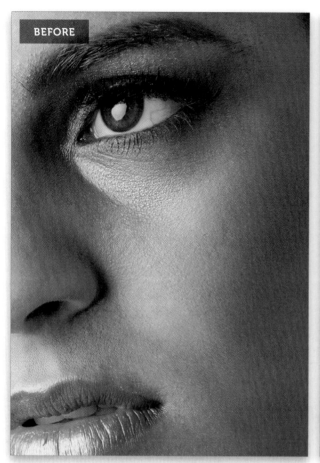

BEFORE

AFTER

Download this image. See pg. xi.

After

Try this technique on another image!

Changing Eye Color

While you wouldn't normally change your subject's eye color if you were just shooting a portrait for them, if you're shooting for a client, the art director might call on you to change eye color to match the color of an outfit, or a scene, or for just about any reason at all. Luckily, this is usually one of the easiest retouches to pull off.

Step One:
In this image, our subject has hazel eyes and we want to change them to blue. So, start by clicking on the Create New Adjustment Layer icon at the bottom of the Layers panel and choosing **Hue/Saturation** from the pop-up menu.

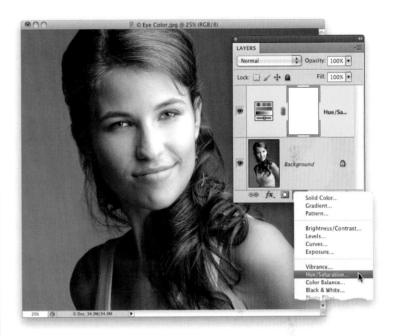

Step Two:
Zoom in on the eye on the right and then, to choose a new eye color, start by turning on the Colorize checkbox in the Adjustments panel. Choose a blue color by dragging the Hue slider to the right to a blue hue. Here, I dragged the Hue slider over to 234. Of course, this makes the entire image appear blue, but we'll deal with that in the next step. For now, my concern is that the blue is too vibrant and artificial looking, so to take the intensity of the blue down, lower the Saturation amount to just 10. Lastly, you can control the brightness of the blue using the Lightness slider. Here, I just tweaked it a tiny bit by lowering the Lightness to –2, which just darkened up the blue a bit.

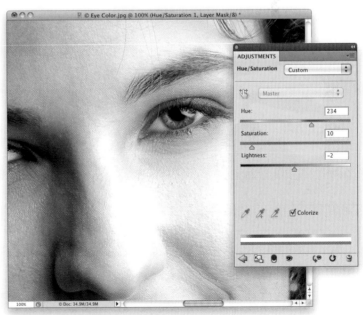

(Continued)

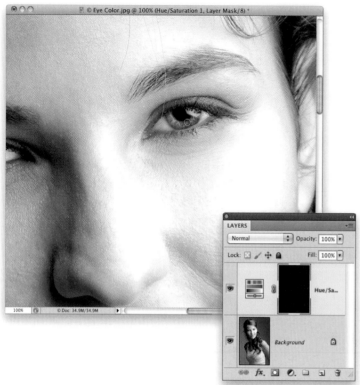

Step Three:
To keep the entire photo from having this blue tint, just press **Command-I (PC: Ctrl-I)**, which inverts the layer mask on the adjustment layer, making the mask black and hiding the blue tint behind it. Now, get the Brush tool **(B)**, choose a small, soft-edged brush from the Brush Picker, make sure your Foreground color is set to white, and paint over just the iris (avoiding the black pupil, as shown here). As you paint, the eye takes on that blue tint (as seen here).

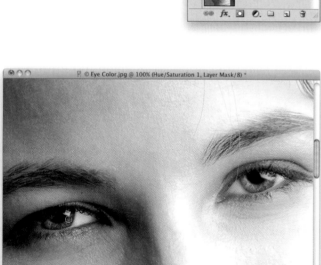

Step Four:
Here's how it looks when you paint in the other eye, as well. Because you lowered the Saturation and tweaked the Lightness, the blue color looks very natural. Of course, you still have the option of backing off that blue a bit by lowering the Opacity of the adjustment layer at the top of the Layers panel.

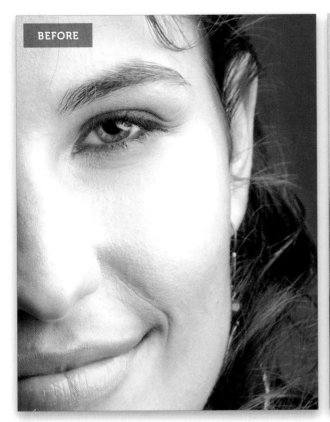

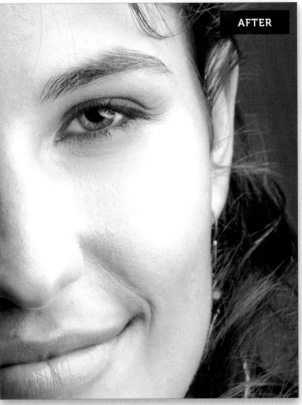

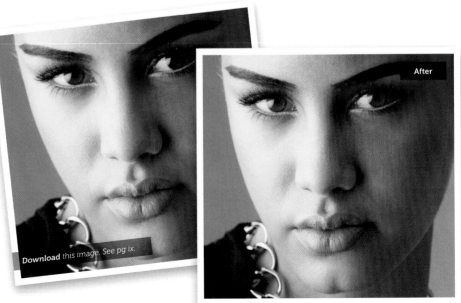

TIP: When changing the color of dark eyes, you may need to drag the Lightness slider to the right a tiny bit in the Adjustments panel. Don't take it too far, though, or it'll just look fake.

Reducing Dark Circles Under Eyes

Although you don't see this on the cover of magazines, most people have dark circles under their eyes. In fact, as long as your subject isn't four years old, it's almost a certainty that they're going to have some kind of dark circles under their eyes. And, depending on the lighting you use, you can make them less noticeable, or more so, but they're almost always there. Here's not only how to reduce or remove them, but how to deal with one of the most annoying side effects of using the Healing Brush (or the Patch tool) to do this type of retouch.

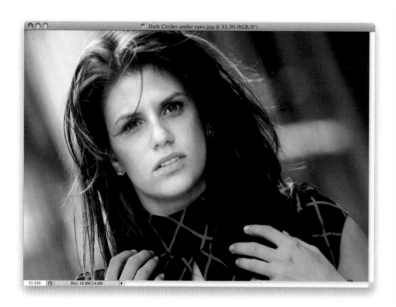

Step One:
Open a photo that has dark circles beneath the eyes that you want to lessen (you have to choose whether you want to reduce them or remove them all together. You'll have to make the call based on the subject's age—if they're over 30, just reduce them).

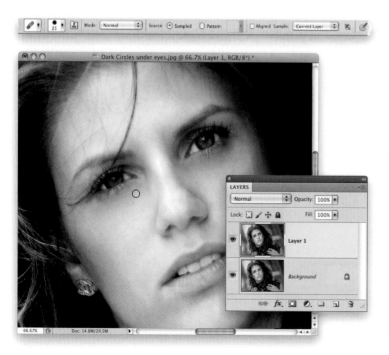

Step Two:
Start by zooming in on the eye area and then pressing **Command-J (PC: Ctrl-J)** to duplicate the Background layer (so we're working on a copy of the Background. This is important, because we're going to use this layer to control the amount of removal later on). Get the Healing Brush tool (press **Shift-J** until you have it) and, in the Options Bar, choose a small, hard-edged brush from the Brush Picker, and make sure the Sample pop-up menu is set to **Current Layer**. Now, totally remove the dark areas by Option-clicking (PC: Alt-clicking) in a nearby area that has kind of the same skin tone as where the dark areas are (usually just below the dark area). Then, paint over the dark areas (and wrinkles) to get completely rid of them as best you can (as seen here). It looks a little artificial at this point (though, you see this look on magazine covers all the time), but we'll adjust that later. For now, just remove the dark areas.

Step Three:

Although the Healing Brush does a pretty decent job of getting rid of the dark areas, it usually leaves kind of a smeared dark area under the eye, which stinks, because you're trying to remove the dark circle, right? So, this retouch usually requires two tools: you start with the Healing Brush (like we just did in Step Two) and then you switch to the Clone Stamp tool. So, get the Clone Stamp tool **(S)** from the Toolbox, then go up to the Options Bar, lower the Opacity of it to around 40%, then change the Mode pop-up menu to **Lighten** (that way, when you use the Clone Stamp tool, you'll only affect areas that are darker than the area you sampled).

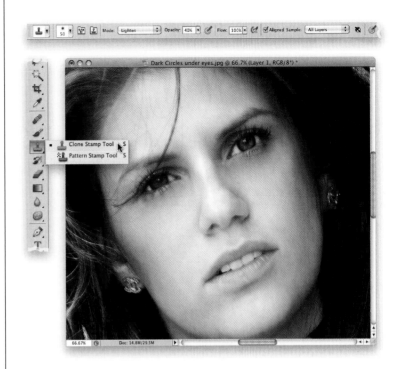

Step Four:

Press-and-hold the Option (PC: Alt) key and click once in an area near the eye that isn't affected by the dark circles. If the cheeks aren't too rosy (like in this image), you can click there to sample, but more likely you'll sample an area just below the dark circles under the eyes.

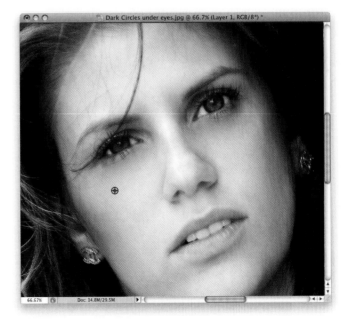

(Continued)

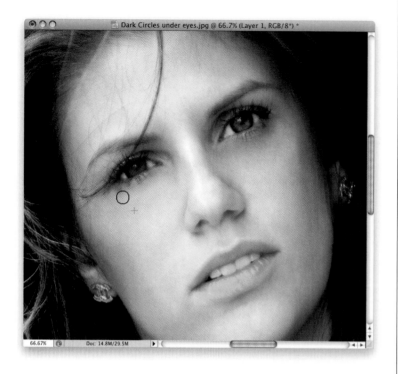

Step Five:

Now, take the Clone Stamp tool and paint a stroke (from left to right) over the dark circles to lessen or remove them. It may take two or more strokes for them to pretty much disappear (go right, then back to the left, and so on), so don't be afraid to go back over the same area again, if the first stroke didn't work.

Step Six:

You can control the amount of dark circle area and wrinkles appearing under the eye by lowering the Opacity of the top layer. Here, I've lowered it to 60%, so just a little tiny bit of the natural dark circle area and wrinkle appear, and of course, the whole retouch now looks much more natural. That being said, remember—there may be situations where, as the retoucher, you decide that for a particular subject (or intended use) you don't want any dark circles or wrinkles to appear whatsoever. If that's the case, just leave the layer opacity at 100%. But, that's a call only you can make. A before and after (at 60% opacity) is shown on the next page.

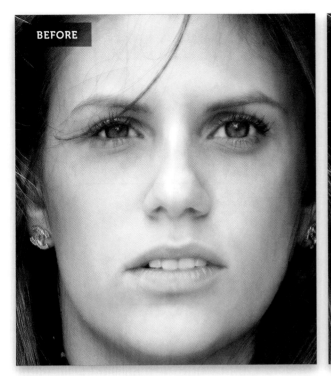

BEFORE

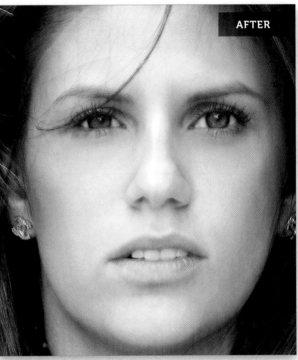

AFTER

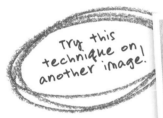

Try this technique on another image!

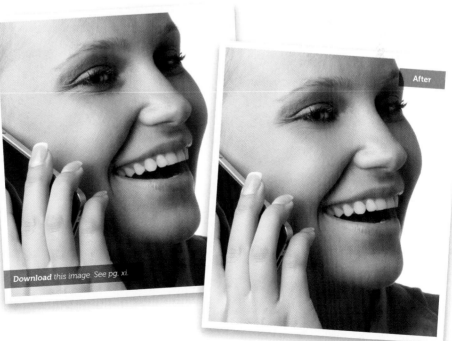

After

Download this image. See pg. xi.

Making Eyes Larger (or Smaller)

This is a very common retouch, especially in fashion or glamour images, because big eyes really draw a viewer's attention (and we generally seem to love big eyes. Look at any Disney cartoon and notice the size of the eyes in their drawn characters. They're huge! But they're huge because they look great). Here's how to make your subject's eyes a little bit larger and how to use a slightly different technique if your subject has...ahem...bug eyes.

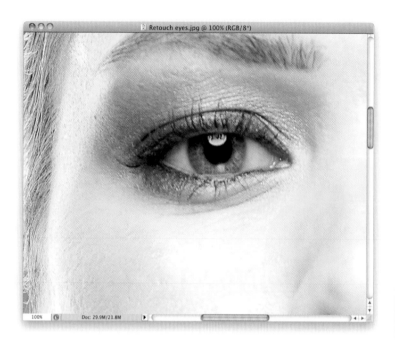

Step One:

Here's a regular-sized eye we want to enhance by making it larger. (By the way, if you want to download the images I'm using here in the book to follow along with, I provided the URL for the book's companion website in the front of the book in "Seven Things You'll Wish You Had Known Before Reading This Book." See? This is one of those things.)

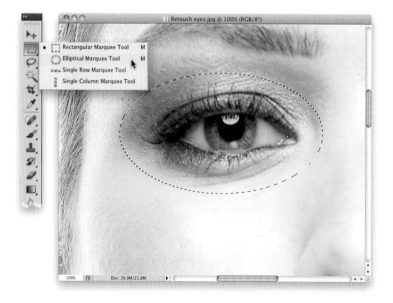

Step Two:

Get the Elliptical Marquee tool from the Toolbox (or press **Shift-M** until you have it. Honestly, I don't know anybody who calls it that. We all just call it the "Round Selection" tool), and make an oval-shaped selection around the eye, like you see here. Make sure you fully enclose the eyelashes inside your selected area, but don't make the selection any larger than necessary—make it pretty much like the size you see here. If you need to move the selection around as you're creating it, just press-and-hold the Spacebar.

Step Three:
To help hide the retouch, we're going to soften the edge of our selection by adding a feather to it. Go under the Select menu, under Modify, and choose **Feather** (as shown here). In the Feather Selection dialog, enter 10 pixels and click OK. This softens the edge all the way around the oval, so you won't see a hard edge around the area we're about to adjust.

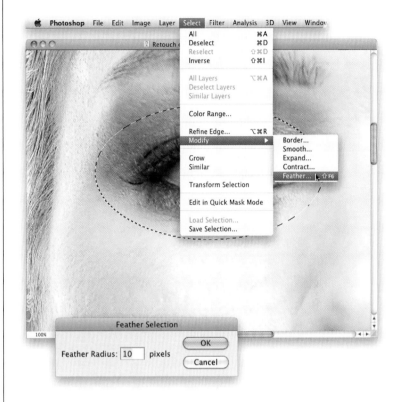

TIP: Feather Selection Shortcut
We use feathering a lot throughout this book, so you might as well learn the keyboard shortcut now to save you loads of time later—it's **Shift-F6**. If you hate that keyboard shortcut (I do), you can create a custom shortcut by going under the Edit menu and choosing **Keyboard Shortcuts**. On the Keyboard Shortcuts tab of the Keyboard Shortcuts and Menus dialog, click on the right-facing arrow to the left of Select and scroll down to Modify. Click on the existing shortcut for Feather, type in a new one (mine's Command-Option-Shift-F), and click OK.

(Continued)

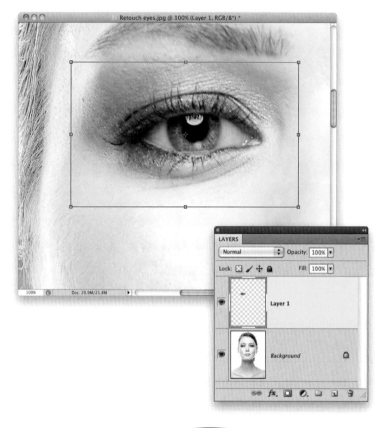

Step Four:

Now, you're going to copy that selected area of the eye up onto its own separate layer. So, press **Command-J (PC: Ctrl-J)** to do that and then press **Command-T (PC: Ctrl-T)** to bring up Free Transform, which puts a bounding box around your eye copy layer (as seen here).

Step Five:

In the Options Bar, you'll see W (width) and H (height) fields. First, click on the little link icon that appears between the two fields to link them together, so when you type in a width, the height will increase the same exact amount. Now, enter a percentage of how much larger you want the eye. Start with 104% (which is actually just 4% larger) and you see the entire eye grow in size. By the way, 4% may not sound like a lot, but it's actually a fairly large move, as you'll see when you try it yourself. I've increased as much as 6%, but usually anything above that, and it can start to look kind of obvious. But, of course, it depends on the image, so use your best discretion. If 9% or 10% looks good, go for it. Press **Return (PC: Enter)** to lock in the transformation.

Step Six:

Because we feathered the edges of the oval selection, it's fairly likely that, at first, you won't see any edges overlapping whatsoever. But if you zoom in tighter, you might see a little extra skin from the larger eye overlapping a bit. If you do, it's easy to fix. Just click on the Add Layer Mask icon at the bottom of the Layers panel (shown circled here in red). Press **X** to set your Foreground color to black, then press **B** to get the Brush tool, and choose a medium-sized, soft-edged brush from the Brush Picker in the Options Bar. Now, just paint over the edges of the larger eye to blend them smoothly away and into the original skin surrounding the eye on the Background layer. You might have to go all the way around the eye, but just try not to erase the eyelashes. Everything else outside that is fair game.

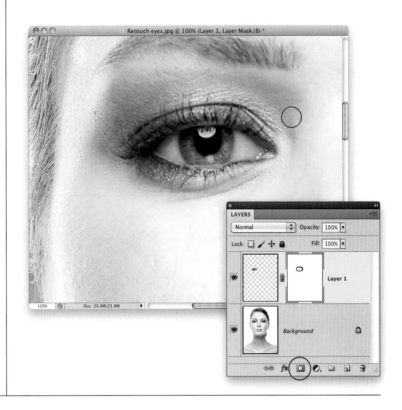

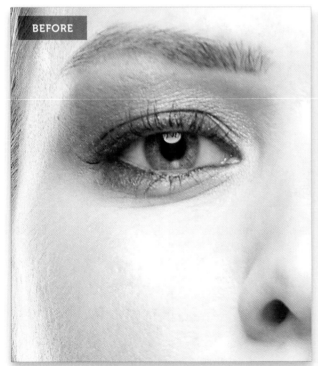

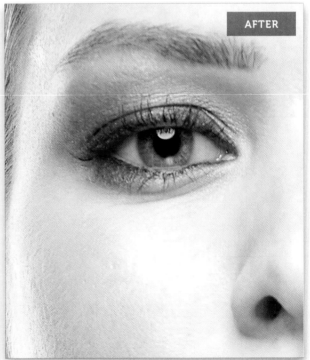

(Continued)

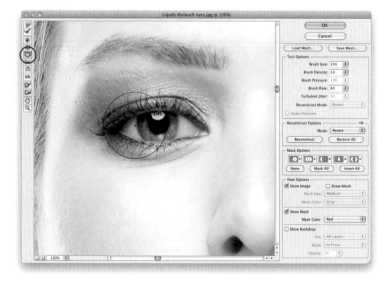

Step Seven:

Another way to increase eye size is to use the Liquify filter. This way works best if you just want to increase the iris itself, and not the rest of the eye and eyelashes, but you can make it work to increase the entire eye (like we just did) if you want. So, start by going under the Filter menu and choosing **Liquify** (it's right near the top of the list) to bring up the Liquify dialog you see here. Get the Zoom tool **(Z)** from the Toolbox in the top left of the dialog and zoom in on an eye.

Step Eight:

Now, get the Bloat tool **(B)** from the Toolbox (it's the fifth tool down, shown circled here in red) and make your Brush Size a little larger than the eye itself. Here's another keyboard shortcut you're going to want to know, because you'll be changing brush sizes quite a bit inside this dialog: Press-and-hold the **Shift key** and then press the **Left Bracket key** to make the brush smaller or the **Right Bracket key** to make it larger (the bracket keys are to the right of the letter P on your keyboard). This shortcut decreases/increases the brush size in increments of 20. Here, I had to press Shift-Right-Bracket key a few times to make my brush really large. (*Note:* If you're not comfortable with the keyboard shortcuts, you can use the Brush Size slider, which is near the top right of the dialog, in the Tool Options section.) Now, move your brush over the left side of the eye and click twice to increase the size of that side of the eye.

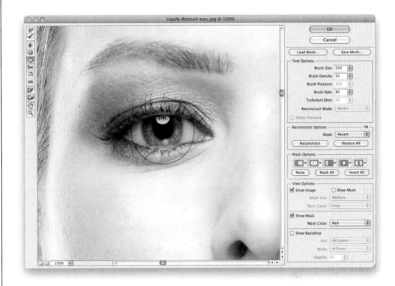

Step Nine:

Move your brush over the center of the eye, click twice again, and that area increases in size. (By the way, if you just wanted the iris bigger, you'd start in the middle and click two or three times to increase just the size of the iris. This brush kind of bulges from the center out, so it works great for making just the iris larger.) Because each click makes the eye bulge out a little larger, you want to move evenly from left to right, so if you click once on the left side of the eye, then you want to be consistent as you move across the eye to the right—click once each time. If you click twice on the left (like we did here), then you need to click twice each time as you move across the eye, so it looks even. Don't paint with this tool, just click. When you reach the far right, if it looks good to you, click the OK button. Also, if you mess up (sometimes you'll click once, and it applies like 10 clicks at once), just press **Command-Z (PC: Ctrl-Z)** to undo that click, then do it again. See the next page for a before and after using Liquify.

(Continued)

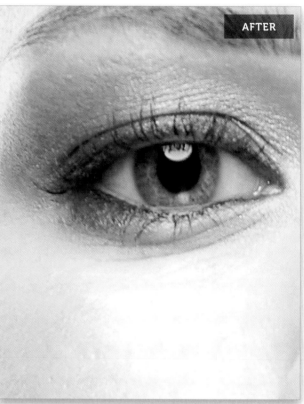

BEFORE

AFTER

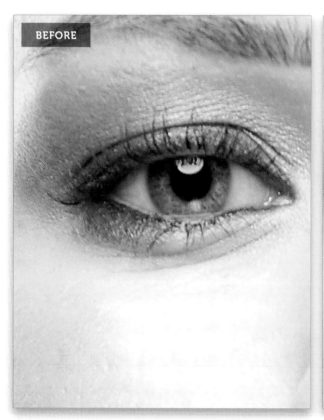

Download this image. See pg. xi.

After

Try this technique on another image!

Swapping One Eye for the Other

If your subject has one eye that is larger, smaller, or open more than the other eye, or if they have a "lazy eye" or any other physical reason where you'd want to swap one eye for the other (including the very common instance where your subject's hair is covering one eye, and where it would be too hard or too time consuming to repair), here's a tried and true way to use one eye to fix the other:

Step One:

Here's the image we're going to retouch, and if you look at her eyes, you'll see that the eye on the right is open wider than the one on the left. So, what we're going to do is use a copy of the one on the right to fix the one on the left, so that they're both open the same amount.

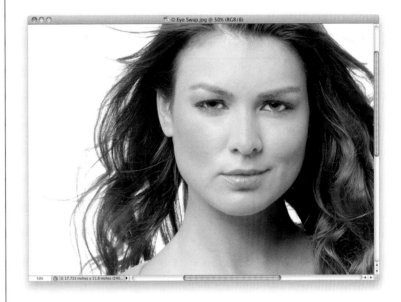

Step Two:

Start by getting the Zoom tool **(Z)** and zooming in on the eyes. Then, with the Elliptical Marquee tool (press **Shift-M** until you have it), make a selection around the entire eye on the right. It's okay if you get a lot of extra area around it— it doesn't matter at this point, we'll deal with that later. For now, just drag out your selection around the entire eye like you see here. By the way, we won't need to feather this selection, because we're going to mask the excess eye area away later with a soft-edged brush.

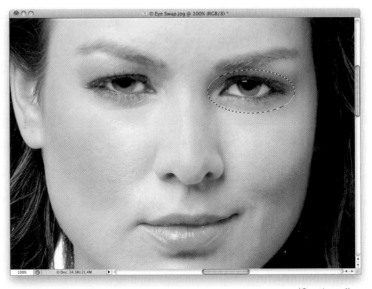

(Continued)

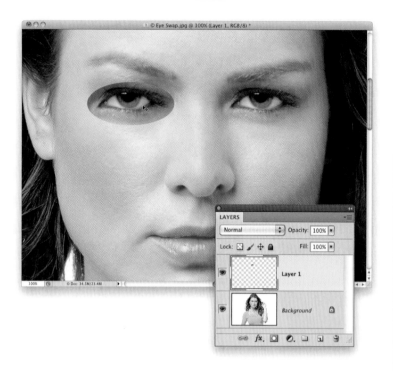

Step Three:

You're going to need to put the selected area up on its own separate layer, so press **Command-J (PC: Ctrl-J)**. Get the Move tool **(V)** and drag this copied eye area on the right over so it covers the eye on the left (as shown here). The lighting on the eye on the right is different than it is on the one on the left, so it's really going to stand out a lot (as seen here), but we'll deal with that in just moment. For now, just kind of get that copied eye in the area of the one on the left. Now, you're probably concerned about more than just the lighting on the copied eye, because now our subject has two left eyes (which looks kinda creepy), so we'll fix that in the next step.

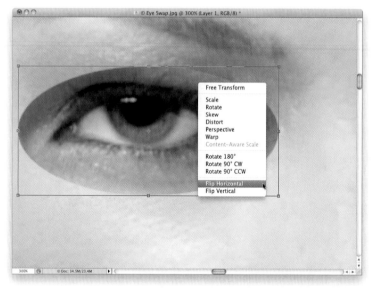

Step Four:

Zoom in more on the eye on the left and then press **Command-T (PC: Ctrl-T)** to bring up Free Transform. Right-click anywhere inside the Free Transform bounding box and a pop-up menu of transformations appears. Choose **Flip Horizontal** from this menu (as shown here) to flip this copied eye horizontally, so it becomes a left eye. Don't press Return (PC: Enter) to lock in the transformation just yet, though.

Step Five:

Here's the copied eye layer after it's been flipped horizontally, and you can see it now looks like a right eye (though there's still some work to be done).

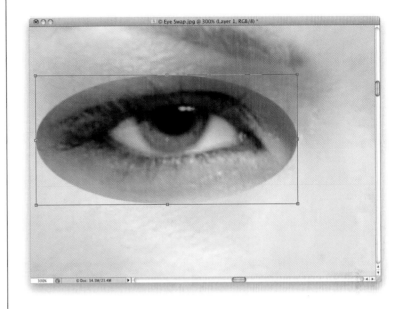

Step Six:

Now we have to align this new eye so it fits perfectly over the old eye (if it's too high, or too far to the left or right, it will look weird). The trick is to, while the Free Transform bounding box is still in place, go to the Layers panel and lower the Opacity of this layer, so you can actually see through the layer (in this case, I lowered it to 43%). That way, you can see the original eye (on the layer below), which you can now use to align the two eyes (use the iris as a guide). Drag it to where it's fairly close, then use the **Arrow keys** on your keyboard to nudge it perfectly into place. Once you get it pretty close, I find it's helpful to lower the Opacity to 0, then back up to 100%, and compare how it looks. You shouldn't see a whole lot of movement when you hide and reveal the copied eye from 0% to 100%. If you see much movement (like it moves left or right, or up or down), you don't have it properly aligned, so try lowering the Opacity even more and try again.

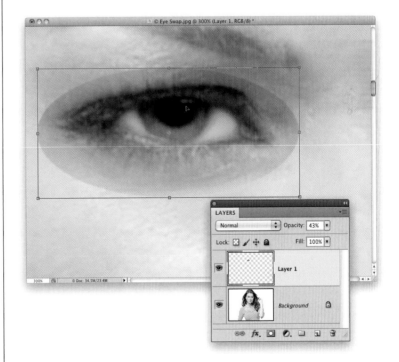

(Continued)

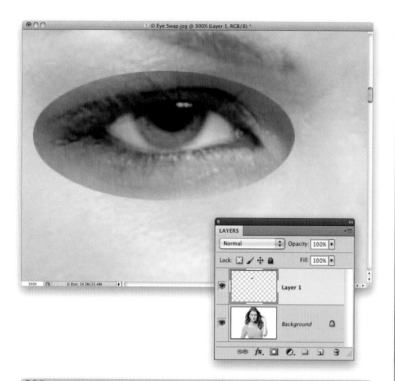

Step Seven:

Once you feel like you've got them pretty well lined up, then you can raise the Opacity back to 100%, press **Return (PC: Enter)** to lock in your transformation, and you're ready to move on. Two quick things: (1) I leave Free Transform in place while I'm nudging things around in case I need to tweak the size of the copied eye a bit to match. Sometimes I need to make it a tiny bit bigger or smaller, depending on which way my subject is facing, or which eye is closest to the camera. And (2) I usually show/hide the eye a few times at this point just to make sure it's right on the money (click on the Eye icon to the left of your copied layer to show/hide it).

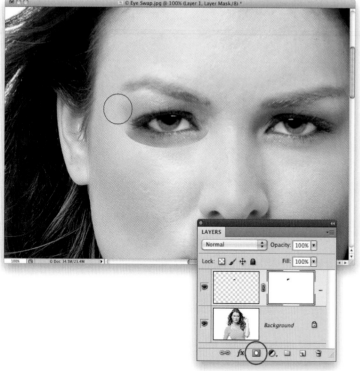

Step Eight:

Now, we're going to get rid of the excess area around the eye. First, click on the Add Layer Mask icon at the bottom of the Layers panel (it's shown circled here in red). Then, get the Brush tool **(B)**, choose a large, soft-edged brush from the Brush Picker in the Options Bar, and with your Foreground color set to black, gently paint over the excess area around the eye, so just the eye remains. Here, I'm painting over the top-left side of the copied eye (I zoomed back out a little so I could see what I was doing better). You'll be surprised how easy this is using a large, soft-edged brush. Because the edges of the brush are so soft, it's easy to just paint away the edges while staying far away from them, and letting the outside edge of your brush do all the work.

Step Nine:

Continue painting around the outside of the eye with your black, soft-edged brush, until just the eye itself is left, and all the excess has been brushed away (as seen here).

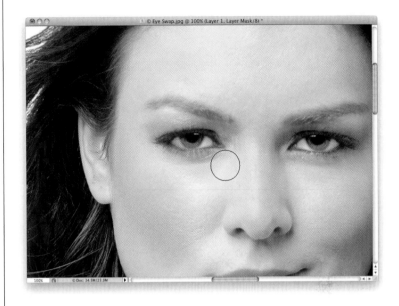

Step 10:

Now, it's time to hide your tracks a bit. One dead giveaway that you've done an eye swap is that the catch light in the new eye on the left is on the wrong side of the eye. Since the copied eye was flipped, your catch lights are now cross-eyed (a dead giveaway), so you'll have to move the catch light itself to the other side of the eye (don't worry—it's easier than it sounds). First, let's create a merged layer, which is a new layer that looks like a flattened version of our image. That way, if we need to go back to this layer again, for whatever reason, it's still there. So, press **Command-Option-Shift-E (PC: Ctrl-Alt-Shift-E)** to create a new merged layer at the top of the layer stack. Then, get the Elliptical Marquee tool again, and drag out a small circular selection around the catch light in the copied eye, with a few extra pixels of black around the outside (as shown here).

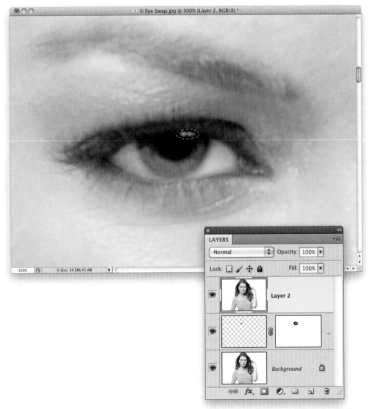

(Continued)

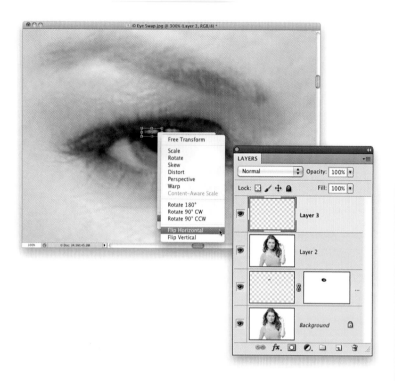

Step 11:

Press Command-J (PC: Ctrl-J) to put this catch light up on its own separate layer and then press Command-T (PC: Ctrl-T) to bring up Free Transform. With the Move tool (V), drag this catch light copy straight over to the left side of the pupil to where it should have been if we hadn't faked it. Now, Right-click anywhere inside the Free Transform bounding box, and choose Flip Horizontal from the pop-up menu (that's right—we're going to flip that catch light back to how it would have looked in the original eye on the left). Press Return (PC: Enter) to lock in your transformation.

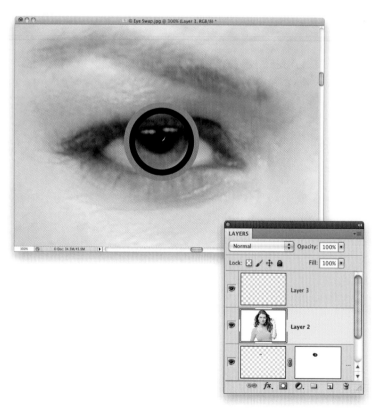

Step 12:

In the Layers panel, click on Layer 2 (the layer with the backwards catch light) to make it active. You can either use the Eyedropper tool **(I)** and click anywhere on the pupil to sample its color (as shown here), and then simply paint over the old catch light using a very small, soft-edged brush, or you can use the Clone Stamp tool **(S)** to clone part of the pupil over the old catch light. Either method will work, so choose whichever is more comfortable to you.

Step 13:

Here, I used the Clone Stamp tool to do my dirty work. I Option-clicked (PC: Alt-clicked) on the pupil to use that as my cloning source (the area I'm going to use to clone over my old catch light), then I painted directly over the old catch light (as seen here) to clone the sampled pupil right over it. (If this doesn't work for you, in the Options Bar, make sure you have the Mode set to **Normal** and **All Layers** selected in the Sample pop-up menu.) The final thing I usually do is to just clone away one or two of the eye-lashes on Layer 2, so the two eyes don't have identical eyelashes. I've found just cloning away one or two makes it look different enough. See a side-by-side comparison on the next page.

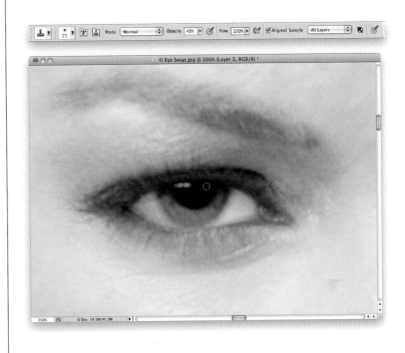

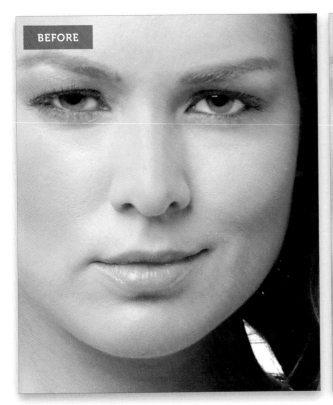

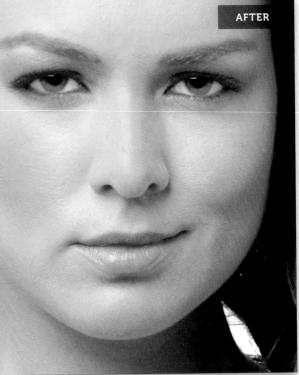

(Continued)

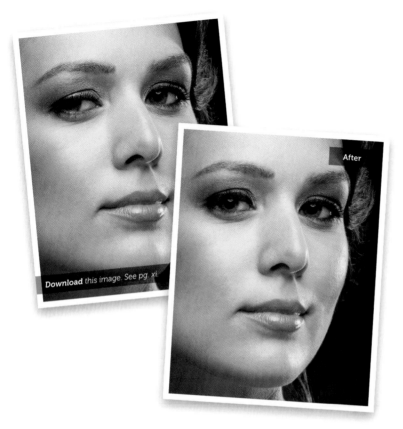

After

Try this technique on another image!

Tip: This second practice image is tricky, because she's not facing the camera directly, so if you use the technique as is, she'll look cross-eyed. Here's how to get around that: At the end of Step Three, add a layer mask and erase the eye itself, leaving just the eyelids and lashes from the copied eye visible. Then, add a new blank layer below that layer. Get the Clone Stamp tool **(S)**, make sure it's set to sample **All Layers** in the Options Bar, then Option-click (PC: Alt-click) on the pupil of the good eye, move over to where the other eye should be, and clone in the good iris and pupil over the other eye. Since they're on their own layer, you can erase any parts that overlap.

Enhancing Eyelashes

Retouching eyelashes is pretty tough, because you basically have to create them. So, to make things easier, I asked my buddy Corey Barker (who's a wizard with Photoshop's brushes) to work with professional makeup artist Shelley Giard to come up with a set of brushes for creating great-looking eyelashes (you get these for free, by the way), including one-click complete lashes. But, his set of brushes also includes individual eyelash hair brushes that work brilliantly (thanks to a little Photoshop trick), and I'll show you the long way, too, using them to create new eyelashes (just in case you're charging by the hour).

Step One:

Here's the image that we want to add some pretty fabulous lashes to (see, this is what happens when you start hanging around makeup artists. You start using words like "fabulous" and "luscious," and other terms you normally wouldn't use while playing *Call of Duty: Black Ops*). We're going to build the eyelashes on their own separate layers, so start by creating your first new blank layer by clicking on the Create a New Layer icon at the bottom of the Layers panel (as shown here).

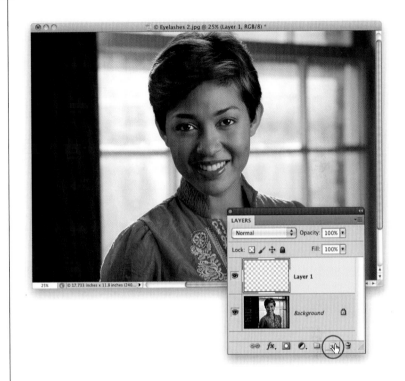

Step Two:

Like I said above, we've created a set of custom eyelash brushes just for you (again, big thanks to Corey Barker and Shelley Giard) and you can download these from the book's companion website (you'll find the address in the book's intro). To get these custom eyelash brushes into Photoshop, first get the Brush tool **(B)**, then click on the Brush icon on the far-left side of the Options Bar (the second icon from the left) to open the Brush Picker. From the Brush Picker's flyout menu, choose **Load Brushes**, and then find the "Scott's Eyelash Brush Set.abr" file that you downloaded (I believe "abr" stands for "Asian Boat Rat") and click Open (PC: Load).

(Continued)

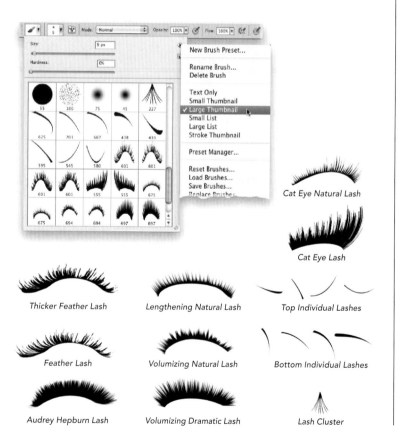

Cat Eye Natural Lash

Cat Eye Lash

Thicker Feather Lash

Lengthening Natural Lash

Top Individual Lashes

Feather Lash

Volumizing Natural Lash

Bottom Individual Lashes

Audrey Hepburn Lash

Volumizing Dramatic Lash

Lash Cluster

Step Three:

These new eyelash brushes will appear at the bottom of the Picker beneath your regular brushes (as seen here. You'll see right- and left-eye versions of each brush). We made the brush sizes really large (some as high as almost 700 pixels), so you can use them on very-high-res images—like 18- to 24-megapixel. The only downside is that if you're not working on very-high-res images like this, you'll have to lower the size of the brush to fit your subject (it's easy enough, though, you just change the Size at the top of the Picker, but it is an extra step). Now, you have to decide if you want to go with some really dramatic eyelashes—maybe some cat-eye eyelashes—or something a bit more conservative. Since she's wearing a pretty conservative outfit (it doesn't look like she's on her way out to a club), we'll go with something a bit tamer. Click on the Feather Lash Right brush we loaded (the first 601 pixel brush, as shown here; the second 601 brush is a similar shape—it's just thicker).

Note: By the way, when you load the brushes and look at their thumbnails in the Brush Picker, they'll appear arched and looked squished in the square thumbnails (you'll see how they're really shaped by looking at your cursor, once you choose a brush). If you want to see them at a larger thumbnail size in the Picker, choose **Large Thumbnail** from the Picker's flyout menu.

Step Four:

Zoom in on the eye on the right of the image and then, in the Brush Picker, lower the Size of this brush until it's about the approximate size of the eye you want to add it to. I move the brush to approximately where I think it might go (as shown here), so I can make a reasonable estimate about how big to make it (in this case, I lowered the slider from 601 pixels down to around 236).

Step Five:

Now, press **D** to set your Foreground color to black, and click once near where you want the eyelash to appear. At this point, it won't be the exact right size, or rotation, or any of that stuff, but we at least need a starting point. So, just click it once (as shown here). Remember, it's on that blank layer you created back in Step One, so you'll have a lot of flexibility about its size and shape after the fact.

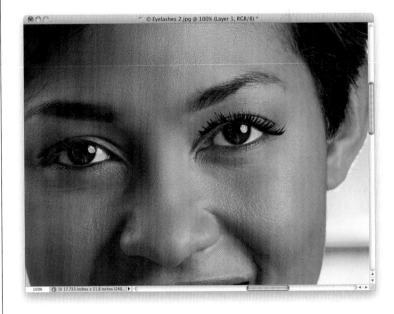

(Continued)

Step Six:
The eyelash needs to be rotated a bit to fit her eye, so press **Command-T (PC: Ctrl-T)** to bring up Free Transform. Click anywhere within the Free Transform bounding box and drag the eyelash, so it's in a better position. Now, move your cursor outside the bounding box, and you'll see that your cursor has changed into a two-headed arrow. Click-and-drag counterclockwise to rotate the eyelash, so it's more in line with the eye (as shown here).

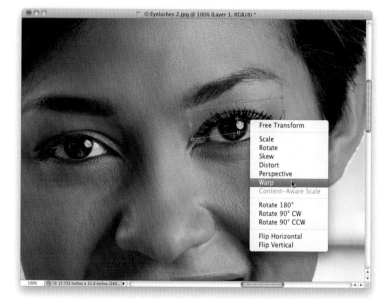

Step Seven:
To make it actually fit the eye perfectly, we're going to warp it. While your Free Transform bounding box is still in place, just Right-click anywhere inside the box, and from the pop-up menu that appears, choose **Warp** (as shown here).

Step Eight:

The cool thing about Warp is that it lets you pretty much treat whatever you're working on (in this case, her eyelash) as if you were using the Liquify filter. You just click anywhere within those nine squares and drag it to reposition it. You don't even have to be clicking on one of those lines— just click-and-drag right on the image, right where you want to move the eyelash, and it'll move and bend like it was liquid (well, less like water, and more like molasses). This lets you pretty much just slide it around until it wraps right around the eyelid (as shown here). I had to nudge it up in the middle to make the eyelash arc more, but again, it's just a matter of clicking-and-dragging the lash where you want it to go.

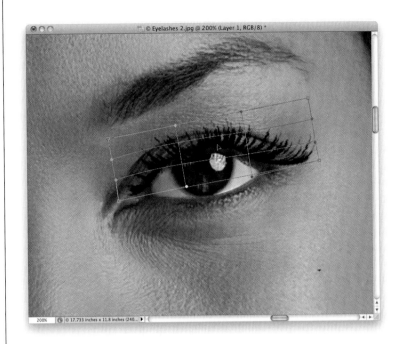

Step Nine:

Once you have the eyelash positioned right where you want it, press **Return (PC: Enter)** to lock in your Free Transform changes. To make the eyelashes blend in better with the existing eyelashes (and to look more natural), I normally lower the Opacity at bit. Here, I lowered it to around 65%, and now it looks much more natural. Now, the top eyelash of one eye is done, and luckily, doing the other eye only takes a fraction of the time, because we use the first eyelash to build the second.

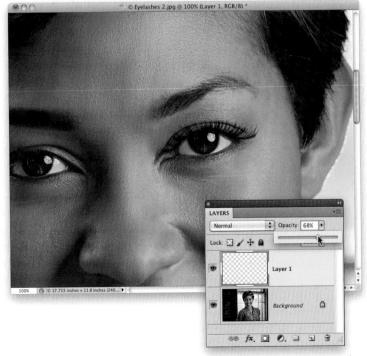

(Continued)

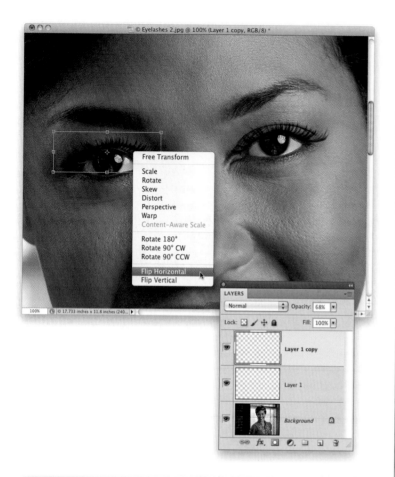

Step 10:

Press **Command-J (PC: Ctrl-J)** to duplicate your eyelash layer, then get the Move tool **(V)** and drag it over the other eye. Now, at this point, you have two right top eyelashes (even though I provided you with both right and left eyelash brushes in my custom set, since this one is already tweaked, you might as well use it and save some time). You'll need to flip this copied right eyelash over horizontally, so it becomes a left eyelash. So, just go to Free Transform, Right-click inside the bounding box, and choose **Flip Horizontal** from the pop-up menu (as shown here).

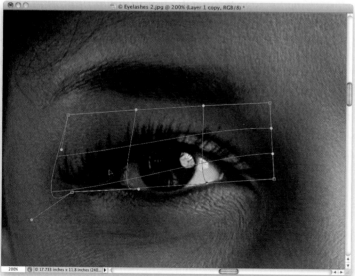

Step 11:

You're now going to do a minor tweak to the shape of the eyelash, so it's a perfect fit on the eye on the left, as well (rarely are both eyes the exact same size and shape). Right-click inside the bounding box again, but this time choose Warp. You can warp this eyelash to be a perfect fit in just seconds by dragging it around like it's liquid (as shown here). When you're done, press Return.

Step 12:

Before we move on to the bottom eyelashes, let's go ahead and start to name our layers (I don't worry about this when it's just one or two layers. But, once you get above three layers, it's a real time saver to know which layer is which, so you don't have to guess). In the Layers panel, double-click directly on the first eyelash layer's name, and name it "Top Right" and then name the copied layer "Top Left." Now, add a new blank layer for the bottom lashes to the top of the layer stack, then go back to the Brush Picker and scroll to the single eyelash brushes. This sounds like it's going to be hard, but honestly, it's a breeze. Start by choosing Bottom Lash 3 (the 687-pixel single-hair brush; yeah, that's one huge brush) and then you're going to need to lower your brush Size to around 16 pixels (as shown here).

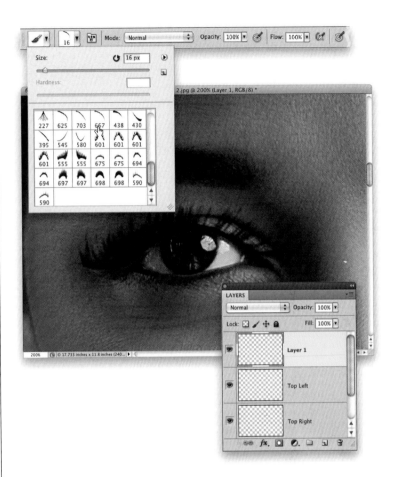

Step 13:

Now, you're going to paint in the bottom lashes. The problem is that every lash you paint will look exactly the same—the same size, angle, etc.—and it'll look pretty weird. Luckily, there's a Photoshop trick to slightly vary the size and angle of each eyelash every time you click, so they look more random and much more realistic. You turn this feature on in the Brush panel (click on the Brush panel icon to the right of the Brush icon in the Options Bar to open it). In the section on the left, turn on the Shape Dynamics checkbox. To automatically vary the size of each hair, drag the Size Jitter slider to 40%, and to vary the angle of each hair, drag the Angle Jitter slider to 3% (that's really all you need). Also, make sure the Control pop-up menu at the top of the panel is set to **Off** (as seen here; if Smoothing is turned on in the section on the left, turn it off). You can see the difference these settings make in the preview window at the bottom of the panel.

(Continued)

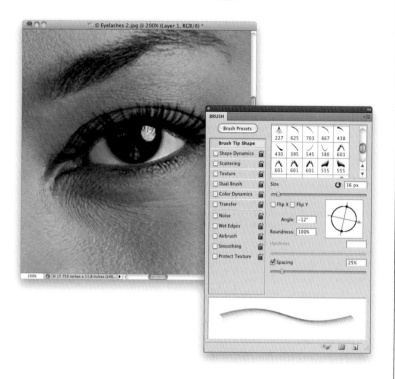

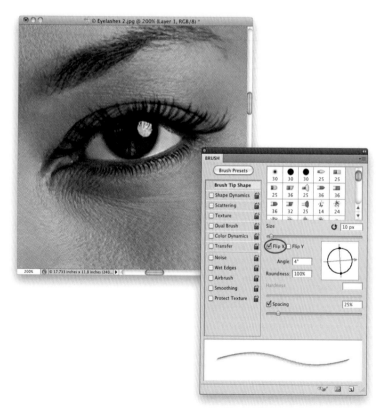

Step 14:

Real eyelashes aren't all at the same angle as you move from left to right under the eye, so you're going to have to manually vary them as you go. To do this, at the top left of the Brush panel, click on Brush Tip Shape. You see that circular Angle preview in the middle right of the panel? You're going to use that to slightly turn your brush after each five or six clicks. I start from the right beneath the eye and make a few clicks (as seen here), then click-and-drag the Angle preview clockwise a little to change the angle (here, I dragged it to –12°). Luckily, the eyelash brush cursor changes onscreen as you do this, so you can hold it up near the eye, make a slight rotation in the Brush panel, and you'll see how the cursor changes. This is much easier and more intuitive than it sounds, so give it a try.

Step 15:

Now, paint a few more lashes, then rotate the brush again in the Brush panel. When you get to the middle of the eye, you're going to have to flip the brush, so the eye lashes fan out like they normally would (they blend to the left on the inside, they're almost straight in the middle, and then they bend to the right as it gets closer to the outside—the part closest the ear. Look at the top lash to see what I mean about how they bend from the left side, straight in the middle, then they bend right). Once you get past the middle, to make the flip, just turn on the Flip X checkbox in the middle of the Brush panel (shown circled here in red), and then rotate the Angle preview, so your lashes are going in the right direction. As you get to the inside of the eye (the part closest to the nose), the size of the eyelashes shrink as well, so be sure to drag the Size slider in the Brush panel to the left a bit (here, I decreased the size to around 10 pixels, from 16 pixels).

Step 16:

Lower the Opacity of this bottom eyelash layer to help blend it in with the real lashes underneath. To add a little depth and dimension to the bottom eyelashes, just add a layer style. Click on the Add a Layer Style icon at the bottom of the Layers panel, choose **Drop Shadow** from the pop-up menu, and then lower the Opacity to around 65%. Also, this is a good time to not only rename your bottom-right lash layer, but to do a little housekeeping and put them into an order that makes sense.

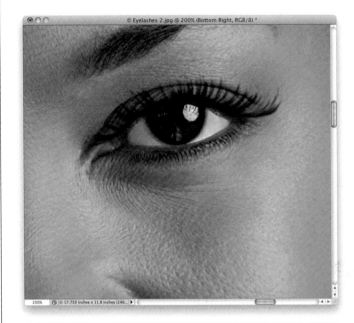

(Continued)

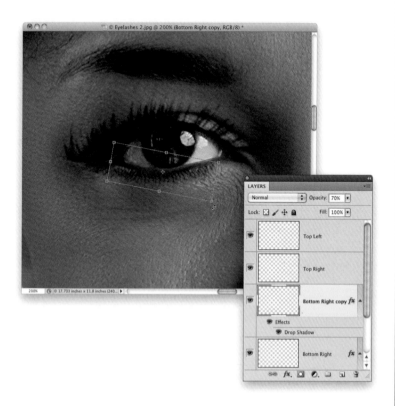

Step 17:

Now, you're going to pull the same trick with the bottom lash that you did with the top—we're going to duplicate that Bottom Right layer and use it for the bottom-left eyelash on the other eye. So, go ahead and duplicate your Bottom Right layer, and with the Move tool (V), drag it over to the other eye and position it as close as you can. Then bring up Free Transform again and move your cursor outside the bounding box to rotate it into position (as shown here).

Step 18:

Lastly, go ahead and rename this duplicate layer "Bottom Left" and then put it right below the Top Left layer. Once you've got a full set of lashes built like this for your image, to keep things organized, let's put them into a folder (Photoshop calls this a Group). This does two things: (1) it keeps your Layers panel from getting cluttered up with dozens of layers as you work, which can really slow you down and add visual confusion, and (2) now you can see a before/after of your eyelashes with just one click (showing or hiding the Eyelashes group) by clicking on the Eye icon to the left of its name. To get these four layers into a group, click on any of the eyelash layers, press-and-hold the Command (PC: Ctrl) key, and then click on the other eyelash layers to select them. Now, from the Layers panel's flyout menu at the top right of the panel, choose **New Group from Layers** (as shown here), give this group a name, and they're now all in one convenient folder.

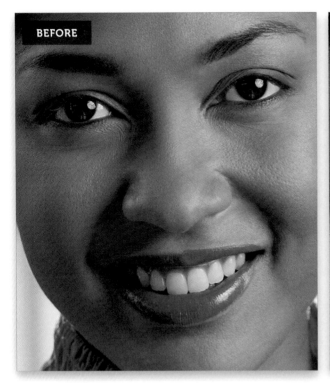

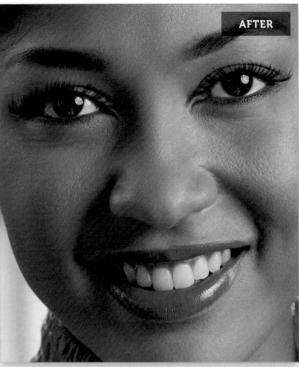

Try this technique on another image!

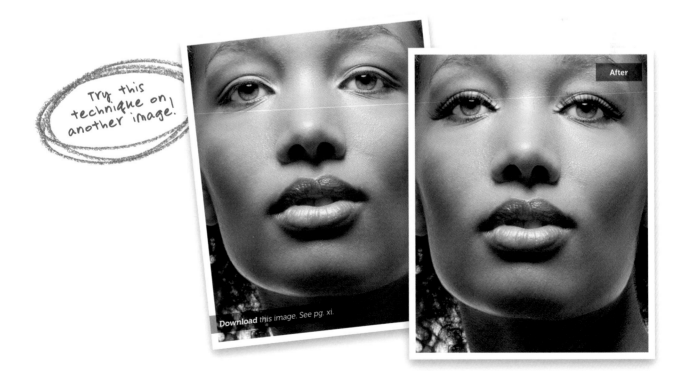

Download *this image. See pg. xi.*

Creating Beautiful Eyebrows

This is one part of the portrait retouching process that a lot of photographers just skip over, probably because it's fairly subtle, but again, this is one of those little things that help give the entire image a more professional look. Once you've done a few, this is also one of those retouches that will really stick out like a sore thumb to you in photos where the photographer didn't retouch the eyebrows. At the end of the technique, I'll also show you a quickie version that does a pretty darn good job of trimming those brows fast.

Step One:

Here's the image we want to retouch, and while our subject's eyebrows aren't at all bad, we can take them up that extra notch and make them look really beautiful.

Step Two:

Zoom in tight on the eyebrow on the left, then get the Pen tool **(P)** and make sure the Paths icon is selected in the Options Bar. (By the way, if you're brand new to this tool, I created a special video just for you, showing you how to use it. It's one of those tools you really want to know how to use to make great selections. Learning how to use the Pen tool will take your skills up a big notch, so make sure you check out the video. You can find it on the book's companion website mentioned at the beginning of the book in "Seven Things You'll Wish You Had Known Before Reading This Book.") What you're going to do here with the Pen tool is draw out a path in the shape that you'd like the eyebrow to be (as seen here. Be mindful of the original shape of the eyebrow as you draw your path, so it doesn't look too freaky or fake). The Pen tool kind of works like a "connect the dots" tool, so if you click in one spot, move to another area, and click again, it draws a straight line between the two points. However, if instead of just clicking, you click-hold-and-drag, it lets you curve the path, which is what I did here to create a path around her eyebrow.

Step Three:

Once you've drawn your path where you'd like the eyebrow to be shaped, you'll want to turn that path into a regular selection by pressing **Command-Return (PC: Ctrl-Enter)**. Now that you have a selection around your eyebrow, we'll work on trimming away everything outside the selection first (which is a big part of this process—removing excess eyebrow), so go under the Select menu and choose **Inverse** (as shown here). This inverses your selection, so that instead of having a selection around the eyebrow, you have a selection of everything *but* the eyebrow (if you zoom out, you'll see the selection border around the photo). The reason we do this is to protect the eyebrow—you can't accidentally erase any part of the eyebrow you originally selected at this point, because it's the only part of the photo *not* selected.

Step Four:

Now, to soften the transition between the eyebrow and the retouch, go under the Select menu, under Modify, and choose **Feather**. Enter 3 pixels in the Feather Selection dialog (seen here) and click OK to soften the edges of your selection.

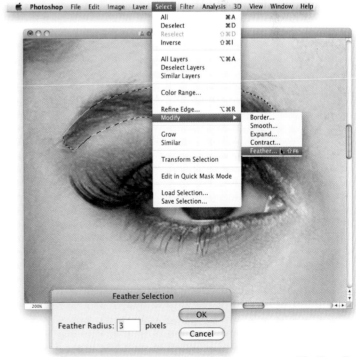

(Continued)

Step Five:

Before we do any retouching, go ahead and create a new blank layer (by clicking on the Create a New Layer icon at the bottom of the Layers panel). Now, press **Command-H (PC: Ctrl-H)** to hide your selection from view (your selection is still in place, but you no longer have to see those annoying "marching ants" while you retouch). (*Note:* When you press Command-H on a Mac, you may get a dialog asking if you want to hide Photoshop or hide its extras. Just click the Hide Extras button.) Now, your first thought might be to grab the Healing Brush, but since your retouch will be right up against the eyebrow (which could cause the Healing Brush to smear the edges—it likes things to be all by themselves, like an island, and doesn't do well when what you're removing is touching something else), get the Clone Stamp tool **(S)** instead, and choose a small, soft-edged brush from the Brush Picker. Now, press-and-hold the Option (PC: Alt) key and click once just above the part of the eyebrow that extends outside your selected area to sample that area and start cloning over the parts of the eyebrow that extend outside your selection (as shown here).

Step Six:

Once you've cloned around the top of the eyebrow, go ahead and clone the bottom (underside) of it (as seen here), as well as both ends (if the skin tone changes as you move around the eyebrow, Option-click again to resample a closer area to where you're cloning). Anything outside your selection (which you hid in Step Five, so it's not distracting) gets trimmed away. Here, I'm trimming away the bottom side of the eyebrow and you can see it starting to take shape (although we're not done yet).

Step Seven:

Now that you've trimmed away the excess on the eyebrow, you're going to fill in what's still there by, again, cloning. Start by going back under the Select menu and choosing Inverse once again. This inverses the selection, so now just the eyebrow itself is selected (by the way, when you choose Inverse, it makes your hidden selection visible again, so if you want, you can hide it again by pressing Command-H).

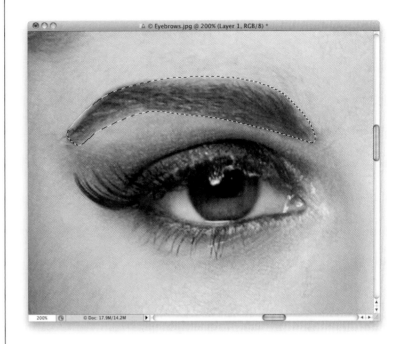

Step Eight:

With the Clone Stamp tool still selected, what you're going to do is Option-click inside the eyebrow itself to sample an area, and then you're going to clone in the direction of the hair, painting from right to left to extend the eyebrow hair out toward the edges. If you clone an area and you see a repeating pattern (where some of the hair looks obviously duplicated), then sample a different area and paint over the duplicate. Fill in all those little gaps for full and smooth eyebrows that fill in your entire selected shape, then press **Command-D (PC: Ctrl-D)** to Deselect. Now, go to the Layers panel, click on the Background layer, and do the exact same thing for the other eyebrow. A before/after of the retouch is shown on the next page.

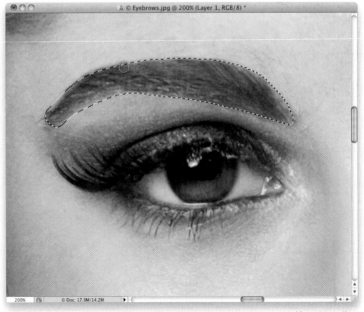

(Continued)

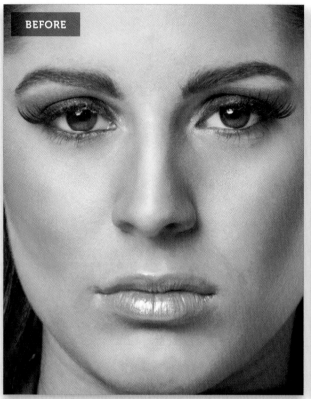

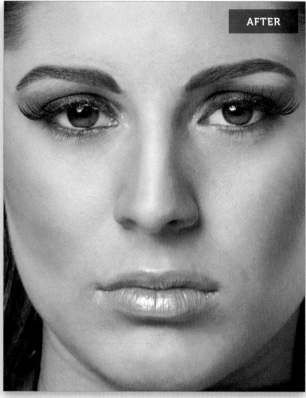

Step Nine:

Here's an alternate method when you need to do a quickie fix, and although this one is really quick, it does a surprisingly good job. You're going to draw a selection about 1/8" to 1/4" right above the eyebrow that needs trimming (as shown here). So, start by getting the Lasso tool **(L)** and drawing out the bottom of the shape—make it kind of like the shape of the eyebrow itself. The sides and top don't really matter (because you're not going to use them), but I generally make my selection the shape of an eyebrow, like you see here.

Step 10:

You need to soften the edges of the selection just a little bit, so go under the Select menu, under Modify, and choose **Feather**. When the dialog appears, enter 3 pixels (just enough to add a little bit of edge softening), and click OK (as shown here).

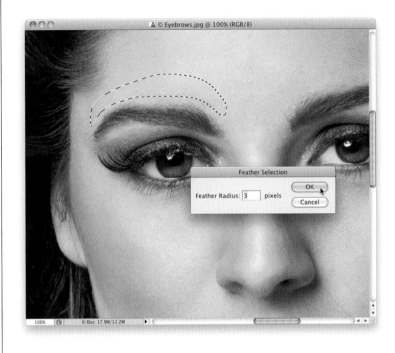

Step 11:

Now, press **Command-J (PC: Ctrl-J)** to place that selected area up on its own separate layer. Switch to the Move tool **(V)** and drag that shape down over the top of the eyebrow (as shown here) and look at how it perfectly trims the top of the eyebrow. Now, go to the Layers panel, click on the Background layer, and do the exact same thing for the other eyebrow. A before and after is shown on the right, and as you can see, it does a pretty nice job.

(Continued)

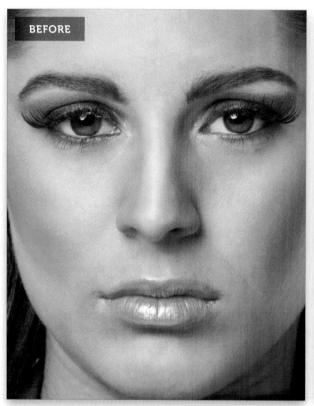

BEFORE

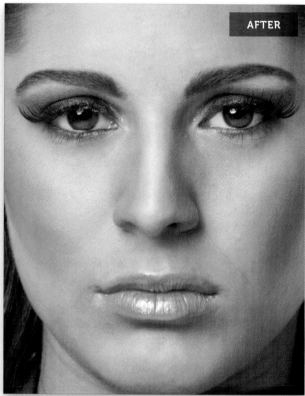

AFTER

Download *this image. See pg. xi.*

After

Try this technique on another image!

Making Fuller Eyebrows

One thing we don't want in eyebrows is gaps, but as you might expect, it's very common to find just that. So, we can literally paint in a few extra hairs to cover up those gaps. Now, if you're thinking, "I'm not good at painting," you don't have to worry. What you're going to do here is so simple that you'll be able to pull it off the first time around, even if you're using a mouse (rather than a tablet).

Step One:
Here's the image we're going to add fuller eyebrows to. Start by clicking on the Create a New Layer icon at the bottom of the Layers panel to create a new blank layer where we'll do all of our retouching (as shown here).

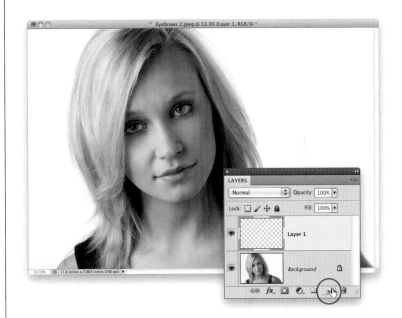

Step Two:
You're going to need to zoom in really tight for this one—I zoomed in to 300% on the eyebrow on the right. Now, get the Brush tool **(B)** and choose a very, very small, soft-edged brush from the Brush Picker that's about the size of the hairs in the eyebrow (here I chose a 1-pixel, soft-edged brush. Of course, you'll have to choose the size based on the photo you're working on. The way I composed this image, it's not really super-tight in on her face, so once we zoom in, a 1-pixel brush is about the size of her eyebrow hair in this photo).

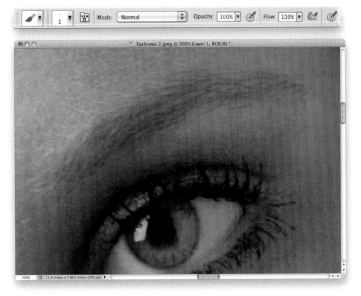

(Continued)

Step Three:
Start by pressing-and-holding the Option (PC: Alt) key, and your Brush tool will temporarily change into the Eyedropper tool, so you can steal a color from the eyebrow hair itself. Click right on a dark area of eyebrow (as shown here) to snag that color as your new Foreground color. Eyebrow hair is usually a slightly different shade as you move from one end of the eyebrow to the other, so don't be surprised if you have to resample the color a number of times while you're working on the eyebrow.

Step Four:
Now, you're going to paint in your own eyebrow hairs, right over any place that has gaps or is thin within the eyebrow (as shown here, where I've painted a few dark brown strokes). It looks pretty bad at this point, and will soon look even worse, but don't worry, it all comes together in the last step. Paint little strokes going from left to right, and follow the direction of the existing hairs as you fill in the gaps.

Step Five:

It's now starting to look really full, and really bad. The brown strokes don't look very real, and they stand out, but that's all going to change very soon—for now just keep painting nice little strokes. If you're using a tablet and pen, just make little flicking-type strokes that follow the direction of the hairs. Make sure you do both ends, and taper off at the end closest to the ear.

Step Six:

To blend your painted eyebrow hair with the real eyebrow hair, you have two choices: (1) Just lower the Opacity of this layer until the two blend together (here, I had to lower it to around 40% for a nice combination). Or, (2) change the layer blend mode to **Multiply** (from the layer blend mode pop-up menu at the top of the Layers panel) and then lower the Opacity to around 30% (Multiply mode does some blending on its own, but it also darkens as it blends, so you usually have to lower the Opacity more than you would if you just left it in Normal mode. But, depending on the eyebrows, Multiply mode usually looks better. You just have to try both and see which one works for the image you're retouching). A before and after is shown on the facing page, using the Multiply mode method.

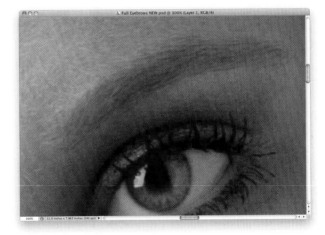

(Continued)

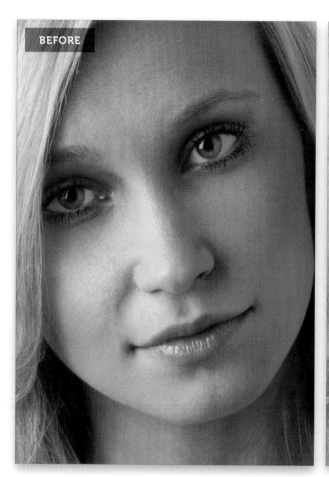

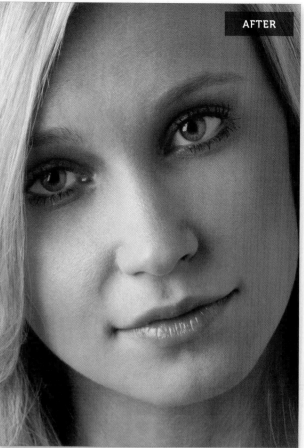

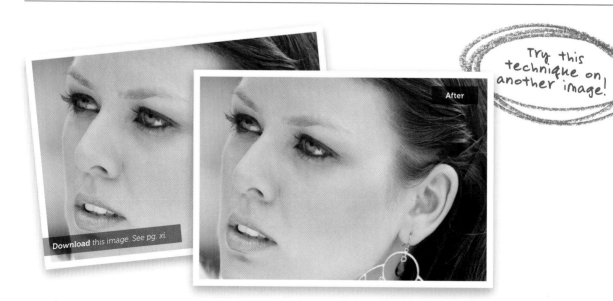

Download this image. See pg. xi.

After

Try this technique on another image!

Darkening the Eyebrows

In those cases where the eyebrows look pretty full, but just need a quick darkening, here's a really quick way to get there. Don't let the fact that we're using Curves throw you off if you've never used Curves before. We're going to do something so simple, you won't even break a sweat. Plus, once you've learned this technique, you can use it anytime you need anything darkened.

Step One:

In this image, her eyebrows are a little light and need to be darkened. So, click on the Create New Adjustment Layer icon at the bottom of the Layers panel and choose **Curves** from the pop-up menu. Then, from the Curves pop-up menu at the top of the Adjustments panel, choose **Darker (RGB)** to darken the midtones in the image. Press **Command-I (PC: Ctrl-I)** to Invert the adjustment layer's mask, and hide this darker version behind a black mask. Grab the Brush tool **(B)**, choose a small, soft-edged brush, make sure your Foreground color is set to white, and paint over just her eyebrows to make them darker (as seen here, where I'm painting the eyebrow on the right).

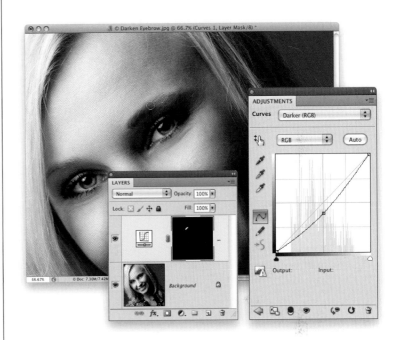

Step Two:

If you think her eyebrows need to be even darker, just go to the Adjustments panel, click on the center point of the curve, and drag it farther down (as I have here). Since you already masked the eyebrows, as you drag the curve downward, only the eyebrows get darker. However, darkening the midtones can change the color of the eyebrows, as well. So, change the adjustment layer's blend mode to **Luminosity** (as seen here) to keep the color looking the same, but give them the added darkening they need. If they look a little too dark, you can simply lower the Opacity of the adjustment layer (as I did here, where I lowered it to 75%).

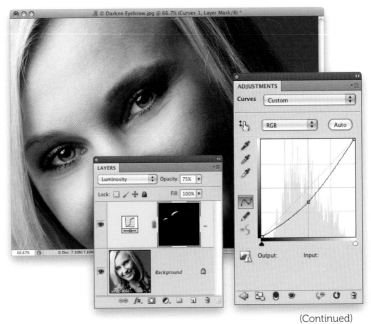

(Continued)

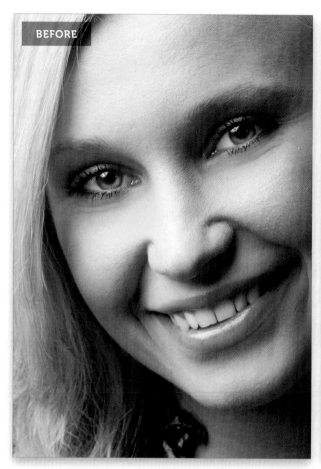

BEFORE

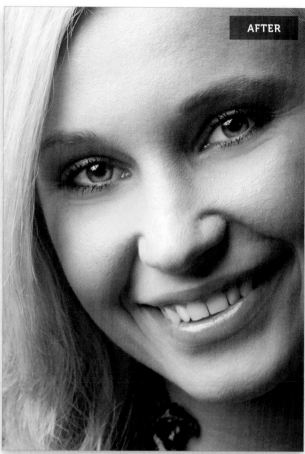

AFTER

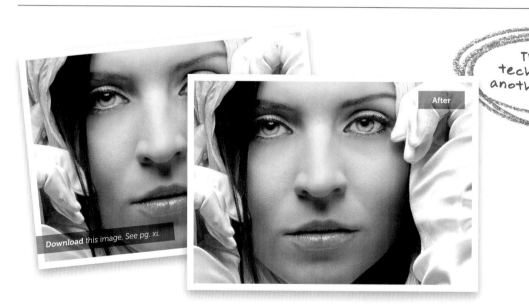

Download *this image. See pg. xi.*

After

Try this technique on another image!

Sharpening Eyes to Make Them Sparkle

Sharpening is the final retouch I do to the eyes, and it's this finishing touch that can really make your subject's eyes sparkle. As you'll learn throughout this book, we don't generally sharpen the entire image at once—it's usually just a part here and a part there, and this is one of those instances where spot sharpening really makes a big difference. Plus, we're going to do this using the most advanced form of Photoshop sharpening ever, which was introduced in Photoshop CS5.

Step One:

Here's the image we're going to retouch, and although I already applied a basic sharpening to the whole image, using the Unsharp Mask filter, I usually sharpen the eyes separately to really give them that sparkle that makes them look alive. I generally do this sharpening on a duplicate of the Background layer. That way, (1) I can easily toggle the layer on/off to see a before/after while I'm sharpening, (2) I can lower the Opacity amount of the layer if I think I've over-sharpened the eyes, or (3) I can delete the layer altogether if I decide I don't want any sharpening at all. So, press **Command-J (PC: Ctrl-J)** to duplicate the Background layer.

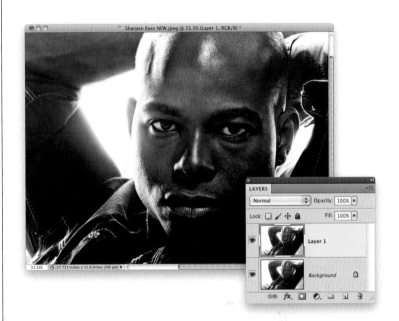

Step Two:

In the Toolbox, nested under the Blur tool, you'll find the Sharpen tool (seen here). It has been in Photoshop for many years, but it has been pretty much unusable, because it usually did more harm than good. It was a harsh type of sharpening that seemed to have a personal grudge against pixels, but that all changed in Photoshop CS5, when Adobe's engineers decided to not only fix this tool, but to make it Photoshop's most advanced sharpening tool (I got that straight from one of Adobe's own Photoshop product managers). This comes courtesy of the Protect Detail checkbox in the Options Bar, so make darn sure that's turned on (as shown here, circled in red), or you'll be using the old version of the Sharpen tool (with the old results).

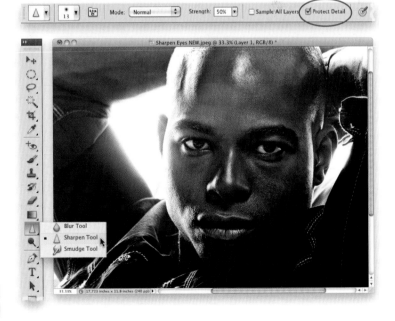

(Continued)

Step Three:

Zoom in on the eyes, then take the Sharpen tool, and paint over an iris. If you look up at the Options Bar, you'll see that the default setting for the Strength is 50%, but I recommend setting it down to around 20%, so the sharpening builds up as you paint over the eye. Using a lower amount like this gives you more control because you're adding sharpening in layers, rather than all at once. Don't just paint over the inside of the eye—sharpening is all about edges. So, make sure your brush cursor extends just a tiny bit outside the edge of the iris (as seen here). Do the same thing with the other eye, and keep in mind that since you did this on a layer, if you need to, you can lower the Opacity of this layer, which lowers the amount of sharpening you've applied to the eyes.

Step Four:

Now, since doing any kind of sharpening can sharpen random bits of noise or change the colors, change the layer's blend mode from Normal to Luminosity. A before/after of the retouch is shown on the next page.

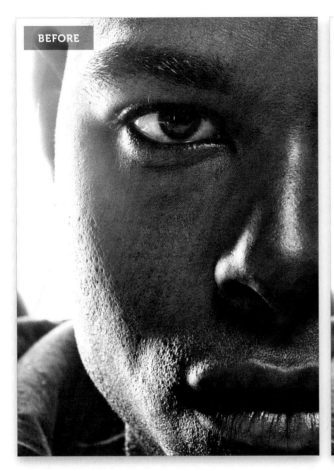
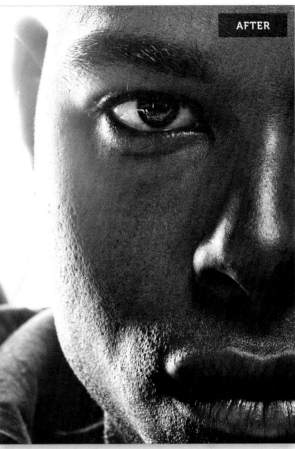

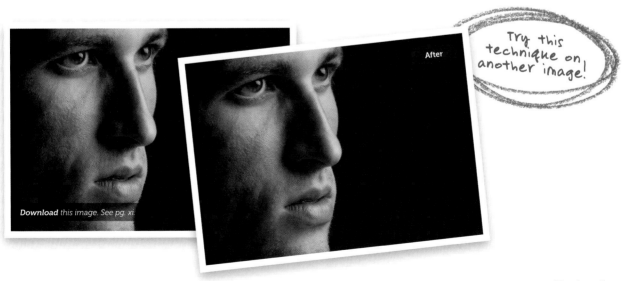

Try this technique on another image!

(Continued)

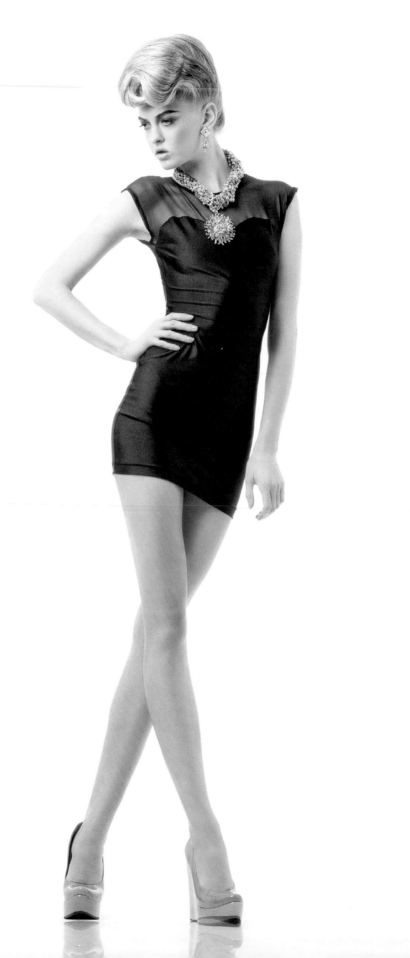

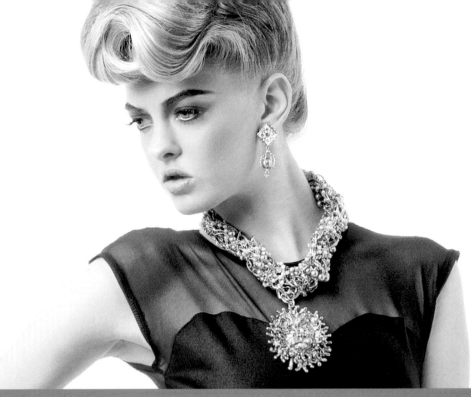

Chapter 2
UNDER MY SKIN
Retouching Skin

Have you ever been on a flight and heard one of the passengers say, "Hey, that was a really nice takeoff!" No? That's because nobody really cares about takeoffs (well, as long as the plane does, indeed, take off). But, when it comes to landing the plane, that's where you really judge the quality of a pilot (well, it's where other pilots judge the quality anyway). Now, if there's one thing I've learned over the years about retouching, it's that nobody in the retouching industry really cares which technique you use to brighten the eyes, or slim someone's love handles, or add highlights to the hair. To them, they're all like takeoffs. But when it comes to skin, the gloves come off. If they catch you blurring the skin to soften it, they will pull out a shank and stab you like a Rikers Island inmate during lockdown (by the way, I have no idea what that means). For high-end retouchers, it's all about creating

flawless skin while maintaining real skin texture throughout, and they are absolute masters at it. They'll spend four hours or more on just the face, going pore by pore, until it's absolutely perfect. So, how are we, as photographers, going to get perfect, non-blurred skin like that? Actually, it's pretty easy. We're going to send our photos to high-end retouchers and have them do it for us, because there's no way we can spend four hours on a face. Ever. Since we have very little time available for retouching at all, we have to cut a few corners when it comes to skin—investing only 5 or 10 minutes on the skin at best. But to do that, we sometimes have to do some unspeakable things that might get us shanked on our way to "the yard," but if we can use some tricks to bring back enough texture (and we bribe them with a pack of smokes), they might let us by with just a snarling glance.

Removing Blemishes

When it comes to skin, I always start by removing the blemishes. One reason is that after you remove all the blemishes, you might not have to soften or smooth the skin at all. Plus, even if you know you're going to have to soften the skin, you're going to have to remove the blemishes first, so it's a great place to start.

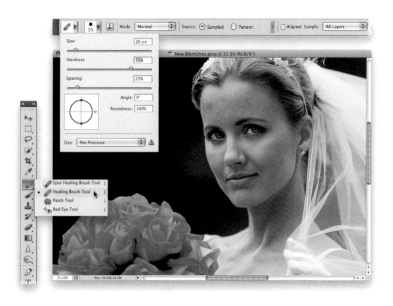

Step One:

Here's the image we're going to retouch. We're going to use the Healing Brush tool (it's nested below the Spot Healing Brush tool) for removing blemishes, because most blemishes are alone and not touching any edges, which is when the Healing Brush works best. If you use it to remove a blemish near the edge of something (right near the lips, or the hair, or eyebrows, etc.), it tends to smear (in which case, you should undo the healing, and switch to the Clone Stamp tool, because it doesn't smear). Now, go up to the Options Bar, click on the Healing Brush icon to get the Brush Picker (shown here), choose a brush size that's just a little larger than the blemish you want to remove, and lower the Hardness to 75% to get a little smoother blending. Also, from the Sample pop-up menu, choose **All Layers**, so it can sample from your Background layer.

Step Two:

Zoom in, then click on the Create a New Layer icon at the bottom of the Layers panel to create a new blank layer. Press-and-hold the Option (PC: Alt) key, and click in a clean area right near the blemish (as shown here). Because this particular blemish is on her forehead, I had to sample (Option-click) to the side of the blemish, because on the forehead, the texture of the skin goes horizontally (side to side). It's not as critical on other parts of the face, but on the forehead you usually get better results if you sample to the side of the blemish, rather than above or below.

Step Three:

Now, move your cursor directly over the blemish. Don't paint, just click once. That's it—it's gone (as seen here). That's how you remove blemishes: sample a nearby area, move your cursor over the blemish, and just click. You don't have to resample (Option-click) each time you remove a blemish, just when you move to a different area of the face (nose, cheeks, chin), as they all have slightly different textures.

Step Four:

Let's move to another part of the face. Same routine: Option-click in a clean area near the blemish, then move over the blemish, and just click. You're going to repeat this process all the way around the face, removing the blemishes one by one. At this point in the retouching process, I just remove the blemishes that really stand out—smaller ones will get removed in the skin smoothing process later on. A before/after is on the following page, and I did nothing more than what you saw on this page—sample, move over the blemish, and just click.

(Continued)

BEFORE

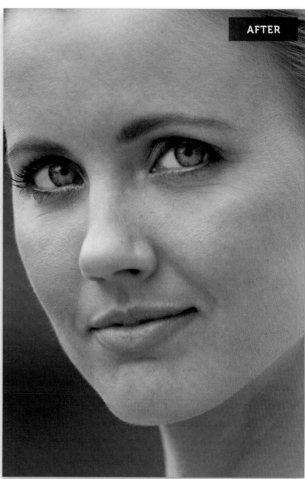

AFTER

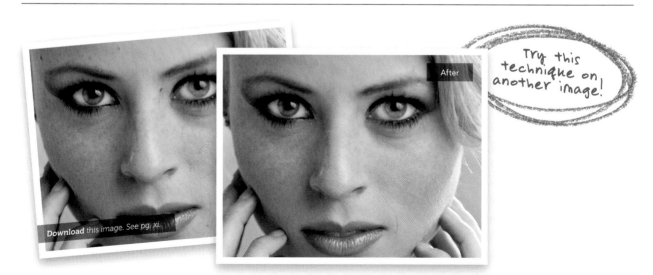

After

Download this image. See pg. xi.

Try this technique on another image!

How to Avoid Plastic-Looking Skin

High-end retouchers cringe when they hear that you applied blurring to the skin, because we've all seen so many examples where the subject has grossly over-blurred skin, with no visible texture, and it looks plastic (like the shot on the left below). So, any mention of skin blurring freaks them out. However, as photographers (and not high-end retouchers), we have to get each photo retouched really quickly, so in some cases we use "controlled" skin blurring, which gives us good-looking skin, but without losing all the texture and detail (as seen on the right below).

Blurred Plastic-Looking Skin (Yeech!):

This is what you want to avoid (see the photo on the left), and what has given skin blurring, in general, a bad name. There are really no visible pores, and the skin looks plastic, which makes the eyes and lips look over-sharpened and weird. In general, it just looks fake and obviously retouched. Okay, over-retouched. Avoid this like the plague (unless you're retouching for children's beauty pageants. For some reason, they dig this).

Softened Skin with Texture:

Although I'm going to show you two ways to soften skin that don't blur the skin at all, sometimes the fastest way for us photographers to get the job done is to use some kind of blurring, but don't worry—when we do, we'll use a trick or two to bring back some of the original texture, so the skin looks realistic (and not plastic, like the image on the right). So, just remember, although blurring in general is bad, if you use the blurring techniques shown here in the book, you'll get smooth-looking skin fast, with texture and detail, but without the fake plastic look. By the way, there's still more retouching left to be done on the photo on the right—it's just an example to show skin smoothing (just in case you were wondering, I used the technique on page 113).

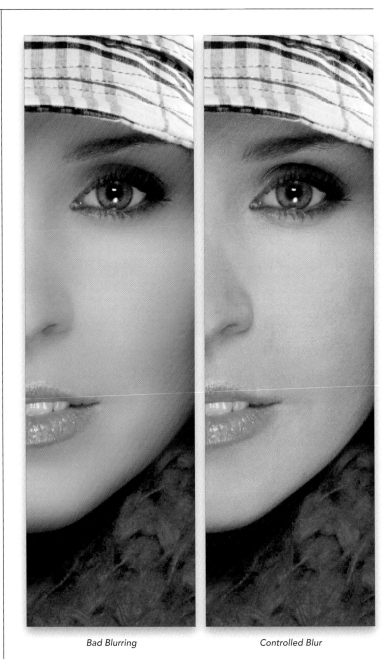

Bad Blurring Controlled Blur

Basic "Quickie" Skin Softening

When you smooth skin, there's definitely a tradeoff: You can use techniques that totally avoid blurring the skin, but they take a really long time. Or, you can use a technique that's really quick, but you'll have to blur the skin a bit (which, in high-end retouching circles, is a huge no-no, because you lose skin texture). As photographers, we sometimes have to get the job done really fast, and that means using some blurring. However, there are two things we do at the end of this technique to help retain some of the original texture, and add some additional texture in. That way, this quickie skin technique actually looks pretty decent for something that takes us no more than two minutes to do.

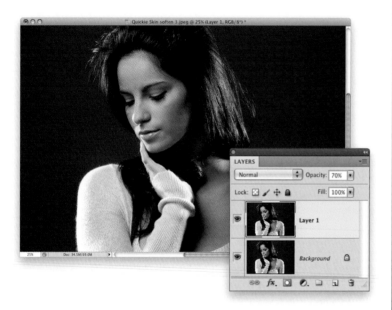

Step One:
Okay, before you consider using this technique, consider this: If your photo will be published anywhere professional retouchers might see it, this isn't the one to use. If it's going to be used on a photo of Uncle Earl for his Christmas card, then it's probably okay (but only if you don't really like Uncle Earl all that much). Of course, before you do any skin softening of any kind, remove all the major blemishes first (see page 86). Once they're gone, press **Command-J (PC: Ctrl-J)** to duplicate the Background layer (as seen here).

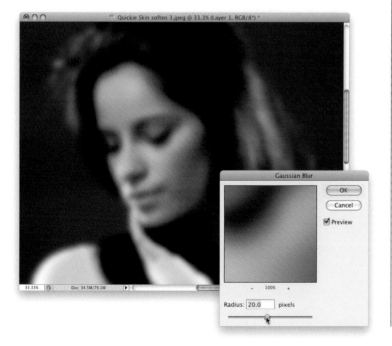

Step Two:
Now, go under the Filter menu, under Blur, and choose **Gaussian Blur**. When the Gaussian Blur dialog appears (seen here), set the Radius to 20 pixels to really blur the entire image (as shown here) and click OK.

Step Three:
Lower the Opacity of the blurry layer to 50% (as shown here) to reduce the impact of the blurring. I know that a lot of people leave this setting at 50%, but the skin looks way too blurry. I'll leave it at 50% for now, though, because it makes it easier to see what you're painting (so, 50% opacity is a visual tool, not a final number by any means).

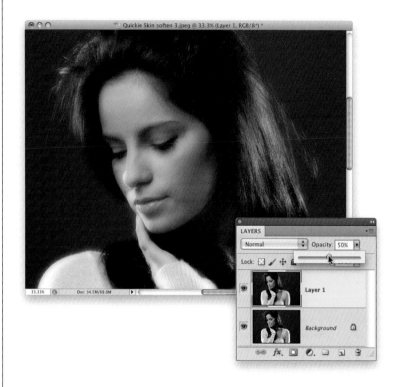

Step Four:
Press-and-hold the Option (PC: Alt) key and click on the Add Layer Mask icon at the bottom of the Layers panel (it's shown circled here in red) to hide your blurry layer behind a black mask (so now your image looks like it did when you first opened it). Press **D** to set your Foreground color to white and get the Brush tool **(B)**, then in the Options Bar, choose a medium-sized, soft-edged brush (at least to start with) and set the Opacity to 100%. Now, paint over everything *except* the areas that are supposed to have full detail, like the eyebrows, eyes, hair, nostrils, lips, teeth, and the edges of the face (you have to stop right before the edges of her face or they will soften). You'll have to shrink the size of your brush when you get to places like the area that goes from her nose down to her top lip (technically called the philtrum, but I always call it "the area that goes from her nose down to her top lip").

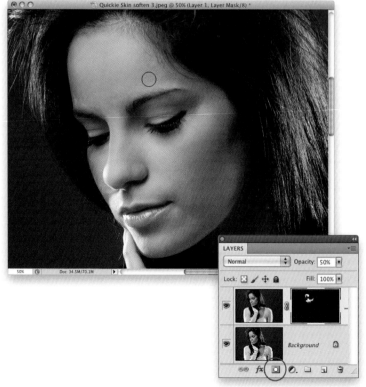

(Continued)

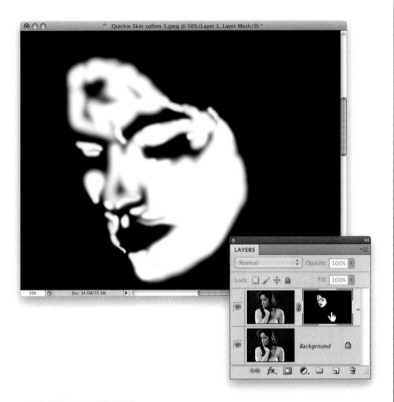

Step Five:

To quickly check to see if you missed softening any areas, go to the Layers panel, press-and-hold the Option (PC: Alt) key, and click directly on the layer mask thumbnail that is attached to your top layer. You'll see the actual layer mask you've been painting on, and any areas that appear in black haven't been softened yet (see those areas on her forehead and nose that I completely missed?).

Step Six:

Just take your brush and paint in white, right on the mask, over any spots you missed (as shown here), until the only places that are still black on the face are those detail areas you didn't want to soften. Now, Option-click on that layer mask thumbnail again to bring back the regular color image.

Step Seven:

Here's where you get some of your skin detail and texture back. Lower the Opacity of your layer to at least 35% (as shown here) and see how that looks. If you can get away with less, try that (but, of course, to see how it really looks, you'll need to see a before/after by toggling the top layer on/off by clicking on the little Eye icon that appears to the left of the layer's thumbnail). I've used as little as 18% on a subject with pretty good skin, but more often it's around 25% to 35%. Remember, the lower opacity you can get away with, the more of the original skin texture you'll get back.

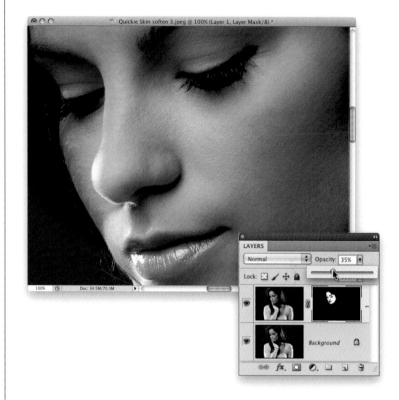

Step Eight:

If you look at the image at this point and think you need even more skin texture (but it looks bad if you lower the Opacity any further), then you can fake the texture using a very popular technique. Start by Command-clicking (PC: Ctrl-clicking) directly on the layer mask thumbnail from your blurred layer, so it loads the mask as a selection. Now, click on the Create a New Layer icon at the bottom of the Layers panel to add a new blank layer, go under the Edit menu, and choose **Fill**. In the Fill dialog, from the Use pop-up menu up top, choose **50% Gray**, and click OK to fill your selected area with gray. Don't deselect yet.

(Continued)

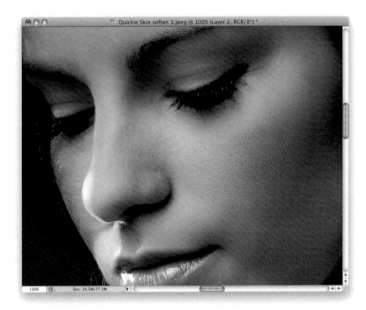

Step Nine:

Go under the Filter menu, under Noise, and choose **Add Noise**. In the filter dialog, enter 2.5% to 3% for your Amount, choose Gaussian for your Distribution, and turn on the checkbox for Monochromatic, then click OK. Now, press **Command-D (PC: Ctrl-D)** to Deselect, then change the layer's blend mode from Normal to **Soft Light** (for more subtle texture) or **Overlay** (for the full texture effect). To see a before/after onscreen when you have more than two layers, simply Option-click (PC: Alt-click) on the Background layer's Eye icon. This will turn off all layers above the Background layer, then you can Option-click again to turn them back on. A before/after at 35% opacity (through Step Seven) is shown on the next page.

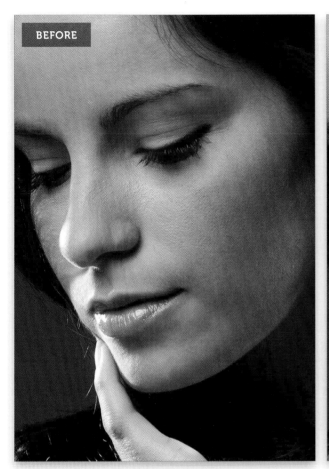

BEFORE

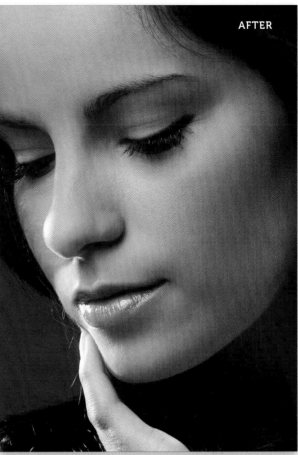

AFTER

Try this technique on another image!

Download this image. See pg. xi.

After

Softening Skin While Retaining Texture

This is a technique I use when I need a nice, quick skin smoothing without blurring out the skin, and it works really well—especially because of how it maintains skin texture. I want to give credit to "byRo," a Brazilian retoucher who invented the technique (he's a forum moderator over at RetouchPRO.com—a really great site for professional retouchers).

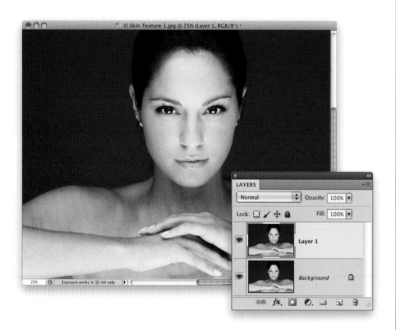

Step One:
Here is the beauty-style image we're going to retouch (the model is leaning on a sheet of plexiglass held up by two assistants. She couldn't put any weight on the plexiglass, because it started to bow, so she's standing there, lightly resting on it). It's hard to see at this zoomed out view, but she's got a nice skin texture, and of course we want to preserve that. This technique does a great job of that. So, start by pressing **Command-J (PC: Ctrl-J)** to duplicate the Background layer.

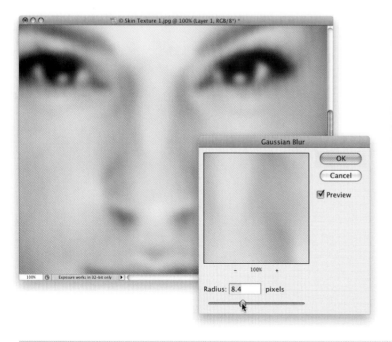

Step Two:
Go under the Filter menu, under Blur, and choose **Gaussian Blur** (don't worry—we're not actually going to blur the skin here, we're just using this dialog to do a calculation for us that we're going to need to use in a different dialog). Drag the slider to the right until you see the skin smooth out, and the different tones of skin start to go away (as shown here). Don't click OK. Instead, just remember the number you stopped at (in this case, it's 8.4). Now, click the Cancel button to close the dialog without applying the blur.

Step Three:

Go under the Filter menu, under Other, and choose **High Pass**. When the High Pass filter dialog appears, enter that number you memorized from the Gaussian Blur dialog—8.4 (as shown here)—and click OK. At this point, our texture layer is really, really sharp (the High Pass filter acts like an Unsharp Mask on steroids, but we'll fix that in just a moment).

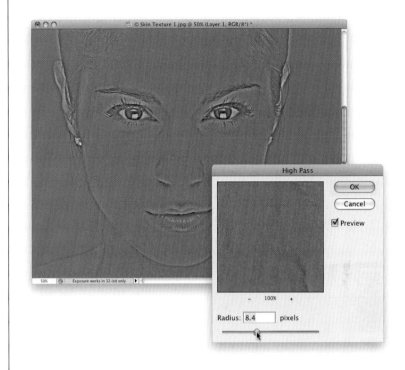

Step Four:

Now, reopen the Gaussian Blur filter again, so we can apply a small amount of blur to this sharp texture layer. First, a little math: you're going to enter an amount of blur that is approximately 33% (1/3) of the amount you entered in the High Pass filter in the previous step. In this case, 33% of 8.4 is approximately 2.8 (I'm not proud of the fact that I had to get a calculator to figure that one out. I should have just chosen 9 and made it easy on myself). So, enter 2.8 and click OK.

(Continued)

Step Five:

Now, you're going to Invert this High Pass layer by going under the Image menu, under Adjustments, and choosing **Invert** (as shown here), or by just pressing **Command-I (PC: Ctrl-I)**.

Step Six:

Next, go to the Layers panel and change the blend mode from Normal to **Linear Light** (as shown here). This is looking really, really bad. But, continue on!

Step Seven:

Lower the Opacity of this layer to 50%, and things are starting to look a lot better for the skin areas—except, of course, for the edges of…well…everything, so we'll have to fix that in the next step.

Step Eight:

Press-and-hold the Option (PC: Alt) key and click on the Add Layer Mask icon at the bottom of the Layers panel (it's shown circled here in red) to hide your High Pass filter layer behind a black mask (as seen here).

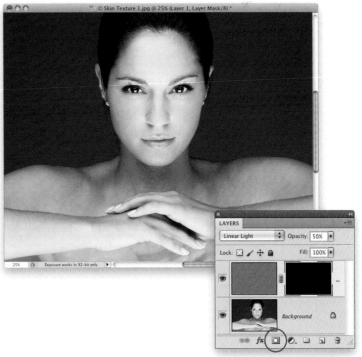

(Continued)

Step Nine:

Now, press **D** to set your Foreground color to white and get the Brush tool **(B)**, then in the Options Bar, choose a medium-sized, soft-edged brush and set the Opacity to 100%. Now, paint just the skin areas (as shown here), avoiding all the detail areas like the eyebrows, eyes, hair, nostrils, lips, teeth, and the edges of the face (avoid the edges of her face, or they will get softer).

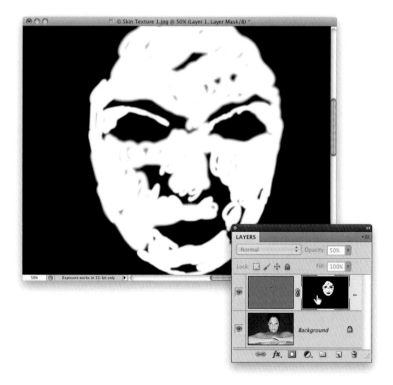

Step 10:

To check and see if you missed any areas, go to the Layers panel, press-and-hold the Option (PC: Alt) key, and click directly on the layer mask thumbnail that is attached to your top layer (as shown here) to see just the layer mask. Any areas that appear in black haven't been painted over yet (clearly, I need this "mask only" view pretty badly). Take your brush and paint in white right on the mask over any spots you missed. Now, Option-click on that layer mask thumbnail again to return to the normal image. Look at the before and after on the next page, and you can see that the skin has been smoothed out nicely, and yet you see lots of texture in it.

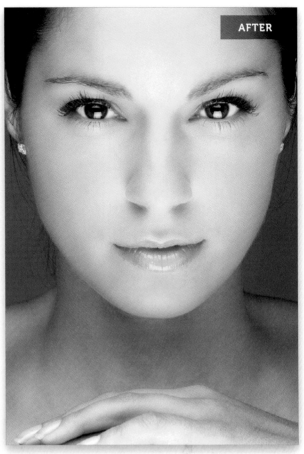

Try this technique on another image.

Softening Skin & Adding Texture Back In

This one takes a few steps, but it's not hard at all. In fact, it's simple, so don't let the number of steps throw you. Also, at one point it does have a teeny, tiny bit of blur in it, but not enough to hurt anybody. It uses the Surface Blur filter at one stage, but don't worry, the whole idea of this technique is to have loads of texture, so don't freak out when you see the Surface Blur filter.

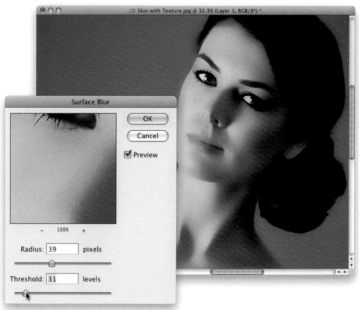

Step One:

As always, before you do any skin softening, remove all the major blemishes using the Healing Brush (see page 86). Here, I removed them already, so we can just focus on softening the skin. Start by pressing **Command-J (PC: Ctrl-J)** to duplicate the Background layer, as shown here.

Step Two:

Go under the Filter menu, under Blur, and choose **Surface Blur**. There are big advantages to using this filter over Gaussian Blur, and one is that it does a better job of preserving edges (rather than Gaussian Blur, which just blurs everything equally). I set the Radius (which controls the amount of blur) to around 39, and I make sure the Threshold slider (which controls the tonal values that get blurred) doesn't get higher than the Radius amount (here, I have set it to 31, and I usually have it between 5 and 10 lower than the Radius setting). This gives a blocky, almost posterized look to your subject's skin at this point. Go ahead and click OK to apply this filter to your image (it's doing a lot of math to make some parts blurry while the edges maintain detail, so don't be surprised if a progress bar appears onscreen, as this one usually takes a few extra seconds to apply).

Step Three:

Now, go to the Layers panel and lower the Opacity of this Surface Blur layer to 50% (as shown here). Although it looks a lot better at this point (and the skin looks pretty decent), the rest of the image also has the effect applied. We just want it on her skin, so we're going to have to mask it.

Step Four:

Press-and-hold the Option (PC: Alt) key and click once on the Add Layer Mask icon at the bottom of the Layers panel. This adds a black layer mask to your blurry layer (seen here to the right of the top layer), which hides the blurry layer, so all you're seeing now is the original, unblurred Background layer. Press **D** to set your Foreground color to white, get the Brush tool **(B)**, and choose a medium-sized, soft-edged brush from the Options Bar. Now, paint over her skin, but be careful to avoid all the detail areas, like her eyes, hair, clothing, eyebrows, nostrils, lips, etc.

(Continued)

Step Five:

To make sure you haven't missed any areas, in the Layers panel, Option-click (PC: Alt-click) directly on the layer mask thumbnail (as shown here). This displays just the mask by itself, and any areas on her face that appear in black aren't getting the effect, so you'll see instantly whether you missed any areas or not. These missed areas are really easy to fix—just take your Brush tool and paint right over them (you're painting right on the mask itself, so you'll be able to see perfectly as you paint). Here, you can see I missed a bunch of areas on her forehead and by her nose, and a few tiny areas here and there. When you're done (don't forget her neck and shoulders), Option-click directly on the layer mask thumbnail again to return to your normal image.

Step Six:

Now that you can see your full-color image again, you're going to load your layer mask as a selection. So, press-and-hold the Command (PC: Ctrl) key and click once directly on the layer mask thumbnail (as shown here). This loads your mask as a selection, as seen here. Remember, that selection is made from your mask, and your mask is a selection of all her skin, but without her eyes, nostrils, mouth, and the other detail areas included.

Step Seven:

While your selection is still in place, go to the Layers panel and click on the Background layer (this is original unsoftened layer). Now, press Command-J (PC: Ctrl-J) to take just that selected area and put it on its own layer (as seen here, where just her original unretouched facial skin is on its own layer now).

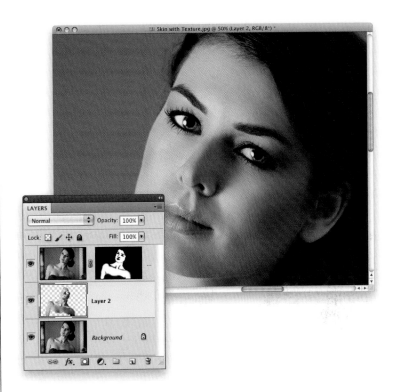

Step Eight:

In the Layers panel, click-and-drag that "just the skin" layer up to the top of the layer stack (so it's the top layer, as seen here). Now, we're going to bring out the texture in her skin by going under the Filter menu, under Other, and choosing **High Pass**. When the dialog appears, drag the Radius slider all the way to the left (so the preview looks solid gray), and then drag the slider to the right until you see lots of nice skin texture coming through your solid gray image. Stop when you see a glow starting to develop (here, I was able to go to around 6.4. When I went too much higher, things started to glow). Click OK.

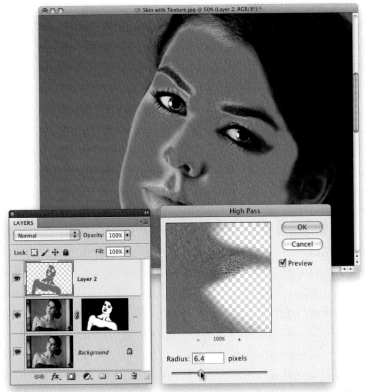

(Continued)

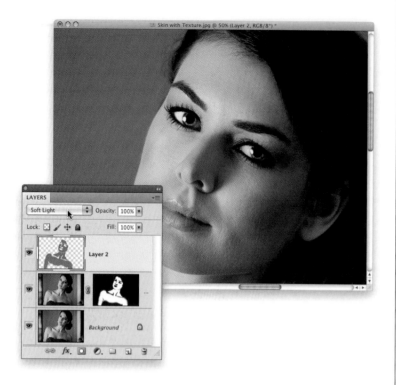

Step Nine:

To have your skin texture layer blend in with your softened skin layer below it, go to the Layers panel and change the blend mode for this High Pass layer from Normal to **Soft Light** (as shown here). There's now a layer of skin texture over your softened layer (so basically, you softened and smoothed the skin, then brought back some skin texture on top to bring back the detail lost by running the Surface Blur filter).

Step 10:

This face texture (High Pass) layer on top gives you its full effect (the most texture) when the layer's Opacity is set at 100%. If you lower the Opacity, it actually makes the skin softer, because you're lowering the amount of texture. Here, I've lowered the Opacity of the High Pass layer a bit to soften up the skin a little more, because there's plenty of texture visible in the image. Whether you lower the texture amount or not is totally your call, but you'll make that call based on the skin of your particular subject. A before/after of the retouch is shown on the next page.

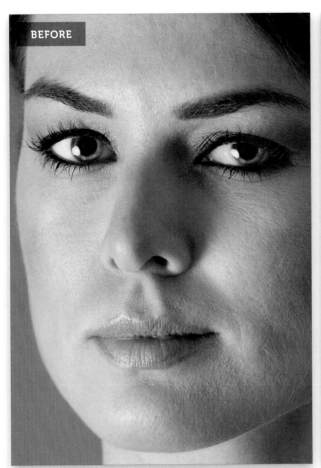

Try this technique on another image!

Download this image. See pg. xi.

After

High Pass Skin Softening

I know, you're probably thinking: "High Pass! Doesn't that make skin sharper?" Normally it does, but in this technique (which has been around for years now), you invert the layer you apply the High Pass filter to, so it acts more like a blurring filter, which sounds bad at first, but this is actually a great technique for keeping texture, and it's faster and easier than the other High Pass methods in this chapter. So, which one looks better? It just depends on the skin of the particular person you're retouching. That's why it's handy to know them all.

Step One:
Here's the image we're going to retouch. Start by pressing **Command-J (PC: Ctrl-J)** to duplicate the Background layer.

Step Two:
Change the blend mode of this duplicate layer from Normal to **Overlay**. Now, press **Command-I (PC: Ctrl-I)** to Invert the layer (it should look pretty bad at this point, like you see here).

Step Three:

Go under the Filter menu, under Other, and choose **High Pass**. When the filter dialog appears, enter 10 pixels, and click OK. This is the part that freaks people out, because normally the photo would look super-sharpened at this point, but instead, it looks pretty blurry (as seen here).

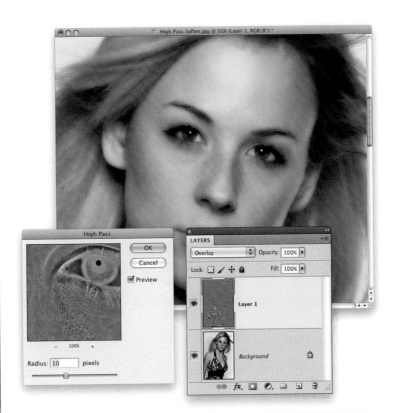

Step Four:

Now, to limit how blurry your image looks, you're going to add a Gaussian Blur (I know, I know…just stick with this and you'll see that somehow it actually works). So, go under the Filter menu, under Blur, and choose **Gaussian Blur**. Just so you can see how this filter affects your image, when the Gaussian Blur filter dialog appears, drag the Radius slider way over to the right, adding lots of blur, and you'll see that the photo gets very sharp, not blurrier. Now, drag the Radius slider all the way to the left (to 0.1 pixels), and it's blurry again. Because we inverted the High Pass layer, everything is working in reverse, but in this case, that's exactly what we want. So, with your Gaussian Blur set at 0.1, start slowly dragging to the right, and somewhere between 1 and 4 pixels (here I dragged to 3.8), the skin will start looking good, and you'll see lots of smooth skin texture, then click OK.

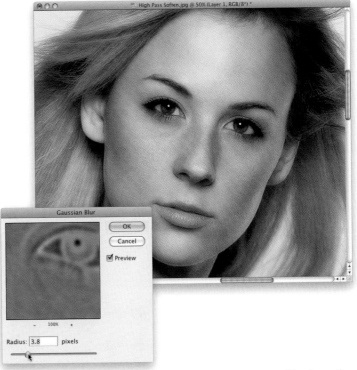

(Continued)

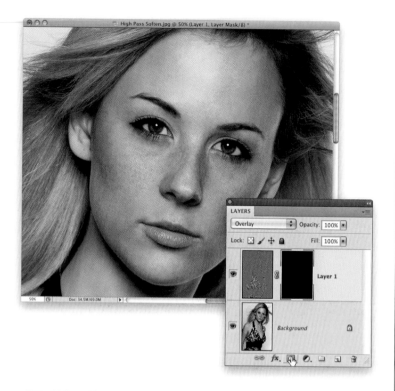

Step Five:

Of course, when you're applying a filter over the entire image like this, it makes everything have that texture, but you just want that limited to the skin (avoiding the detail areas like the eyes, lips, eyebrows, and so on). So, press-and-hold the Option (PC: Alt) key, and click on the Add Layer Mask icon at the bottom of the Layers panel to hide the textured layer behind a black mask (as seen here).

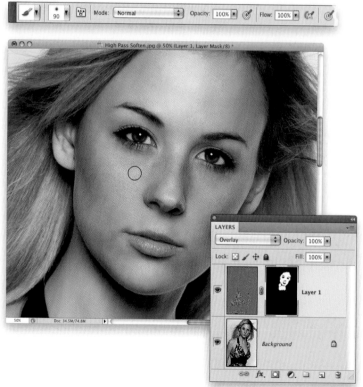

Step Six:

Now, get the Brush tool **(B)**, choose a medium-sized, soft-edged brush with the Opacity set to 100% up in the Options Bar, make sure your Foreground color is set to white, and paint over the skin areas to reveal the softened texture in those areas. Don't forget to Option-click (PC: Alt-click) on the layer mask to only see the mask, and to see if you've missed any spots, just as we did in the previous skin softening techniques.

Step Seven:

If the texture seems too intense, all you have to do is lower the layer's Opacity until the skin tone looks right (I lowered it to 85% here). A before/after is shown on the next page.

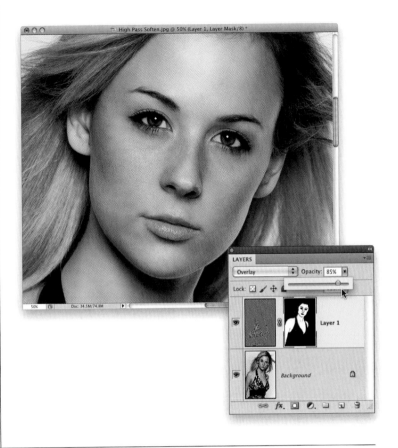

Try this technique on another image!

Download this image. See pg ix.

After

(Continued)

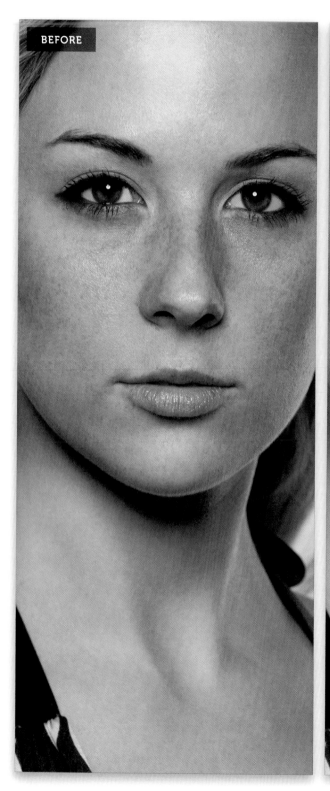

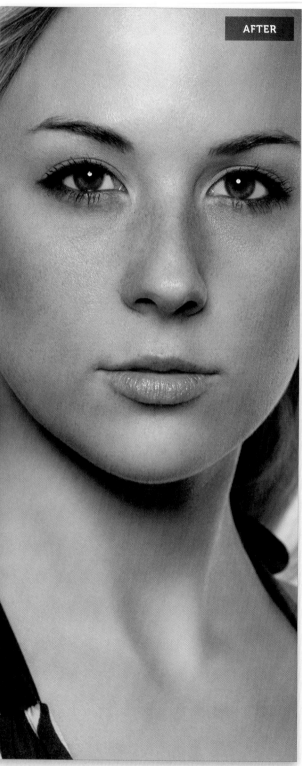

Softening Skin Using Channels

Corey Barker, one of my "Photoshop Guys" here at Kelby Media Group, came up with a slick skin softening technique that lets us keep lots of skin texture, because it's based on using the skin texture as the mask part of a layer mask. What's cool about this technique is that, if you feel the skin needs extra softening, you can add a Surface Blur along the way, but the really cool thing is that you don't have to—you can avoid the blurring altogether (it's totally up to you). My thanks to Corey for letting me share this technique with you here in the book.

Step One:
Here's the image we want to retouch. As always, we start by removing the blemishes, so the image you see here has had them removed using the Healing Brush tool and the exact technique you learned earlier in this chapter.

Step Two:
Go to the Channels panel (go under the Window menu and choose **Channels**, if it's not already open) and click on the Red channel (as shown here). In portraits, the Red channel almost always has the least amount of skin texture in it, but while you're already in the Channels panel, go ahead and click on the Green and Blue channels for just a moment, and you'll see what I mean (they have all the serious skin texture—the stuff we don't want).

(Continued)

Step Three:
Press-and-hold the Command (PC: Ctrl) key, and click directly on the Red channel's thumbnail (as shown here) to load this channel as a selection.

Step Four:
This step is totally optional, and I encourage you to try this technique without using this step (which will forever be known as the "evil blurring step" by high-end retouchers, who will scorn you for this, so I beg you—try it without this step at least once and see what you think). To do this optional, bonus, don't-really-try-this step, first you have to Deselect what you did in the previous step, so press **Command-D (PC: Ctrl-D)**. Now, duplicate the Red channel by dragging it down onto the Create New Channel icon (which looks just like the Create a New Layer icon). Next, go under Filter menu, under Blur, and choose **Surface Blur**. Enter 5 pixels for the Radius and 5 levels for the Threshold, and click OK. Press-and-hold the Command (PC: Ctrl) key, and click directly on the duplicate Red channel's thumbnail (named "Red copy" in the Channels panel) to load this channel as a selection. Now, just continue on with the rest of the technique.

Step Five:

Go back to the Layers panel and click on the Create a New Layer icon to add a new blank layer. Now, while your selection is still in place, click on the Add Layer Mask icon at the bottom of the Layers panel, and it takes your selection and turns that into your layer mask. Take a look at the thumbnail for the layer mask attached to this layer, and you'll see what I mean. Remember, any other time we add a layer mask, it's always solid black or solid white (well, until we start painting on it, anyway), but here the layer mask looks like the Red channel. That's the secret to this technique (but this will make more sense in just a moment). Another big difference is that we're not going to paint on the layer mask, like usual. Instead, we're going to paint on the blank layer itself, and then the layer mask will be used to maintain the texture. To do this, you need to go to the Layers panel and click on the blank layer's thumbnail (as shown here), so the layer is active, instead of the mask.

Step Six:

Get the Brush tool **(B)**, set the brush's Opacity to 20% up in the Options Bar (unless you're using a tablet with Pressure Sensitivity turned on, in which case you can leave it set at 100%), choose a large brush, then Option-click (PC: Alt-click) on the skin area right around where you want to smooth the skin to sample the color, and start generally building up strokes over the area you want to soften. As you paint over the area, it starts to soften. You'll have to let it build up, so paint over the area at least a couple of times, and as you paint, you'll see the skin starting to soften. The more you paint, the softer it gets, so you don't want to paint too much.

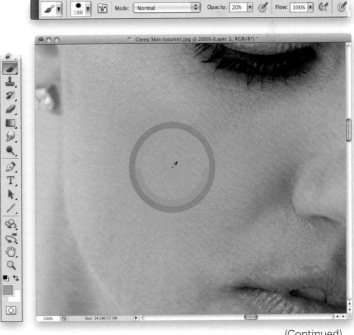

(Continued)

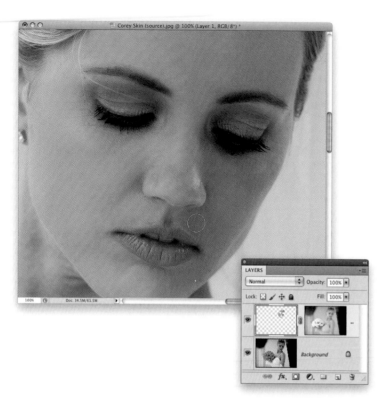

Step Seven:
The real key to making this technique work for you is to make certain you resample again and again as you move around the face to different color tones. Also, you'll need to shrink your brush size as you move around to tighter areas, but don't forget to resample again and again as you move around. Here, I've painted over nearly all the areas I wanted to soften, being careful not to soften the lips, nostrils, eyes, eyebrows, hairs, and so on.

Step Eight:
Okay, this step is really just to help you understand what's going on in this technique (and it will help you understand why her skin looks so plastic in the shot you see here). Press-and-hold the Shift key, and click directly on the layer mask thumbnail attached to your layer, and it hides the effect of the mask from view (and puts a big red X over your mask, as seen here, to let you know it's hidden). Now her skin looks really plastic, because without that mask, all you've really done is sampled a flesh tone and then painted a solid color right over her skin. To toggle this on/off so you can compare, just keep that Shift key held down and click on that layer mask thumbnail and few times, and you'll see exactly what's going on. When you're done, just make sure the mask is active again (so there's no big red X across it).

Step Nine:

The great thing about this is that you did all this painting on a layer, so if you think the skin looks too soft, you can just lower the Opacity to reduce the intensity of the softening (here, I lowered the Opacity to 70% to keep even more skin texture). A before and after of our work is shown on the next page.

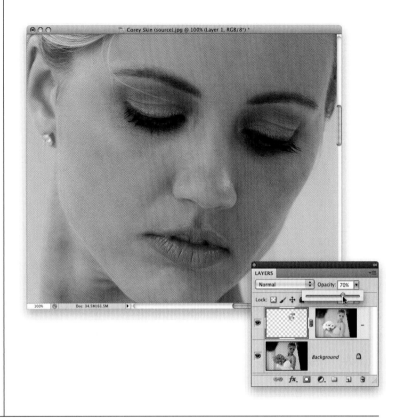

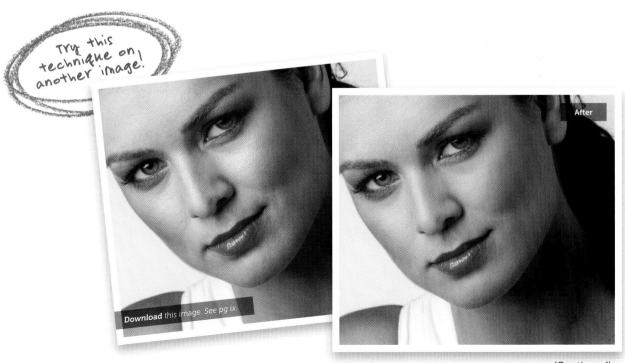

Try this technique on another image!

Download this image. See pg ix

After

(Continued)

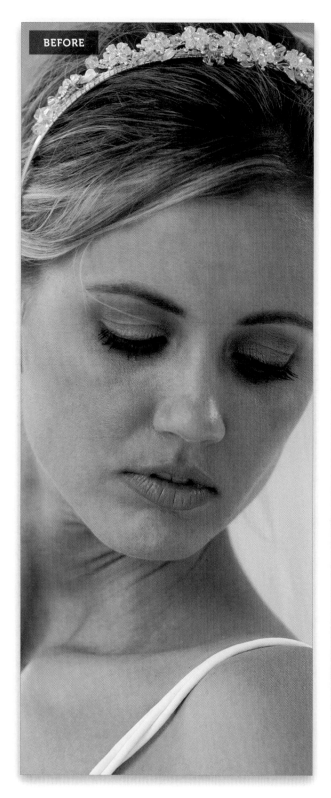

Reducing or Removing Wrinkles

The older the subject, the deeper and longer any wrinkles on their face may be. The thing about wrinkles is that, for the most part, you can't remove them or the subject looks weird. Instead, you just have to reduce them by lightening the shadows in the wrinkles themselves. The thing to keep in mind when reducing wrinkles is that you want to make your subject look 10 years younger, not 40 years younger.

Step One:

Here's our subject, and we're going to do a simple two-step process to remove the wrinkles. First, we're going to remove all the wrinkles completely, then we're going to bring back some of them to make it look realistic. Start by clicking on the Create a New Layer icon at the bottom of the Layers panel to create a new blank layer (we'll be doing all our retouching up on this new layer).

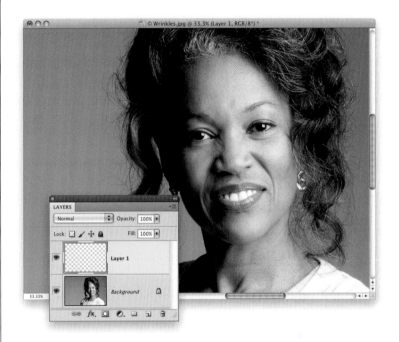

Step Two:

Zoom in, and get the Healing Brush tool (press **Shift-J** until you have it). In the Options Bar, choose a small brush size and, from the Sample pop-up menu, choose **All Layers** (if it's not already chosen). That way, when you use the Healing Brush on this new blank layer, it will sample from your photo on the Background layer. Option-click (PC: Alt-click) in a clean area near some wrinkles (as shown here). Make sure you choose an area to sample that has a similar texture to the area surrounding the wrinkles.

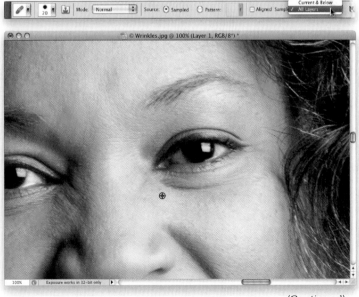

(Continued)

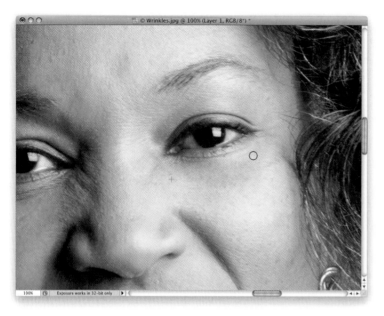

Step Three:

Now, you're going paint over the wrinkles with the Healing Brush. In this case, I painted a stroke from left to right over the wrinkle under the eye on the right. In the capture shown here, you can see where my brush cursor is, and you can also see the little crosshair cursor (+) that shows the spot I sampled from. Now, here's some good news: since you're going to bring back some of these wrinkles a little later on, making absolutely perfect wrinkle removal isn't a big worry. So, if you remove a wrinkle and it doesn't look great, don't sweat it, because a lighter version of the wrinkle is coming back soon, and it will cover up most of your work here anyway.

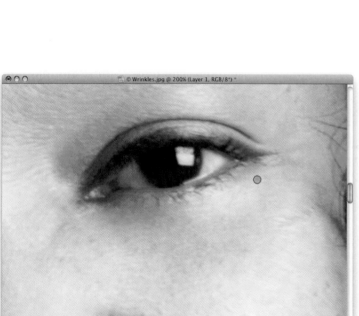

Step Four:

Chances are it's going to take more than just a few strokes to get all of the wrinkles, so feel free to paint more strokes to completely remove them. Here I zoomed in tighter, and worked on the next wrinkle up. I also had to remove a few little "straggler" wrinkles left over right near the eyelashes and at the corner of the eye. It took around three big and six little strokes to remove all the wrinkles here.

Step Five:

Let's switch over to the other eye and repeat the process: use a small-sized brush, and sample (Option-click) near the area of wrinkles you want to remove (as shown here).

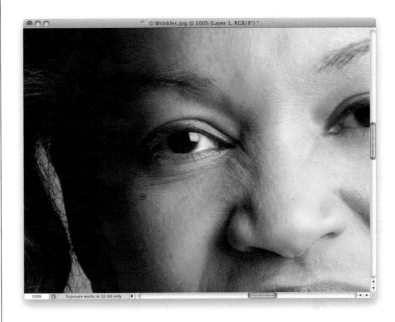

Step Six:

Now, paint a stroke going from left to right to remove the bottom wrinkle, like I did here (I zoomed in tight to 200% here, so you could see better. While zooming beyond a 100% full-size view makes things a little soft and pixelated, you have to do it sometimes with detail work).

(Continued)

Step Seven:

Here, you can see I've removed the wrinkles from beneath the eye on the left, but we've got to do a little more work in this area. You also need to remove those wrinkles to the left of her nose. They're much more noticeable than the ones to the right because of the lighting, but either way, you're going to have to remove them. Start by sampling in a nearby area that has basically the same texture, but doesn't have a wrinkle in it.

Step Eight:

Now, start painting over the wrinkles to make them go away. You might have to resample a few times to get this entire area (you can see me resampling here), but just be patient and remove most of the wrinkles. Compare this side of the nose with the one in Step Seven, and you can see it's quite a bit better. Again, it's not perfect, but because we're going to be bringing some of those wrinkles back, it doesn't have to be.

Step Nine:

Let's move down to the cheeks and mouth area. She has some little smile lines right above her lips, extending from one end to the other like a half-oval. We're going to get rid of those first. Option-click in a nearby clean area (as shown here).

Step 10:

Paint over those smile lines (again, it might take more than one stroke) until they're gone (as seen here). Now, we're going to tackle something much larger—the larger smile lines on her cheeks extending down to her jaw. Our goal here is to completely remove them, and then when we bring them back, it will soften those shadows, which makes them look less deep, and makes the subject look younger (the older we get, the deeper these lines get, and the darker the shadows get. Man, this getting old thing is a blast!). Here, I've sampled near the bottom of the line on the right side of her mouth, just to the right of the line.

(Continued)

Step 11:

Now, you're going to paint away that entire line. It's going to take a few strokes and a medium-sized brush to get this one done. Plus, you'll probably have to resample a few times, in other nearby clean areas, along the way (as I have here).

Step 12:

I did the smile line on the other side of her face the exact same way. It took a few strokes to completely remove it, but if that's what it takes, that's what it takes. So, here's the image with the most obvious wrinkles, crow's feet, and smile lines completely removed. Now, you can see how freaky it looks when you remove all the wrinkles from a person's face (the goal is to make her look 40—not 14). In the next step, we'll fix that fast.

Step 13:

The final step is simply to lower the Opacity of your healing layer (the layer you did all your healing on from the beginning) in the Layers panel to bring back some of the original wrinkles. Here, I've lowered the layer Opacity to 40%, and you can see how natural it looks. The shadows are all lighter, and while you can see all the wrinkles, they look less deep, which makes her look younger. The amount will be different for every person you retouch, based on their age and their wrinkles. If you're doing this on someone much younger, and you just want a hint of natural wrinkles, then you might leave the Opacity up at around 80%, but again, you have to make the call based on age, amount of wrinkles, etc.

Step 14:

If you want to bring back a little more of an area, like the laugh lines, just click on the Add Layer Mask icon at the bottom of the Layers panel, then get the Brush tool **(B)**, lower its Opacity to around 10%, make sure your Foreground color is set to black, and paint over the lines or wrinkles you want to bring back a little more. You can see the before and after (at 40% opacity) on the next page.

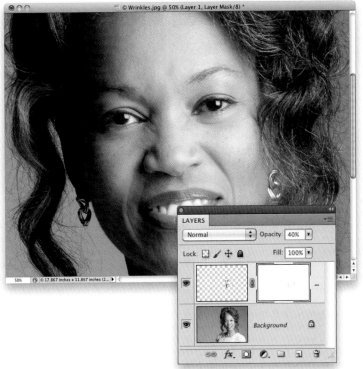

(Continued)

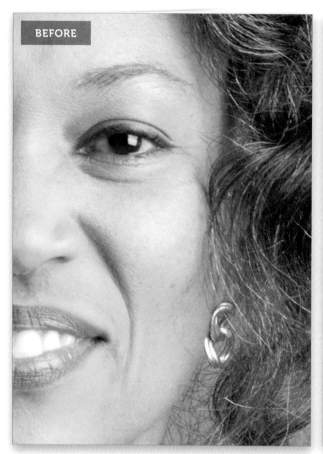

BEFORE

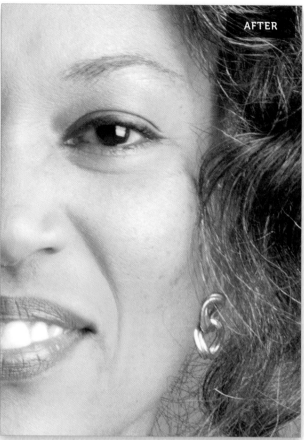

AFTER

Download this image. See pg. xi.

After

Try this technique on another image!

Removing Hot Spots

Hot spots are those shiny areas on your subject's face that reflect the lighting and almost make their face look like they're sweating. I try to fix these while we're on the shoot, but one set of shots with them always seems to sneak through (unless I have a makeup artist on the set—they never let the models get shiny). If a few sneak into one of your sets, here's how to quickly get rid of them:

Step One:

Here's a shot of our subject, with hot spots on the bottom of her forehead, on her nose, her cheek on the right, and her chin. The Patch tool (shown here) works well with these larger repairs, but you can use the Healing Brush tool to do this, too. If you do, though, you have to remove the entire hot spot in just one stroke (you'll see why in a minute).

Step Two:

Zoom in on her face, then press **Command-J (PC: Ctrl-J)** to duplicate the Background layer—we'll do all our patching on that layer. Take the Patch tool and draw a selection around the hot spot on her forehead (as shown here). The Patch tool works just like the Lasso tool for making selections, so you'll feel pretty comfortable with it the first time you use it.

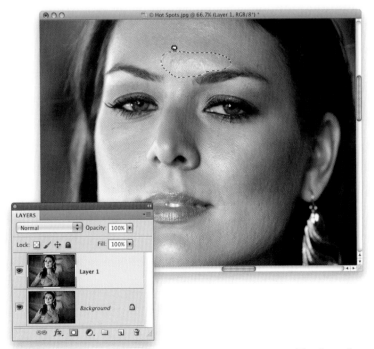

(Continued)

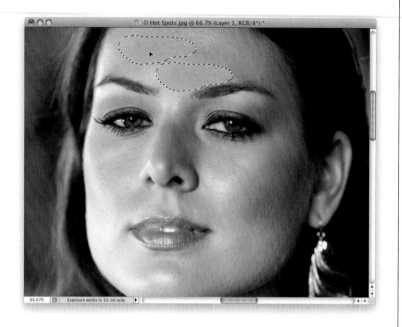

Step Three:

Now, click inside your selected area and drag that selection to a nearby area that has a similar texture (so, somewhere on the forehead), but isn't shiny (as shown here). Release your mouse button (or remove your pen from the tablet surface), and your selection snaps back to its original position (over the hot spot), and your hot spot is gone. Sadly, so is the highlight, which we don't want to lose—a nice highlight area adds dimension, so we don't want it removed—we just want the amount of highlight lessened, so we'll fix that in the next step. For now, whatever you do, don't deselect (you need to keep your selection in place).

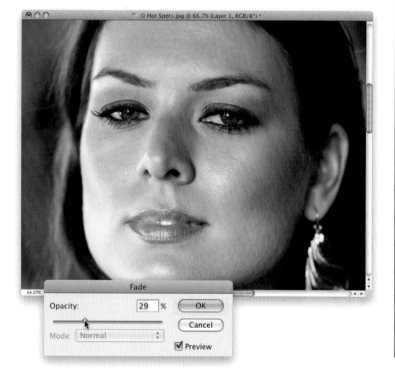

Step Four:

Press **Command-H (PC: Ctrl-H)** to hide your selection around the area where the hot spot used to be. Now, go under the Edit menu and choose **Fade Patch Selection**. This brings up the Fade dialog (shown here), which I like to think of as "Undo on a slider." At 100%, you have the full effect of whatever you did last (in this case, you used the Patch tool to remove the hot spot, and everything else, on her forehead). If you lower the Opacity to 0%, it would all come back as if you never did anything. So, your job here is to lower the Fade Opacity amount until the highlight comes back, but you want to stop before the shininess comes back. In this case, 29% brought back the highlight we want, without the shiny stuff we don't want. Click OK, and you're done with that hot spot.

Step Five:

You're going to continue this process on each of the other hot spots, and don't be surprised if you use a different Fade Opacity amount for each one—just use your best judgment. Also, Fade only works on the very last thing you do, which is why immediately after you use the Patch tool, the very next thing you need to do is Fade it—the Fade command will disappear as soon as you do anything else (luckily, it doesn't count the Command-H [Hide Selection] keyboard shortcut as a step). So, I always do it in this order: (1) remove the hot spot, (2) hide the selection, and then (3) go right to Fade and lower the Opacity. Now, select the hot spot on her chin (as shown here) and drag it to a nearby clean area with similar skin texture.

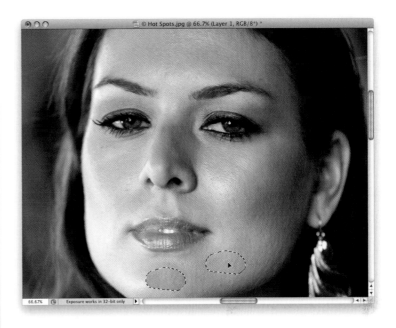

Step Six:

Hide the selection (so you can clearly see what you're doing), then go under the Edit menu, choose Fade Patch Selection, and lower the Opacity until it looks about right (as shown here; for this hot spot, the amount that looked right to me was 36%). Remember, all your patching was done on a copy of the Background layer, so if you feel like the highlights all still look a little too dull, you can lower the Opacity of the layer a little bit and it will all back down proportionally. A before/after of the retouch is shown on the next page.

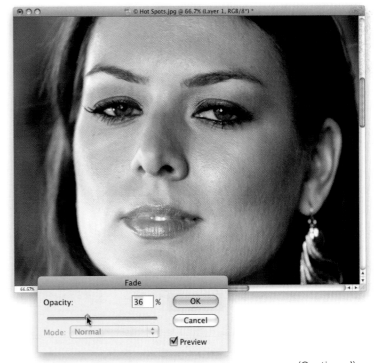

(Continued)

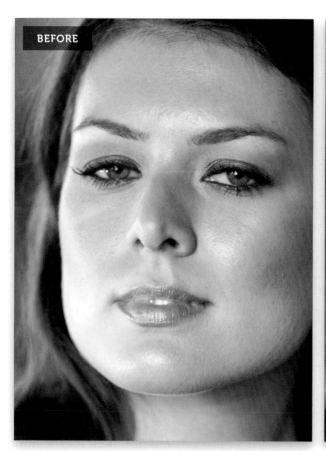
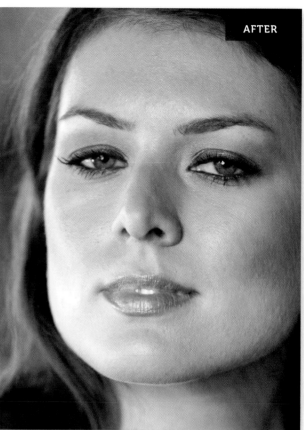

BEFORE

AFTER

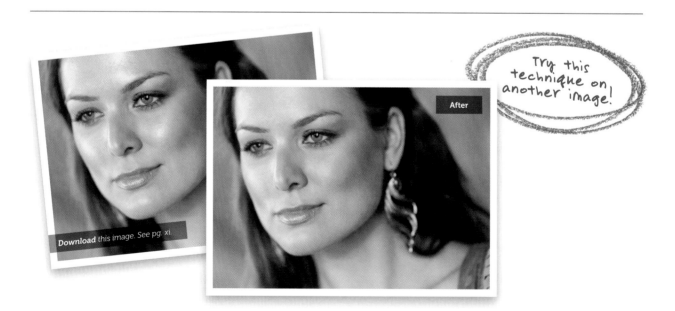

Download this image. See pg. xi.

After

Try this technique on another image!

Balancing Skin Tones

You're definitely going to run into situations where your subject has a patch of skin, maybe on their arm, or back, or leg, that is either brighter or darker than the surrounding skin. So, we should do a quick retouch to balance those areas before we start any kind of skin softening or smoothing. You don't want to spend a lot of time on this, but if you can get the skin tones in these areas closer in just 60 or so seconds, it makes things easier down the road. Luckily, it's a very quick and easy technique.

Step One:
Here's the image we want to retouch, and if you look between our subject's collarbone and her chest, you'll see a large area of skin that's darker than her surrounding skin. Ideally, we'd like to balance these areas of skin before we do any skin softening or enhancing.

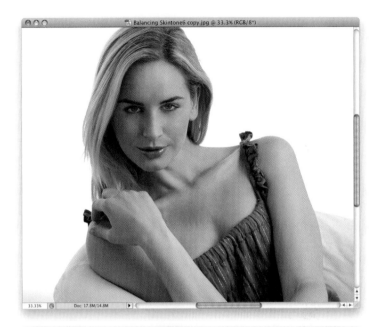

Step Two:
Get the Lasso tool **(L)** and trace right around that darker area (as shown here). Try to keep your selection pretty darn close to that area, but don't spend a lot of time making it exactly perfect, because you're going to add a huge feather to the edges that will make up for not having a perfect selection, but you should at least try to get close. Now, go under the Select menu, under Modify, and choose **Feather**. When the dialog appears, enter 10 pixels if you selected a smallish area, or 20 pixels if it's a larger area, like the one we have here.

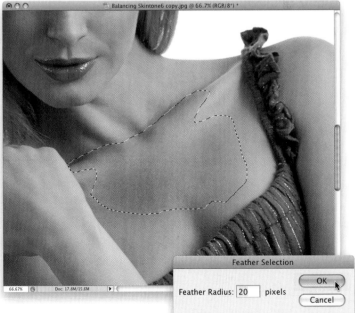

(Continued)

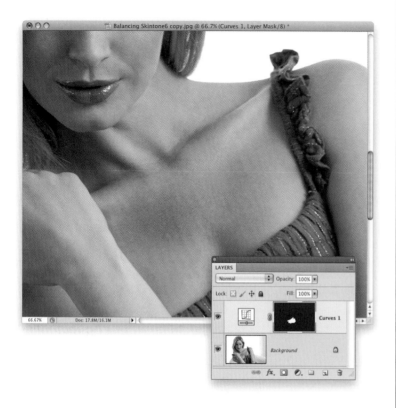

Step Three:

Now, click on the Create New Adjustment Layer icon at the bottom of the Layers panel and choose **Curves** from the pop-up menu. Notice that your selection is already masked out on the Curves adjustment layer mask.

Step Four:

Now, don't worry, even if you've never used Curves before, you'll be able to do this. You're going to change the tone of these patches of skin (whether they're too dark, like the ones shown here, or too bright, which is often the case) by adjusting the midtones. So, start by clicking once right on the center of the diagonal line in the Curves graph (shown circled here in red) in the Adjustments panel to add a point to the midtones area of the curve. So far, pretty easy, right? You just click once right in the middle of the line.

Step Five:

All you're going to do now is drag that middle point diagonally up and to the left to brighten that whole darker area. Just drag a tiny little bit, keeping an eye on your selected area as you drag, and with just a little bit of dragging, you'll be able to make that darker area of skin match the surrounding area (this is much easier than you'd think, so make sure you try it for yourself). Also, if the area had been brighter, instead of darker like it is here, you'd drag that center point diagonally down toward the bottom-right corner. Either way, this is usually a very small movement, and to know exactly how much to move, keep an eye on the area of skin you're adjusting. Also, it sometimes helps to move the curve a lot—making it much brighter—and then pull it back down again to match (this is kind of like turning the focus ring on your lens so it goes way out of focus, and then turning it back the other way to snap it into sharp focus. By putting it way out of focus, it makes seeing when it's in sharp focus that much easier. Same thing here).

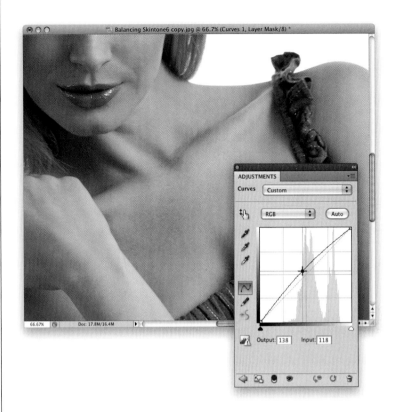

Step Six:

Now that we've balanced that large area, if you wanted to take it a step further, I see two other remaining parts of that same general area that could use a little more balancing. So, first, in the Layers panel, click on the Background layer. One area is on the right side of her collarbone, so go ahead and trace it with the Lasso tool (as shown here), and then apply a 10-pixel feather. The reason we're only using 10 pixels this time is because the size of the selected area is so much smaller.

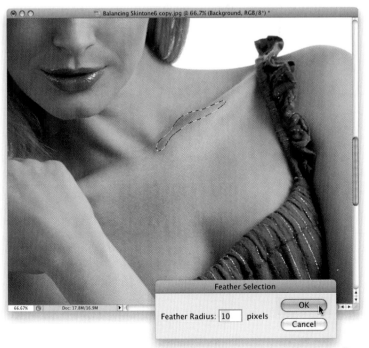

(Continued)

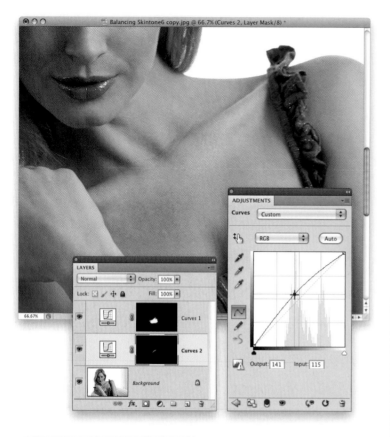

Step Seven:
Add another Curves adjustment layer, click on the center of the Curve to add a point to the midtone area, and once again, drag up just a tiny bit until that darker area better matches the surrounding skin (as shown here). You can see, once again, it's just a tiny move of that Curve.

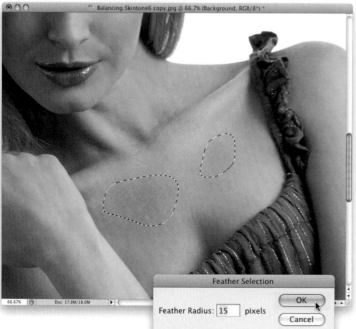

Step Eight:
The last thing I might adjust is those remaining dark areas within that first large area we brightened. Click back on the Background layer, and trace around them with the Lasso tool (select the first area, then press-and-hold the Shift key, and select the second area), add a 15-pixel feather (for medium-sized areas), and add a Curves adjustment layer. Add a point to the center of the curve, and move it just a little bit up, once again, to brighten those areas. Just a reminder: This process should be pretty quick, and you won't do it to every photo, just to ones where a darker or lighter area of skin really jumps out at you. A before and after is shown on the next page.

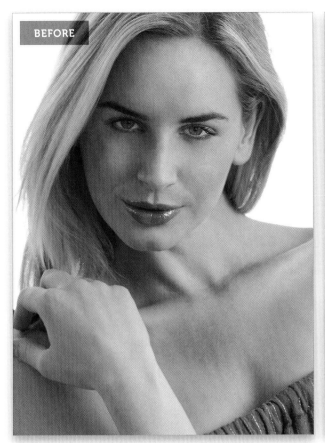

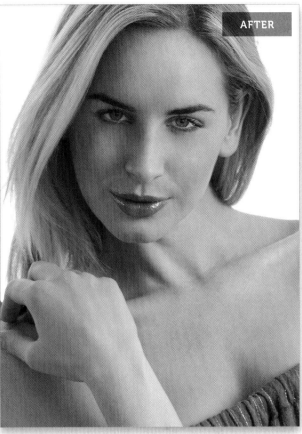

Try this technique on another image!

Reducing Stubble

This is a quick trick for getting rid of, or lessening, facial stubble. I'm not sure what else to say about it, but that one sentence alone just looked kinda lame, so please consider this extra sentence filler.

Step One:
Here's the image we're going to retouch, and you can see he has a one- or two-day growth going on. If you want to get rid of that, or reduce it, start by pressing **Command-J (PC: Ctrl-J)** to duplicate the Background layer.

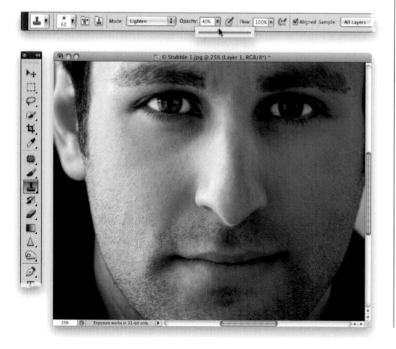

Step Two:
Now, get the Clone Stamp tool **(S)**, go up to the Options Bar, and change the Mode from Normal to **Lighten**, then lower the Opacity to 40% (as shown here). By changing the blend mode to Lighten, you're telling the tool to only affect pixels that are darker than the area you've sampled (so when you sample a clean area of skin, it will only affect pixels darker than that clean area).

Step Three:

Get a small, soft-edged brush, press-and-hold the Option (PC: Alt) key, and click once in a clean area of skin nearby the area where you're going to start "cleaning up." Move your cursor over some of the stubble and start painting it away, following the contours of the stubble (in other words, clone in the direction the hairs are going).

Step Four:

Continue your way around the face, and don't forget to resample (Option-click on) different areas from time to time to keep things looking random. Also, resample any time you're repairing a different area of the face, because the skin texture and tone may change. Here, I've gone down the side of his face, and part of the side of his stubbly mustache.

(Continued)

Step Five:
Here's what it looks like after about a five-minute cloning job (so it could use a little more work, but you get the idea). You can still see plenty of original skin texture using this technique, which is why I prefer it to just blurring it all away.

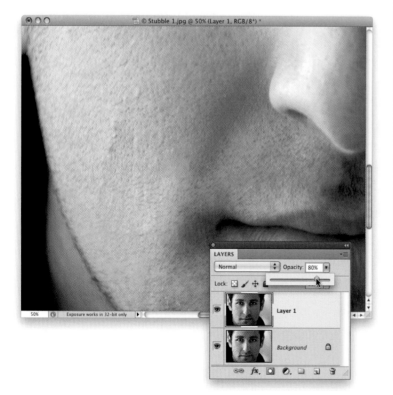

Step Six:
If it looks a little too clean for you, just go to the Layers panel and lower the Opacity to bring a tiny bit of the original stubble back from the Background layer (here, I lowered the Opacity to 80% and I think it looks clean, but a bit more natural).

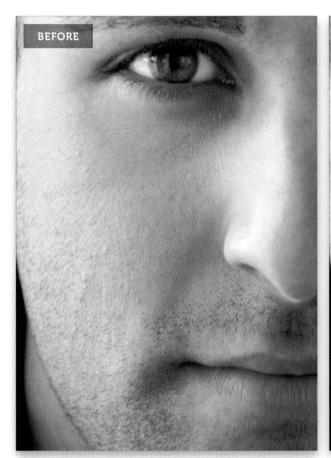

BEFORE

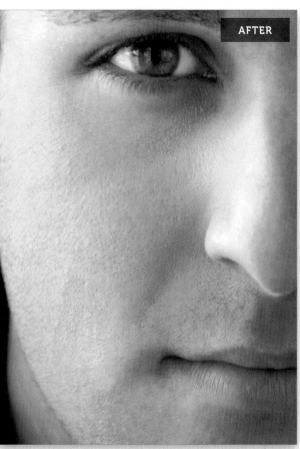

AFTER

Try this technique on another image!

Tip: When the whiskers are lighter than the skin, because of their color or how the light hits them, you'll need to change the Mode of the Clone Stamp tool to **Darken** (instead of Lighten) to affect them.

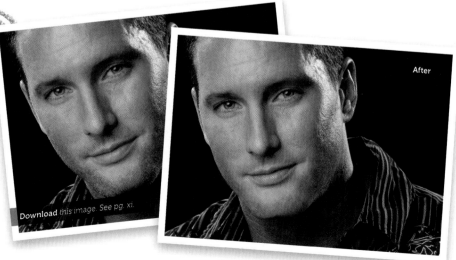

Download *this image. See pg. xi.*

After

Applying Digital Makeup

Professional makeup artists are worth their weight in gold during a shoot, and I hire one every time I can, because they are miracle workers (and they make our retouching jobs dramatically easier). What I'm going to show you here won't replace using an MUA, but if you need to touch up, add, or enhance makeup, you'll find this really helpful. We're starting from scratch on a face with no makeup at all, and going through the whole process. A big thanks to professional MUA Shelley Giard for guiding me through how she applies makeup in the real world, and to and my friend and brush master, Corey Barker, for his help and input.

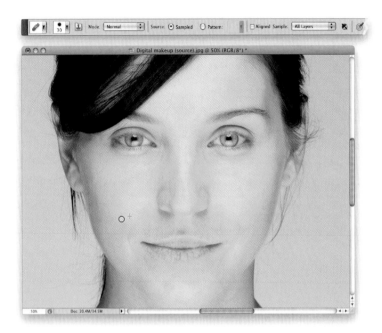

Step One:
Here's the image we're going to apply digital makeup to—we asked our model not to wear any makeup for this shoot, so we could apply it all from scratch. Of course, we start by removing any major blemishes or wrinkles first, before we add any makeup, so let's do that first using the Healing Brush tool (press **Shift-J** until you have it), and the technique for removing blemishes you learned on page 86. Also, she has a couple of stray hairs crossing onto her face, so go ahead and get rid of them, too, using the Healing Brush (that one hair going right over her eye was a pain. You'll have to switch to the Clone Stamp tool **[S]** with a really small brush for that one). If those stray hairs on the side of her face are distracting you (they are me), you can get rid of those, too, using the technique on page 196. Also, since we're going to be applying eye makeup before long, you might want to remove any red eye veins (page 32).

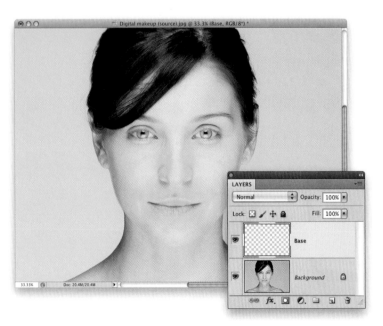

Step Two:
Ahhhh, that's better. It could still use a lot of retouching work (like filling in that gap in her hair, for one), but at least the main distracting stuff is out of the way. Start by clicking the Create a New Layer icon to add a new blank layer, and name it "Base" (as seen here). We're going to use this layer to balance out the skin tones, and make the skin look even (from a makeup point of view, anyway). Next, we'll set up our brush for painting the Base layer.

Step Three:

Get the Brush tool **(B)**, choose a large-sized, soft-edged brush, then go up to the Options Bar and lower the Opacity to 10%, so the strokes you make build up, one on top of another. Now you're going to press-and-hold the Option (PC: Alt) key to temporarily switch to the Eyedropper tool, and click once on a bright area of skin (as shown here) to make that your Foreground color. Release the Option key to return to the Brush tool.

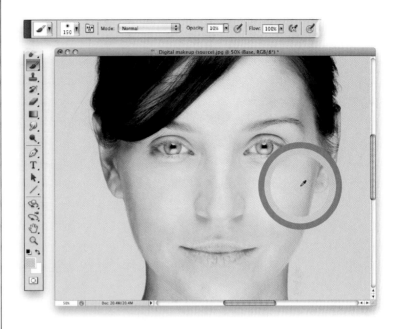

Note: If you're using a Wacom tablet, this works great using pressure sensitivity: click on the Brush panel icon next to the Brush icon in the Options Bar to open the Brush panel, click on Transfer in the list on the left, then from the Flow Jitter and Opacity Jitter pop-up menus, choose **Pen Pressure** (as shown here). Then set your Opacity in the Options Bar to 100%, because now you're controlling both the flow and opacity with how hard you press down on the tablet with your pen—in this case, you'll press down very softly.

(Continued)

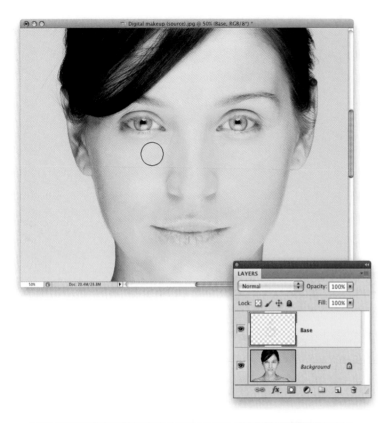

Step Four:

Now you're going to lightly build up color over the areas of her face that are white, so the skin tone looks even (don't worry, we're going to highlight and contour the bone structure in a minute). If you're using a tablet, press lightly and build up your strokes. If you're not, your brush is already set at 10% opacity and you'll see a similar type of buildup. Here, I'm painting on both cheeks, down the top of her nose, on the white areas on her forehead, on her chin, on either side of her nose, kinda below her eyes (as seen here), and basically any area that looks whiter than the rest, you're going to tone using that flesh-tone color. If you toggle on/off this Base layer (by clicking on the Eye icon to the left of the layer in the Layers panel), you'll see the difference this buildup made. Of course, since you did this buildup on a separate layer, if it looks too intense (you think you built up too many strokes), you can just lower the opacity until it looks right to you.

Step Five:

It's time to add some contouring, and we'll start by defining her cheekbones. Create a new blank layer (name it "Dark Contour"), change its blend mode to **Multiply** (so strokes made on this layer darken that part of the image), then use the same temporary Eyedropper tip you learned earlier to sample the darker skin tone from her shadow areas (as shown here).

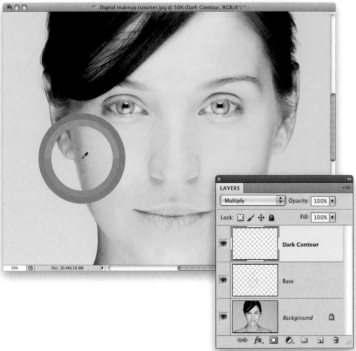

Step Six:

You're going to darken beneath her cheekbone, so use the same Brush tool, but you might want to lower the Opacity setting to around 5% for this step, because those dark strokes are really going to jump out at you. Now, take your brush and lightly paint strokes from top to bottom in that shadow area, following the same lines, almost down to her jaw, and building up as you go, painting over the same stroke a few times. Again, you're on a separate layer, so if it looks too dark when you're done, you can lower the layer's Opacity (here, I lowered mine to 60%).

Step Seven:

Next we'll add some highlighting, so add a new layer, name it "Light Contour," change its blend mode to **Screen** (so our paint strokes on this layer get brighter), then increase your brush's Opacity back to 10%. Now, sample a bright area of her skin using the Eyedropper tool (I chose a bright area right on her cheek), and then paint a stroke like the bottom half of a donut under both eyes (Mmmm. Donut). Also paint a few strokes right down the center of the nose, a little right under the nose, and on the front of the chin (basically, anything that protrudes forward from the face). If it's too bright, lower the layer's Opacity a little (I lowered mine to 79% here). Add another new layer, name this one "Blush," and change its blend mode to Multiply.

(Continued)

Step Eight:

Now you'll need to choose a color for your blush. Click on the Foreground color swatch (at the bottom of the Toolbox) to bring up the Color Picker. In this case, we're going to use a pinkish flesh tone (if you want the same settings I used here, type this in the RGB fields: R=226, G=165, B=159). We added dark contouring under the cheekbones back in Step Six, but now you're going to accentuate the cheekbones themselves. Start by lowering your brush's Opacity to 5%, then begin painting light strokes, and building up gradually over the cheekbone (as shown here) using this pinkish flesh tone color. Again, if it looks too intense, lower the layer's Opacity. Once you're done, in the Layers panel, Command-click (PC: Ctrl-click) on all these makeup layers to select them, then choose **New Group From Layers** from the panel's flyout menu to combine these into a layer group. Name it "Foundation." If the whole thing looks too intense, lower the Opacity of this group (I lowered mine to 70%).

Step Nine:

Now let's work on the eyes (of course, I would fill in and darken the eyebrows, but I covered that back on pages 76, and 80). We'll start with applying eye shadow (we're going to do a casual daytime eye shadow look). Create a new blank layer, name it "Eye Shadow," and change its blend mode to Multiply. You're going to use the same brush settings, and same pinkish flesh-tone hue, as we did for the blush in the last step. Before we start painting, zoom in on one of the eyes.

Step 10:

Shrink the size of your brush, and then begin lightly painting over the eyelid to bring in the color (as shown here). By the way, don't forget to do both eyes. Next, we'll add some eyeliner to give the impression of darker and thicker lashes (again, just remember—this is digital makeup. If we want to add thicker lashes, we can use the technique on page 57).

(Continued)

Step 11:

Create a new blank layer, change its blend mode to Multiply, and name it "Eyeliner." You're going to use the same brush settings again, but you're going to need to click on the Foreground Color swatch and, in the Color Picker, change your color to a dark brown (I used: R=124, G=91, B=55 here). Shrink the size of your brush so it's very small (I used just a 5-pixel, soft-edged brush here), but you need to make the brush a little bit harder, so increase the Hardness amount (in the Brush Picker up in the Options Bar) to around 20%. Now, trace right along the upper lash line to darken it. Start at the inner corner and continue out to the end of the eye (as shown here). Do the same thing on the bottom lash line, as well—painting right along the line where the lashes meet the eyelid. Don't forget the other eye.

Step 12:

Now you're going to highlight the brow bone, which opens up the eyes a bit. Create a new blank layer, change its blend mode to Screen, and name this layer "Brow Bone." You're going to use the same brush settings, but make the brush size quite a bit larger, and set the Hardness amount back to 0%, so the brush is really soft. Use the Eyedropper to sample a bright area of skin right under her eyebrow, then paint a few strokes over the brow bone area to build that up a bit with a brighter tone (it's brighter because the layer is in Screen mode), then do around the tear duct area, as well. Again, if it seems too bright, just lower the layer's Opacity a bit. Once you do both eyes, go to the Layers panel, select all those eye makeup layers, put them into a layer group, and name it "Eye Makeup."

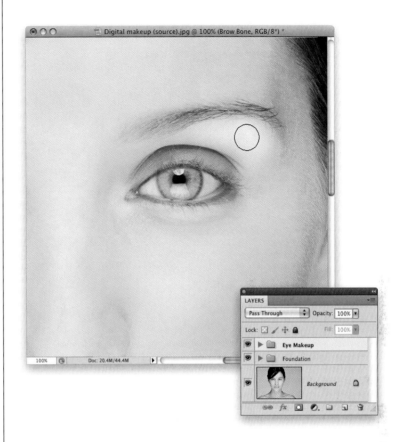

Step 13:

Now, let's work on the lips. We're going to smooth out the lips, then add in some color, but before we do that, for this particular image, we're actually going to insert a small retouch (so we're going to step aside from applying makeup for just a moment). We're going to create the missing center dip in her top lip. Start by clicking on the Background layer. Now, go under the Filter menu and choose **Liquify**. Next, get the Forward Warp tool **(W)**, and then push the top center of her lip down just a tiny bit to make an indent. Push it down so it creates a subtle shape of a "V" (as shown in the After here), then click OK to lock in your retouch. Okay, back to makeup.

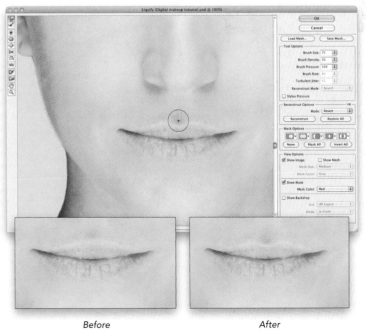

Before *After*

(Continued)

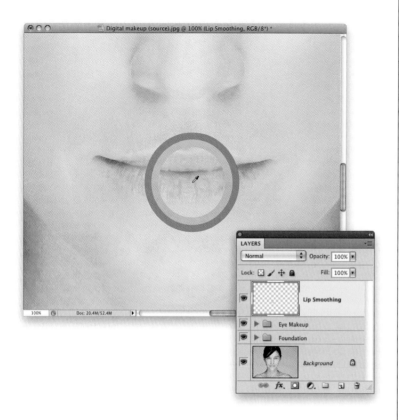

Step 14:
Before we add color, to keep the lips from looking too dry, we're going to smooth out some of the rough areas a bit. In the Layers panel, click on the Eye Makeup group at the top, then create a new blank layer above it, and name it "Lip Smoothing." You're going to use the same brush settings, but you want to use the lip color, so press-and-hold the Option (PC: Alt) key to get the Eyedropper tool, and click on the existing lip color (as shown here) to make it your Foreground color, then paint over the lips a bit, building up tone, until it starts to smooth those rough edges.

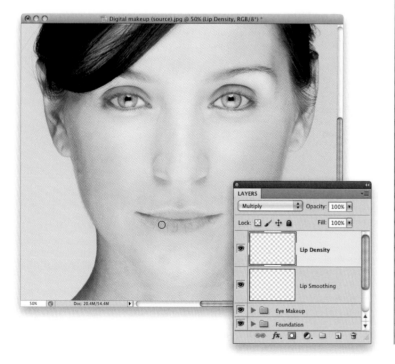

Step 15:
Now we're going to darken the density of the lips. Create a new blank layer (name it "Lip Density"), and change its blend mode to Multiply. You can use the sample color you already have, because it will automatically appear darker since you're on a Multiply layer. Now, begin painting over the lips to darken them (as shown here).

Step 16:

It's time to add some highlights back into the lips. Create a new blank layer (name it "Lip Highlights"). Press **D**, then **X** to set your Foreground color to white, keep your brush size about the same, and use the same brush settings we've been using. Now, you're going to paint some horizontal strokes over the middle center of the top and bottom lips, kind of in an arc, following the contour of the lips, to add a highlight area. It'll probably be too bright, but that's okay, you can tone it down after the fact by lowering the Opacity setting of the layer.

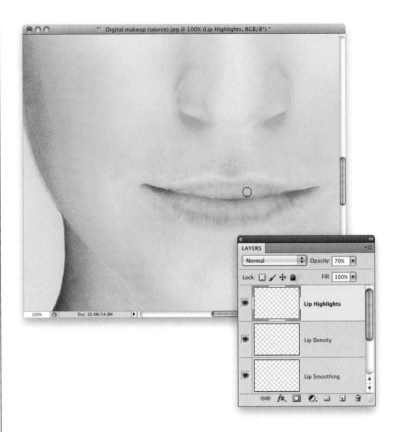

Step 17:

Lastly, just to keep things organized, I would go to the Layers panel, select all those lip layers, put them into a layer group, and name it simply "Lips."

(Continued)

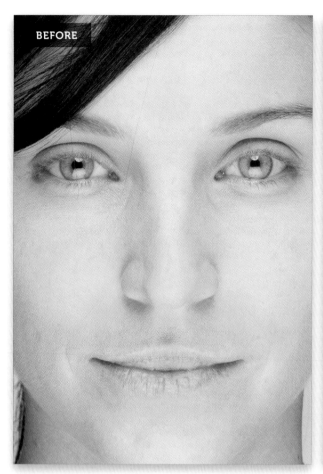

BEFORE

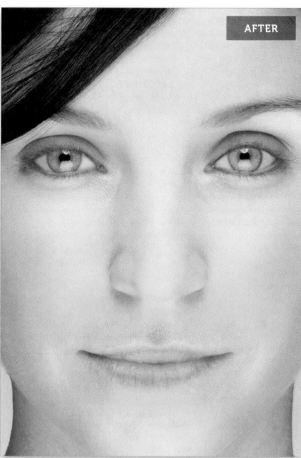

AFTER

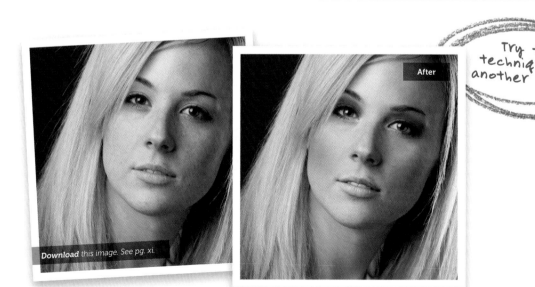

After

Download *this image. See pg. xi.*

Try this technique on another image!

Creating Porcelain-Looking Skin

In this technique, you actually turn the skin white (then I wipe out all the skin texture, and add a few other tweaks). I used to use a series of screen layers, and another popular technique had you using the Diffuse Glow filter, but now I use a trick I picked up from my friend, German retoucher Calvin Hollywood, where now turning the skin porcelain white takes just two sliders and five seconds. Of course, we do other stuff, too, but at least the white skin part is now incredibly simple.

Step One:
Here's the image we're going to convert to a porcelain skin look. You're going to need to do the main part of this in either Photoshop's Camera Raw or Lightroom's Develop module, because you need the Oranges slider in the HSL panel that doesn't appear in Photoshop's normal Hue/Saturation feature. So, start by opening your image in Camera Raw. (By the way, it does not have to be a RAW image to open it in Camera Raw—Camera Raw in CS5 supports TIFFs, JPEGs, and even PSDs. To open an image in Camera Raw from Bridge, just click on it and press **Command-R [PC: Ctrl-R]**. To open it using the regular Photoshop Open [PC: Open As] dialog, just select the photo, then from the Format [PC: Open As] pop-up menu, choose **Camera Raw**.)

Step Two:
Once your image is open in Camera Raw, click on the HSL/Grayscale icon, then click on the Saturation tab (or scroll down to the HSL/Color/B&W panel in Lightroom's Develop module and click on HSL, then click on Saturation). Drag the Oranges slider all the way to the left (as shown here). Depending on the image, you may not need to drag it all the way, but for this image, I took it all the way to the left. At this point, her skin doesn't look white, it looks kind of gray, so we'll fix that next. But one of the things it does do well is it keeps the color in the eyes and lips, which we'll need later.

(Continued)

Step Three:

Next, click on the Luminance tab, drag the Oranges slider to the right (as shown here, where I dragged to +82), and the skin turns white. Now, if you look closely, there's still some red left under her eyes, around the top of her ears, and on her neck and hands, so we'll have to do a little adjusting to this particular image that you probably won't always have to do. Here, we need to get rid of those areas. Also, I want to be able to bring back some of her original hair color. The trick to do this is to open the image in Photoshop as a Smart Object. That way, we can return to the Camera Raw dialog any time by just double-clicking on the layer's thumbnail. So, press-and-hold the Shift key and the blue Open Image button will change to Open Object (shown circled here in red). Clicking it will open your image as a Smart Object.

Step Four:

Here's the image opened in Photoshop as a Smart Object. I need to make a duplicate of this Smart Object layer, so I can return to Camera Raw's HSL/Grayscale panel and remove the extra red areas, but I need to do that without disturbing the original layer. There's a weird thing about Smart Object layers: if you just duplicate the layer like usual, the new layer is linked to the original layer, so any changes you make to this duplicate layer are also automatically applied to the original layer. We need to break this link, so we can edit them individually (which is one of the big benefits of Smart Objects). To make a copy and break that link, just Right-click directly on the Smart Object layer in the Layers panel, and choose **New Smart Object via Copy** from the pop-up menu, as shown here.

Step Five:

Now that you have a duplicate Smart Object layer, you can edit it separately. Double-click on its layer thumbnail and the image opens in Camera Raw. Go to the HSL/Grayscale panel, click on the Saturation tab, and drag the Reds to the left until the red leaves the area under her eyes, on her ears, and so on (as shown here, where I dragged to –93). Now, click OK to apply these changes to just this single layer.

Step Six:

Press-and-hold the Option (PC: Alt) key and click on the Add Layer Mask icon at the bottom of the Layers panel to hide this layer behind a black mask. Now, press **D** to set your Foreground color to white, get the Brush tool **(B)**, choose a medium-sized, soft-edged brush from the Brush Picker, and paint over the reddish areas to remove them (as shown here).

(Continued)

Step Seven:

Now, let's duplicate the original background layer, so we can bring back some of the original color. In the Layers panel, Right-click on the bottom Smart Object layer, then choose New Smart Object via Copy from the pop-up menu. Drag this duplicate layer to the top of the layer stack (so it's the top layer in the Layers panel), and double-click on the thumbnail to open it in Camera Raw. Next, from Camera Raw's flyout menu (at the top-right corner of the Panel area), choose **Camera Raw Defaults** (as shown here) to reset the image to how it looked when you first opened it. If you did some tweaking to the image before we started this, you can do that again now, but we're just going to use this to get her hair color back, so if that looks okay to you, just click OK.

Step Eight:

Add a black layer mask to this layer, too, and paint in white over her hair to reveal its original color. I know it's a bit much at this point, but we're going to back off the intensity in a moment, so for now just paint it back in. You might have to decrease the size of your brush quite a bit to paint over some of those areas where there's just a little bit of hair extending down onto her skin. It doesn't have to be perfect, because it won't be nearly as dark in just a moment, and it won't stand out as severely.

Step Nine:

Go and lower the Opacity of this layer, so the original color doesn't overwhelm the rest of the image (as shown here, where I lowered mine to 46%).

Step 10:

Now, we're going to make a merged layer (a layer that looks like a flattened version of our image), so press **Command-Option-Shift-E (PC: Ctrl-Alt-Shift-E)** and it creates a new layer on top of the layer stack (as seen here). Next, we're going to do something very different than we do in other parts of this chapter. You see, here, we're not concerned with keeping skin texture. In fact, we're going to remove all of it. You can blur the skin (as I'm doing here, using the "Quickie" method you learned earlier in this chapter), or use the Healing Brush tool to remove pores, or use whichever horribly destructive technique you like to remove the texture and replace it with smooth, porcelain-like skin.

(Continued)

Step 11:

If you want really, really white skin, you can tweak this a little bit more to really white it out. Click on the Create New Adjustment Layer icon at the bottom of the Layers panel, choose **Selective Color** from the pop-up menu, then in the Adjustments panel, switch the Colors pop-up menu to **Whites**. Now, drag the Black slider to the left and you get mega-white (as seen here, where I dragged to –45).

Tip: Make the Lips Really Red

If you want to make the lips really red here, you can add a Selective Color adjustment layer and choose Blacks from the Colors pop-up menu, then drag the Black slider to the right. That really saturates the red in the lips.

Step 12:

We're actually going to change her lip color to a dark, almost black, silver look, that better matches the look (for this photo, anyway). Start by making another merged layer and remove the color from this layer by pressing **Command-Shift-U (PC: Ctrl-Shift-U)**, which is the keyboard shortcut for Desaturate. This removed all the color, but it didn't do much for making her lips dark silver, so we'll fix that next.

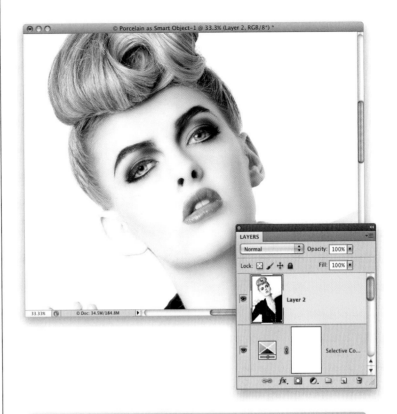

Step 13:

We're going to use a very simple move to darken her lips. Choose **Levels** from the Create New Adjustment Layer pop-up menu, and when the Levels options appear in the Adjustments panel, move the shadows Input Levels slider (the black one on the left underneath the histogram) to the right quite a bit to fill in the shadows, and then move the midtones Input Levels slider (the gray one in the middle) to the right, as well. It trashes the rest of the image, but we're only worried about the lips, which look pretty good at this point. Press **Command-E (PC: Ctrl-E)** to merge this Levels adjustment layer with your desaturated layer right below it, so they're just one layer (but the image will look exactly the same).

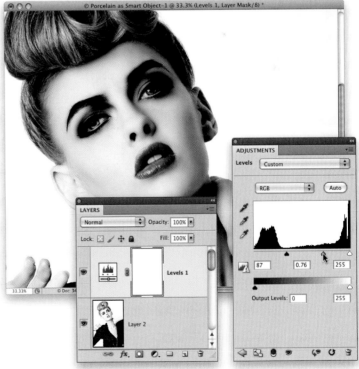

(Continued)

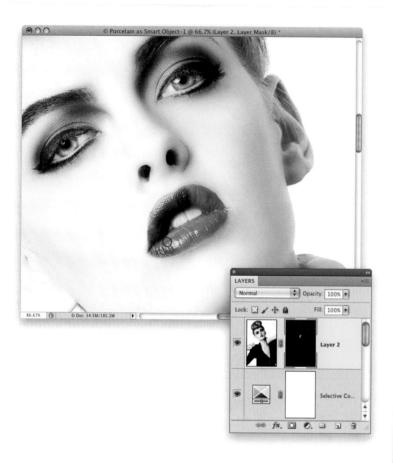

Step 14:
Option-click (PC: Alt-click) on the Add Layer Mask icon to hide this darker layer behind a black mask (as seen here). Then, get the Brush tool, choose a small, soft-edged brush, and with its Opacity set at 100%, set your Foreground color to white and start carefully painting over the lips (as seen here) to bring in the darker color.

Step 15:
There's a lot of lipstick bleed along the edges of the lips, so lower the Opacity of your brush quite a bit and paint along those areas just outside the lips that are still a little red. Since the skin around it is white, you don't have a lot to worry about, but just be reasonably careful and paint over those red areas with your low-opacity brush until they're all gone. Although there are a lot of steps in this technique, it takes just a few minutes, so don't let that throw you off—it's easy and quick. A before/after of the retouch is shown on the next page.

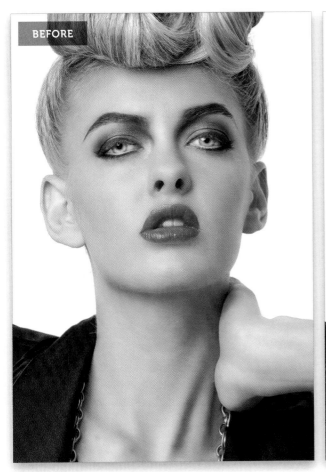

BEFORE

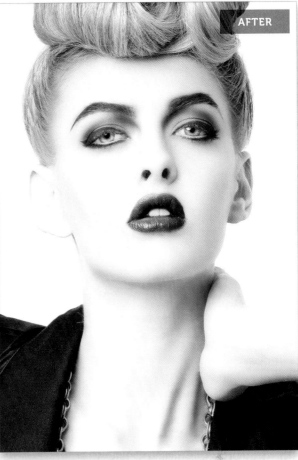

AFTER

Try this technique on another image!

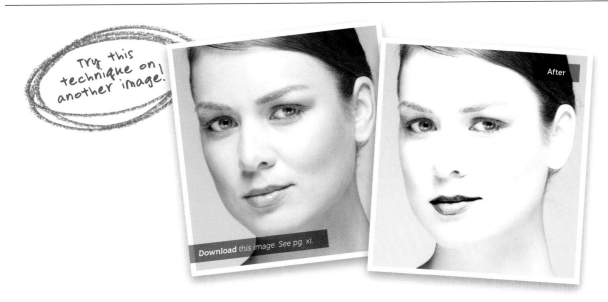

Download this image. See pg. xi.

After

Sharpening Portraits

In most cases, sharpening a guy's skin is easy, because nice, sharp skin texture usually looks pretty good on guys. However, when sharpening a woman's skin, we want to avoid sharpening the existing skin texture as much as possible, and instead have our sharpening just affect the detail areas, like the eyes, eyebrows, mouth, etc. Here are three great ways to do just that: one that's super-quick and does a pretty good job, one that takes a bit of time and effort, but you're guaranteed to have the sharpening only where you want it, and a third in Camera Raw.

Step One:
Here's the image we're going to sharpen (the cover shot of this book), and we'll start with the quick and easy version (and the one you'll probably use the most), which has you targeting just the Red (of the RGB—Red, Green, Blue) color channel, and then applying your sharpening there, because there's so little skin texture on the Red channel (as you'll see). But, first, let's look at the other channels, so you'll see precisely why we choose the Red channel to hold our sharpening.

Step Two:
Go to the Channels panel (if it's not open, go under the Window menu and choose **Channels**), and click on the Blue channel (as shown here). I zoomed in a bit so you can get a clear look at the skin texture, and you can see there's plenty of it. This is the last place you'd want to sharpen, because you'd be sharpening the skin texture big time.

Step Three:

Next, try clicking on the Green channel (which doesn't make a bad black-and-white conversion), and while there's less skin texture here, there's still a pretty decent amount. Since our goal is to side-step all that texture, the Green channel wouldn't be a good choice.

Step Four:

Click on the Red channel, and look at the image now. Basically, what's on this channel is all the detail areas, like her eyes, eyebrows, lips, and hair—the very stuff you want to sharpen. But if you look at her skin, there's very little texture or detail there at all, which is why this is a great place to sharpen photos of women. So, now that you're on the Red channel, go under the Filter menu, under Sharpen, and choose **Unsharp Mask**. When the filter dialog comes up, enter your favorite settings. I generally use Amount: 120%, Radius: 1.0, and Threshold: 0 when sharpening on the Red channel like this.

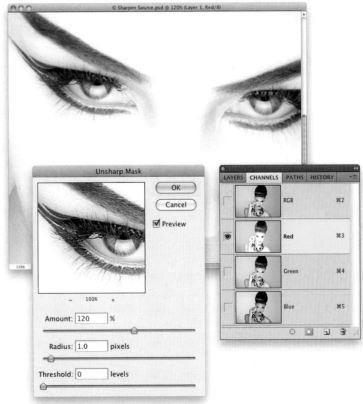

(Continued)

Step Five:

Click OK to apply the Unsharp Mask filter to the Red channel, then in the Channels panel, click back on the RGB channel (as shown here) to return to the full-color image (as seen here). Look at the eyes, lips, even the jewelry—they all look sharper, yet we avoided applying a lot of sharpening to her skin. Plus, the big advantage of this technique is that you can record an action for it (see page xxii), which will totally automate this process for you, so it's down to just one click, and five seconds later—it's done.

Step Six:

The second method takes more time and effort on your part, but with this method, you get the sharpening exactly—and only—where you want it. The first part of this sharpening method is also the method I use for sharpening men's skin (I'll tell you where to stop in Step Seven). Start by going under the Image menu, under Mode, and choosing **Lab Color**, then press **Command-J (PC: Ctrl-J)** to duplicate the Background layer. This converts your RGB image to Lab Color mode, and while your Channels panel definitely looks different, it doesn't change the look of your image, or do any damage to it. Basically, it separates the color in your image from the detail in it, putting all the color in the "a" and "b" channels, and leaving the detail in the Lightness channel. In the Channels panel, click on that Lightness channel, then apply your sharpening. I bumped up my Unsharp Mask settings here quite a bit (to Amount: 81%, Radius: 1.5, and Threshold: 0), so you can really see a clear difference between what you see in the filter's preview window, and what you see in the image itself.

Step Seven:

Go back under the Image menu, under Mode, and choose **RGB Color** to return to RGB mode. When the warning dialog appears, choose Don't Flatten. Now, if we were sharpening a man's skin, we'd be done, and you can end the sharpening process here (at the beginning of Step Seven). However, if you're sharpening a woman's skin, you'll need to do some more work. So, press-and-hold the Option (PC: Alt) key and click on the Add Layer Mask icon at the bottom of the Layers panel to hide this super-sharpened version of your image behind a black mask (as seen here). Then, press **D** to set your Foreground color to white, get the Brush tool **(B)**, choose a small, soft-edged brush at 100% Opacity, and paint over all the areas that you want sharpened in your image (for example, the eyebrows, eyes, eyelashes, mouth, edges of the nostril openings, hair, jewelry, fingernails, and so on). So, this method does take some time, but you get exactly what you want sharpened, and you completely avoid the skin.

Step Eight:

The third way to sharpen a woman's skin is to open the image in Photoshop's Camera Raw, and use its pretty darn brilliant built-in sharpening masking there. To do that, go under Photoshop's File menu and choose **Open (PC: Open As)**, and in the dialog, click on the JPEG, TIFF, or PSD image you want to sharpen, and then from the Format (PC: Open As) pop-up menu at the bottom, choose **Camera Raw** (as shown here) and click the Open button.

(Continued)

Step Nine:

When your image opens in Camera Raw, click on the Detail icon to open the Detail panel, and you'll see four Sharpening sliders at the top. The Amount and Radius are like the ones found in the Unsharp Mask dialog, but it's the Masking slider that holds the trick for sharpening women's skin. Start by pressing-and-holding the Option (PC: Alt) key, then click-and-hold on the Masking slider (as shown here) and the preview area will turn solid white (as seen here). This lets you know that the entire image is being sharpened equally.

Step 10:

Now, start dragging that Masking slider to the right, and as you drag it, parts of the image will begin to turn black. Those black areas are now *not* getting sharpened, which is great, because as you can see in the preview area now, her skin is all in black (not getting sharpened). The areas that appear in white are getting sharpened, and are exactly the areas we want sharpened—the eyebrows, eyes, hair, edges of the nostril openings, lips, jewelry, and edge detail on her face. It's really pretty darn amazing that one slider can do all the masking for you—but it does. So, drag this slider to the right until just those detail areas appear in white (here, I dragged over to 61), and now you're ready to apply your sharpening.

Step 11:

Drag the Amount slider to the right until the sharpening looks good to you (I generally leave the Radius at 1.0, and the Detail slider, which is really more of a "halo avoidance slider," so you don't get halos or other sharpening side effects, set at its default setting of 25, as seen here). For this image, I dragged the Amount slider to 72. That's all there is to it. Now, click the Open Image button to reopen the image in Photoshop, or the Done button if you're done retouching this image. On your next project, take a minute to try all three methods of sharpening, and see which process and/or result feels the best to you, because all three do a great job of sharpening without accentuating the skin texture. You can see a before and after on the next page.

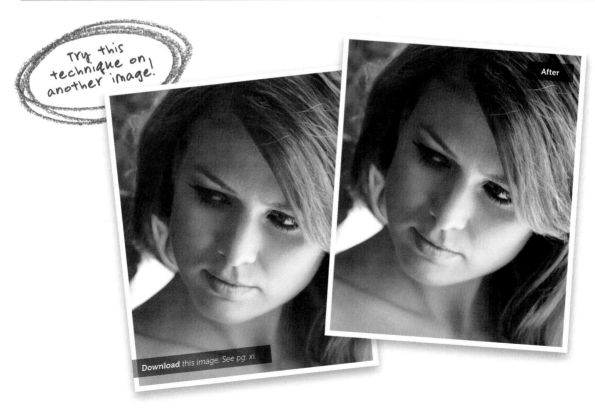

Try this technique on another image!

Download this image. See pg. xi.

After

(Continued)

Chapter 3
FACE TO FACE
Reshaping Facial Features

Every profession winds up developing its own special jargon, which helps people quickly and effectively communicate with others in their same line of work. Well, not surprisingly, retouchers have their own jargon, too, and since you're going to be doing some of your own retouching, you don't want to feel out of place when you get around a full-time retoucher, so you'll want to learn some of their lingo so you can "talk the talk." The first thing to learn is that retouchers see a person's face very differently than photographers do. For example, let's say you're shooting a portrait session, and your subject casually jokes that they think their nose is "a little too big" (a hint they want it retouched). So, you might say to a friend, "I did that headshot of Cindy, and she wants me to reduce her nose a little bit." However, a pro retoucher would never say that. For example, here's a typical conversation between two retouchers looking at a photo of your subject, Cindy. "Hey, Frank, did you see the schnoz on that model?" And his retouching colleague might answer back, "How you plannin' on taming that big honker? Pucker tool?" Then the first guy would answer back, "I dunno. That's one heck of a beak!" It's that kind of crisp, to-the-point communication that enables retouchers to work as efficiently as possible. Now, as photographers, we're not expected to refer to every subject who has love handles as having "lard bags," nor will they look down upon us if we call excess skin at the top of their neck a "double chin," when retouchers refer to it simply as "nasty neck fat." You're not expected to know all of this lingo yet, but if I were you, I'd start testing a few of these out on your portrait subjects right away, so you're fluent when the time comes.

Reshaping the Face and Head

If you need to make an adjustment to your subject's cheeks, chin, ears, or even their head, the first place I go is to the Liquify filter, because it was born for retouches like this. The thing you have to watch out for in a retouch like this is that you don't move parts of the face or head that you don't want to be reshaped, so we're going to spend part of our time letting the Liquify filter know what's okay to move, and what needs to stay put.

Step One:
Here's our shot to retouch. It's a classic beauty-style shot (I always jokingly refer to this as the "Oil of Olay" look), and typically this look has your subject's hair pulled back tightly behind her head in a ponytail (which means you have to clone out any of it that peeks out from behind her neck. Honestly, it's easier just to tape it in place behind her neck during the shoot than to have to retouch it later). In this retouch, we're going to primarily tuck in the left and right sides of her jaw, and we're going to tuck in the ear on the left side, but at the end, I'm going to reshape her entire head, even though it really doesn't need it (so if you need to do it, at least you'll know how).

Step Two:
Go under the Filter menu and choose **Liquify**. When the Liquify dialog appears, choose the Freeze Mask tool **(F)** from the Toolbox (it's shown circled here in red), and paint over all the facial features on your subject's face that you don't want moved when you do your retouch. You literally just paint over the lips, nose, eyes, eyebrows, forehead, and surrounding skin to basically "lock down" those areas (as shown here). As you paint, a red tint appears over those areas to show you which areas are frozen. By the way, if you make a mistake and accidentally freeze something you didn't want frozen, you can paint over it with the Thaw Mask tool (I am not making this up), which appears directly below the Freeze Mask tool in the Toolbox.

Step Three:

Now that your frozen area is in place, you don't really need to see that distracting red oval in the center of your image, so I always hide it by going to the View Options at the bottom right and turning off the Show Mask checkbox (it's shown circled here in red). Next, get the Forward Warp tool **(W)**, and choose a brush that's a little larger than the area you want to adjust, then, using very small, gentle little nudges, tuck in the left side of the jaw a bit (as shown here). By making the brush this large, it moves the whole area as one unit. If you make it much smaller, you run the risk of moving just part of the jaw, and then you have to go back and try to retouch your mistake, so in this one particular case, bigger is better. Now, just tuck in that side a bit by nudging your brush inward at a 45° angle toward her face. Remember, gentle little moves—just nudge it. *Note:* Moving things too much with Liquify is a common mistake you can see even in major magazines, causing that funky squished or stretched-pixel look. So, be careful out there, and use the Liquify tools judiciously.

TIP: Faster Brush Size Changing

Using the **Command-[(Left Bracket key; PC: Ctrl-[)** or **Command-] (Right Bracket key; Ctrl-])** shortcut to change your brush size (the first making it smaller, the latter making it larger) is notoriously slow because it goes up/down in 1-pixel increments. To greatly speed things up in Liquify, use the Shift key (so it's **Shift-[**), which jumps up/down 20 pixels at a time. This Shift shortcut is the only way I resize brushes—the 1-pixel method is just too slow.

(Continued)

Step Four:

Next, go to the jaw on the right side and tuck that in a bit, as well. Again, small, gentle nudges look best. After you're done, take a look at the side of her neck on both sides—right below where you retouched. Now that you've moved her jaw in, you might want to make a small inward move near the top of her neck, as well, using the same brush and same technique (totally up to you).

Step Five:

Click OK and take a look at your results (a mini before/after is shown here). You can see what a difference this retouching move made. Now, I would generally stop at this point, but while we're here, I want to fix the ear on the left side (it's sticking out farther than the one on the right), and we're going to reshape her head to make it even less round (which, again, isn't necessary, but it gives you an idea of what can be done when you need to).

Step Six:

We're going to use the same technique here that we just used to reshape her jaw—we're going to freeze the part of the face that's touching the ear, then we're going to nudge the ear in a little bit. Start by going back into Liquify and getting the Freeze Mask tool, then paint right down the edge of her face on the left side, leaving the ear untouched. That way, when we nudge her ear inward, it won't change the shape of her face—only the ear will be affected. Get the Forward Warp tool again, make the brush a little smaller than the ear (so we can mostly focus on moving the center of the ear inward), and nudge it in toward her face (as shown here), and after just a few little nudges—it's fixed.

Step Seven:

We're going to do the whole head reshaping now—just for practice. Start by freezing the center of her face again and hiding the mask, like we did back in Step Two. Next, using the Forward Warp tool, make your brush really huge (don't forget that Shift key tip from back after Step Three) and nudge over the entire left side of her head (as shown here).

(Continued)

Step Eight:

Now, switch over to the right side of her head and do the exact same thing, using that huge brush and smooth, small, gentle nudges in toward her face.

Step Nine:

Lastly, shrink down that brush and tuck in the sides of her neck. Since we've made her head much thinner, you don't want her trim little head sitting on some big ol' thick neck. Now, while this is much thinner than I personally would make her head, I've seen images that have had this type of thinning done and more. It's all a matter of taste (yours and the client's), but now at least you know what can be done if you need to.

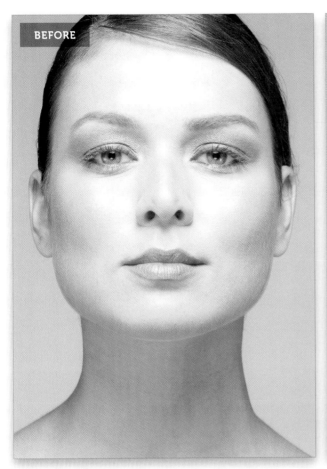

BEFORE

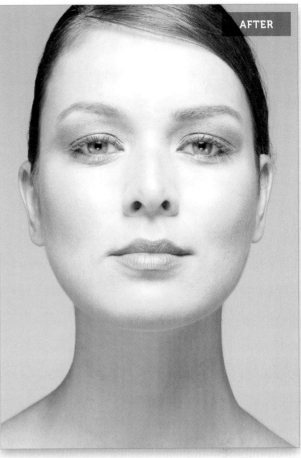

AFTER

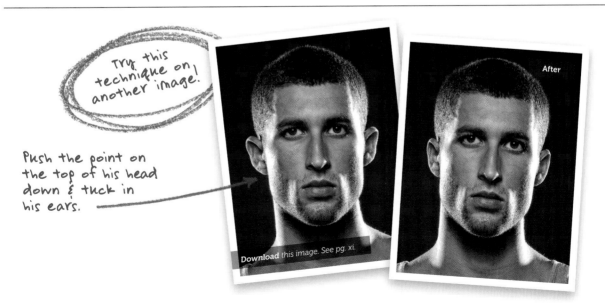

Try this technique on another image!

Push the point on the top of his head down & tuck in his ears.

Download this image. See pg. xi.

After

Making Features More Symmetrical

More often than not, the features on your subject's face won't be perfectly symmetrical (one eye might be higher than the other, or their nose might be a little crooked at the nostrils or the bridge, or one side of their smile might extend higher than the other, and so on). Luckily, you can bring all these misaligned features back into alignment using just a few tools, and some techniques you've already learned (but we do get to learn a helpful new tool this time, as well).

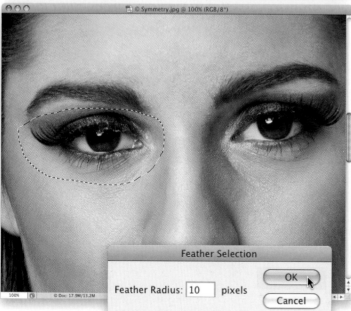

Step One:

Here's the image we want to retouch, and if you really study her face, you'll see that the eye on the left is a little smaller and the eyelid is not as open as the eye on the right. However, the eye on the right is also up a little higher and angled in a bit more than the one on the left (just two eyes, and yet there are four differences between them). Also, take a look at her ears—the one on the right is sticking out more than the one on the left (mostly because of how her hair is situated, but nevertheless, it looks different). Her nose is slightly larger on the right side than the left, and it's twisted just a tiny bit. Lastly, take a look at her lips, and compare the left side with the right, and you'll see the shape changes from one side to the other. Now, you're going to retouch all of that.

Step Two:

We'll start by evening out the size of the eyes. Get the Lasso tool (**L**) and make a very loose selection around the eye on the left (as shown here). Make sure you include plenty of skin around the eye area, but not the eyebrow. Now, to soften the edge of the selection (which will help it blend in better after we resize it), go under the Select menu, under Modify, and choose **Feather**. When the Feather Selection dialog appears, enter 10 pixels (as shown here) and click OK.

Step Three:

Press **Command-J (PC: Ctrl-J)** to copy your selected eye area up to its own layer. Now, to resize it, you're going to use Free Transform, so press **Command-T (PC: Ctrl-T)**. When the Free Transform bounding box appears, press-and-hold the Shift and Option (PC: Alt) keys, so when you drag a point it does two things: (1) it stays proportional as you drag, so you don't distort the eye, and (2) it increases in size outward from the center point, rather than from a corner point (that's what the Option key brings to the party). Now, grab a corner point and drag outward until the size of the eye on the left approximately matches the size of the one on the right (as shown here). Press **Return (PC: Enter)** to lock in your resizing.

Step Four:

Go ahead and adjust the other eye. First, click back on the Background layer but then, this time, make your lasso selection around both the eye and eyebrow (as shown here), because we're going to need to move them together as a unit. Don't forget to add a 10-pixel feather to soften the edges.

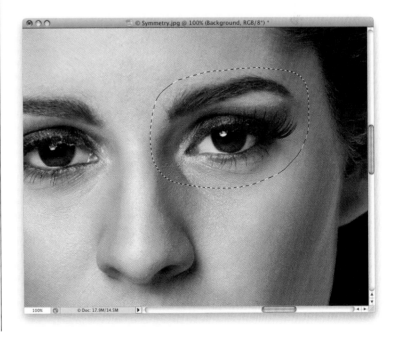

(Continued)

Step Five:
Duplicate this selection and bring up Free Transform again, but this time you're going to use the **Down Arrow key** on your keyboard to nudge the eye and eyebrow combo down a few pixels until the eyes line up straight across from each other. Next, move your cursor outside the bounding box and your cursor changes into a two-headed arrow (as seen here). Now, you need to rotate the eye clockwise a little bit, so it matches the eye on the left. Press Return when you're done, then press **Command-Option-Shift-E (PC: Ctrl-Alt-Shift-E)** to merge all your layers into a new layer on top of the layer stack.

Step Six:
Next, you're going to work on opening the eyelid on the left side a bit. With your merged layer active, go under the Filter menu, and choose **Liquify**. Get the Freeze Mask tool **(F)** and paint over her eyebrow on the left. That freezes it in place, so it can't be accidentally moved while you're adjusting the eyelid. Now, get the Forward Warp tool **(W)**, choose a small brush size, and gently nudge her eyelid above the eye on the left up just a little bit (it's hard to see my brush cursor here, because it's black and we're over a dark part of the image, but I started above her pupil making very small, gentle nudges just a tiny bit upward. It doesn't have to move a bunch—just a little. Remember, you're trying to match the eye on the right, so keep an eye on how it looks as you're nudging, so you don't move too far). Don't click OK yet.

Step Seven:

Now, let's work on making both sides of her nose more symmetrical. We're going to start by shrinking the right side of the nose using the Pucker tool **(S)**. This tool basically collapses the pixels under it, so you have to be very gentle with it (are you sensing a theme here?). Don't paint with it. Instead, just lightly click, and each time you do, it kind of shrinks whatever is under the brush, with the greatest effect happening in the center of the brush. Get a large brush (like you see here) and just click over the right nostril a few times, very gently. Don't be surprised if after one of your clicks, all of a sudden, the entire side of the nose gets sucked in and it looks horrible. I've always said this is a bug in Liquify, but I haven't gotten anybody at Adobe to agree yet—it's like the sensitivity suddenly jumps to 100. Anyway, when it happens to you, just press **Command-Z (PC: Ctrl-Z)** to Undo the cave-in and try again with very light clicks, not strokes.

Step Eight:

Once you get the right side of the nose to more or less match the left side, you'll see that the nostrils aren't matching up. To fix this, you'll need to nudge the top of the nostril on the right down a bit using the Forward Warp tool **(W)** with a slightly smaller brush, as shown here. It will take a few nudges to get it pretty close to how the one on the left side looks, just remember the rule—small, gentle nudges. If you mess up, undo, and try it again.

(Continued)

Step Nine:

Now, look at the bridge of the nose. The left side is out of line a bit (versus the right side), so take your brush and just nudge it into line (as shown here).

Step 10:

Our last retouch on the nose will be to slightly twist the entire nose counterclockwise to make it straight. You do this using the Twirl Clockwise tool (**C**; it twists things, kind of like a whirlpool, as you click-and-hold it down). Choose a huge brush size that covers the entire nose (like you see here). By default, the tool wants to twirl in a clockwise rotation, so to go counterclockwise you need to press-and-hold the Option (PC: Alt) key first, then click-and-hold the tool over the nose (like you see here) for just a moment or two. As soon as you do, you'll see the nose start to twirl (and you'll immediately get what this tool does). Release the mouse button when the nose looks straight. If you mess up, just undo, and then try again.

Step 11:

Don't click OK yet, but here's a mini before/after of just the changes to the nose. The changes looks much more subtle at this small size than they will on your screen, and you'll see it much better at the end of the retouch, but I at least wanted you to see the nose retouch at this point.

Before *After*

Step 12:

Looking at the retouch up to this point, take a closer look at her ear on the right side, and the right side of her lips. As mentioned back in Step One, to have everything look more symmetrical, we're going to have to adjust them so both sides are somewhat similar. So, in the Liquify dialog, get the Freeze Mask tool and paint over the side of her face near her right ear to freeze it. Then, get the Forward Warp tool again and nudge her ear in a bit (as seen here).

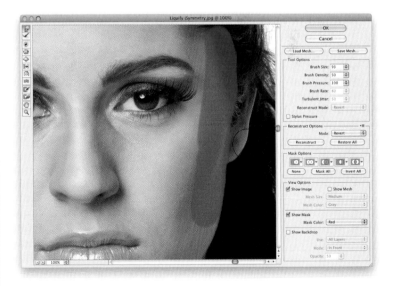

(Continued)

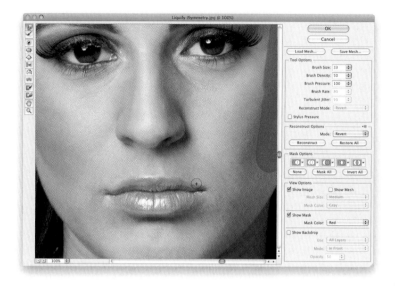

Step 13:

Now, shrink your brush size way down, and let's balance out the lips by just nudging the right side of the top lip down a bit, and basically nudging the right side around until it looks more like the left side (as shown here). I know that all these changes look very subtle, but in a moment, they'll all come together to create a very pleasing symmetrical look for your subject's features.

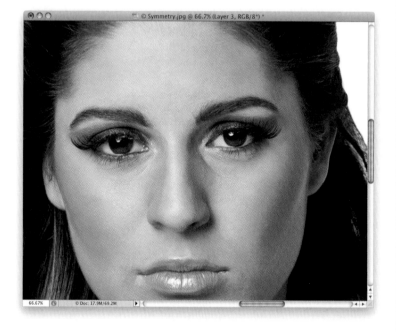

Step 14:

Click OK in the Liquify dialog to see how the changes you just made look in the overall composite image (seen here). A before and after, that's zoomed out a bit, so you can really see how it affects the overall face symmetry, is shown on the next page. Things to look for: eye size, rotation, eyelid fix, and alignment. The right side of the nose matches the left. The lips are more balanced, and the ears are balanced, as well

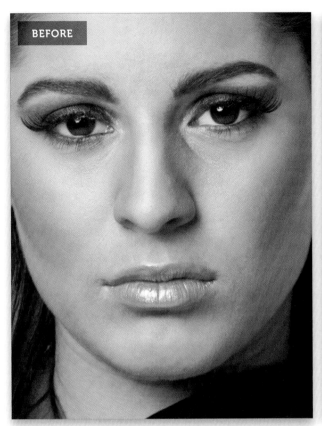

BEFORE

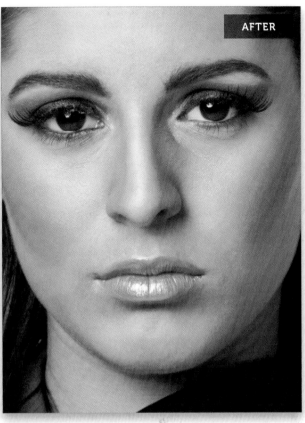

AFTER

Download *this image. See pg. xi.*

After

Try this technique on another image!

Tip: Here, I lifted the eye on the left a bit, so it aligned better with the one on the right.

Sculpting the Face by Dodging & Burning

This is a very popular technique that accentuates the existing highlights and shadows in your subject's face, and gives the face lots of depth and dimension for a really pleasing look. This adds so much dimension, I take the extra time to do this to nearly every image I retouch, so for me, it's almost like a "finishing move" that gives the image that extra depth.

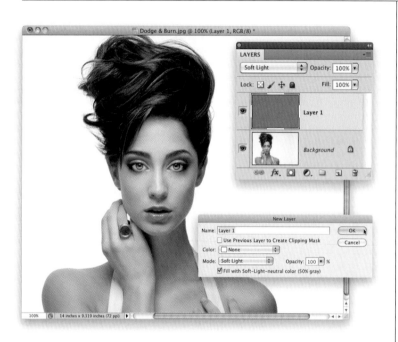

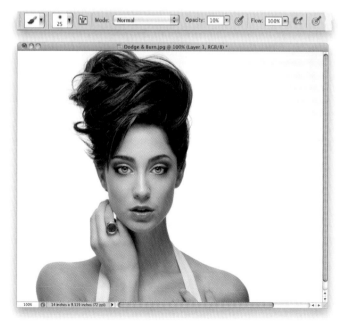

Step One:

Here's the image we're going to use for our dodging and burning project. (*Note:* This dodging-and-burning technique is for sculpting the face. It's not to be confused with the dodging-and-burning technique used by high-end retouchers for smoothing skin, using the pixel-by-pixel, pore-by-pore method.) Start by going to the Layers panel and choosing **New Layer** from the panel's flyout menu. In the New Layer dialog (shown here), change the blend Mode to **Soft Light**, then turn on the Fill with Soft-Light-Neutral Color (50% Gray) checkbox, and click OK. This adds a new layer filled with 50% gray (as you see here), but because it's set to Soft Light, it appears transparent, which makes it perfect for dodging and burning, because later we can blur this layer to soften the effect.

Step Two:

Get the Brush tool (**B**), choose a medium-sized, soft-edged brush from the Brush Picker up in the Options Bar, and while you're there, lower the brush Opacity amount to 10%. You want to be able to gradually build up your strokes as you go (of course, if you're using a Wacom tablet, just leave your Opacity set at 100%, and use the Pressure Sensitivity of the tablet to control the buildup of your strokes).

Step Three:

Now, here's what we're going to do: on this new layer, we're going to paint over the dark shadow areas in black to make them darker, and then paint over the highlight areas in white to make them brighter (so, things that extend out from the face get brighter, and the shadow areas get darker). Here, with my Foreground color set to black, I'm making a few strokes along her cheek on the left to darken that area. So, exactly what areas are we going to darken? Basically, we darken the areas on either side of the bridge of her nose, right under her bottom lip, and along the cheekbones on either side of her face.

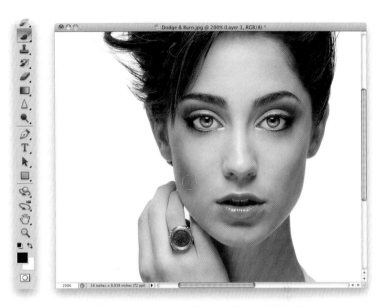

Step Four:

Another area I always burn is right along the hairline, all the way around her forehead (as shown here), kind of making a semi-circle going from her left ear, up to the top of her head, then down to the other ear. In this case, some of her hair is blocking me from going all the way down on the left side of her face, but that's perfectly fine.

TIP: Changing the Ring Color

The ring the model is wearing was actually a dark green when I took the shot, but I didn't think it matched her eyes very well with it that close to her face. So, with the Elliptical Marquee tool (press **Shift-M** until you have it), I put a circular selection around the center of the ring, went under the Select menu, under Modify, chose **Feather**, and added a 2-pixel feather to soften the edge a bit. Then, I pressed **Command-Shift-U (PC: Ctrl-Shift-U)** to Desaturate the green part of the ring, making it black and white. While my selection was still in place, I added a new blank layer, got the Eyedropper tool **(I)**, clicked it once on her iris to steal that color and make it my Foreground color, then pressed **Option-Delete (PC: Alt-Backspace)** to fill the circle with that color. Then, I changed the layer blend mode to **Color** and deselected. That's it.

(Continued)

Step Five:

After the face, I move down to the subject's neck and darken all the shadow areas there and on their shoulders and arms, if they're visible (as seen here). I follow the contours of the skin, so where you see my cursor, I'm painting almost up-and-down strokes (at a little bit of an angle). When I'm doing dodging and burning like this, I prefer to take a few extra strokes, and make the burning really dark (which makes it easier for me to see what I'm doing as I go), knowing that later, I'll be able to control the amount by lowering the opacity of the layer. Once you've burned over all the shadow areas, it's time to do your brightening by switching your Foreground color to white.

Step Six:

Now, it's decision time. You can do your dodging on the same layer you did your burning on, or if you want even more control, you can choose to do your dodging on its own separate layer, so you can vary its opacity separately from the burning layer (just so you know, I usually do mine on the same layer). If you want to keep them separate, then create another Soft-Light-Neutral Color (50% Gray) layer just like you did in Step One, and then do your dodging on that layer. Again, I do both on the same layer myself, so that's what we'll be doing here. Now, with your Foreground color set to white, and using the same brush settings, start painting over the highlight areas to make them even brighter. Here, I'm painting over that highlight that runs along the edge of her chin on the right. This highlight is there because of the way I backlit the shot in the studio, so it won't always be there, but since it's a highlight, I accentuate it with dodging. Don't forget to follow the contours of her skin, painting long strokes from the bottom of her chin up to the side of her cheek.

Step Seven:

So, which things do we brighten when we're dodging? Typically, I brighten any areas that protrude outward from her face, so I dodge the highlight that runs the length of the center of her nose (as shown here), I dodge both cheeks just outside the dark area that surrounds the bridge of her nose, then the center of her forehead, the center of the front of her chin, the two little ridges right above her top lip, the area just above her eyes (where eye shadow goes), and just below the bottom left and right sides of her lips. You'll have to vary your brush size—making the brush smaller for small areas (like her chin, or right above her top lip) and much larger for things like highlights down her arms or shoulders.

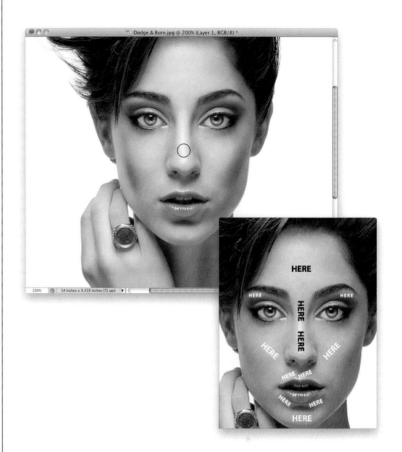

Step Eight:

I continue by dodging the highlights on her neck, hands, shoulders, and pretty much everywhere there are highlights created by the lighting I used. Basically, if it's bright, I make it brighter, and if you look in the Layers panel, you can see how the darker and lighter areas appear on that gray layer. Also, by now you're probably thinking that this dodging and burning looks really obvious, and way over the top, and at this stage, it does. But, don't worry, we're not done yet.

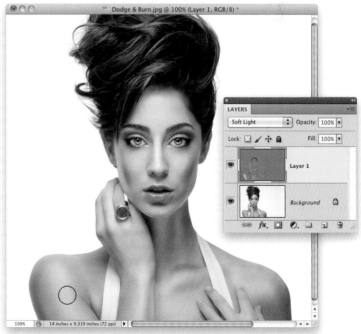

(Continued)

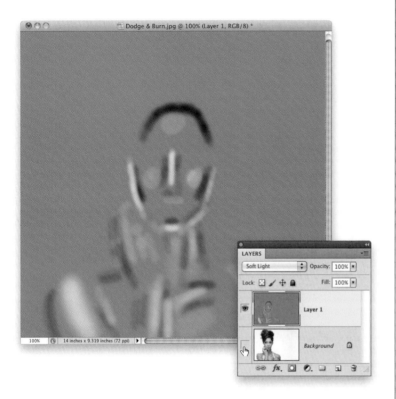

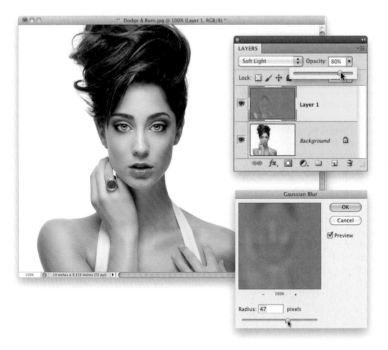

Step Nine:

Here, I hid the Background layer (by clicking on the Eye icon to the left of the layer), so can you see what we've really done, which is to paint a bunch of black, white, and gray strokes over our subject. You'll also notice that the brush strokes don't seem very soft, which is why the next step is so important, and it's one of the two final things we do to control the amount of this retouch.

Step 10:

Turn the Background layer back on, so you can really see what's happening to your dodging and burning. To soften your strokes, go under the Filter menu, under Blur, and choose **Gaussian Blur**. Now, you're going to blur the living daylights out of those paint strokes to make them much softer and smoother, and have them blend nicely with the rest of the image. When the Gaussian Blur dialog appears, drag the Radius slider quite a bit to the right to totally blur your strokes (as seen here, where I dragged to 47 pixels) and have them smoothly blend the dodging and burning. It helps to toggle the Preview checkbox in the dialog on/off a few times, so you can really see the effect it has and to help choose the right amount of blurring. When you've found the right amount, click OK. Now, you get to dial in just the amount of overall dodging and burning by going to the top of the Layers panel and lowering the Opacity of your dodging/burning layer. If you used two different layers (one for dodging; one for burning), then you can use the Opacity slider to control each individually. In the final image, I lowered the Opacity to around 80%, but I often go much lower than that. Here, I wanted to leave it higher, though, for example purposes.

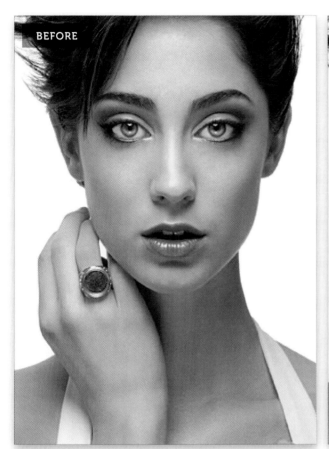

BEFORE

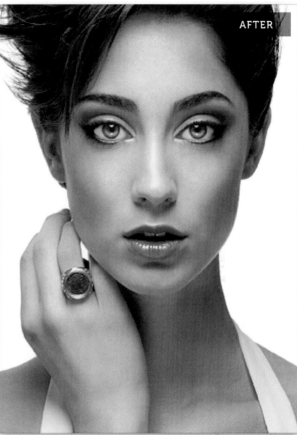

AFTER

Try this technique on another image!

After

Download this image. See pg. xi.

Chapter 4
HAIR
Retouching Hair

I know, at first glance, it looks like I just took the most obvious name possible for a chapter on retouching hair, but I'm actually naming this chapter after the 1968 Broadway musical, *Hair*, which is, coincidentally, enjoying a revival on Broadway right now, and playing to packed houses for the same reason it did back in '68—the actors are naked. That's right, nudie nakedness, which is exactly what you're going to see a lot of in this chapter. Okay, not really, but you were getting psyched there for a moment, weren't you? Come on, admit it, you were like, "Cool!" for just a second there, and then I pulled the rug out from under you, just like they pull their clothes off in this chapter (see, I got ya again, didn't I? Man, you are incredibly naughty for a photographer/retoucher). Anyway, this chapter is about how to make people's hair look lustrous,

which is a word you don't get to use every day (well, it's not a word you want to use on the playground if you hope to walk away without a few broken bones), but the word "lustrous" is actually derived from the Latin phrase lustyamadeus, which loosely translates to "naked conductor," which is exactly what you'll find on page 72. (Man, you are so gullible. So now you're actually naughty and gullible. You're naughtible.) Now, if I really wanted to make sure you read this chapter, I wouldn't have named it "Hair," I would have named it "Bare." Better yet, "Bare Naked" or perhaps "Bear Naked" or "Br'er Rabbit" (man, did that just take an unexpected turn). Anyway, there's nothing in this chapter that I would be embarrassed to show to my brother-in-law, who manages a casino/truck stop just outside Vegas, and I think that alone speaks volumes.

Adding Highlights to Hair

I use this retouch on nearly every portrait I shoot, because not only does it add more depth and dimension to the look of the hair, it actually enhances the lighting you used to make the shot.

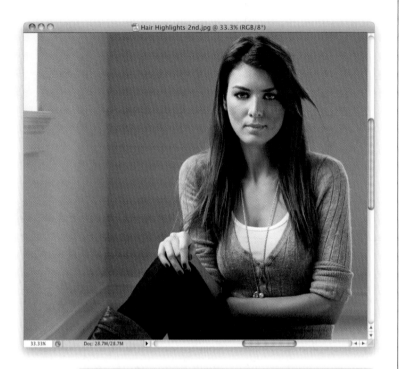

Step One:
Here's the image we're going to work on (don't forget to download it from the website mentioned in the book's intro up front). Because of the light from the window, she already has some good highlights on the left side, and there are also some on the right, but we're going to enhance both to make her hair really have shine (and to make the lighting look even better, which isn't a bad thing).

Step Two:
Start by duplicating the Background layer by pressing **Command-J (PC: Ctrl-J)**, then change the blend mode of this layer from Normal to **Screen** (as shown here). This makes the entire image much brighter (as you can see here).

Step Three:

As you saw in Step Two, the entire photo is brighter, but of course, we only want the hair brighter, and then just the highlight areas. So, press-and-hold the Option (PC: Alt) key, and click on the Add Layer Mask icon at the bottom of the Layers panel (it's shown circled here in red). This hides this brighter layer behind a black mask. Now, get the Brush tool **(B)**, choose a small, soft-edged brush set at 100% Opacity up in the Options Bar, make sure your Foreground color is set to white, and start to paint over the brightest areas of her hair (the highlight areas). As you do, it reveals a brighter version of her hair. So, basically, if you see a bright area of her hair, paint over it to make it brighter (as you see here, where I'm painting over the hair on the left side of the photo near her shoulder).

Step Four:

Continue painting the highlights up at the top of her head, as well. These aren't nearly as bright, but that's all the better—you're making the subtle highlights up there less subtle.

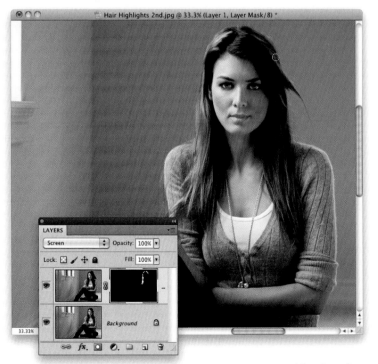

(Continued)

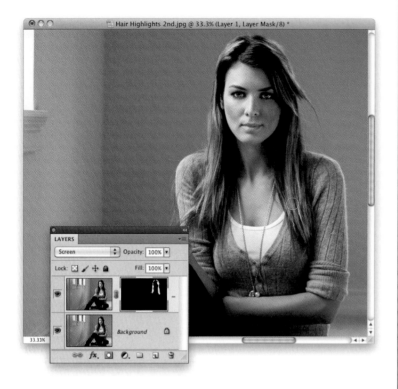

Step Five:
Here, I'm painting over highlights on the right side. Continue all the way around, until all the highlight areas are painted over, so they reveal the lighter layer in just those spots.

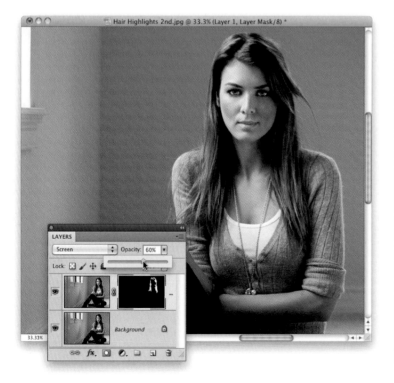

Step Six:
Now it's time to tweak the brightness amount, so it looks natural, by lowering the Opacity of this brighter layer. In this example, I had to lower it to 60% to give us the final image you see here, which looks pretty natural, but depending on the image, you might have to go lower, or even leave it at 100%—that's a call you'll have to make as the photographer/retoucher.

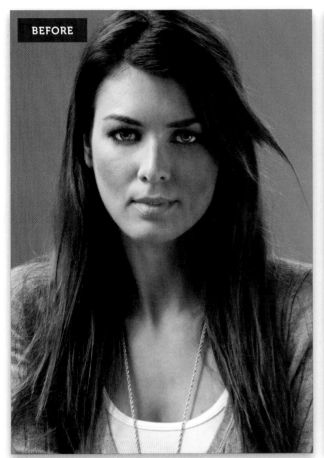

BEFORE

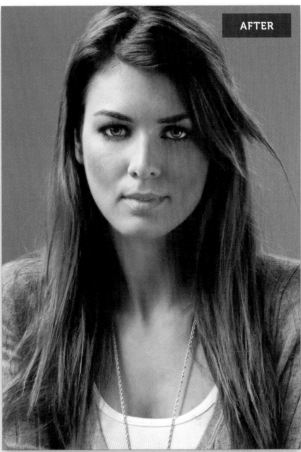

AFTER

Try this technique on another image!

Download this image. See pg. xi.

After

Removing Stray Hair Strands

This is another one of those little things that makes a big difference, and once you take the few extra minutes to remove stray hairs, when you see portraits where the photographer didn't take the time, they stick out like a sore thumb. Luckily, this one is much easier and faster than you might think (as long as the stray hairs extend outside of your subject, which is usually the case. If they cover an eye, or extend onto their face or clothes, be prepared to become a very patient person).

Step One:
Here's the image we want to retouch, and if you look closely, the subject's hair is…well…it could use some anti-static retouching—mostly on top, and a bit on the side, and there's one hair extending onto her forehead we should probably fix while we're there, too. Start off by duplicating the Background layer by pressing **Command-J (PC: Ctrl-J)**. We'll be doing all our stray hair removal on this layer (which not only gives us an out if things get really squirrelly, but it's a great way to see a quick before/after).

Step Two:
Because we're going to have to trim right up to the sides of the hair, the Healing Brush isn't going to work well on this retouch—it would smear the edges when we got up close to the outside edge of her hair. So, instead, my tool of choice for this is the Clone Stamp tool **(S)**, with a hard-edged brush, like the one you see me choosing here from the Brush Picker. Now, it's time to zoom in (to at least 100%) and get to work. (*Note:* If your background isn't an even color, you may have to start with the Healing Brush tool, and switch to the Clone Stamp tool as you get closer to her head.)

Step Three:

The actual brush size you choose should be just a little bit larger than the hairs you want to remove, so don't just go with the size I'm using here for your other projects. Look at the hair strands and choose your brush size based on that—a little larger than the strand you're trying to remove. Now, pick a starting point where you can follow around the head and not miss any spots (I'm starting on the lower-left side of the photo here). Here's what to do now: press-and-hold the Option (PC: Alt) key and click once just outside the strand you want to remove, in a clean area without any hair. It needs to be pretty darn close, so the color, tone, and texture you're sampling here are nearly identical to what's around the strand you're about to remove.

Step Four:

Start at the end of the hair farthest away from the head, and follow along the path of the hair, almost like you're tracing it, and stop when you reach her head (as seen here). The little plus sign to the left of my brush tip cursor shows you how close to where I'm painting I sampled (Option-clicked) in the previous step. Don't sample so close that you clone over yourself (and repeat some of the hair you're trying to remove), but get fairly close. If you make a mistake, just press **Command-Z (PC: Ctrl-Z)** to Undo your last stroke and try again. If you need to undo more than one stroke, press **Command-Option-Z (PC: Ctrl-Alt-Z)** up to 20 times to undo your last 20 steps (that's all you get by default). If you think you'll need more undos, then you and I need to have a talk (kidding!). Go to Photoshop's Preferences (under the Photoshop menu on a Mac, or the Edit menu on a PC), to Performance, and where it says History & Cache, type in a higher number of History States. It takes up more memory, but you get more undos.

(Continued)

Step Five:

That's basically the process—you sample near a strand of hair, and use the Clone Stamp tool to remove it, stopping right at the main body of her hair. Now, that being said, you notice how the hairs are starting to look kind of straight and lopped off in a straight line (retouchers call this "helmet head")? I try to do two things to keep things looking a little more random: (1) I don't remove all the stray hairs— I try to leave a few short ones here and there, so it looks somewhat natural, and (2) I try not to leave them looking cut off straight. Here's a great tip for what to do for that: get the Smudge tool from the Toolbox (shown here, nested below the Blur tool) and, using its default settings and a brush size just a tiny bit bigger than the hair, paint a few strokes over the ends. It pulls the hair out, so it tapers at the end and looks natural (just paint your strokes in the direction of the hair). Now, let's look at this really annoying strand here, because it's going to pose its own problem. Start by switching back to the Clone Stamp tool and sampling right above it (as shown here).

Step Six:

Clone it away, starting at the part farthest away from the head, and stopping right at the edge of the rest of her hair. You see how it just kind of stops there, like you broke the hair as if it were an uncooked strand of spaghetti? If I see that, I usually use the next technique, where we pick up and move existing hair to cover problems. But, in the next step, I'll show you something else I do, which breaks the rules, but only a tiny bit.

Step Seven:

You're going to Option-click (PC: Alt-click) inside the hair, just above the "broken off" end of the strand you just removed, and use that to cover the end a bit. Now, just move down over the broken off end, and simply click once (as shown here).

Step Eight:

This kind of moves the end back a little more inside the hair, and it doesn't look as obvious. Yes, this is a very subtle thing, and you have to decide if it's even worth doing for the intended final use (for example, if the final use is somebody's Facebook profile photo, I'm not sure I'd even consider doing this), but again, as the photographer, you have to decide what level of retouching is necessary for the job. Now, just continue around the head, going from the left, up over the top, and ending on the right, removing as many stray hairs as you feel is practical. Just remember not to make it look like you did this with the Path tool or a pair of scissors.

(Continued)

Step Nine:

Now, let's look at stray hairs that extend over the skin, like you see here on her forehead, where one big one, and a few friends, are encroaching on our otherwise unfettered skin area (I know, I went all *Masterpiece Theatre* on you there for a moment). Since part of it is on skin, and part of it goes near the hair, I use a two-tool approach in cases like this.

Step 10:

I start with the Healing Brush tool (press **Shift-J** until you have it) to get rid of most of the stray hair extending over the skin. We're basically doing a skin repair, and the Healing Brush works well for this, so sample (Option-click [PC: Alt-click]) an area of skin very near the stray hair and paint over it, stopping when you start to get near the hairline (as seen here).

Step 11:

Switch to the Clone Stamp tool again, and choose a very small, soft-edged brush at 100% opacity. Sample a clean area very near the last bit of hair you need to remove, and clone that final section away, so it's completely gone (as seen here). While I was there, I cleaned up the other few stray hairs over the skin using the same two-tool combination.

Step 12:

Now, you can see other hairs out of place that are over the main parts of her hair (meaning they're not extending onto her skin, or onto the background. They're just messy hairs). For example, take a look at the hair I have circled here in red. For these, I mostly use a technique for moving pieces of hair (which you'll learn next), because when you start cloning hair, it usually looks kind of fake. It might look okay from a distance (and fine for low-res Web photos, or Facebook profile pages, and stuff like that), but if this is going to be a print or an image that really matters, you'll need to move existing pieces of clean hair down over the stray hair to cover it.

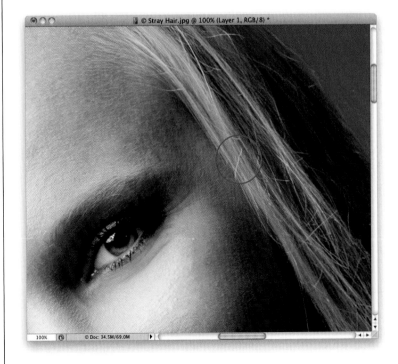

(Continued)

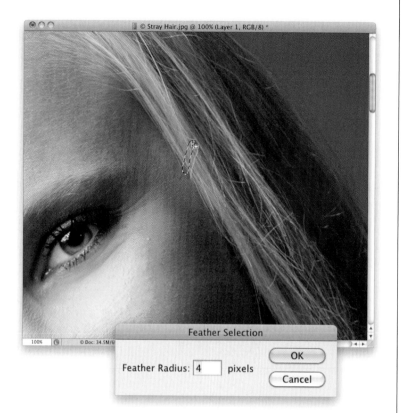

Step 13:
Start by getting the Lasso tool **(L)** and draw a selection around the hair in question, leaving just a little space around it. While you still have the Lasso tool, click inside your selected area and drag that selection just a tiny bit above the hair, to a clean area of hair, as seen here (of course, if there isn't a clean area above it, try just below it). Now, to soften the edges, go under the Select menu, under Modify, and choose **Feather**. When the Feather Selection dialog appears, enter 4 pixels for just a tiny bit of edge softening, and click OK.

Step 14:
Press **Command-J (PC: Ctrl-J)** to lift that selected area of clean hair and put it up on its own layer. Now, switch to the Move tool **(V)**, and drag this layer down and position it right over the stray hair to cover it completely (as shown here). If you made your selection small enough, it should be a perfect fit and not overlap anything or cause any other problems. If, for some weird reason, it's not a perfect fit, press **Command-T (PC: Ctrl-T)** to bring up Free Transform, then press-and-hold the Command (PC: Ctrl) key, click on one of the Free Transform corner points, and bend the hair so it fits the right way (holding that key lets you distort the shape the way you want it), then press **Return (PC: Enter)** to lock in your transformation. Again, you probably won't need to do that last part, but hey—ya never know.

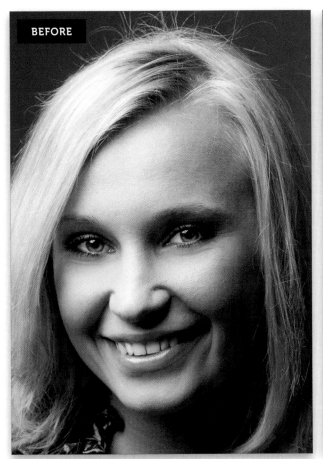

BEFORE

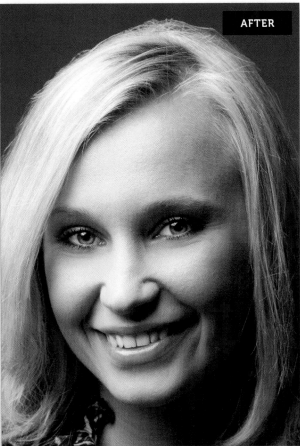

AFTER

Try this technique on another image!

Download this image. See pg. xi.

After

Fixing Gaps in Hair

Retouching hair is one of the trickiest retouches, because the Clone Stamp tool and the Healing Brush tool usually give you pretty lame results. So, you usually have to move hair from one place to another to cover the problem, and this is one of the situations where you need to do just that—covering a gap in the hair caused by your subject's position, or movement, or a fan, or one of the dozen things that cause a gap to appear temporarily and mess up your shot. Here's the best way I found to fix it:

Step One:
Here's the image we want to retouch, and you can see the gaps in her hair, just above her shoulders. Again, using the Clone Stamp tool or Healing Brush tool here would be a nightmare (and a dead giveaway), so instead, we're going to pick up chunks of nearby hair and use them to cover the gaps.

Step Two:
Get the Lasso tool (**L**) and draw a selection over a chunk of hair that's near the gap you need to remove (as shown here, where I've selected an area just to the right of the gap on the left). You're going to need to soften the edge of this selection, so it blends in when we move it over the gap. So, go under the Select menu, under Modify, and choose **Feather**. When the Feather Selection dialog appears, enter 4 pixels and click OK. By the way, 4 pixels isn't a magical number—it's just my starting place. The higher the number, the softer (and more transparent) the edges will be, so if they seem too soft, try 3, or even 2.

Step Three:

Now, press **Command-J (PC: Ctrl-J)** to place that chunk up on its own separate layer. Switch to the Move tool **(V)** and move that chunk layer over to the left until it covers the gap. Now, although it does sometimes happen, more often than not, it's not going to cover the gap perfectly and just blend right in with the hair around it. So, in the next step, you're going to have to tweak it, but don't feel like you made a bad selection—you nearly always have to transform the copied hair chunk a bit to make it work.

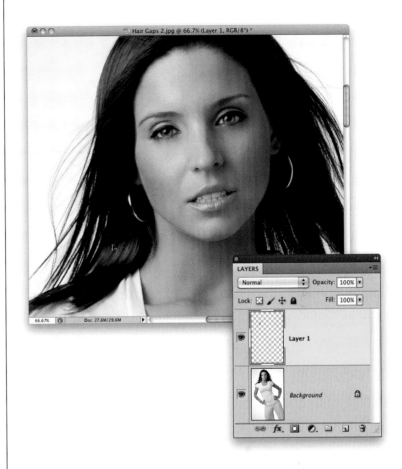

Step Four:

Press **Command-T (PC: Ctrl-T)** to bring up Free Transform, so you can rotate the chunk clockwise to match up with the existing hair around it better (as shown here). Just move your cursor outside the Free Transform bounding box, and your cursor changes into a two-headed arrow (seen here). Now, just click-and-drag in a small circular motion to your right and the chunk rotates. Once it's rotated, you may have to move your cursor inside the bounding box to reposition the chunk a little to make the hair match up better. Granted, it's not perfect, but that's okay— we still have more tweaking to do.

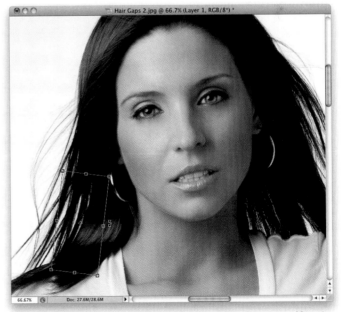

(Continued)

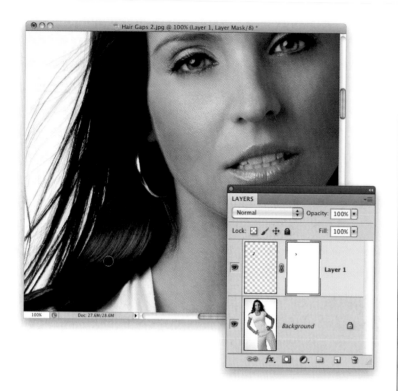

Step Five:

Press **Return (PC: Enter)** to lock in your Free Transform rotation. You can kind of see an edge area on the right side of the chunk that isn't quite blending very well, so we're going to mask that away in just a couple of brush strokes. Click on the Add Layer Mask icon at the bottom of the Layers panel to add a layer mask to this layer. Now, get the Brush tool **(B)**, press **X** to set your Foreground color to black (because your layer mask is white), set your brush Opacity to 100%, and choose a small, soft-edged brush. Paint a few small strokes over the top of the chunk to help blend that part in with the surrounding hair.

Step Six:

If you look at the top of the copied area in Step Five, you can tell pretty easily that it is a duplicate of that area next to her earring, so we're going to copy a darker area of hair just above the gap we're fixing. Click back on the Background layer, use the Lasso tool to make a new selection, feather the selection, and copy it up onto its own layer. Since we're trying to cover the top of our first fix, click-and-drag this new copied layer above the first copied layer. Then, use the Move tool to drag it into place, and use Free Transform, if you need to, to rotate it.

Step Seven:

In this case, it looks like we covered most of that bright spot, but there's still a small bright area beneath our last fix. So, press Command-J (PC: Ctrl-J) to duplicate that last fix, then use the Move tool to drag it down a little, add a layer mask, and paint some of the edges away to make it blend better.

Step Eight:

Use the same process to fill in a little more on the left side. After you get some of it filled in, you may want to press **Command-Option-Shift-E (PC: Ctrl-Alt-Shift-E)** to create a merged layer, then make your selection from it. When you're done with the left side, move over to the right side and fill those gaps, too. Now, we got lucky with this one, that all it took was a little rotation to get these chunks pretty close to where all we had to do was a little masking. Sometimes, you'll have to actually flip the hair horizontally, so it doesn't look like a copy of hair sitting beside itself (a dead giveaway). If that's the case, once you bring up Free Transform, just Right-click inside the bounding box and when the menu appears, choose **Flip Horizontal**. Then you'll have to rotate it back into place, but this little horizontal flip can really help hide that fact that you "borrowed" hair from a nearby area. See the next page for a before and after.

(Continued)

BEFORE

AFTER

Download this image. See pg. xi.

After

Try this technique on another image!

Changing Hair Color

This is fairly common, especially if you're working with an art director who wants the model's hair to match the clothes, but luckily, most of the time, a change of hair color is fairly subtle, and not from one extreme to another.

Step One:

Here's the image where we're going to (eventually) change her hair color from blonde to brunette, but we're going to have a couple of stops at different colors along the way, along with a technique variation, so you've got lots of options (especially if your subject, or client, wants a big variation in color).

Step Two:

Start by getting the Quick Selection tool **(W)** and then literally paint over your subject's hair to select it. If it over-selects, and starts selecting her face, you can remove that spillover by pressing-and-holding the Option (PC: Alt) key and painting over the spillover areas to deselect them. Use a fairly small brush, and just keep painting until it's all pretty much selected (as shown here). Also, you don't have to worry about making a perfect selection for two reasons: (1) we're going to have Photoshop fine-tune the selection for us in the next step, and (2) we'll automatically have a layer mask, so we can fine-tune the mask just by painting on it if it needs tweaking. So, relax, and get your selection kinda close, then move on to Step Three.

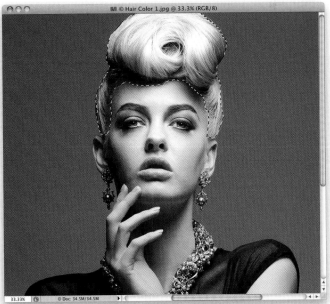

(Continued)

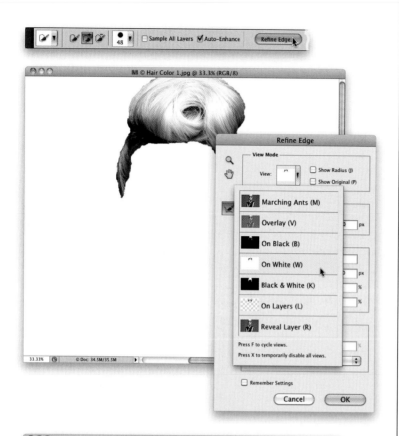

Step Three:

Once your selection is in place, and while you still have the Quick Selection tool, go up to the Options Bar up top and click on the Refine Edge button (as shown here). This brings up the Refine Edge dialog, and gives you a preview of your selection (you can choose to view your selection on different backgrounds—choose the **On White** background from the View pop-up menu, so it looks like it does here). You can see from the selection we have here, it's pretty harsh and jaggy, but don't worry—that's all about to go away.

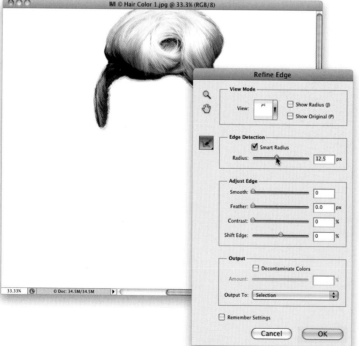

Step Four:

To get a much better, smoother, and more encompassing selection, go to the Edge Detection section of the dialog and turn on the Smart Radius checkbox. This helps you get a better, more accurate edge around your selection (especially helpful with hair), but just turning on the checkbox isn't enough—you need to then take the Radius slider and drag it to the right (as shown here), and you'll see the edges start to change from harsh to very usable (as seen here). Again, they don't have to be perfect—you can always edit the mask we're going to make in a moment by just painting on it. So, at this point, we're definitely closer, but if it's not perfect, just roll on.

Step Five:

When you click OK in the Refine Edge dialog, the dialog goes away and your selection is back in place, and of course, even though you can't see it, your selection is dramatically better. So, click on the Create New Adjustment Layer icon at the bottom of the Layers panel, and choose **Hue/Saturation** from the pop-up menu. Now, changing hair color is as easy as dragging the Hue slider in the Adjustments panel. Here, I dragged it to the left a little bit and the hair turned pink. Once you make an adjustment like this, you'll be able to see much more clearly if you missed any areas with your selection, and luckily, your Hue/Saturation adjustment layer comes with a layer mask, so you're ready to edit. If you see you missed an area, get the Brush tool **(B)**, make sure your Foreground color is set to white, choose a small brush, and paint right on the photo on the area you missed to add it. If you selected too much, paint on that area in black to get rid of it.

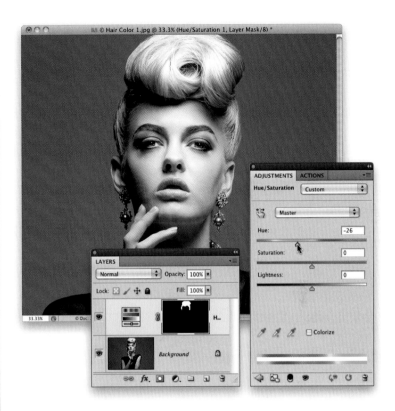

Step Six:

Now, if the color is too intense, drag the Saturation slider to the left (I usually have to do this to some extent when changing hair color, or the new color becomes too overpowering, so you can almost count on having to lower the Saturation amount. While you're there, go ahead and lower it quite a bit and her hair turns almost silver, which in this case looks kinda cool). Okay, the variation I talked about earlier is to turn on the Colorize checkbox at the bottom of the Hue/Saturation options in the Adjustments panel (shown circled in red here) and you get a different result from your Hue, because now rather than just shifting the Hues that are there, it's pouring a tint on top of your color.

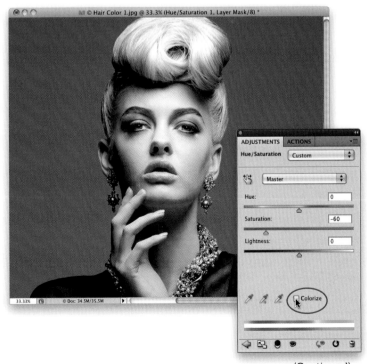

(Continued)

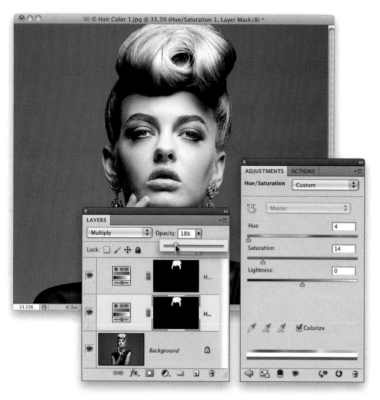

Step Seven:

To change her hair to brunette, we're going to change the pop-up menu at the top of the Adjustments panel back to **Default**, then go to the Layers panel and change the blend mode of this Hue/Saturation adjustment layer to **Multiply**. We're just going to use this layer for the blend mode change, so, press **Command-J (PC: Ctrl-J)** to duplicate the layer. We'll now change the color using this duplicate layer, so in the Hue/Saturation options in the Adjustments panel, turn on the Colorize checkbox, and drag the Hue slider almost all the way to the left, until it reads 4, then lower the Saturation until the color look about right to you (here, I lowered it to 14). Now, click back on your first adjustment layer, and lower its Opacity until the color looks more realistic (usually around 18%, as shown here). *Note:* The Multiply layer works for changing light hair to a darker color. If you need to change dark hair to a lighter color, you'd change the blend mode to **Screen** instead.

Step Eight:

This last step is optional, but if it looks like you still are missing any part of her hair, now is when you'll fix it (there were a few hairs by each ear and along the temple on the left that I missed in my selection, and that still looked blonde). So, get the Brush tool, and lower the Opacity in the Options Bar to around 30%, then paint over the hairs you missed. By painting with a low opacity like this, you can build up the color—perfect for these small, wispy hairs. Then you'll need to copy this layer mask over the one on the bottom Hue/Saturation adjustment layer, so they match. To do this, simply press-and-hold the Option (PC: Alt) key and click-and-drag the mask on the top adjustment layer over the one on the bottom adjustment layer. A dialog will appear asking if you want to replace the mask, so click Yes and you're done.

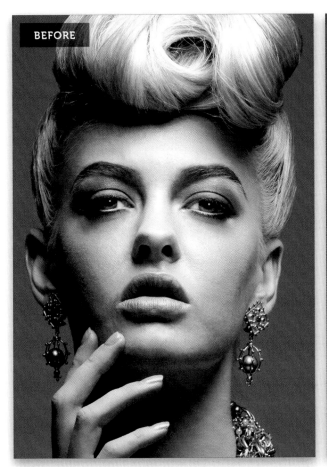

BEFORE

AFTER

Try this technique on another image!

Download this image: See pg. xi

After

Darkening a Part Line

Since the human eye is drawn to the brightest part of an image, you don't want your viewer's eye drawn to the part in your subject's hair. Sometimes that's the case, but luckily for us, it's a pretty quick fix. This is one of those retouches that you may not have to do to every portrait, but when you need it—it makes a big difference.

Step One:

Here's the image we're working on, and if you look at the part in her hair, it's just wide enough, and the light is positioned in just such a way, that it accentuates the part line and draws your attention up there. So, we're going to darken that area to make it appear thinner and less noticeable. Start by pressing **Command-J (PC: Ctrl-J)** to duplicate the Background layer.

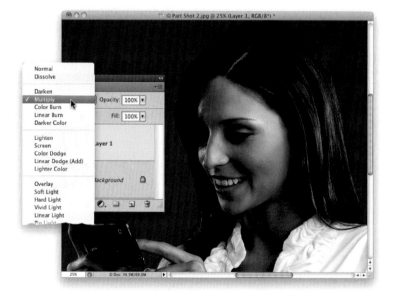

Step Two:

Change the duplicate layer's blend mode to **Multiply**. Notice how much darker her part looks compared to Step One. Of course, the rest of the image is way too dark, but we'll fix that in a minute.

Step Three:

Since we only want the part area darker, press-and-hold the Option (PC: Alt) key, and click on the Add Layer Mask icon at the bottom of the Layers panel (it's circled in red here). This adds a black layer mask, hiding the darkened layer.

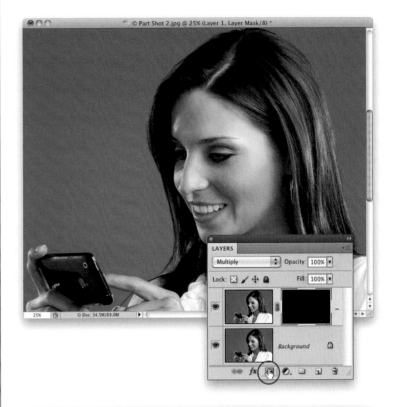

Step Four:

Now, get the Brush tool **(B)**, choose a medium-sized, soft-edged brush, and make sure your Foreground color is set to white. Start painting over the part area to darken it. If you think it looks too dark, you can always lower the layer's Opacity, although I didn't do that here. You can see before and after images on the next page.

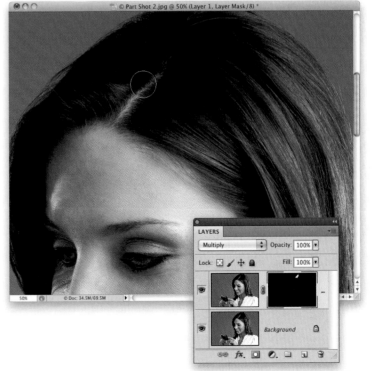

(Continued)

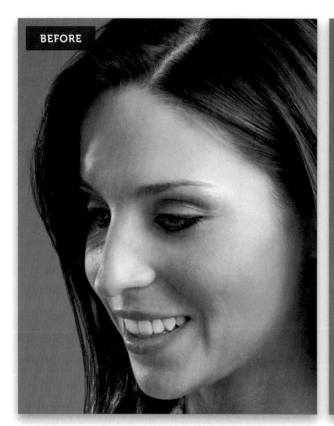

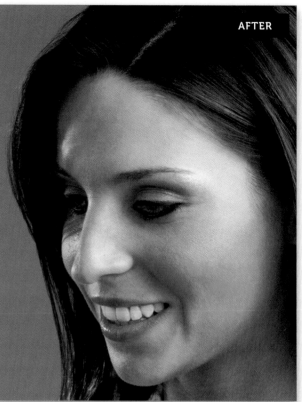

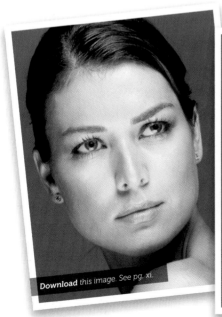

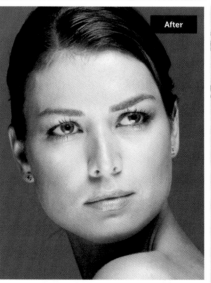

Download *this image. See pg. xi.*

Try this technique on another image!

Hiding Roots

This retouch, where you're lightening your subject's roots, is a pretty common retouch, and it's pretty quick and easy in most cases. I'm going to show you my standard method, but I'm adding an additional step at the end that I now use in my retouching—a darkening step to add more dimension—that I picked up from retoucher Christy Schuler, and that makes such a difference.

Step One:
Here's the image we're going to be working on. You can download it from the companion website, mentioned in the book's introduction, and follow right along. The roots aren't too bad here, but once we tweak 'em, you'll see it makes a difference. Start by clicking on the Create a New Layer icon at the bottom of the Layers panel to add a new blank layer.

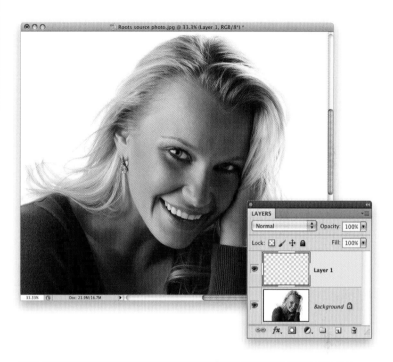

Step Two:
Get the Eyedropper tool **(I)**, which we're going to use to steal (okay, borrow) a color from a bright part of her hair. So, let's do that: take the tool and click it once on the brightest area of her hair, as shown here. By the way, that big round ring that appears is there to help you see precisely which color you're choosing as you click.

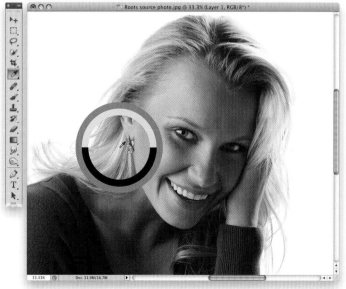

(Continued)

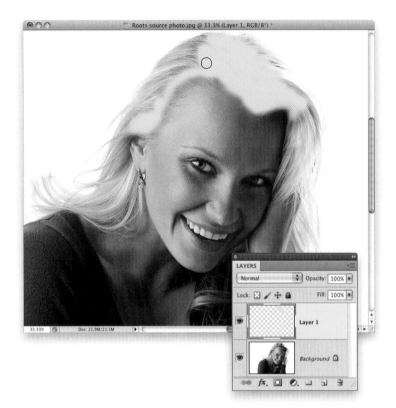

Step Three:

Get the Brush tool **(B)**, choose a medium-sized, soft-edged brush, and paint over the dark areas at the base of her hair and in her part line (as shown here). Don't worry if you don't get every bit of it at this point—you'll be able to easily add more in just a minute.

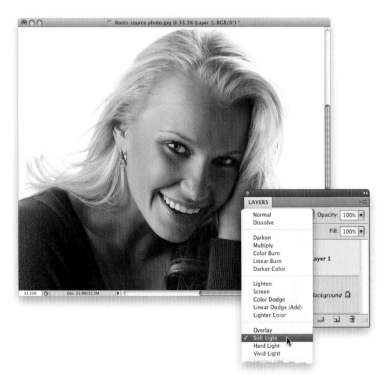

Step Four:

To get this painted layer to blend into your photo on the Background layer, go to the Layers panel and change the blend mode for this paint layer from Normal to **Soft Light** (as shown here). Now you can see the painted area blend with your image (compare what you see here with the image in Step One—look at how much lighter the base of her hair, where the roots would be, is now).

Step Five:

Now that you've changed to Soft Light mode, and your Foreground color is still the color sampled from the brightest area of her hair, to add more areas, you can just paint right on the photo, and it blends in as you paint (as seen here, where I'm painting another area of hair on the left side of the image).

Step Six:

Here's the additional step I now add that makes a difference in the depth of the retouch: Take the Eyedropper tool and sample a darker area of her hair. Then, with the Brush tool, with the Opacity lowered to around 15%, so it's very subtle, paint a few strokes over the darker areas within the areas you just lightened a moment ago (as shown here). Just paint a few strokes here and there to give it some dimension—this little step helps to make it look more natural and realistic.

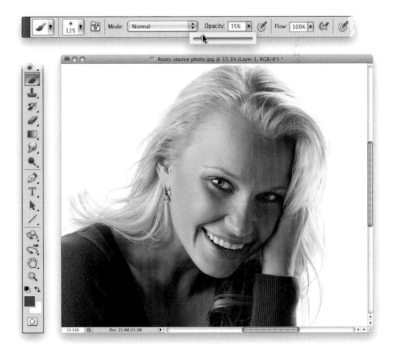

(Continued)

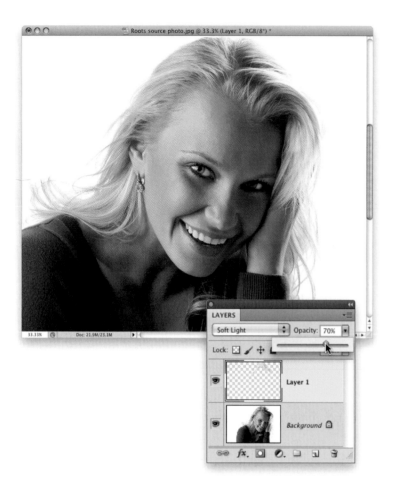

Step Seven:

Lastly, since this was all done on its own separate layer, you have the option of toning down the entire retouch by simply lowering the Opacity of this paint layer in the Layers panel. Here, I lowered it to around 75%.

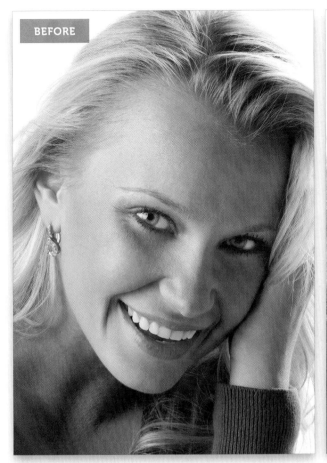

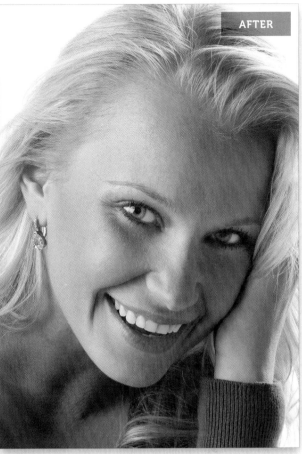

Try this technique on another image!

Download this image. See pg. xi.

After


Chapter 5 LIPPS, INC.

Retouching the Lips and Mouth

If you're thinking, "Aren't the mouth and lips kinda the same thing?" then you need this chapter more than I thought. You see, the lips are actually designed to aid in the intake of food and to help articulate both sound and speech, where the mouth is the part that gets you in trouble (well, it gets my kids in trouble if they get "mouthy." Of course, they get in trouble if they get "lippy," too, but that's only because they should be taking in food more and articulating both sound and speech less). Either way, they are different as best as I can tell. For one thing, your lips don't have teeth. Well, mine don't anyway. But, have you ever taken a really good look at someone's teeth? I mean really gotten in there, rooting around like a periodontist on a weekend pass? Well, I can tell you, I've done it (with my dog), and it's pretty disgusting, and that's why it's so important to retouch teeth (and floss, but I can tell you, my dog doesn't like it one bit). Anyway, all sorts of funky things can happen to a person's lips, like chapping, or cracking, or chapping and cracking, or crackling, or there can be tiny bits of Cracker Jack on them, too—the list goes on and on. And don't get me started about the teeth. First, there's yellowing, which comes primarily from eating corn or squash, which is why I never eat either, and instead I only eat white fruits and vegetables, like parsnips, shallots, and cauliflower (have you ever had a parsnip, shallot, and cauliflower hoagie? Try one, and I guarantee you'll find yourself considering suicide). Anyway, this chapter has a retouch for all those horrible maladies that can befall a set of lips and a mouth, and before you know it, your subject will like be looking like Angelina Pitt's.

223

Making Lips Larger

In the same way we find larger eyes more attractive, larger lips have wide appeal, too, so a fairly common retouch is to make the lips larger. This is one of those retouches that can look really funky if you go too far, because not every subject can pull off the "big-lip look" (so to speak), so remember that a little "big" goes a long way with this retouch.

Step One:
Here's the image we're retouching, and while the size of her lips actually looks pretty good with the symmetry of her face, when you make them a little bigger, they look a little better. While, technically, you could do this retouch using the Liquify filter, I think this technique, which doesn't distort the lips at all, gives a much more realistic result.

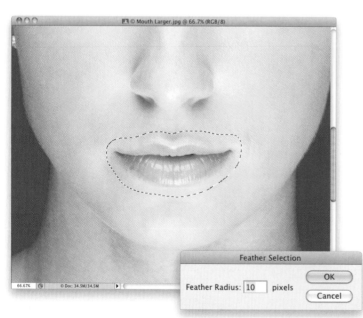

Step Two:
Zoom in on the lips, then get the Lasso tool **(L)** and draw a very loose selection around them. Notice that I didn't just select the lips themselves, but quite a bit of skin around them, as well. This is key to making your retouch easy, because it's easier to blend skin with skin, than skin with the edges of lips. So, don't be shy when making your selection—make it nice and loose, like the one I made here. Now, to soften the edges of your selection (so it blends in smoothly), go under the Select menu, under Modify, and choose **Feather**. When the Feather Selection dialog appears, we're going to enter a larger number than usual—type in 10 (as shown here)—and then click OK to soften those edges. Next, press **Command-J (PC: Ctrl-J)** to duplicate this selection and place it up on its own separate layer.

Step Three:

Press **Command-T (PC: Ctrl-T)** to bring up the Free Transform bounding box around the lips and skin area you copied to its own separate layer. Then, go up to the Options Bar, and click on the link icon (shown circled here in red) in between the W and H fields, so the width and height amounts are linked together (so when you enter a number in the W field, the H field gets the exact same amount). Now, in the W field, type in 110% (which automatically enters 110% in the H field for you) to increase the size of the lips by 10%. Of course, you could just press-and-hold the Shift key, grab a corner point, and drag outward, but you're more likely to overdo it that way. A 10% size increase is an amount you can usually get away with without anyone knowing you retouched it. Any bigger and it starts to look fake (unless your subject has really thin lips, in which case, you just have to use your best judgment on how big to make them).

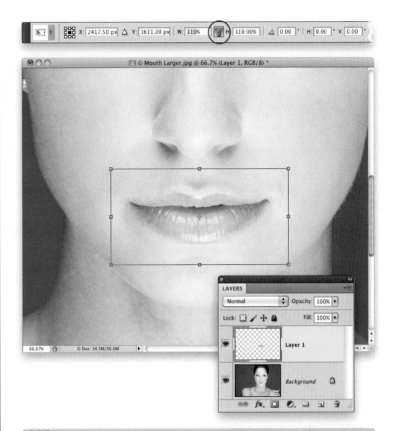

Step Four:

Press **Return (PC: Enter)** to lock in your transformation, and don't be surprised if things look amazingly good at this point. That's because of the large Feather amount you added, which, in many cases, blends the skin on the top layer with the skin on the Background layer, but there's only one sure way to check. Toggle the top layer on/off a few times (by clicking on the Eye icon to the left of the layer) and see if you see any visible edge. If you do, just click on the Add Layer Mask icon at the bottom of the Layers panel, then get the Brush tool **(B)**, and choose a small, soft-edged brush from the Brush Picker. With your Foreground color set to black, just brush along any visible edge to make it blend in (as shown here). By the way, the edge was so subtle here, I had to toggle it on/off to see it at all. A before/after of the retouch is shown on the next page.

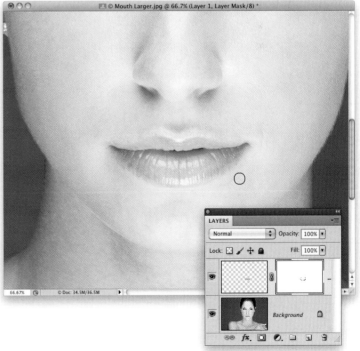

(Continued)

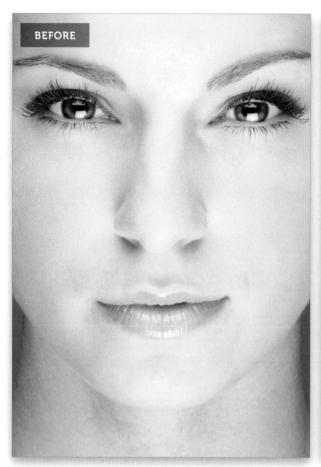

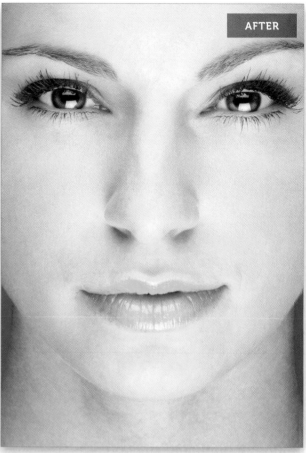

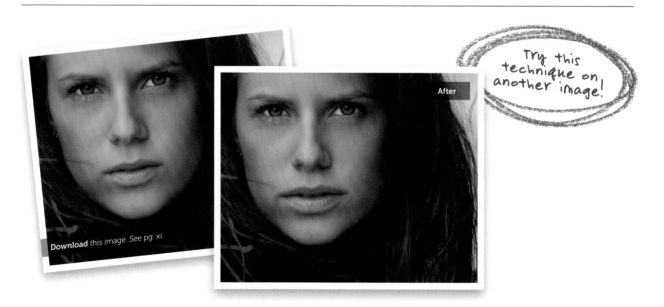

Download this image. See pg. xi.

Try this technique on another image!

Creating Glossy Lips

Besides making them bigger, one of the most requested retouches for lips is to make them look glossy. My favorite method is to use the Color Range feature to select the existing highlights in the lips and then enhance those.

Step One:

Here's the image we're going to work on, and although there are a few highlights in her lips, they're really pretty flat looking and don't have that glossy look. So, we're going to take what's there and enhance it to make them look shiny and glossy, and we're going to make Photoshop do all the heavy lifting.

Step Two:

Start by zooming in tight on the lips, so you can really see them, then go under the Select menu and choose **Color Range** (as shown here). Color Range lets you make a selection based on a range of color, but it also has a feature most folks don't realize, and that is the ability to have it select just the shadows, midtones, or highlights in an image, and that's what we're going to take advantage of here.

(Continued)

Step Three:

When the Color Range dialog appears, from the Select pop-up menu at the top, you're going to choose **Highlights**, as shown here. (By the way, that Select menu is where you choose which method you want Color Range to use to make its selection. The default being Sampled Colors, which makes it start selecting where you click the eyedropper tool. In this case, we don't need that, but I just thought you might like to know.)

Step Four:

When you set the Select menu to Highlights and click OK, it makes a selection of all the highlight areas in your image (as seen here). Don't let what you see onscreen throw you, though, because the way Photoshop is designed, it can't accurately display certain very small selected areas, so you'll find that it usually selects much more than you see selected with the "marching ants" selection borders. So, even if it doesn't look like it did much, just go ahead and roll with it for now.

Step Five:
Press **Command-J (PC: Ctrl-J)** to take the selected areas and copy them up onto their own separate layer. Now, to make the highlights even brighter, at the top of the Layers panel, change the blend mode of this layer from Normal to **Screen** (as shown here), and now it's really bright. Of course, it doesn't look very good at this point, but that's just because all we really want is the highlights on the lips—not that all that other stuff (which makes the skin look blotchy and harsh), but we'll fix that in the next step.

Step Six:
Press-and-hold the Option (PC: Alt) key and click on the Add Layer Mask icon at the bottom of the Layers panel. This adds a black layer mask to your layer, hiding the brighter Screen layer behind that mask, so your photo looks back to normal. Now, with your Foreground color set to white, get the Brush tool **(B)**, choose a small, soft-edged brush set to 100% Opacity in the Options Bar, and paint over the highlight areas on the lips. They immediately start to look glossy as you reveal the brighter highlights from the Screen layer (as seen here).

(Continued)

Step Seven:
Paint over both lips to reveal the enhanced highlights, which makes them look glossy, as seen here. If they're too bright, you can always lower the Opacity (like I did here, where I lowered it to around 75%). That's the advantage of having the highlights on their own separate layer—you can reduce their strength.

Step Eight:
But what if you need more highlights—you need them to be brighter? If that's the case, just duplicate the Screen layer (press Command-J) and it becomes twice as bright without doing anything else. Of course, if one Screen layer isn't enough, two is probably too much, right? If that happens, just lower the Opacity of the second Screen layer (if you lower it to 50%, then you'll be at 1½ strength. Pretty cool, eh?).

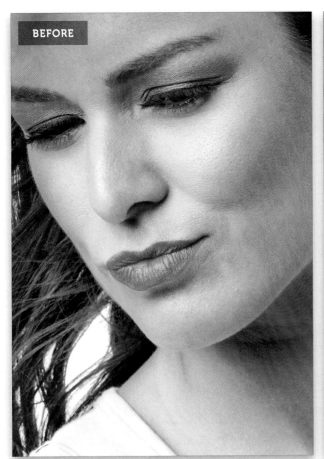

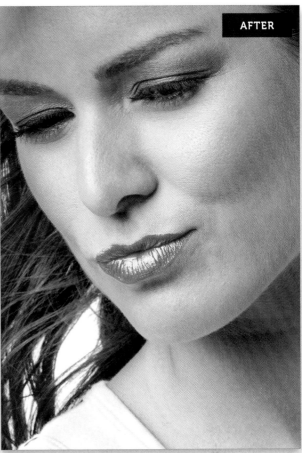

Try this technique on another image!

Download this image. See pg. xi.

After

Applying or Tweaking Lipstick

If you want to change the color of your subject's lipstick, or if they didn't wear any lipstick at all, here's how to tweak the existing color, and add lipstick if you need it (well, not you, but the subject. You knew what I meant, right?).

Step One:
Here, our subject chose a lipstick color that's very muted to match the overall mood and tone of the photo, but if you wanted to punch up that color (maybe you want to draw attention to her lips or bring them out more), the retouch is a pretty quick and easy one.

Step Two:
Zoom in on the lips, get the Lasso tool **(L)**, and draw a very large, loose selection around the lips and the skin area around them. We're doing this, rather than carefully making the selection of the lips, because getting rid of that extra selected area is literally a 15-second job, and much easier than making a really accurate lip selection. That's not always the case in retouching, but in this one, it works just fine. So, make a Lasso selection like the one you see here.

Step Three:

Next, click on the Create New Adjustment Layer icon at the bottom of the Layers panel, and choose **Hue/Saturation** from the pop-up menu. Since you have a selection already in place, it adds a black layer mask with just your selected area available for adjustment, which is just what we need. In the Adjustments panel, click on the Targeted Adjustment tool (or TAT, for short) that lives in the upper-left corner of the panel (it's shown circled here in red). Then, click that tool directly on one of her lips (I clicked it on her bottom lip, just below the large highlight area in the center of it) and drag to the right. As you do this, Hue/Saturation senses which colors are under your cursor and it adjusts the saturation for just those colors. Here, it switched to the Reds channel, and increased the Saturation, which affected both the lips and the skin around it (as seen here).

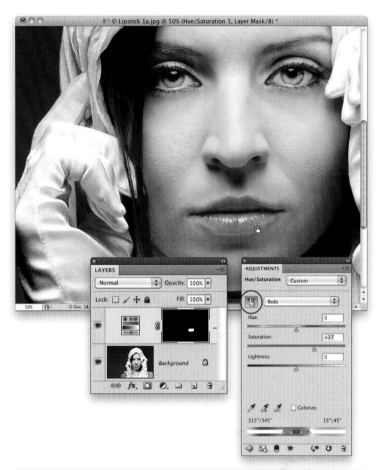

Step Four:

Now that you've given her a new shade of lipstick (a more saturated, vivid color, in this case), get the Brush tool **(B)**, and with your Foreground color set to black, paint right over the selected skin areas to mask them away. This is the 15-second part—it's amazingly easy to remove this extra area. Just keep in mind that when people put on lipstick, there's generally a little overspill, so it helps to zoom in close to make sure you don't erase the overspill areas, which would return you to the original lipstick color. Here, I've erased the extra skin on the right side, but you'll continue all the way around the mask.

(Continued)

Step Five:

Here's what it looks like after you've removed all the extra skin. If you want to make sure you didn't accidentally miss an area, press-and-hold the Option (PC: Alt) key, and click directly on the black layer mask thumbnail in the Layers panel (it's shown circled here in red), and it will just show you the mask. Now, you can just paint right over any areas outside the lips themselves that appear in white. Option-click on the layer mask again to return to your full-color image.

Step Six:

If your subject didn't wear lipstick, or you want to do a pretty major color change, then you'd still do the first couple steps (selecting the lip area and all that stuff). But, after you create the Hue/Saturation adjustment layer, you need to turn on the Colorize checkbox at the bottom of the Adjustments panel (circled here in red), and now you're adding a tint to the selected area. This tint is pretty strong, so to keep things from looking overly freaky, you'll have to lower the Saturation amount quite a bit. Here, I've shifted the Hue, so the color of her lips kind of matches her eyes, which looks terrible by the way, but at least it shows how drastic a move you can make using the Colorize checkbox.

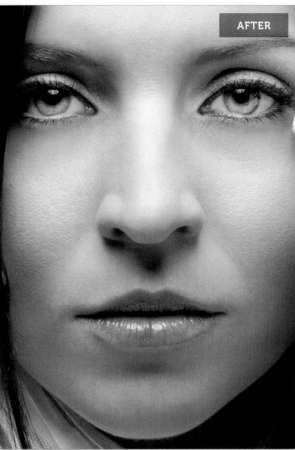

Try this technique on another image!

Changing the Shade of Lip Color

This is a really handy technique for making the lips really stand out by shifting the shade of the lip color, brightening the natural highlights, and then lastly, doing a quick cleanup to give you really gorgeous lips.

Step One:

Here's the image we're going to retouch by shifting the shade of the lips. If we wanted to change the entire color to something completely different, we'd probably reach for a Hue/Saturation adjustment layer (like we did in the previous technique), but in this case, we're just going to shift the color that's already there. My favorite option for doing this is Selective Color, so click on the Create New Adjustment Layer icon at the bottom of the Layers panel and choose **Selective Color** from the pop-up menu (as shown here).

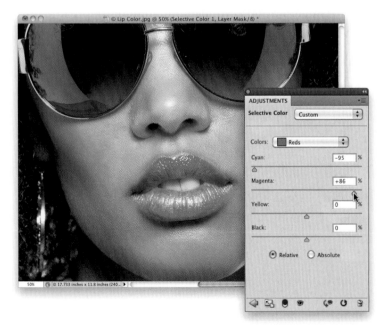

Step Two:

When the Selective Color options appear in the Adjustments panel, by default the Reds are already selected, so all you have to do is move the top three sliders to push the lip color to a different shade (the fourth slider, Black, controls the lightness or darkness of the Reds). Let's start out by clicking-and-dragging the Cyan slider almost all the way to the left (I dragged it to –95%), then let's drag the Magenta slider almost all the way to the right (as shown here, where I dragged it to 86%). Of course, it doesn't just change the shade of the lips, it shifts the red for the entire image, but don't worry—we'll fix that next.

Step Three:

Press **Command-I (PC: Ctrl-I)** to Invert the Selective Color adjustment layer's layer mask, which hides the red color version behind a black mask (as seen here in the Layers panel). Now, with your Foreground color set to white, get the Brush tool **(B)**, and choose a small, soft-edged brush set to 100% Opacity in the Options Bar. Then, carefully start painting over the lips (as shown here), and the new shade appears as you paint.

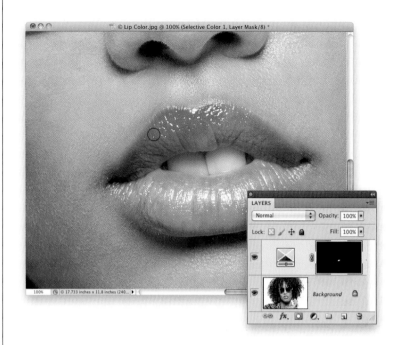

Step Four:

Continue painting until the lips are fully painted in, as seen here (this is another case where having a tablet and wireless pen really pays off, because painting in the lips like this with a pen takes all of 10 seconds).

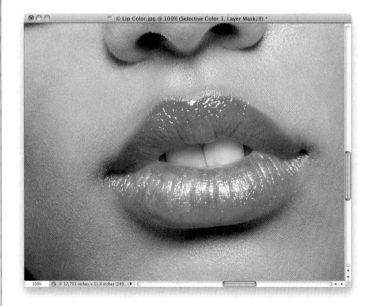

(Continued)

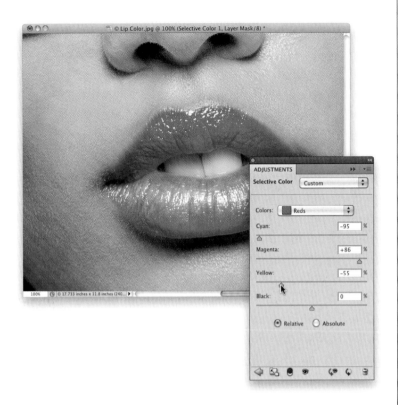

Step Five:
If you want to shift the shade to something different, try dragging the Yellow slider to the left—as seen here, where I dragged it over to –55%. Look at the difference in the shade now.

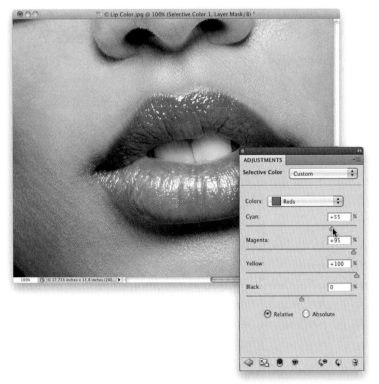

Step Six:
If you want more of a red look to the lips, just increase the amounts of Cyan and Yellow by dragging them both way over to the right. Here, I dragged Yellow all the way over 100%, and then Cyan to 55% (I also increased Magenta a bit to 95%), and the lip color is really starting to look good.

Step Seven:

If you want that deep, rich, ruby red lip look, here's what to do: Start by returning all your Selective Color sliders to 0% (just choose **Default** from the Selective Color pop-up menu at the top of the panel), so they're not having any effect at all, and the lips are back to how they looked when you first opened the image. Now, press-and-hold the Command (PC: Ctrl) key and click directly on the black layer mask thumbnail over in the Layers panel (as shown circled here in red). This puts a selection around the lips, made from the mask you painted earlier.

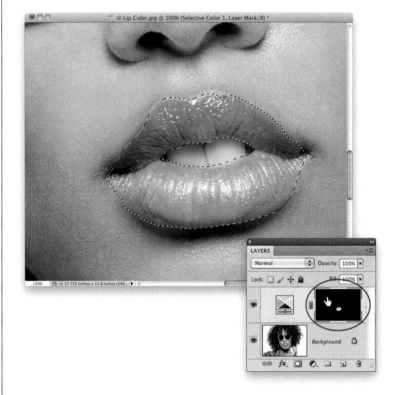

Step Eight:

Now, click on the Create a New Layer icon at the bottom of the Layers panel to create a new blank layer, press **D** to set your Foreground color to black, and then press **Option-Delete (PC: Alt-Backspace)** to fill your lip selection with solid black. I know it looks bad at this point, but that's all about to change. Go to the top of the Layers panel and change the layer blend mode from Normal to **Soft Light** and bam—the lips become that ruby red (as shown here). But, because your Selective Color adjustment layer is below it, you still have control (as you'll see in the next step). Press **Command-D (PC: Ctrl-D)** to Deselect.

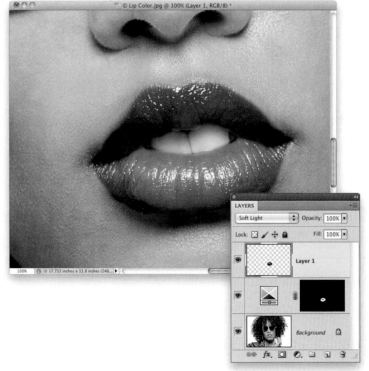

(Continued)

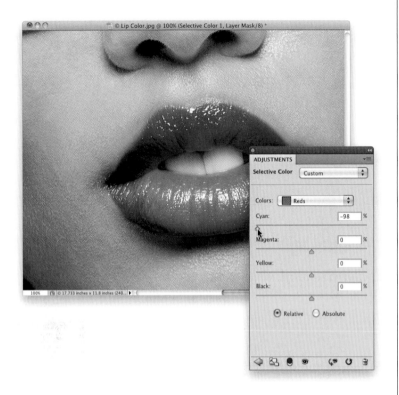

Step Nine:

In the Layers panel, click on the Selective Color adjustment layer and then in the Adjustments panel, drag the Cyan slider back over to the left. Here, I dragged it over to –98%, and look how it shifts the shade once again.

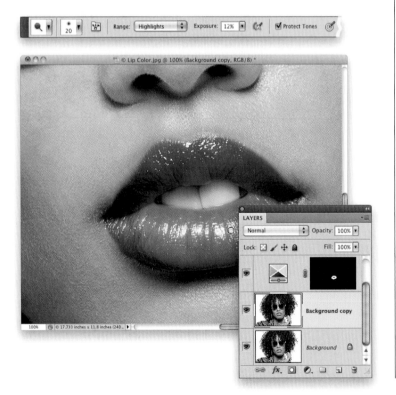

Step 10:

That's the end of the shade-shifting part, but if you've got spare time and really wanted to go in and take things a step further, I would start by brightening up the highlights on her lips. You can use the technique found on page 227, or if you want to do something quicker, just click on the Background layer in the Layers panel and press **Command-J (PC: Ctrl-J)** to duplicate it. Get the Dodge tool **(O)**, and up in the Options Bar, set the Exposure to around 12% and make sure **Highlights** is selected in the Range pop-up menu. Then, with a small, soft-edged brush, paint a few strokes over all the bright highlight areas in the lips to make them even brighter (as seen here, where I'm painting over the highlight on her bottom lip). This makes a bigger difference than you might think.

Step 11:

If you have a few more minutes, you could clean up the inside and the outside of the lips a bit. If you've got lots of time, you could do one of the skin softening techniques in Chapter 2. But, more likely, if you've got an extra five minutes or so, you'll just want to get in there with the Healing Brush and Clone Stamp tool and remove all those little hairs under her lip and on the corner of her mouth. Do the inside of the lips with a very small Healing Brush (press **Shift-J** until you have it), and just Option-click (PC: Alt-click) to sample a nearby clean area and then click over little specks, spots, and anything that looks out of place. When you get to the little hairs under her lip, switch to the Clone Stamp tool **(S)**, lower the brush Opacity to 35% in the Options Bar, choose a very small, soft-edged brush, zoom in tight, and then just Option-click to sample a clean area and clone those little hairs away (as shown here, where I'm cloning under her lip). A before/after of the retouch is shown on the next page.

(Continued)

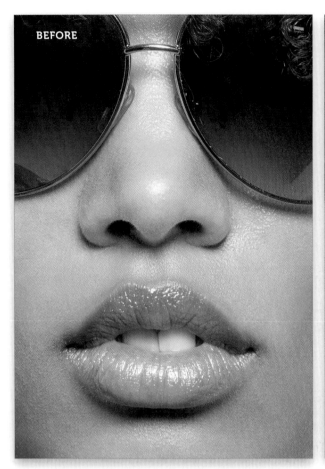

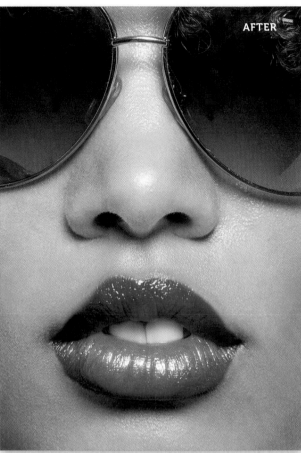

Try this technique on another image!

Repairing Teeth

Depending on your subject, this can be just a minor tweak, or a major reconstruction. Luckily, in most cases, you'll be able to fix most problems with teeth using the Liquify filter, but sometimes, you have to rebuild a tooth or two from scratch. *Note:* I did a teeth rebuild once during a live retouching workshop, and a dentist came up to me right after my session to scold me, because I apparently flattened out a tooth he said was essential for chewing food. He felt better once I reminded him that the photo wasn't going to eat anything. ;-)

Step One:
Here's the image with teeth we want to retouch. First, let's evaluate what we need to do: I see that the two front teeth are a little too long compared to the rest of the other teeth (the front two should be a little longer than the surrounding others, but just a little). So, that's one thing to fix. Then, I would remove some of the points from the canine teeth, and repair the gap on the canine tooth on the right. Lastly, I would straighten out the bottom teeth.

Step Two:
Go under the Filter menu and choose **Liquify**. When the Liquify dialog appears (shown here), start by zooming in tight (press **Command-+ [PC: Ctrl-+]** a few times). Then, make sure you have the first tool at the top of the Toolbox selected (on the left side of the dialog; it's called the Forward Warp tool, which lets you nudge things around like they were made of molasses). The key to working with the Liquify filter is to make a number of very small moves—don't just get a big brush and push stuff around. Make your brush size (from the Brush Size field on the right) a little larger than what you're retouching (here, my brush is a little larger than one of the two front teeth). Now, just gently nudge the front teeth upward a few times each to shorten them, and then once or twice in the center between them to make them even. Also, while you're there, you can flatten out the bottoms of them, too—just choose a smaller brush and gently nudge them upward. It's already looking better.

(Continued)

Step Three:

Now, if you look closely, you can see that on the bottom of the front tooth on the right, there's a little indent that we can easily fix. Make your brush size really small (just a tiny bit bigger than the indent), and pull down on the indent until it lines up with the rest of the bottom of the tooth to make it nice and flat and smooth (as seen here). Let's now work on the two teeth on either side of the front two—same tool, same technique, smaller brush (because these teeth are smaller in size). Gently nudge these teeth downward a little to make them longer. Keep gently nudging them downward, until they're almost as long as the front two (but not quite as long).

TIP: Quick Before and After

If you want to see a quick before and after of your retouch, just turn the Show Backdrop checkbox (near the bottom right of the dialog) on and off.

Step Four:

Now, go to the canine tooth on the left (you can see my brush cursor there), and just push upward on the pointy part with the same tool (gently, gently, using a few little nudges—don't nudge it all at one time). This helps flatten it out a bit, but of course, now she won't be able to chew— hey, it's cheaper than buying caps. Once we're done in Liquify, we'll fix the gap on the other pointy canine tooth manually. But, you can go ahead and fix the other top teeth.

Step Five:

Using the same tool, we're now going to start straightening the bottom teeth. The bottom-middle tooth on the left is leaning toward the left, so with the Forward Warp tool, choose a brush size like the one you see here, click right on the line to the left of the tooth, then click-and-hold, and nudge that line over to the right to straighten it out a bit (like you see here). Now, the rest of this is going to be nudging the tops of the bottom teeth down, nudging the lines between them to the left or right to make them straighter, and pulling up where the teeth start to slant downward.

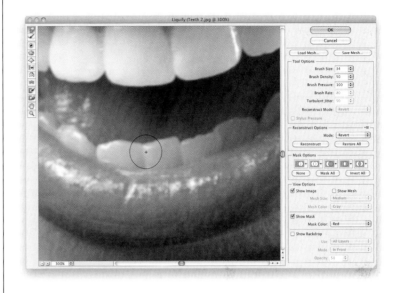

Step Six:

Again, you're going to use that same brush, but a little smaller brush size. So, start by pushing the top right of that same bottom-middle tooth down along the right edge of the tooth, because it's extending upward too far. Again, just gently nudge it down using a few strokes. Do you see a pattern in this type of retouching? Most of the time, unless it's something very large you have to move, you're better off moving it a little, letting go of the brush, and moving it a little more, releasing, then doing it again and again—very small increments work best.

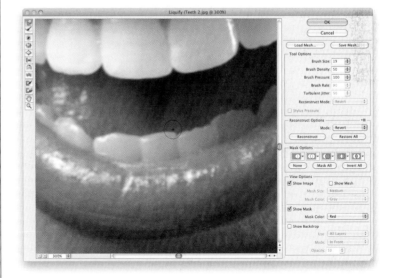

(Continued)

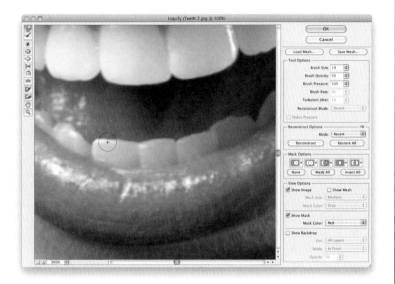

Step Seven:

If you look at the next tooth to the left, you'll see the left side of it slopes down a bit. So, you're going to have to pull that side up, so it's flat (as shown here) and aligns with the other bottom teeth. Same technique, same brush, just repeat what you've been doing with small, subtle nudges.

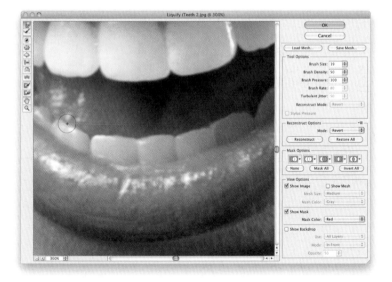

Step Eight:

Now, move to the next tooth to the left and build up the right side of the tooth (it's sloping downward), then nudge down the left side of the tooth. Just a little bit more Liquify work to go, but you can see the bottom row is already looking much better.

Step Nine:

Move to the next tooth on the left, and do the same thing, then move to the bottom teeth on the other side and fix those, as well (you kind of have to fix all of them in this image, though I usually just worry about the ones in front).

Step 10:

Now, we're going to work on that other pointy canine tooth in the top right, but first, we can do one last thing here in Liquify to make our job easier. Make the brush size larger, then remove the "pointyness" (yes, that's a word. Okay, it's not, but it should be) by nudging the bottom of the tooth upward a bit (as shown here). You can now click OK to apply all your Liquify filter changes, and we can get to work on filling that pointy tooth's gap.

(Continued)

Step 11:

You're going to need to make a selection in a shape that you want to add to the tooth, so I'm making a selection that covers the gap, and snuggles up against the other tooth (as seen here). I made this with the Lasso tool **(L)**, but you can use any tool you're comfortable with (my first choice is usually the Pen tool, because making a precise path and turning that into a selection usually gives you the best results—it just takes a little longer. But, since I have a tablet and wireless pen, it was just too easy to draw this quick little selection with the Lasso tool). You're going to want to soften the edges of your selection (so it doesn't look harsh where your new tooth area meets the tooth beside it), so go under the Select menu, under Modify and choose **Feather**. Enter 2 pixels in the Feather Selection dialog (shown here) for just a little softening, and click OK.

Step 12:

Create a new, blank layer by clicking on the Create a New Layer icon at the bottom of the Layers panel, and then get the Clone Stamp tool **(S)**, so we can cover up that gap by cloning in some of the tooth from above the gap. From the Brush Picker, choose a small, soft-edged brush, then Option-click (PC: Alt-click) on a highlight area on the tooth to sample that area for cloning. Move straight down and start painting over that gap. Don't worry, you won't accidentally paint over the other tooth. By putting a selection in place first, it's like putting up a fence—you can't paint outside that fenced-in area. So, just paint right across until it's all cloned in.

Step 13:

Now, press **Command-D (PC: Ctrl-D)** to Deselect and see your newly cloned tooth, then press **Command-E (PC: Ctrl-E)** to merge the layers. In this particular case, the tooth looks weird—not because of the retouch, but because of how the real light falls on that tooth. It's brighter than the other teeth, and that brightness looks kind of yellow, so we'll need to deal with that. Again, you won't normally have to do this, but just in case this happens to you, at least you'll know what to do. Get the Lasso tool again (or the selection tool of your choice) and make a selection around that entire brighter, yellower tooth (as seen here). Add a 1-pixel feather, if you like, to slightly soften the edge.

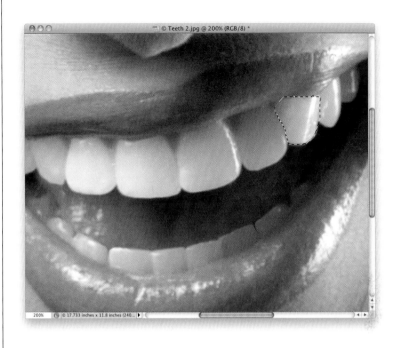

Step 14:

At the bottom of the Layers panel, click on the Create New Adjustment Layer icon and choose **Hue/Saturation** from the pop-up menu. From the second pop-up menu at the top of the Adjustments panel, choose **Yellows**, then drag the Saturation slider to the left (as shown here) until the yellow in the tooth goes away (here, I had to drag it nearly all the way to the left, so it matched the other teeth), then deselect.

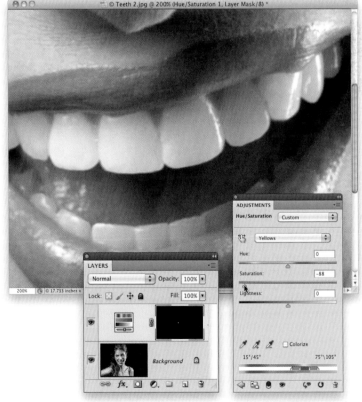

(Continued)

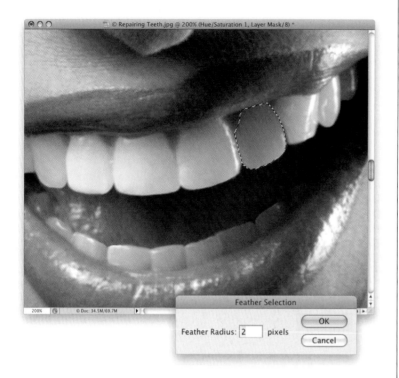

Step 15:

The last thing we're going to do here is to brighten the tooth to the left of the tooth we just fixed. It has a little bit of a shadow on it, and we want to make it look like it's more in line with the other teeth. So, get the Lasso tool again and make a selection of that tooth. Add a 2-pixel feather, to soften the edges a little.

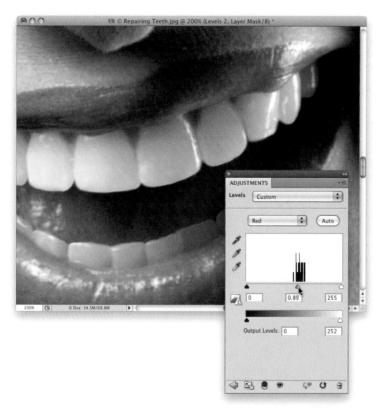

Step 16:

Click on the Create New Adjustment Layer icon again, but this time, choose **Levels**. In this image, there is a lot of red in the shadow area, so when the Levels options appear in the Adjustments panel, change the pop-up menu above the histogram to **Red**. Now, drag the gray midtones Input Levels slider, under the histogram, to the right a little to reduce the reds and brighten the area. Each image will be different, so you'll just have to go through each color in the pop-up menu, and drag the midtones or shadows Input Levels slider until the color matches the surrounding teeth better. Here, I also switched to **Green** and dragged the shadows Input Levels slider to 3, then switched to **Blue** and dragged the midtones Input Levels slider to 1.06.

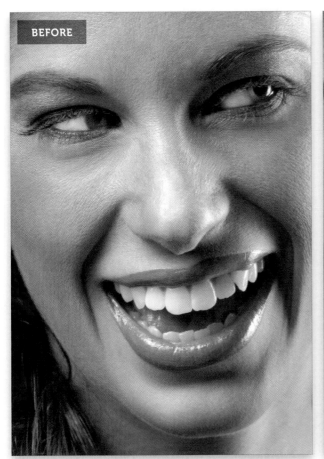

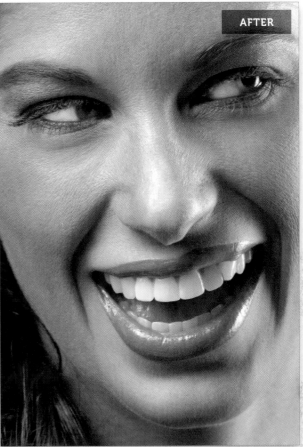

Try this technique on another image!

TIP: You can fix all of the gaps in between the teeth here in Liquify, but be sure to use the Freeze Mask tool **(F)** to freeze teeth next to the ones you're working on.

Download this image. See pg. xi.

After

Whitening Teeth and Reducing Yellowing

Nice white teeth look just beautiful (which is one reason why so many people each year spend thousands on porcelain veneer caps), but most people have some-to-moderate yellowing. In most cases, you'll pretty much want to remove all the yellow, and even do a little brightening, but if your subject has very yellow teeth, you won't be able to remove all the yellowing, or they'll look obviously retouched. So, in those cases, you'll just reduce and tone down the amount of yellowing, so it's not distracting. Here's how to do both:

Step One:
Here's the image we want to retouch, and our subject's teeth have just a slight yellow discoloration. Nothing major, and in fact, I think with everything around him being white (his shirt, the background, etc.), it probably makes it stand out more, where normally you wouldn't notice at all. But when we do the retouch, and you see the final image, you'll see it was worth it.

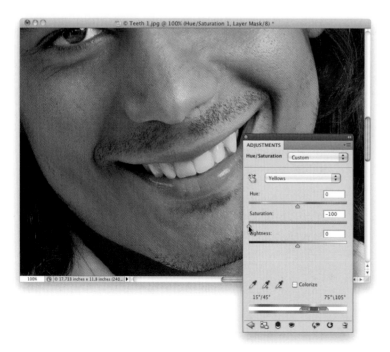

Step Two:
Zoom in on the teeth, then click on the Create New Adjustment Layer icon at the bottom of the Layers panel and choose **Hue/Saturation** from the pop-up menu. In the Adjustments panel, change the second pop-up menu at the top from Master to **Yellows**, then drag the Saturation slider all the way to the left (as shown here) to remove all the yellows from the entire image. Now, take a look at the teeth and see how they look. In 99% of the cases, they'll look great at this point, but in this particular case, they still seem to have a hint of color in them, which usually means there's some red in there, as well.

Step Three:

Switch the same pop-up menu to **Reds** now (as shown here), reduce the Saturation a bit (as shown), and now the teeth look right. Of course, we've totally trashed his skin, but we'll fix that in the next step.

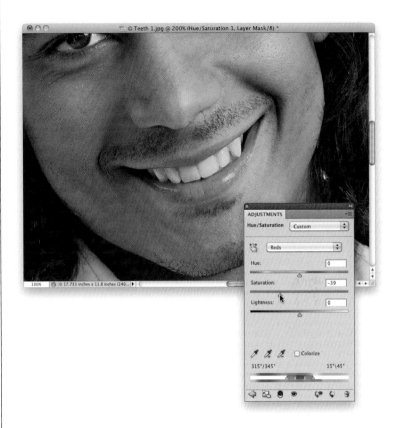

Step Four:

Press **Command-I (PC: Ctrl-I)** to Invert the Hue/Saturation adjustment layer's layer mask, turning it black. Now his skin looks normal, because the entire adjustment we just made is hidden behind that black mask. We just have to paint over his teeth to reveal the retouch, so make sure your Foreground color is set to white, get the Brush tool **(B)**, choose a small, soft-edged brush (like the one you see here) from the Brush Picker, and start painting over the teeth. As you do, the yellowing is replaced with nice white teeth (as seen here, where I'm painting over two of his teeth). We're not quite done yet, though.

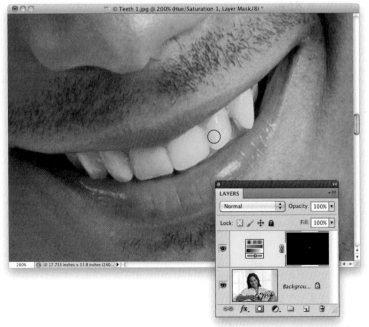

(Continued)

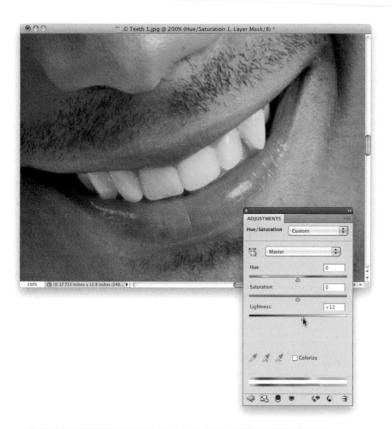

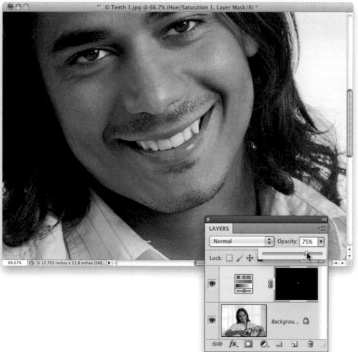

Step Five:

Continue painting over all the teeth until all the yellow is gone (as seen here). Now, you've created a mask for the teeth, so any other changes you make in the Hue/Saturation Adjustments panel will only affect the teeth, right? Right! So, let's brighten his teeth a bit, as well. Switch that pop-up menu at the top of the panel back to **Master**, then drag the Lightness slider to the right just a little bit (as shown here). It's easy to get carried away with this slider, so be careful not to overdo it. Here, I only increased the brightness to +12. If you go much farther, it can start to look really fake (depending on the image, of course. Some need more lightening than others).

Step Six:

At this point, you've removed all the yellowing and brightened the teeth. One thing to keep an eye out for is that your teeth don't look gray, because you've removed so much of the color. If you think that's the case (and in this one, it might be), then you can go to the top of the Layers panel and lower the Opacity of your Hue/Saturation adjust-ment layer to bring back just a little hint of the color. Here, I've dropped the Opacity to around 75%, and that was just enough to make the color of the teeth look very natural.

Step Seven:

To finish things off, I would adjust the pointy canine tooth on the right using part of the "Repairing Teeth" technique you just learned on the previous pages. But first, you'll need to flatten your layers, so press **Command-Option-Shift-E (PC: Ctrl-Alt-Shift-E)** to merge your layers into a new layer, creating a flattened version of your image at the top of your layer stack.

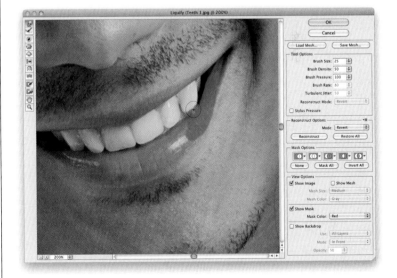

Step Eight:

Luckily, in this case, you can do the whole thing just using Liquify, but because the tooth is nearly touching his bottom lip, you're going to have to use a second tool in Liquify to keep his lip from moving. You're going to use the Freeze Mask tool to freeze his bottom lip, so it stays in place when you nudge up the pointy tooth. So, from the Filter menu, choose **Liquify**, then get the Freeze Mask tool (it's the fourth tool from the bottom in the Toolbox), and paint over his bottom lip right below that tooth. As you paint with the Freeze Mask tool, it paints in red (as seen here). Now, get the Forward Warp tool **(W)** and use it to nudge the pointy part of the tooth upward, and then you can nudge part of it over to fill in the gap. You'll find this is surprisingly easy to do and it takes just a few seconds. When you're done, click OK to compete your retouch.

(Continued)

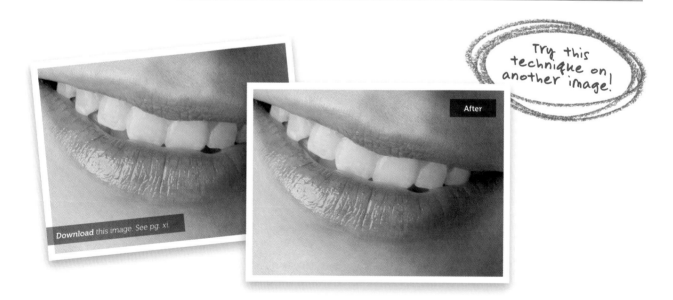

Chapter 6 SLIM SHADY

Slimming and Trimming

For the entire first part of my career, I never did any retouching where I had to slim or trim my subjects, and I think it's because I used to call them three or four days before the shoot, and warn them not to eat anything but bouillon from that moment on, until two days after the shoot (or when their check cleared, whichever came first). But, after a while, they started catching on, and I'd find them sneaking a carrot stick or some leafy greens on the set, and before you knew it, I was throwing every Photoshop trick in the book at their photos, including the "Stringbean filter," the "Beanpole maker," and the often over-used "Scrawnify filter." So, here's the thing: I know talking about weight issues, even ones we'll fix in Photoshop, is a touchy topic, and since it's my goal to deal with my subjects in a caring and compassionate manner, I go out of my way not to use insulting or degrading terms that might offend. To help out with this, I thought that, throughout this chapter, we could use friendly code words instead. So, for example, where you might read the phrase, "…we're going to make a slight adjustment to the vertical proportions," you know that what I actually mean is "…this guy's a porker." But, of course, I would never say that in print. Also, if you read, "…his face is somewhat rounded," what I mean is "…this guy's a porker." Now, in some cases, it's not the person's physique that's causing the problem, it's a fold in their clothing, or the fit of their clothing, so you might see me say something like, "…we're going to tuck in this fold on his shirt," which of course means "…this guy's a porker," or it could mean "…I smell bacon." Either would be correct.

Overall Slimming

This is one of the fastest and easiest retouches in the entire book, and yet it's probably one that you'll use the most. I've never applied this technique to a photo and (a) been caught, or (b) not had the client absolutely love the way they look. The hardest part of this technique may be not telling your clients you used it.

Step One:

Here's the image we're going to retouch. If you want to maintain the exact same size (height and width) as the original, you'll need to duplicate the Background layer as your first step. If you don't care if the final image is slightly trimmed in width, you can just work on the Background layer (though I still always recommend working on a duplicate layer, so all your retouches are separate from the original, and you can undo those any time by just deleting the layer).

Step Two:

On your duplicate layer, press **Command-A (PC: Ctrl-A)** to select the entire image, then press **Command-T (PC: Ctrl-T)** to bring up Free Transform.

Step Three:

Now, normally, we press-and-hold the Shift key when using Free Transform, so things stay proportional, but this time, you're not going to do that. Instead, you're just going to click on the left-center Free Transform handle and drag it to the right to slim the overall image. If you look up in the Options Bar, you'll see the W (width) field update as you drag, and for most subjects, you can keep dragging until you hit around 95% (so, just a 5% slimming), as shown here. This 5% rule works great for two reasons: (1) it's enough that it really makes a difference, yet (2) it's not so much that it's obvious something has been done. There are some subjects where you can go a little further, maybe to 93%, but most of the time, 5% is all you'll need, and sometimes even less than that. Look at your subject while you're dragging—don't look at the numbers until you're done dragging and see where it lands.

Step Three:

When your person looks "naturally" slimmer, press **Return (PC: Enter)** to lock in your transformation. Doing this transformation leaves you with some excess white canvas area on the left side of the photo, but luckily, your original selection will still be in place (from back in Step Two), so just go under the Image menu and choose **Crop** (as shown here) to remove the excess white space and crop your image down to size. Press **Command-D (PC: Ctrl-D)** to Deselect, and you're done! There's a before and after on the next page to show you how effective this quick little move is.

(Continued)

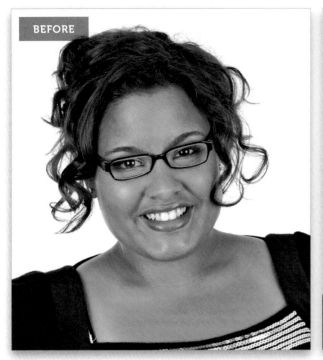

BEFORE

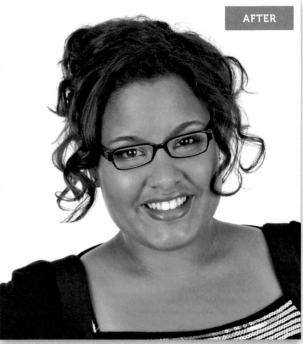

AFTER

©ISTOCKPHOTO/JUAN MONINO

Download this image. See pg. xi.

After

Try this technique on another image!

Slimming One Person in a Group Shot

This is a retouch you do when there's more than one person in the photo, but you want to slim just one them. This is one of those techniques that, when you look at it, you think, "There's no way this is going to work." But it actually works amazingly well, even though it only takes a few seconds, and surprisingly you don't use any feathering on your selection, which goes against almost everything we've done throughout the book. Go figure.

Step One:
Here's the image we're going to retouch, and we're going to make the subject on the left slimmer, while leaving the subject on the right untouched.

Step Two:
Get the Rectangular Marquee tool **(M)**, and make a rectangular selection over most of your subject (as shown here). It's okay that we're selecting right over her nose and part of her mouth, though I generally try to avoid having the selection go right through an eye.

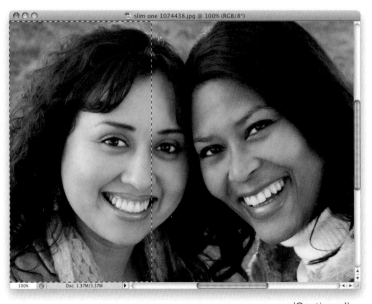

(Continued)

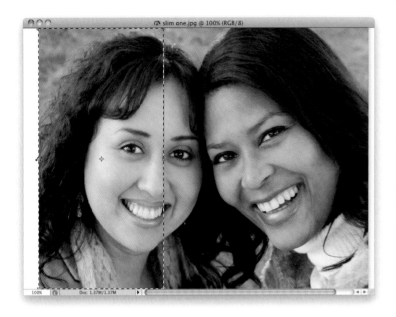

Step Three:

Now, you're not going to feather the selection to soften it and you're not going to put it on its own separate layer (both of these are reasons why this retouch doesn't make much sense, but stick with me, because it really works). Instead, press **Command-T (PC: Ctrl-T)** to bring up Free Transform around your selected area, grab the left-center point, and drag inward to the right (as shown here) until your subject looks slimmer. Once they look good, press **Return (PC: Enter)** to lock in your transformation, and then press **Command-D (PC: Ctrl-D)** to Deselect. Now, you'll have to use the Crop tool **(C)** to crop the image down to size (and to get rid of that white gap on the left). You'd think there would be some kind of seam or line, but there's just not (as long as you don't feather). A before/after of the retouch is shown on the next page.

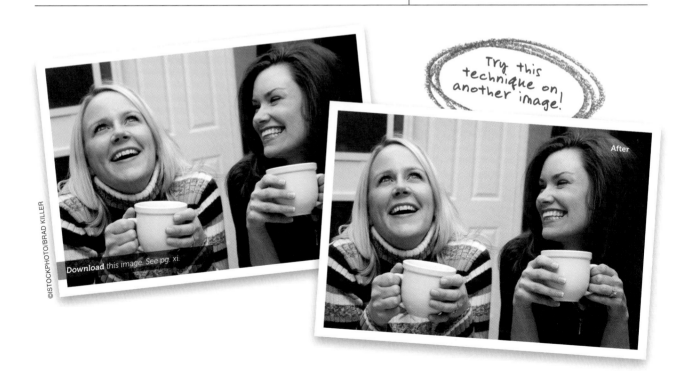

©ISTOCKPHOTO/BRAD KILLER

Download this image. See pg. xi.

Try this technique on another image!

After

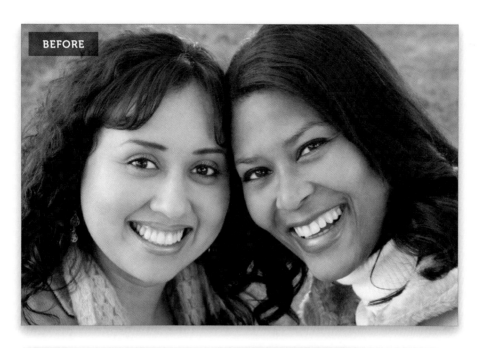

Reducing a Double Chin & Thinning the Face

There will be times where you want to slim just one or two areas on your subject's face, and not affect the entire image, like we did previously in the "Overall Slimming" technique. For reducing a double chin, jowls, or just thinning the face (and leaving the rest untouched), your first thought might be to grab the Liquify filter, but sometimes you can get the job done more efficiently using a different tool, or by using Liquify in combination with other tools, like we're going to do here.

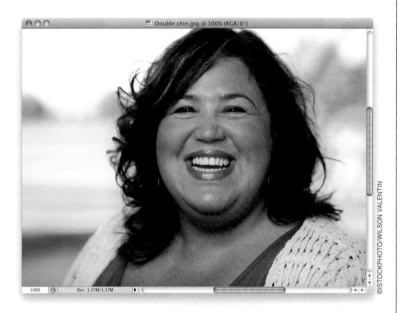

Step One:
Here's the image we want to retouch. Basically, we want to reduce her double chin, lighten the shadow areas beneath her chin, and then because of some of the changes we'll make, we'll need to finish off with a simple Liquify adjustment, and together these do a really nice job of slimming and trimming the face and reducing a double chin.

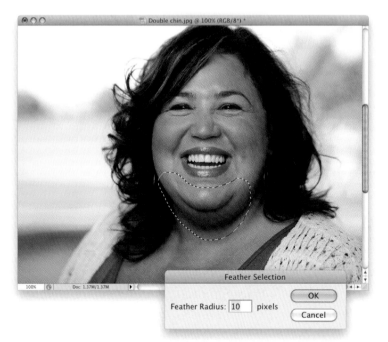

Step Two:
Get the Lasso tool **(L)** and draw a very loose selection around your subject's jaw and the lower part of the face on both sides (as shown here). Now, soften the edges of the selection by going under the Select menu, under Modify, and choosing **Feather**. When the Feather Selection dialog appears, enter 10 pixels and click OK.

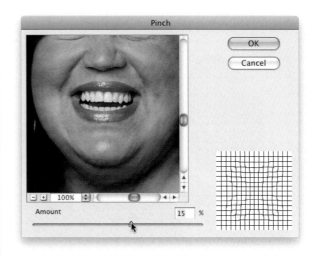

Step Three:

Go under the Filter menu, under Distort, and choose **Pinch**. When the Pinch dialog appears, drag the slider to the left to 15% (as shown here). This particular filter doesn't show a full on-screen preview, so you have to look inside the filter dialog's little preview window to see how this affects your subject (I chose 15% here, but depending on your subject, you might need to use slightly more or less, but keep the amount fairly low, because you'll probably apply this filter more than once. As usual, that depends on your subject). To see a quick before and after of what the filter is doing, just take your cursor and click-and-hold right inside the preview window to see the before, then to see the after, release the mouse button (or unclick your pen).

Step Four:

Click OK, and the Pinch filter is applied to your selected area (as shown here). I've found that, in most cases, applying the filter once just isn't enough (it's too subtle), so to apply the same filter again, using the exact same settings, press **Command-F (PC: Ctrl-F)**.

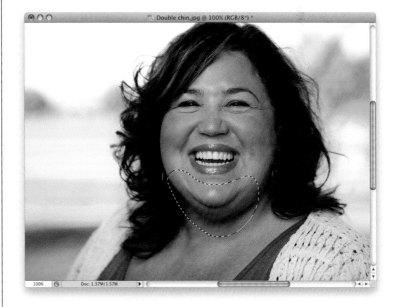

(Continued)

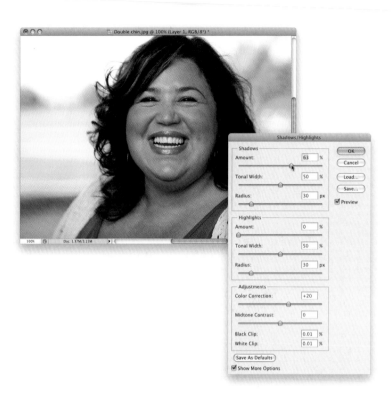

Step Five:

Now that we've applied that Pinch filter, next let's try to lighten the shadows on her neck to de-emphasize the depth of the double chin. While your selection is still in place, press **Command-J (PC: Ctrl-J)** to put that area up on its own separate layer. Now, to lighten those shadows, you could use the Dodge tool at a low opacity, and paint over the shadow until it lightens, but in this case, it's faster to lighten that entire area. So, go under the Image menu, under Adjustments, and choose **Shadows/Highlights**. When the dialog appears, drag the Shadows Amount slider to the right until the shadows have lightened up pretty significantly (I dragged it to 63 here). By the way, if your Shadows/Highlights dialog looks much smaller than this one, it's only because you don't have the Show More Options checkbox at the bottom turned on.

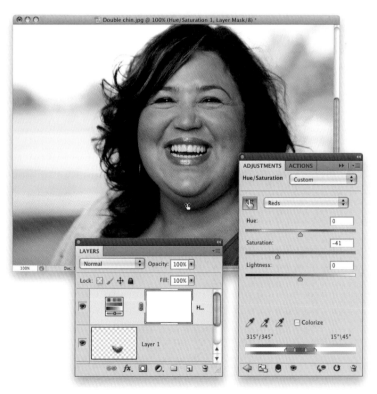

Step Six:

On this particular image, there's an orange color cast on the area under her chin, and it's made more obvious by lightening the shadows in that area (while that might be just on this particular image, I still think we need to fix it while we're here). Click on the Create New Adjustment Layer icon at the bottom of the Layers panel, and choose **Hue/Saturation** from the pop-up menu. Then, get the Targeted Adjustment tool (TAT, for short) from the top-left corner of the Adjustments panel. Click it right on the orange part of her chin, and drag to the left to reduce the reds in that area (as shown here).

Step Seven:

Press **Command-I (PC: Ctrl-I)** to Invert the layer mask on this Hue/Saturation adjustment layer, so the version of her chin with the desaturated reds is hidden behind a black mask. Now, take the Brush tool **(B)**, choose a medium-sized, soft-edged brush at 100% opacity, make sure your Foreground color is set to white, then paint along the underside of her chin to remove that orange color cast.

Step Eight:

Press **Command-Option-Shift-E (PC: Ctrl-Alt-Shift-E)** to merge your layers up onto a new layer. Now, step back and look at the image. One side effect of applying the Pinch filter two or three times is that your subject's chin tends to get a little pointy. If that happens, go under the Filter menu and choose **Liquify**. Choose the top tool in the Toolbox (the Forward Warp tool), choose a really large brush size, and gently nudge the chin back up into place. Also, now that her chin area is much smaller, I'd take that same brush and push in a little bit on both the left and right side of her face to trim the face a bit, as well.

(Continued)

©ISTOCKPHOTO/QUAVONDO

Download this image. See pg. xi.

After

Try this technique on another image!

Tip: I basically followed the same steps with this image, but I only applied the Pinch filter once and then at the end, I used Liquify to nudge his neck and the left side of his face in a little.

Thinning Arms or Legs

We use the same technique on arms that we do on legs, and because you're working with larger areas here, we actually do all our trimming by picking up and moving parts of the arm (or leg) itself, rather than just pushing it around with Liquify. The technique you're about to learn is probably the most popular method of thinning arms and/or legs, because the results, especially along the edges of the arms and legs, are right on the money.

Step One:
Here's the image we want to retouch, and because it was taken with a 24–70mm wide-angle lens (at 40mm, on a full-frame camera), the image looks a little distorted near the edges, which makes her arms look much bigger than they actually are, so we're going to retouch each arm down so they look normal-sized. Again, although we're doing this technique on our subject's arms, it works exactly the same way on legs.

Step Two:
Start by getting the Lasso tool **(L)**, and draw a selection that is at least an inch onto the subject's skin (like you see here), and then as you continue making your selection, make sure you include a large chunk of the background, too (as shown here).

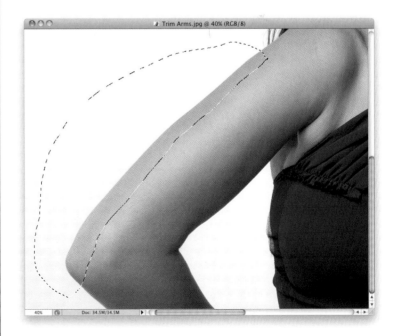

(Continued)

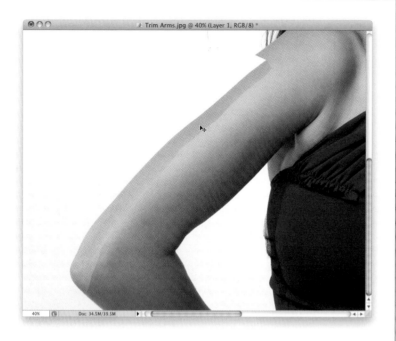

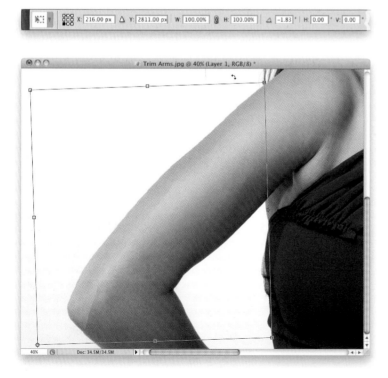

Step Three:

You're not going to feather the selection (we don't want the edges to be smoothed). Instead, first let's just put our selected area up on its own separate layer by pressing **Command-J (PC: Ctrl-J)**. Now, switch to the Move tool **(V)**, and drag the selected area inward toward the arm to trim it right up. Make sure the bottom-left side of the arm (right near the elbow) stays in line with the part of the arm you didn't select just below it (as shown here). Now, the arm is much thinner, but we have two new problems to deal with: (1) there's a big nasty chunk taken out of her arm up near her shoulder, and (2) there's a visible edge from where you made your selection earlier. We'll fix those next.

Step Four:

First we'll fix the chunk, so press **Command-T (PC: Ctrl-T)** to bring up Free Transform. We're going to rotate this arm piece layer, but before we do that, go up to the Options Bar. Do you see that tiny grid of nine dots up in the top-left corner? Those correspond with the nine points of the Free Transform bounding box. By default, the center point is selected, which means if you rotate, it will rotate your image around the center point (kind of like the way a steering wheel works). However, in this case, you need it to rotate from the bottom-left corner point. That way, the bottom-left corner stays in place (which is want we want, since it's already perfectly lined up), while the rest rotates. So, in that little grid, click once on the bottom-left corner dot to select it, then move your cursor outside the Free Transform bounding box to turn it into a two-headed arrow. Now, click-and-drag counterclockwise to tilt your arm piece until it lines right up with the rest of her shoulder (as shown here), which covers that chunk. Once it looks good, press **Return (PC: Enter)** to lock in your transformation.

Step Five:

The second thing we need to clean up is the edge. So, click on the Add Layer Mask icon at the bottom of the Layers panel to add a layer mask, then press **X** to set your Foreground color to black, get the Brush tool **(B)**, choose a medium-sized, soft-edged brush, set your brush Opacity to 100%, and paint right over that line, and the edge goes away (as shown here).

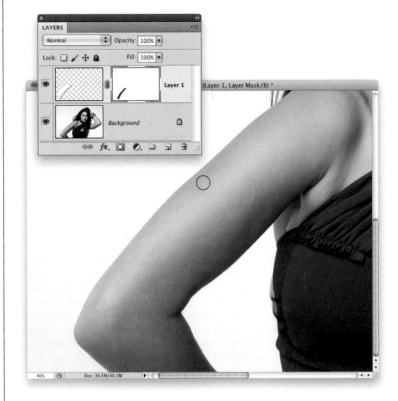

Step Six:

Next, you're going to work on the lower part of the arm (it still looks kinda thick, and now it doesn't match with the thinning you just did on the upper arm). Start by making a merged layer (a new layer that looks like a flattened version of your image) by pressing **Command-Option-Shift-E (PC: Ctrl-Alt-Shift-E)**. Then, use the Lasso tool again to make a selection similar to the one you did on the upper arm (like you see here).

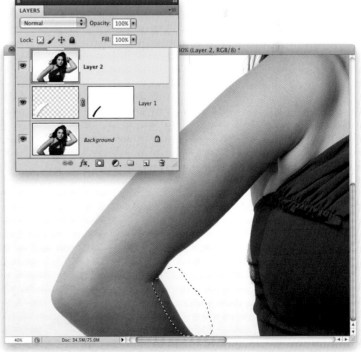

(Continued)

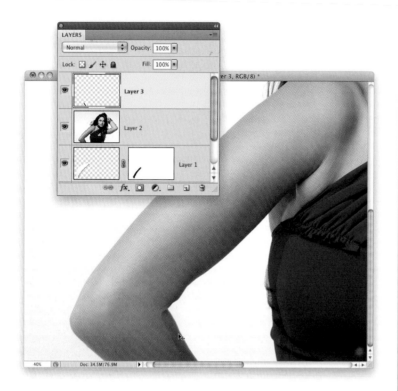

Step Seven:

Put that selection up on its own layer, like we did before, and get the Move tool again. Drag the lower arm piece inward toward the center of that part of the arm (as shown here) to thin that part considerably.

Step Eight:

Now, add a layer mask to this layer, and with the Brush tool (same settings), just paint right over the visible edge on the arm to blend your retouching seamlessly right in (as seen here). It's looking pretty good, except for one thing: there's a little lump of skin left over from your move, on the bottom side of her upper arm, right near the inside of her elbow (it's above and to the right of where you see my brush cursor here). That little lump has got to go!

Step Nine:

Create another merged layer (the flattened-look layer). Get the Clone Stamp tool **(S)**, and choose a small, hard-edged brush, because the edge on her arm where you're going to retouch is a hard edge (actually, after you choose your hard-edged brush from the Brush Picker, you can get better results here by lowering the Hardness amount to around 75%, so it's a "mostly-hard-edged brush"). Also, make sure your Sample pop-up menu in the Options Bar is set to **Current Layer**. Now, take the Clone Stamp tool, Option-click (PC: Alt-click) somewhere on the background, but right nearby the area you want to fix (as shown here), and then just clone that little lump away by painting right over it (as seen here). The little plus-sign cursor shows how close to where I would be cloning that I sampled (**Option-clicked**).

Step 10:

Now, switch to the other arm, and we're pretty much going to do the same thing, but I think I can save you one step in this process. Instead of moving the piece of arm, then rotating it into place, to avoid having that big chunk cut out, we can just rotate to trim up the arm, which removes the whole chunk thing altogether. Start by getting the Lasso tool **(L)** and selecting the part you want to move inward (as shown here).

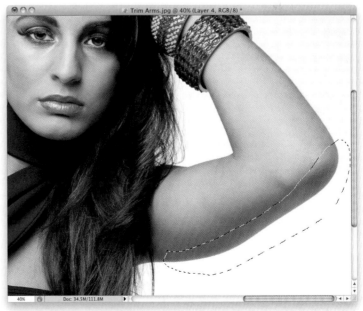

(Continued)

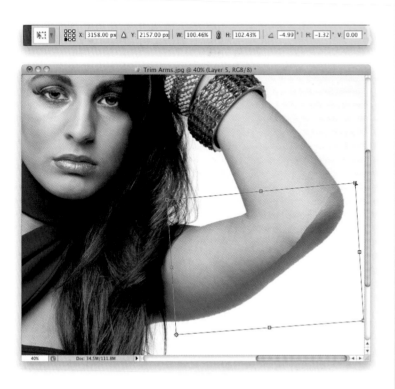

Step 11:

Press Command-J (PC: Ctrl-J) to put that selected area up on its own layer, and press Command-T (PC: Ctrl-T) to bring up Free Transform again. Up in the Options Bar, make sure the bottom-left corner point is selected in the grid (so, the bottom-left corner of your selection is locked into place), then just move your cursor outside the Free Transform bounding box and click-and-drag counter-clockwise to rotate to your selected area inward (as seen here). Don't lock in your transformation just yet, though. Now, to get the top part of her arm to perfectly match up as you rotate, just **Command-click (PC: Ctrl-click)** on the top-right corner point of the bounding box, and you can distort that side of your selection as you drag to make it match up perfectly. Basically, it's going to fall a little tiny bit short, so by holding that keyboard shortcut, you can just stretch it to fit. Once it looks good, press Return (PC: Enter) to lock in your transformation.

Step 12:

You'll still have a hard edge to deal with, so click on the Add Layer Mask icon at the bottom of the Layers panel to add a layer mask to this layer, make sure your Foreground color is set to black, get the Brush tool, and paint over the edge to blend it in right away (as shown here). There's one more thing left to do.

Step 13:
Start by making yet another merged layer. Then get the Lasso tool one more time, and select the top part of her arm (as seen here). Put that selection up on its own separate layer.

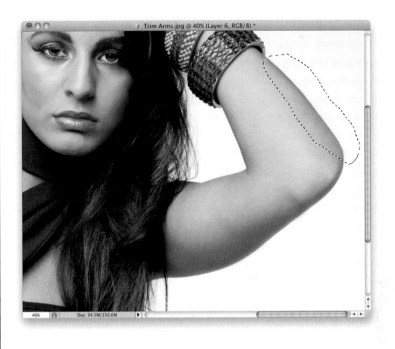

Step 14:
Bring up Free Transform again, but this time you're going to need to rotate, with the top-left corner locked down, toward the elbow (so it rotates around that point instead). So, go up to the Options Bar and, in the grid, click on the top-left corner point. Now, rotate that part of the arm clockwise until it almost meets up with the rest of her arm. There will be a small gap in the skin where it doesn't meet up again, but now you know what to do: press-and-hold the Command (PC: Ctrl) key, grab the bottom-right corner point on the bounding box, and just drag it until it aligns perfectly with the rest of the arm (as seen here).

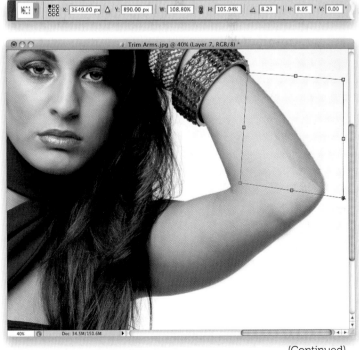

(Continued)

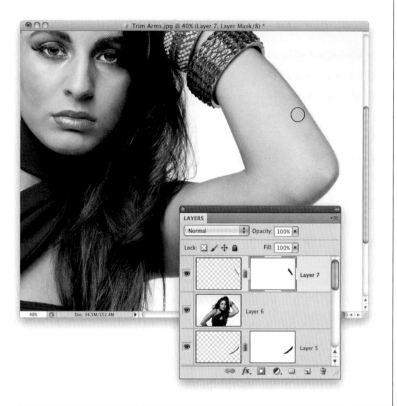

Step 15:

Time to deal with the hard edge again: add a layer mask to this layer, and paint in black over the edge to blend it away (as shown here). *Note:* If you think the elbows look a little too pointy, make another merged layer, go under the Filter menu and choose **Liquify**. Use the top tool in the Toolbox on the top left, and just nudge those pointy elbows up a tiny bit to flatten them out (I didn't do that here, but I thought I'd mention it, just in case). Also, while I was at it, I nudged the skin of the armpit on the left to the right a little bit.

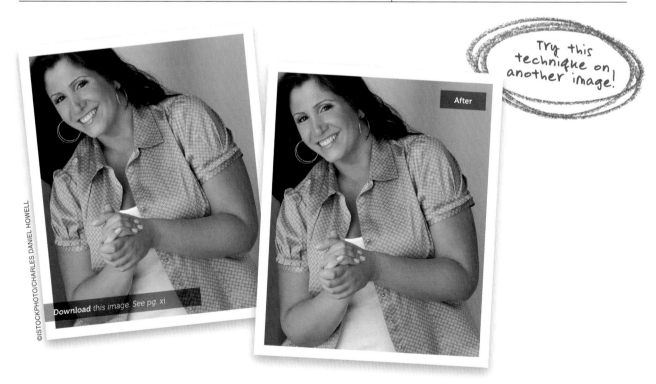

Try this technique on another image!

After

Download this image. See pg. xi.

©ISTOCKPHOTO/CHARLES DANIEL HOWELL

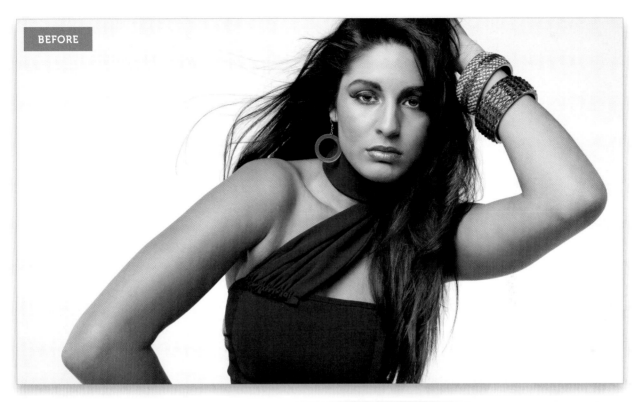

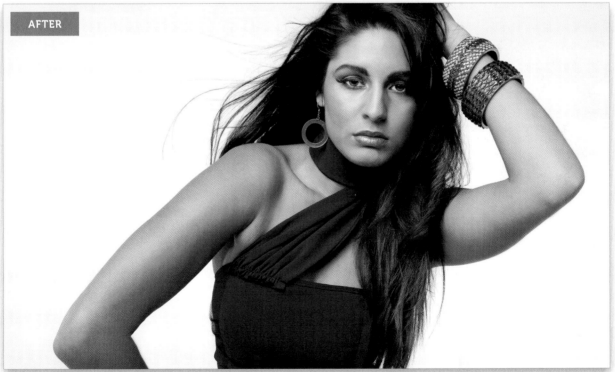

Getting Great Abs

If you want to take your subject's abdominals up a notch, it's a matter of just over-emphasizing what's already there (or creating what's not there) by adding shadows and highlights to add definition and a toned look in that area.

Step One:
Here's our shot to retouch. We're going to basically dodge and burn the abdominals to accentuate the lines that are already kinda here, and make them really stand out, which gives your subject's abs that "cut" look. We're going to start with burning, so go ahead and get the Burn tool (press **Shift-O** until you have it). Up in the Options Bar, set your Range to **Midtones**, and your Exposure to 10%, so we can build up our strokes gradually. Make sure the Protect Tones checkbox is turned on.

Step Two:

We're going to do our dodging and burning on a separate layer, but we're going to use a special Soft Light gray layer for this (a layer filled with gray, but in Soft Light mode, it ignores the gray fill, and instead provides us with a great base to dodge and burn upon). Start by going to the Layers panel's flyout menu and choosing **New Layer**. When the New Layer dialog appears, choose **Soft Light** for your Mode, and then turn on the checkbox that now appears below it for Fill with Soft-Light-Neutral Color (50% Gray), and click OK. Now, we're ready to start dodging and burning.

Step Three:

Choose a medium-sized, soft-edged brush from the Brush Picker, and then look for any natural shadow areas in the abdominal area (no matter how slight) and start painting a few strokes down that external oblique line (as shown here, where I'm painting a dark vertical stroke down to the left of her navel). You're going to have to paint a number of strokes here to get it to build up, because our Exposure is set so low. Go ahead and make it darker than you think it should be, because we'll be able to adjust it to the right amount later, since our burning is on its own separate layer.

(Continued)

Step Four:
Now, burn the shadows on the right external oblique side (though there really isn't an ab line there), and down the center vertical ab line leading down to the navel (as shown here). I know, at this point, things are looking pretty overdone, but again, we'll tweak this in the final step to make it look more natural.

Step Five:
Next, you're going to paint a few horizontal strokes coming inward, to the center, off those vertical burn lines you just created on each side. You're actually going to start right at the line, and then paint kind of an arc downward a little (like the arrow shows here) to help build up more depth.

Step Six:
Now, switch to the Dodge tool (press **Shift-O** until you have it) to lighten the areas right beside your shadows to give the abs more definition. Use the same settings up in the Options Bar (set the Range to **Midtones**, and the Exposure to 10%), then choose a little smaller, soft-edged brush, and paint a line just to the left of your left burned stroke (as shown here). This helps make the abs look deeper and more defined. Continue this for the other areas you burned, using the Dodge tool to create highlights beside your shadows.

Step Seven:
Next, choose a larger-sized, soft-edged brush and paint over the four areas surrounding the navel to make them brighter, so they looked "raised" up a bit, which further helps the definition (as shown here).

Step Eight:
Now, once you're done with this dodging, we can finally tone the whole effect down quite a bit, so we have a natural-looking retouch. Go to the Layers panel, and lower the Opacity of your Soft Light layer (as shown here, where I lowered the Opacity to 40%) until the abs look natural (as seen in the After photo on the next page. Again, how low you go will be different depending on the image, but for this particular image, 40% looked about right).

(Continued)

BEFORE

AFTER

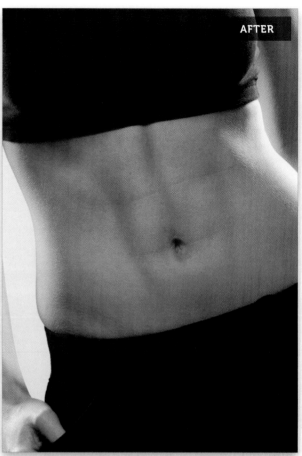

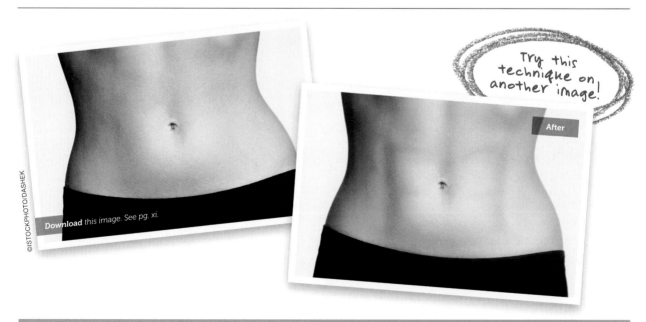

Try this technique on another image!

After

Download this image. See pg. xi.

Fixing Clothes (Lumps, Bagging & Folds)

I give the clothes a once over in every portrait I retouch, because whether your subject is trim or not, having funky lumps or folds in their clothes can really be unflattering (and make your subject look heavier than they are, no matter how they're built). Even if your subject is wearing tight-fitting clothes, you'll find spots where the fabric has folded or rolled, and it really spoils the lines of the clothing, so it's definitely worth doing.

Step One:
Here's the image we want to retouch, and if you look at the right side of her blouse, there are lots of little areas along the outside that need smoothing out.

Step Two:
Go under the Filter menu and choose **Liquify** to bring up the Liquify dialog you see here. Zoom in tight on the area where we want to retouch (the right side). You can see, once you zoom in, there are all sorts of areas sticking out, pushing in, and just bagging up. What's going to make this one a little tricky is that window frame behind her, because we're going to make sure we don't distort that frame while we're fixing her blouse. We're going to use the first tool in the Toolbox, the Forward Warp tool, for most of our retouch, so go ahead and click on it now (if it's not already selected).

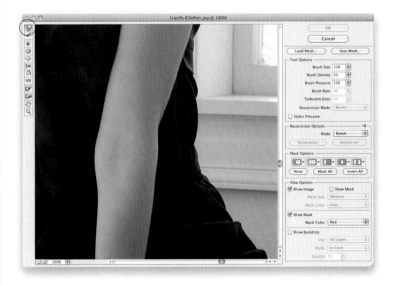

(Continued)

Step Three:
Choose a brush size that's just a little bit larger than the fold you want to tuck in, and just push it in to the left (as shown here). But wait!!!! The fold we're working on here is right along a detail area of the window frame, so you're going to need to make sure your cursor is directly on that line in the wood work, and that you keep your cursor in a straight path going left as you move the brush. That is so it extends that part of the frame perfectly as you paint. Give it a try and you'll see what I mean.

Step Four:
Fixing the next fold up is easy, because there's no detail area or line there in the window frame—you can just push it in to the left, and the frame moves with you to fill in the gap (as shown here).

Step Five:

For the rest of her blouse, the song remains the same—you push in parts that need to be pushed in, and if an area has dipped in, you can gently push it back out (just make sure you make your brush size a little bigger than what you're pushing out). Again, here we're going right along a line in the window frame behind her, with my cursor starting right on the line, so the frame moves right along with me as I push.

Step Six:

Go ahead and get the easy stuff out of the way. Following along the edge of the frame, like you see here, makes most of this pretty easy and routine at this point, so just keep doing what you're doing.

(Continued)

Step Seven:

Now, move down to her b-double-oh-tee-why and retouch the area sticking out there, as well. So far, so good.

Step Eight:

When you get to these larger parts of her blouse, along the sleeve, you have bigger areas to move, and you'll need a bigger brush (if you use a smaller brush size, it will move in little chunks, which makes it harder and more time consuming to even everything out). The problem here is that, if you use a larger brush size (like the one you see here), it's going to move and distort the line where the window meets the frame. So, you'll need to freeze (lock down) that area, so it doesn't move when you move her blouse. Get the Freeze Mask tool **(F)** and paint a stroke right down that line (as seen here in red. The frozen area shows up in red, so you'll know which parts are frozen), then just gently push the sleeve area inward, and you'll see that the frozen area stays locked down. If you want, you can now use the Thaw Mask tool (the tool right below the Freeze Mask tool in the Toolbox) to unfreeze that area.

Step Nine:

Okay, here's where it starts to get sticky. I want to move this next section of her blouse inward a bit to smooth it out, but when I tuck that area in, it smudges the frame behind her (as seen here, where the bottom of the frame just kind of smears). My first thought was to freeze that area, and I tried that, but it's just too close to the blouse and it didn't really work at all. In this case, you're better off trying to fix this after the fact with the Clone Stamp tool, so that's what we'll do. After you've moved the blouse, go ahead and click OK.

TIP: Try the History Brush First

Once you click OK, try the History Brush tool **(Y)** first. I think of the History Brush as "undo on a brush," because if you just grab it and paint with it, it paints the image to what it looked like when you opened it, so you might be able to just paint that part of the frame right back in. I tried that and it didn't work in this case (rats!), but it has saved me a ton of work in other cases, so it's worth at least trying it out.

Step 10:

Now that we're done Liquifying, get the Lasso tool **(L)** and draw a careful selection around the area you're going to retouch. You can make it larger than the area, but make sure you're careful to keep it right up against her blouse (as shown here). The reason we do this is that, by putting a selection there first, it's like putting a fence around the area, and keeps you from accidentally cloning over an area you don't want cloned. So, it's kind of like freezing her blouse, because now you can only clone inside that selected area. The good news is that you can sample (Option-click [PC: Alt-click]) outside the area, but you can only paint inside it.

(Continued)

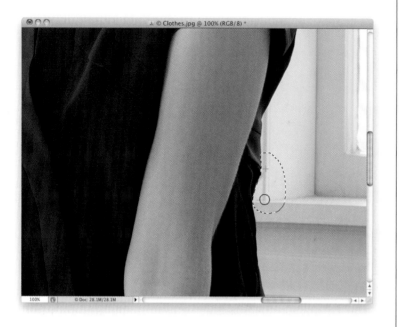

Step 11:

Now, get the Clone Stamp tool **(S)**, press-and-hold the Option (PC: Alt) key, and click once on the part of the frame you want to clone just outside the selected area. Click right on one of the seams, and then move straight downward and start painting to clone in that part of the frame (as shown here). One thing that really helps when cloning along a straight line like this is that once you Option-click that spot, and you move your cursor down to where you want to start cloning, it shows a preview inside your brush cursor of what you're about to clone. I know this sounds kind of funky just reading this here, but once you try it, you'll see what I mean, and how helpful it is.

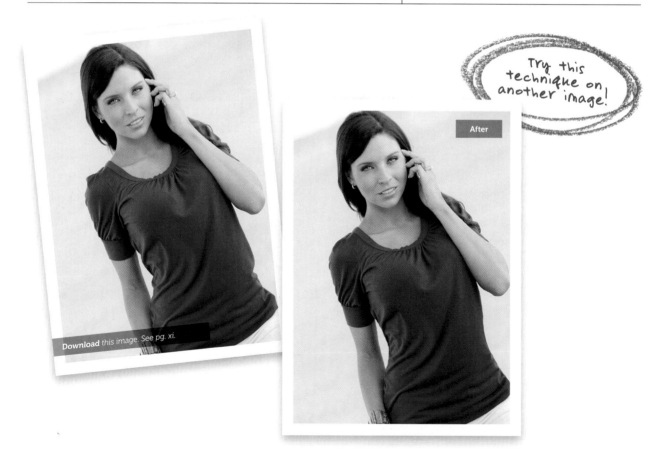

Download this image. See pg. xi.

After

Try this technique on another image!

BEFORE

AFTER

Chapter 7

TAKING FIVE

My 5-, 15-, and 30-Minute Retouches

Okay, so as photographers, we don't have the luxury of being able to spend hours on a retouch. Heck, we don't have the luxury of spending even an hour, because (a) we usually don't get to bill separately for the retouching (unless you live in New York, where you're allowed to bill for everything from air to paper clips), and (b) the time we spend retouching is time we're not shooting, which is what we do get paid for, so we need to get back to work as quickly as possible. Honestly, most of my retouches fall within the 5-to-15-minute range. Every once in a while, I have an important image, and I spend 30 minutes on it, but that's about it, because I've got to get back to shooting (or filling out invoices for paper clips). So, I wanted to give you three real-world scenarios, and take you from start to finish on what I would do to an image if I had just 5 minutes, or just 15, or if I got lucky and had 30 minutes to go from the unretouched photo to a final image. There's another topic we haven't yet discussed that plays into all this, and that is the famous "Factor3," which you always hear retouchers talking about. Factor3 actually refers to a mathematical calculation that's commonly used to help determine how much time a retouch is likely to take. This calculation is based on multiplying the number of blemishes on your subject's face by the gross tonnage of a Soviet freighter, and then dividing the sum by the number of hairs you'll have to clone out of your subject's nostrils, which I can tell you in most cases is 38. It delivers a surprisingly accurate time frame, especially since the gross tonnage of a Soviet freighter can vary from 17,053 to 18,605 tons fully laden. This is precisely why an HP 33s scientific calculator is sometimes included right in the box when you buy a Wacom tablet. Now you know.

Retouching Checklist

One of the things I'm asked the most is: "How do you know what needs to be retouched?" To help answer that, I put together this list of 60 areas to at least consider for retouching, which you can quickly go through to make sure you're covering all your bases. Now (and this is important), hopefully you're not going to do all 60 things to any single photo (or you have an entirely different problem. Well, your subject does), but at least by checking this list, hopefully you'll keep from having something sneak by you. Also, I created a Photoshop panel for you that contains this entire list (see page xiii).

FACE:

1. Are there red veins in the eyes?
2. Whites of the eyes should be white, but not overly white.
3. Is there good contrast in the eyes?
4. Do you see catch lights in the eyes?
5. Do the irises need brightening?
6. Does the color of the irises need to be changed or enhanced?
7. Darken the circle around the iris.
8. Sharpen the eyes.
9. Are both eyes symmetrical?
10. Do the eyes need to be larger?
11. Are both eyelids open enough?
12. Check eyelashes (top & bottom).
13. Are the eyebrows dark enough?
14. Do the eyebrows need filling in?
15. Trim any extra eyebrow hairs away.
16. Check the shape of the eyebrows.
17. Are the eyebrows symmetrical?
18. Does the nose need to be smaller?
19. Do the cheeks need to be tucked in?
20. Check the size of the ears.

SKIN:

21. Remove any blemishes.
22. Remove or reduce moles or individual freckles.
23. Remove or reduce wrinkles.
24. Remove dark circles under eyes.
25. Remove or reduce smile lines.
26. Reduce any hot spots.
27. Is the skin tone consistent?
28. Does the skin color of the face match the rest of the body?
29. Repair blotchy skin.
30. Does the skin need smoothing?

31. Does the skin need additional makeup applied?
32. Add dodging and burning to sculpt the face.
33. Are the hands, elbows, knees, or feet too red?
34. Remove veins in the arms, wrists, hands, and feet.
35. Sharpen the portrait.

MOUTH & LIPS:

36. Fix pointed teeth or gaps.
37. Remove any yellowing on teeth.
38. Brighten teeth.
39. Enhance the size of the lips.
40. Enhance lip color.
41. Brighten up highlights.
42. Clean up lips (spillover, lip liner, smudges, etc.).

HAIR:

43. Remove stray hairs.
44. Remove strands that cross other hairs.
45. Remove strands that appear over skin.
46. Remove strands that cross over eyes and eyebrows.
47. Fill any gaps in hair.
48. Add highlights to hair.
49. Change hair color.
50. Darken part line.
51. Fix roots.

BODY:

52. Reduce any double chin or jowls.
53. Does the subject need slimming?
54. Reduce love handles.
55. Trim arms or legs, if necessary.
56. Do the legs need lengthening?
57. Do the arms and legs appear symmetrical?
58. Are there any distracting armpit wrinkles or any pit fat that needs reducing?
59. Enhance the abs, if visible.
60. Smooth and straighten clothing.

My Five-Minute Retouch

When you can only invest five minutes in a retouch (which probably means you have a bunch of images to retouch), you have to work smart. You're not going to be able to do a lot of detail work on the eyes or skin—you just have to make sure the main areas get taken care of. You're going to have to make some compromises to the list of things you want to do, versus what you're going to have time to do. But, two things can really help you fit seven minutes of retouching into a five-minute bag: (1) use actions for stuff you do over and over, and (2) use a tablet.

Step One:
Here's the original unretouched shot. Just giving it a quick look, here's what I'll try to retouch in the five minutes we have: (1) brighten the eyes and eye socket areas, (2) remove any major blemishes, (3) clone away the two buckles beneath the blouse straps, (4) soften the skin, (5) smooth out the folds on the sides of the blouse, and then (6) sharpen the eyes and the overall image. That's six things in only five minutes, which means you'll need to spend only 30 seconds on some things, so you'll have 60 seconds to spend on others. Don't sweat it if you go over by 30 seconds or so at first (making it a 5½-minute retouch). Since you'll probably be doing this on 20 or so images at a time, by the time you get to the twentieth, you'll probably have it down to 4½ minutes. Here we go…

Step Two:

First, we're going to fix the eyes and eye sockets all at once by just lightening those entire areas, like we did back on page 27. So, zoom in on the eyes, duplicate the Background layer, and change the blend mode of the duplicate layer to **Screen** to make the whole image brighter. Then, add a black layer mask to hide this brighter version of her. With your Foreground color set to white, paint over her eyes and the surrounding eye socket areas (as shown here, where I'm painting over and around the eye on the right). I know right now it looks like she's been lying in the sun with sunglasses on, but we'll fix that next.

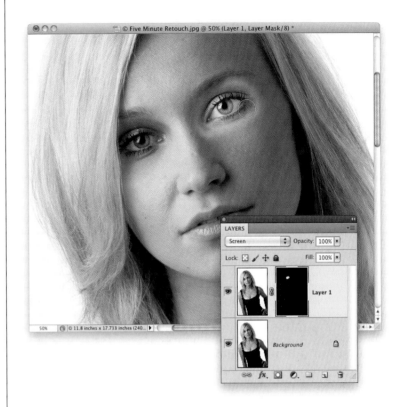

Step Three:

Lower the Opacity of the Screen layer (as shown here) to the point where your brightening matches the rest of her face (here, I lowered it to 52%). If you see any edges that look brighter, change your Foreground color to black and paint right over those edges to get rid of them (I had to do a little of that here, just under one of her eyes, and you may need to lower your brush's opacity). We don't have the time to do any detail work on the eyes, but they certainly look much better here than they did in Step One. Now, you can choose to flatten your image (**Command-E [PC: Ctrl-E]**), or create a merged layer, but with only five minutes, you're not going to be going back and tweaking things so much that you're going to need to maintain all your original layers. So, this is when you "flatten and move on," and I'll be doing this with each retouch that I do here.

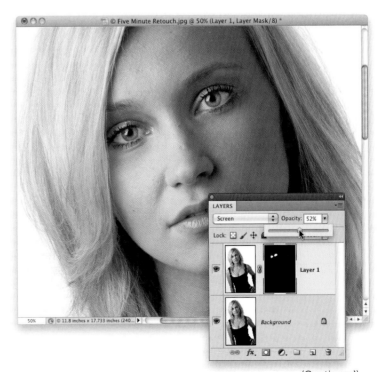

(Continued)

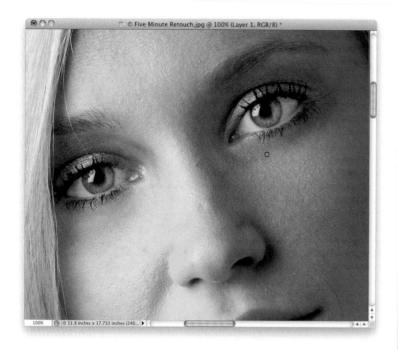

Step Four:
Duplicate the Background layer again, then switch to the Healing Brush tool, Option-click (PC: Alt-click) in a clean area beneath a wrinkle, and completely remove as many wrinkles under her eyes as possible, like you learned back on page 119. Use a small brush size and avoid the eyelashes as much as you can, because we're not going to work on those at all. For now, just remove as many wrinkles as possible in as little time as possible. We're going to bring some of these wrinkles back in the next step, so don't sweat making this wrinkle removal perfect—just get close.

Step Five:
Now, go to the Layers panel and lower the Opacity of this layer, so just a little bit of the wrinkle, and the darkening under her eyes, comes back for a more natural look. If your subject is someone older, make sure you don't leave this Opacity setting too high, or they'll look weird. The older your subject is, the more wrinkles they're expected to have. Your job is to make them look 10 years younger—not 40 years younger. Okay, we're done with the eyes and eye areas (critical retouches), so now let's go get rid of the blemishes, just like we did back on page 86.

Step Six:
Flatten your layers again, and then with the Healing Brush still selected, make your brush just a little bit larger than the blemishes you're going to remove. Option-click (PC: Alt-click) in a nearby area of clean skin (as shown here), then move your cursor over a blemish and just click once to remove it. Since all you're doing is just moving around and clicking, this goes really quickly. Don't worry about tiny little blemishes, because they'll be hidden somewhat in the skin softening process. For now, just remove the stuff that really stands out. Also, as you make your way near her mouth, remove those little smile lines on either side of it.

Step Seven:
Here's what it looks like after 15 seconds of individual clicks, and two brush strokes to remove the smile lines. Getting rid of blemishes is one of the things you want to leave yourself the most time for, because we've only done one section of her face, and we used up 15 or 20 seconds.

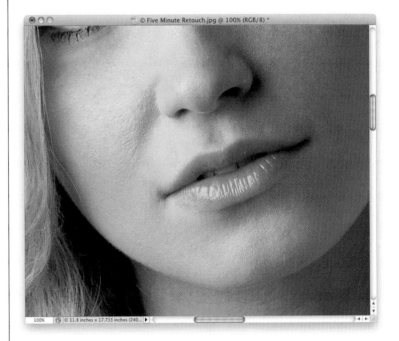

(Continued)

Step Eight:

Work your way down from top to bottom (that way you won't miss any areas like you would if you were just jumping around). When you get to her neck and chest, don't forget to only remove the most obvious and large blemishes—the rest will pretty much get taken care of during skin smoothing, so don't waste your time getting every single one. Here, I've removed a few of the bigger blemishes from the right side of her chest, and now I'm moving over to the center and left. You'll also see some areas where the skin is a lighter color than the surrounding area (like she's peeling a little from a sunburn a week ago), so just remove the most obvious of those by painting over them with the Healing Brush, as well. If this was a larger area that needed to be fixed, you could use the technique you learned back on page 131.

Step Nine:

This is one you're going to have to make a call on whether to fix or not, because it's going to eat up a minute all by itself. See those little metal buckles sticking out beneath the straps of her blouse? Because they're reflecting the lighting, they draw the eye, and to me they're really distracting, but if it doesn't bother you, just jump straight over to Step 13. If it's driving you nuts (like it is me), then get the Lasso tool **(L)** and draw a quick, loose selection around the buckle on the right, but make sure you get your selection nice and snug up against the material of her blouse (as shown here). Remember, as you learned back on page 289 when we were fixing clothes, by putting this selection here first, you're making sure your cloning stays inside that area, and that you don't run the risk of accidentally painting on her blouse.

Step 10:

Get the Clone Stamp tool, and then sample an area nearby that has the same tone and texture as what we're trying to remove (in this case, the buckle is in a shadow area, so I sampled right below where the buckle is—you can see where I sampled from by where the little cross-hair cursor is here), and then quickly clone that buckle away. This took just a few seconds, thanks to the fact that the selection was in place. Without it, I would have had to be really careful, and work with a small brush. With it, I can use a medium-sized brush and just "get 'er done!"

Step 11:

Now, this is where I got worried, and why (if I had any sense) I would have let this part of the retouch go. The buckle on the other side is a nightmare. There's hair overlapping it, and getting a convincing retouch with hair intact is going to take some serious time. So, I went with "Plan B," which is to just cover it up with some of the black strap. This isn't going to be a pretty fix, but with the limited time we have, I just want to make sure it doesn't draw the eye. Draw a quick Lasso selection around it (like you see here), that's snug on the side up against the strap.

(Continued)

Step 12:
Switch back to the Clone Stamp tool and sample an area on the strap an inch or so below where the buckle is, and then just clone right over the buckle, basically extending the strap where the buckle used to be (while I was at it, I also cloned away the stray threads to the right of the strap on the left). I told you this wouldn't be pretty (and it's not), but these are the kind of trade-offs you have to make when you've only got a few minutes to invest, and 19 more pictures waiting to be re-touched. Like I said, I probably should have let this go, and spent more time on making the rest of the retouch look good, but I decided to go "all-in" and get rid of those buckles. I wish I had just had the makeup artist fix this during the shoot, and then I wouldn't have had to deal with it at all. I'm all for fixing it during the shoot. That way, I could have skipped this part altogether.

Step 13:
Now, we're going to do some quickie skin softening, like we did back on page 90. Because we only have five minutes, we're going to break my "no blurring skin" rule a tiny bit, but we're going to bring back lots of skin texture, so it'll look pretty decent when we're done. Start by dupli-cating the Background layer (remember, we've been flattening as we go to save time), then add a 20-pixel Gaussian Blur. Lower the Opacity of this layer to 50%, so you can easily see the blur (don't worry, we're not going to leave it at 50%—we just want it set high, so we can easily see what we're painting as we go), and add a black layer mask to hide your blurry layer (as seen here).

Step 14:

Get the Brush tool, and with your Foreground color set to white, choose a medium-to-large-sized, soft-edged brush at 100% Opacity (if you use too small a brush, you'll never make it in five minutes), and paint over all the skin areas, being careful to avoid the eyes, eyebrows, hair, nostrils, lips, the edges of her face, and anything that should remain sharp.

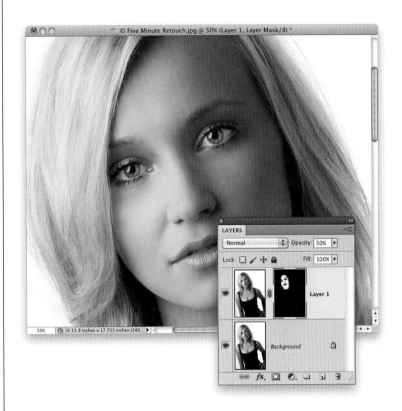

Step 15:

Once you get it kind of roughed out, Option-click (PC: Alt-click) on the black layer mask thumbnail in the Layers panel, so you can see just the mask (seen here). Now, you can quickly see exactly which areas you missed and you can paint right over them in white on the mask (areas in white are getting softened). See all those little black spots I missed on her neck and cheek? And I missed an entire area to the right of her eye on the right. You can toggle back and forth between this mask and the full-color image by just Option-clicking on the mask in the Layers panel. That way, you can check to make sure you don't accidentally blur over an area that should be sharp.

(Continued)

Step 16:

Once you're done painting, Option-click back on the layer mask thumbnail to return to the full-color image. Now, here's where you can bring detail back. Although we painted at 50% opacity, we only did that so we could easily see where we're painting as we go, but 50% is too high an amount—it obliterates the skin texture, and her skin looks plastic. Your job, then, is to lower the layer's Opacity setting as low as you can go to retain some of the smoothing, and yet still see skin texture. In most cases, that's somewhere between 25% and 35%. Here, I lowered it to 30%, and then zoomed in, so you can see the skin texture, which is definitely clearly visible. If you can get away with 20%, and you think the skin is improved, all the better, but this is a call you'll have to make based on your subject's skin.

Step 17:

Now, let's tackle all those unflattering folds on the sides of her blouse. Flatten your layers, then go under the Filter menu and choose **Liquify**. Using the Forward Warp tool, we're going to use the same technique you learned back on page 285 for dealing with folds in clothes like this. The key to this is working with a small brush size—one that is the approximate size of what you'll be working on. So, if you're pushing in/out a small fold, your brush should be about that same size. If you're moving a large area, use a large-sized brush, so it all moves as a unit.

Step 18:

There are two things I would do here: Look back at the image in Step 17 and you'll see that the top of her blouse on the right side of her breast looks pushed inward, which makes her breast look flat on that side. We're not going to make her breast larger, but I think we need to use a large brush and push that right side out a bit, so it looks fuller and matches the shape of the breast on the left. So, start by fixing that. The key is to use a very large brush, but without distorting her arm on the right. Compare this capture, with the blouse pushed out, versus the one shown in Step 17. Next, let's work on the folds going down the right side of the blouse. Switch to a much smaller brush, and start pushing out those tucked-in areas between the folds on her side. With folds, it's a process of pushing out the crease, then tucking in the side. Again, just keep your brush size small and gently nudge the folds in and out until it starts to flatten out nicely, without looking too uniform, or it'll look retouched. Here, I'm about 2/3 of the way down on her side, pushing in a fold.

Step 19:

Do the same fold-fixing to the other side of her blouse, and while you're there, I'd tuck in the sides a little bit, giving a slight curve to her side, so it matches the right side (as seen here). Now, you can click OK to apply these changes.

(Continued)

Step 20:
Now, let's apply some overall sharpening, like you learned back on page 160. Since this is a photo of a woman, we want to avoid sharpening the skin as much as possible, so go to the Channels panel and click on the Red channel. This restricts the sharpening we're about to apply to mostly the non-skin areas (the Red channel doesn't hold a lot of skin texture detail), and since we're applying this sharpening to just the Red channel, I can apply more than I normally would. So, apply an Unsharp Mask filter, using settings of Amount: 120%, Radius: 1, Threshold: 3.

Step 21:

Click back on the RGB channel at the top of the Channels panel to return to the full-color image. Get the Sharpen tool (like you did back on page 81) and paint a few strokes over the eyes (as shown here) to finish off our retouch. Now, if you're looking at this image and thinking we missed some things that should be retouched—you're right. Doing a five-minute retouch means you fix what you can fix in five minutes and move on to the next image. So, for this image, we covered the most important areas we could, in a really fast and efficient way. Now, if you ran a timer to see how you did, and you're at seven minutes or 10 minutes, don't let it get you down (also, remove any time you spent on the buckles). What makes you faster at this is simply repetition. The more times you do this, the less you'll have to read out of the book what to do next, and the faster you'll get. You'll get this down to four minutes before you know it.

(Continued)

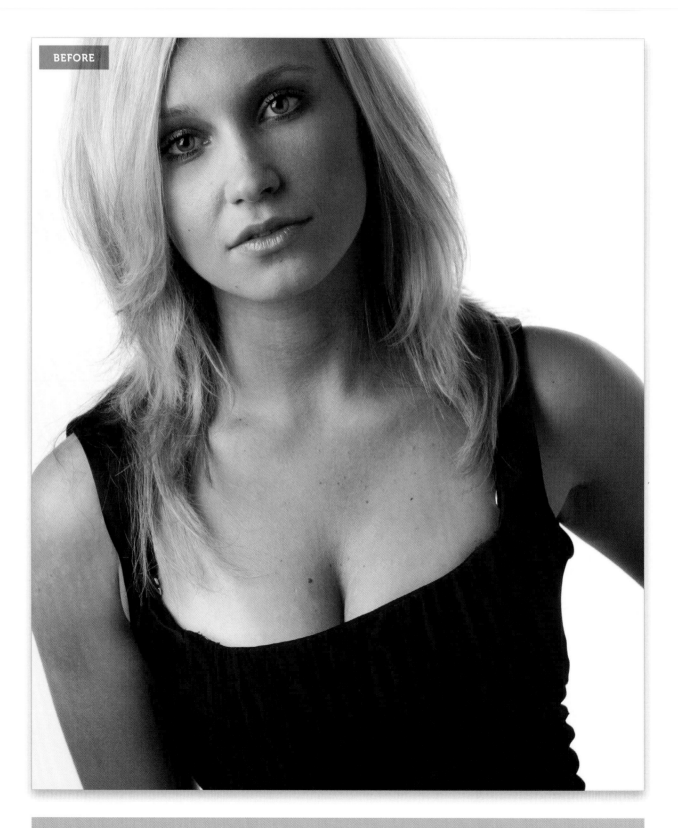

AFTER

My 15-Minute Retouch

I try to keep my regular, run-of-the-mill retouching tasks to around 10 to 15 minutes, but keeping it closer to 10 makes a big difference. For a standard shoot, in most cases, I give the subject five to six finished images for their portfolio or project. If I spend just 15 minutes on each image, that's an hour and a half of editing for just six images. If I can take it down to 10 minutes an image, it's only an hour, but that's an hour I'm not shooting, so working fast and efficiently is key. Most of my retouching falls in the range of what you'll see me doing here (hopefully, I can do it in less than 15, but of course, it depends on the subject, and the client).

Step One:

Here's the original, unretouched shot. I know what you're thinking, "Hey, the hair is covered, so this won't take as long." Actually, I chose this one because it's going to take the full 15 minutes (remember, removing flyaway hair doesn't take long), because of her skin, which has lots of tiny bumps (almost like goose pimples), and although we can't remove them all, we can hide a lot of them and still retain lots of skin texture. Here, we're going to work on the skin, eyes, and eyebrows. We're also going to remove the strap from the shoulder on the left, and we're going to tone the scarf she's wearing, as well. Don't worry, you'll be plenty busy.

Step Two:

I'm going to zoom in tight on one part of her face, so you can see the goose bumps I was talking about, and a few blemishes, as well. Here's the strategy based on us keeping this a 15-minute retouch: we're going to start by removing the major blemishes and bumps the way we did on page 86, mostly ignoring the smaller ones, because the skin softening technique we're going to use next will help lessen them quite a bit. So, create a new layer for your blemish removal. Next, get the Healing Brush tool, then go up to the Options Bar and, in the Brush Picker, set the Hardness to 75% (as shown here) to get a little better blending along the edges.

Step Three:

Now, with a very small brush size—just a tiny bit bigger than the blemishes and bumps we want to remove—sample a clean area near a blemish or bump, then move your cursor over each one and just click. Don't paint. Click (like you learned back in Chapter 2). This is when a tablet with a wireless pen really pays off, because you can tap the head of a pen a lot of times in a minute. Make your way around, removing just the largest and most obvious blemishes, lines, or bumps. Remember to sample in a clean area near where you'll be healing, and don't hesitate to resample as you move from the side of the face, to the cheek, to the nose. They all have slightly different skin textures, so you need to sample from those areas.

Step Four:

Just move around her face and forehead, and continue this process of removing only the biggest, most distracting bumps, lines, or blemishes. It's okay to spend a little extra time doing this, because the main retouch on this image will be the skin. The other stuff is pretty quick and easy. So, for example, if you had a dollar to spend on retouching, I'd spend 40¢ on this removing blemishes part. The skin smoothing that comes next is pretty quick, so take a few extra seconds on this.

(Continued)

Step Five:

We're going to do a simplified version of the skin smoothing technique you learned back on page 96. It's simplified because, rather than determining how much of the High Pass filter you should apply, I'm going to give you a number that (a) works okay for your average high-res image (not ideal, but okay), and (b) is easily divisible by three. So, create a new merged layer at the top of your layer stack, then add a High Pass filter with a Radius of 9 pixels.

Step Six:

Next, you'll apply a Gaussian Blur filter to your High Pass layer using an amount that's one-third as much as you used in the High Pass filter. So, from the Filter menu, under Blur, choose **Gaussian Blur**, and in this case, you'd enter 3 pixels, and then click OK to blur the High Pass layer a bit. Now, invert that High Pass layer.

Step Seven:

Go to the Layers panel and do two things: (1) change the blend mode of this layer to **Linear Light**, and (2) lower the Opacity to 50% (as shown here).

Step Eight:

Of course, we want to limit this smoothing to just the skin, and not the detail areas, so add a black layer mask to hide this smoothing layer (as seen here, in the Layers panel). With your Foreground color set to white, get the Brush tool, choose a medium, soft-edged brush at 100% Opacity, and start painting over her skin. Of course, as always, avoid areas that shouldn't get softened, like her eyebrows, eyes, inside of her nostrils, lips, the scarf, and so on. As you paint, you'll see that it smoothes out the bumps, yet there is a lot of texture, courtesy of that High Pass layer. Don't forget to paint over her shoulder on the left and her fingers (avoid the fingernails, though).

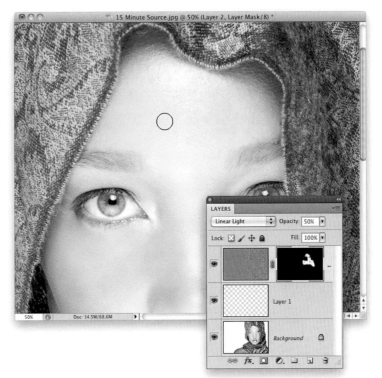

(Continued)

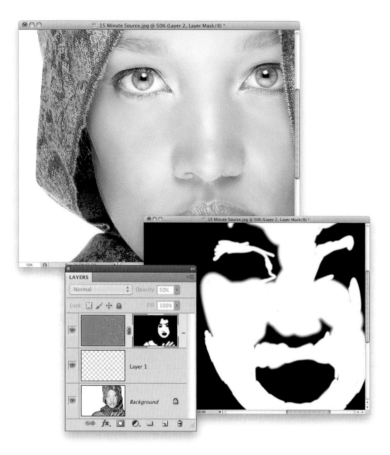

Step Nine:

Here's how the image looks at this stage. The skin is softened and the transitions between the shadow and highlight areas are smoothed out. To make sure you didn't miss any areas, Option-click (PC: Alt-click) directly on the black layer mask thumbnail in the Layers panel and you'll see the black-and-white mask (shown here at the bottom). You can paint in white, right on the mask, over any areas you might have missed. At this point, the opacity of this layer is at 50%, but if you feel you can get away with a lower amount (40%, 35%), I would consider it. Zoom out a bit to make seeing the overall image easier, lower the Opacity, and then try a few different opacities to see which one looks best (I ended up leaving it at 50%).

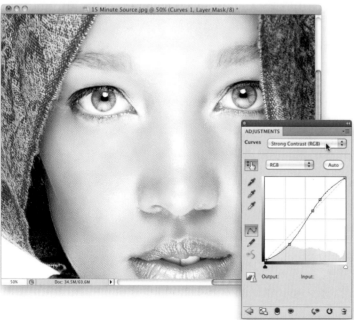

Step 10:

Now that we've spent all this time on the skin, we'd better finish up all the other stuff fairly quickly, so let's move on to the eyes. We're going to use a trick I mentioned on page 4 here. Add a Curves adjustment layer. Then, from the Curves pop-up menu at the top of the Adjustments panel, choose **Strong Contrast (RGB)** (as shown here).

Step 11:

Invert the layer mask to hide the contrasty version of your image behind a black mask. With your Foreground color set to white, get the Brush tool, choose a medium, soft-edged brush at 100% Opacity and paint over the eyes to add lots of contrast (as seen here). Tweaking the contrast like this can tend to actually change the color of the eyes, but since we just want more contrast, change the blend mode of this layer from Normal to **Luminosity** (as shown here), so you get the contrast, but not the color shift. Compare the eyes here, with the eyes in Step Nine, and you can see what a difference this quick trick makes.

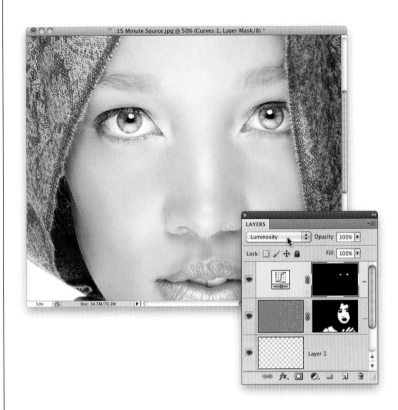

Step 12:

Now, let's work on the eyebrows, which need to be darkened, like you learned back on page 79. Add another Curves adjustment layer to the top of your layer stack, and from the Curves pop-up menu at the top of the Adjustments panel, choose **Darker (RGB)** to darken the mid-tones in the image. Invert the layer mask to hide this darker version, then paint over just her eyebrows (in white, of course) to make them darker (as seen here, where I'm painting the eyebrow on the right).

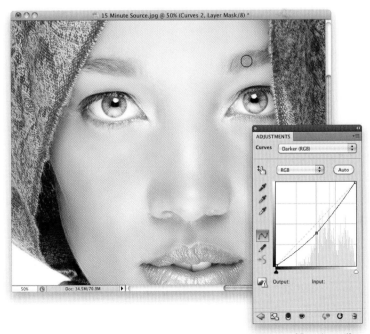

(Continued)

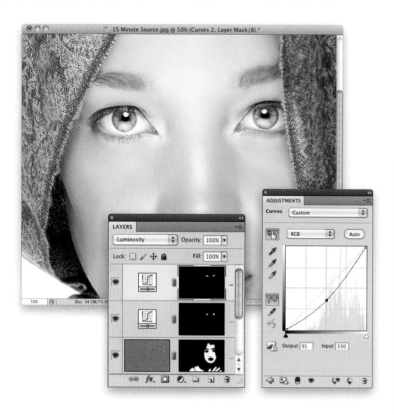

Step 13:

If you think her eyebrows need to be darker, just go to the Adjustments panel and drag the center point of the curve farther down (as I have here). Since you already masked the eyebrows, as you drag the curve downward, only the eyebrows get darker. However, just like with the eyes, darkening the midtones can change the color of the eyebrows, as well. So, don't forget to change the adjustment layer's blend mode to **Luminosity** (as seen here) to keep the color looking the same, but give them the added darkening they need.

Step 14:

Next, let's work on removing the orange strap on her shoulder. This is going to take two different retouches: one to remove the strap, and then where her shoulder is indented, you're going to have to smooth that out, as well. So, start by creating a new merged layer at the top of your layer stack (we'll need this because we're going to pick up part of her shoulder later on) and then zoom in on her shoulder.

Step 15:

For large things like this, I prefer to use the Patch tool, rather than the Healing Brush. But, the problem with using either for a retouch like this is they don't like edges—they smear if what you're trying to remove is touching an edge. So, what I do is start by using the Clone Stamp tool. Here, what I'll do is make a break in the strap, so it's no longer touching anything. So, grab the Clone Stamp tool **(S)**, start down at the bottom where the strap touches the bottom of the image, Option-click (PC: Alt-click) to sample a clean area of skin, and just clone away a little ½" gap. Then do the same thing up near the top (as shown here), but leave the part of the strap that lies in the indent (we'll be fixing that next).

Step 16:

Get the Patch tool (we'll use it kinda like you did when you removed the hot spots on page 127), and draw a loose selection around the strap, just like you would with the Lasso tool. Now, click your cursor inside your selected area and drag your selection over to a clean nearby area (I dragged mine straight over to the right, where you see my cursor here), and then release the mouse button. Your selection snaps back to its original location and the strap is gone (as seen here)! You can press **Command-D (PC: Ctrl-D)** to Deselect, and if there are any tiny bits left over, just get rid of them with the Healing Brush. But, in this case, it pretty much did the trick first time out for me.

(Continued)

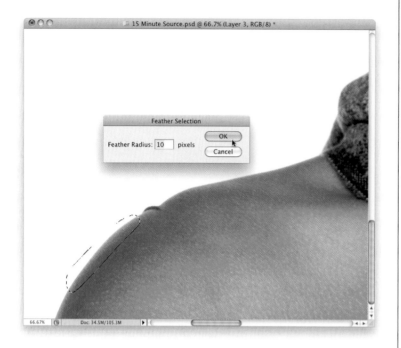

Step 17:

We still have that little bit of strap and the indent it caused to get rid of. We're going to use the body sculpting technique we used back on page 271, except here, we'll feather the selection. So, get the regular ol' Lasso tool and draw a loose selection around a part of the shoulder that doesn't have an indent (as shown here). Make sure you grab some of the background, as well as a decent amount of skin. Next, let's soften the edges of the selection, so it blends in with the rest of the skin. Go under the Select menu, under Modify, and choose **Feather**. When the dialog appears, enter 10, and click OK.

Step 18:

Duplicate that selection to get it up on its own layer, and then use the Move tool to drag that chunk of shoulder up over the area with the indent. Of course, it's not going to line up (as you can see), so bring up Free Transform. Now, move your cursor outside the Free Transform bounding box and it changes into a two-headed arrow. Click-and-drag downward to rotate the copied piece of shoulder, so it lines up with the part of the shoulder that we're trying to fix.

Step 19:

Keep rotating until it lines up perfectly. Since you feathered the edges, you probably won't even have to do any edge blending (but if you do, you could always just add a layer mask and paint it away in black). Once it's rotated to perfectly line up (like you see here), press the **Return (PC: Enter) key** to lock in your rotation.

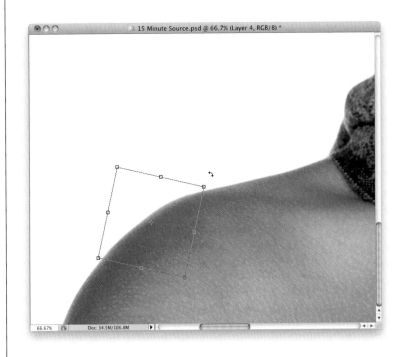

Step 20:

Now, to add some contrast to her scarf, do like we did with her eyes and eyebrows: add a Curves adjustment layer to the top of your layer stack, and then, from the Curves pop-up menu at the top of the Adjustments panel, choose **Medium Contrast (RGB)**. My original idea was to darken just the scarf (so we'd darken the whole image with a Curves adjustment layer, and then mask in just the scarf), but once I chose Medium Contrast, I thought the whole image looked pretty good, so let's just leave it as is. But, go ahead and change the layer blend mode to **Luminosity**, so we don't get a color shift.

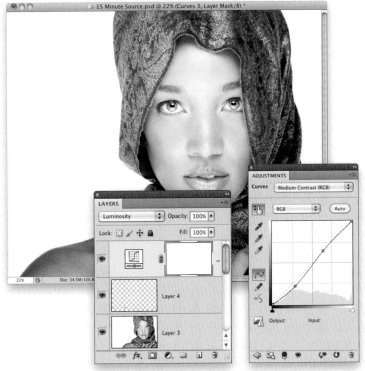

(Continued)

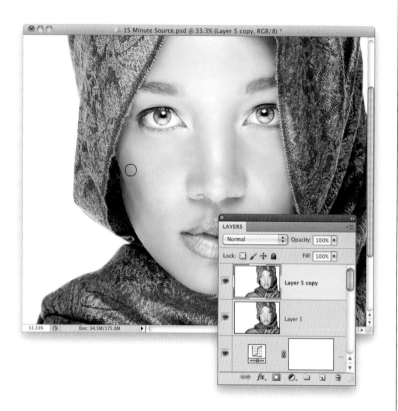

Step 21:

If you have time left (I ran a timer during my retouch, and I had over two minutes left), I would do some dodging and burning to sculpt the face. So, first create another merged layer, then duplicate that layer—this will be where you do your dodging and burning (you already learned this back in Chapter 3, along with the differences between using CS5 or newer, or working with an older version of Photoshop). I always start with burning (darkening), so get the Burn tool, set your Exposure in the Options Bar to 10% or 12%, choose a medium-sized, soft-edged brush, and start painting over the shadow areas (see page 185 for an example of where to burn).

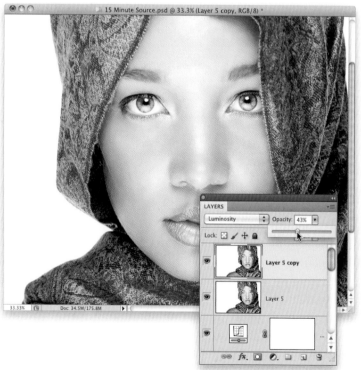

Step 22:

Now, switch to the Dodge tool and brighten the highlight areas, like the straight-line highlight going down the top of her nose, her chin, her forehead—basically everything that extends outward from the face (again, see page 187 for more on what to dodge). Dodging and burning like this tends to change the color of the image, so change the blend mode of this layer from Normal to **Luminosity** (as seen here), then lower the Opacity quite a bit, so it blends in with the image (here I lowered it to 43%).

Step 23:

It's time to sharpen and finish this baby up (before our 15 minutes are up), so merge your layers once again. We want to sharpen the image without sharpening her skin detail, like we did on page 160, so go to the Channels panel and click on the Red channel. Now, our sharpening will be applied just to this channel, and you can see by looking at the channel, there's not much skin detail here at all (it's mostly in the Green and Blue channels). So, by sharpening here, for women's skin, you can avoid making the skin texture stand out. Add an Unsharp Mask filter, using settings of Amount: 120%, Radius: 1.0, Threshold: 3, and click OK.

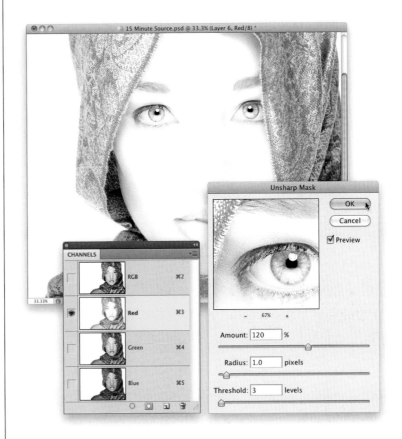

Step 24:

Now, click back on the RGB channel at the top of the Channels panel to return to the full-color image. To finish things up, let's give those eyes a final sharpening. Get the Sharpen tool (only do this if you have Photoshop CS5—see page 81) and sharpen both irises by painting over them with a soft-edged brush, with the Strength set at 20%. Since your Strength is set pretty low, you may have to paint a few strokes over them to get them nice and sharp—just be careful not to over-sharpen. Well, our 15 minutes are up, and we covered a lot of territory here. Remember, don't be upset if this took you 20 minutes or more. You'll get much faster the more you do this. So, for now, just get the steps down—the speed will come next.

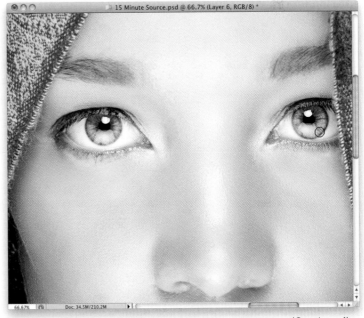

(Continued)

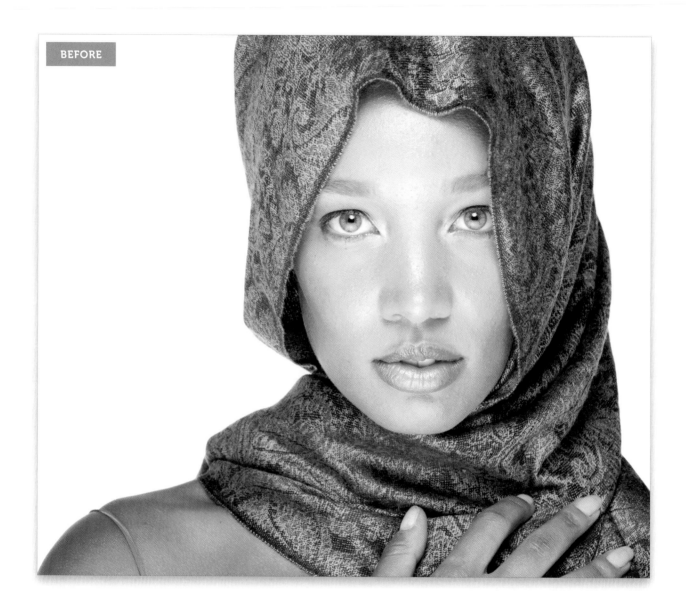

AFTER

My 30-Minute Retouch

Here, I'm going to show you my workflow for a start-to-finish beauty-style retouch. We're not retouching this for the cover of a fashion magazine or anything like that, so my goal is to make this a 20- to 30-minute retouch from start to finish. You might think that, because our subject has great skin, the process will be really simple, but not having to do that much with her skin really only saves us one step, so you'll still stay pretty busy for the next 20 to 30 minutes.

Step One:
Here's the original unretouched shot, so we're starting from scratch. Let's start with a quick evaluation of what we're going to retouch, and we'll go from top to bottom. As always, we have lots of stray hairs to fix, some minor gaps in the hair on the left side of her forehead, and we need to remove that extra sprig of hair coming off her neck and going down her back. We'll also need to darken the part in her hair. From there, we'll fill in the eyebrows a bit, and enhance the top and bottom eyelashes, too. She has an earring hole in her earlobe we need to remove, and the top of her ear has a red patch that needs to be removed, as well. But, we're not done yet. Zoom in just a little.

Step Two:
If you look at her eyes, you'll see we need to remove some red veins from them, and add contrast and sharpening to them, as well. There are a few lines under her eyes, so we'll remove those, too. We have some more hair going over into her ear that has to go, and we have minor skin blemishes that need to be removed from her face, along with some freckles and blemishes on her neck and shoulders. We'll also lessen or remove most of the lines on her neck. I know that seems like a lot, but the good news is this should be a pretty quick and easy retouch (especially since we have so little to do to the skin).

Step Three:

Although I evaluate the image from top to bottom (to figure out which retouches I might need to do), I usually start the actual retouch by retouching the thing that bothers me the most first. That way, it's no longer distracting me, and I don't wind up rushing through other retouches, so I can finally get to fix the part that's driving me crazy. In this particular case, it's the red veins in her eyes that bother me the most, so we'll start there, using the technique you learned on page 32. But more often than not, it's large blemishes that I usually wind up getting rid of first. So, let's get to it (start your timer). First, zoom in really tight on the eye on the right and then create a new layer. Get the Brush tool and choose a small, soft-edged brush set to 20% Opacity. Then, Option-click (PC: Alt-click) in a clean area of eye right near the red veins to switch to the Eyedropper tool, and sample and set your Foreground color, then just paint a series of strokes over each vein until they're gone.

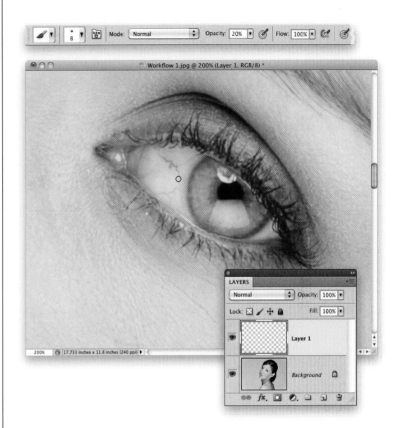

Step Four:

Just keep painting them, one-by-one, remembering to resample (I had to resample a number of different times as I moved to different areas of the eye, because light falling on a spherical eye causes the tone to change), until they're gone (doesn't take very long at all). By the way, don't forget to do both eyes. Also, we're going to add a tiny bit of noise to this layer. So, go under the Filter menu, under Noise, and choose **Add Noise**. When the filter dialog appears, choose 1%, Uniform distribution, turn on the Monochromatic checkbox, and click OK. Since we're doing an entire start-to-finish retouch, you're going to have a lot of layers, so this would be a good time to start naming your layers. Name this one "Eye Veins" (okay, that was kind of obvious).

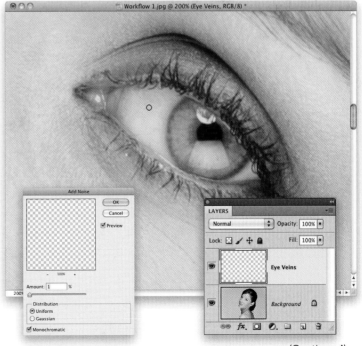

(Continued)

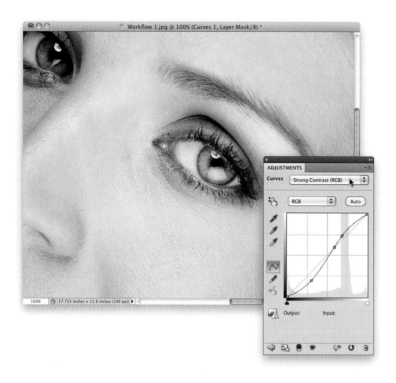

Step Five:

Next, we'll add some contrast to the eye, so add a Curves adjustment layer (we learned this trick on page 4). From the Curves pop-up menu at the top of the Adjustments panel, choose **Strong Contrast (RGB)**. This adds an S-shape to the curve, which increases the highlights and shadows, which increases the contrast in the image (as you can see here).

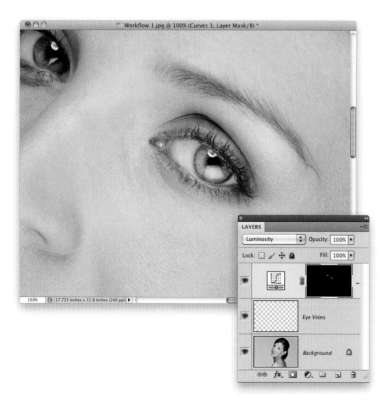

Step Six:

Of course, this contrast curve totally trashed her skin color (and we don't generally want to add contrast to a woman's skin), so Invert the adjustment layer's layer mask, hiding the contrasty version of her behind a black mask. Now, get the Brush tool, choose a small, soft-edged brush set to 100% Opacity, and then paint over each iris to give them lots of contrast (like you see here). This strong amount of contrast actually changed the color of the eyes a little bit (that's pretty common), so to get around that, at the top of the Layers panel, change the blend mode of this adjustment layer from Normal to **Luminosity** (as shown here). Also in the Layers panel, toggle the visibility of this Curves adjustment layer on/off a couple of times, and you'll see what a difference this makes.

Step Seven:

Three more things left to do to her eyes: First, create a merged layer at the top of the layer stack to work on. Now, let's darken the outer ring of the irises using the technique you learned back on page 6, where we make a selection of an iris, feather it, and put it up on its own layer (I'm doing each iris on its own layer here, instead of both on one, because the lighting is different on each eye). Next, change the layer blend mode to **Multiply**, Command-click (PC: Ctrl-click) on the layer thumbnail to bring the selection back up, and then contract it. Hit the **Delete key** to knock a hole out of the center of the darker eye, leaving just the darker outer ring, and then deselect. If there's any spillover, add a layer mask and paint it away in black. Don't forget the other eye. In this case, when I did the eye on the left, because of where I positioned the lighting, that eye is darker, and the ring looked too dark at 100%, so I reduced its Opacity to 37%.

(Continued)

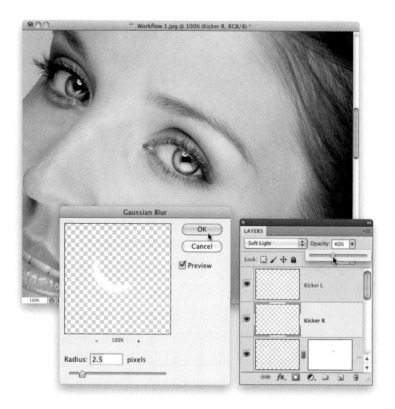

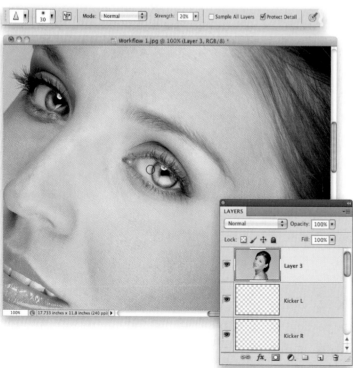

Step Eight:

Now, you're going to create those iris kickers that make the eyes sparkle (from back on page 12) by first clicking back on the merged layer and creating a new blank layer, then drawing a white circle over the iris a little smaller than the iris itself. Deselect, then cut off the top half of your circle (put a rectangular selection across the top half of the circle, then hit Delete and deselect. I used the Polygonal Lasso tool for the rectangular selection, since her face is on an angle). Command-click on the layer thumbnail to put a selection around your half-circle. While the Polygonal Lasso tool is active, click-and-drag that selection upward about half the height of the half-circle and hit Delete. Deselect, and you're left with a quarter-moon shape. Now, add a 2.5-pixel blur to soften, change the layer blend mode to **Soft Light**, then lower the Opacity until it looks right to you (for me, the right eye was 40%; the left 80%. I also moved both iris kicker layers to the top of the layer stack).

Step Nine:

We still need to work on the eyebrows and eyelashes, but our last little tweak to the eyes is to sharpen them separately from the rest of the image. In Photoshop CS5, I use the Sharpen tool, because it's got the best sharpening algorithm of anything in Photoshop (as I explained back on page 81). So, start by creating another merged layer, then get the Sharpen tool and, at a Strength of around 20% and with the Protect Detail checkbox turned on in the Options Bar, paint over each iris and pupil—don't forget to paint a little over the edges of the irises to make them really sharp. Now, take a look at her eyebrow on the right, because we're about to fill it in, trim the top, and heal away any stray eyebrow hairs.

Step 10:

First, we'll do the fill (like you learned back on page 75). Just a reminder: this eyebrow fill-in looks awful until we're done with it. Also, if you were doing this for a makeup company, you'd be filling in the eyebrow by copying the original hairs one at a time, but for our 30-minute retouch, we're just going to get the Brush tool, then quickly sample the color of the eyebrow hairs (by pressing-and-holding the Option [PC: Alt] key to switch to the Eyedropper tool). So, create a new blank layer (name it "Right Eyebrow"), then with the Brush tool, Option-click to sample, and paint in 1- or 2-pixel-wide, soft-edged strokes over the thin areas (as seen here at the top. The cursor is so small here, it's hard to see, but I'm painting 2-pixel strokes over her eyebrow hairs, following the same direction as the hairs). Now, change the blend mode of this layer to **Multiply**, then lower the Opacity of it until it blends right in with the existing hair and looks natural (here I lowered the Opacity of the Right Eyebrow layer to 40%).

Step 11:

Next, let's trim the top of the eyebrow (like we learned back on page 72). First, click back on your last merged layer (Layer 3), then take the Lasso tool and draw an eyebrow-shaped selection (like the one you see here) in a clean area right above the eyebrow. Add a 3-pixel Feather to soften the edges, copy this selection up onto its own layer, name it "Trim Eyebrow," and then move the layer to the top of the layer stack.

(Continued)

Step 12:
Switch to the Move tool and drag this area downward toward the top of the eyebrow, until it trims off the top and makes it nice and smooth (like you see here). Lastly, using the Healing Brush, let's clean up the stray hairs on the left end of the brow (as shown here) and under the center (you can see them in Step 11). If anything smears, undo it, switch to the Clone Stamp tool, and use a small, soft-edged brush instead. Now, while I was retouching in this area, I noticed a small bluish vertical vein just below the far-right side of the eyebrow (again, look back at Step 11 to see this), which I removed, along with a few little skin bumps.

Step 13:
Now, we'll move on to the eyelashes. Create a new blank layer, name it "Top Right Lash," and then get the Brush tool. Load the eyelash brush set that you downloaded from the book's companion website (see page 57) and choose the Feather Lash Right brush (shown circled here in red). For this image, you need to lower the size of the brush to around 300 pixels (remember, it's okay to have the lash be too big at first, because you can size it down. What you don't want is to make it too small and then have to stretch it larger, because the brush will get pixelated and soft). Now, just click the eyelash brush once on your blank layer, somewhere near where it's going to go (as shown here).

Step 14:

Bring up Free Transform, and rotate the eyelash, so it matches the angle of the eye, and then size it down to match the size (by the way, the way to make sure you've chosen the proper right or left brush is the longer lashes should be at the outside of the eye—the end closest to the ear). Next, you're going to Right-click inside the Free Transform bounding box and choose **Warp** from the pop-up menu (as shown here) to tweak the eyelash, so it perfectly fits the eye (as you learned back on page 60).

Step 15:

Lower the Opacity of the lashes layer, so that it blends in better with the natural lashes in the image (here, I lowered it to 40%). Now, on to the bottom lashes (from the same technique in Chapter 1). Create a new blank layer, name it "Bottom Right Lash," and then go to the Brush Picker again, but this time choose one of the single eyelash brushes (I like the Bottom Lash 3 single lash brush, shown circled here). For this image, lower the Size to around 32 pixels using the Size slider at the top of the Picker. Don't forget to go to the actual Brush panel and set your 32-pixel brush up, so it varies the size and shape as you paint with it (here, I set the Size Jitter to 40%, and the Angle Jitter amount to 3%. See page 63 for more on this).

(Continued)

Step 16:

Now that your brush is set up to automatically vary size and angle slightly, you'll need to choose the direction to match the natural eyelashes (which form an arc under the eye, with the lashes fanning from left to right). In the Brush panel's Brush Tip Shape options, click-and-drag the brush direction preview to change the direction of your eyelash brush. You're going to start painting just to the right of the center, so have your lashes arcing to the right a bit, then start painting along the lash line (as shown here). It's way too much at this point, but we'll fix that in a moment.

Step 17:

Change the direction so the lashes are straight and paint over the center, then rotate the brush again as you get near the left side of the eyelashes (nearest the nose). As you get closer to the nose, you'll need to shrink the lash size and angle as you go, because the left side should have smaller lashes than the right. So, just remember to rotate the brush and adjust the Size slider in the Brush panel as you go. By the way, I don't normally do the right, then the center, and then back to the left. I normally start on the inside side of the eye and work my way out, but I just wanted to do it this way to help you understand what has to be done. You can paint your strokes any way you're comfortable with, as long as you vary the direction and size as you go. Now, to make the bottom fake eyelashes blend in with the real ones, lower the layer Opacity of your Bottom Right Lash layer to around 40% and then add a Drop Shadow layer style. *Important:* Don't forget to do the other eye—both top and bottom lashes!

Step 18:

The last thing we want to do with the eyes is to heal away those small lines beneath them (look back in Step 17 and you'll see them) using the technique you learned on page 119. So, create another merged layer and then switch to the Healing Brush tool. Just a simple healing with a small brush will do the trick. Lastly, let's put all these eye layers together in a group (so we're not dealing with all these layers for the rest of our retouch). Select all of the eye layers in the Layers panel, then choose **New Group from Layers** from the panel's flyout menu. Name this set "Eyes" and now they're all in one tidy folder.

Step 19:

Now, let's clean up the hair, using the technique on page 196. First, create a new blank layer (name it "Hair Cleanup"), then get the Clone Stamp tool, and choose a small, hard-edged brush (we have to use a fairly hard brush tip like this, so we don't soften the edge of her hair when we reach it, but if the hard edge seems too hard, in the Brush Picker, lower the Hardness from 100% to 75%). Her hair is more in focus on the top of her head, and less so on the side, so you might have to vary the softness a bit. Now, go around the head and clone away any stray hairs (as shown here) by sampling a clean background area right near the hair you want to remove, then painting over it to clone it away.

(Continued)

Step 20:

Continue going around removing the stray hairs, but leave a few here and there or it'll look like she has plastic hair (here I've cleaned up most of the stray hairs, including a few crossed hairs within her head). Now, let's work on darkening the part in her hair, like you learned back on page 214. Start by creating a merged layer, then change the layer's blend mode to **Multiply**. Option-click (PC: Alt-click) on the Add Layer Mask icon at the bottom of the Layers panel to add a black layer mask, hiding the darker version of your image. Now, get the Brush tool, choose a medium-sized, soft-edged brush, and paint in white over the part area (as shown here). If you think the part looks too dark, reduce the layer's opacity.

Step 21:

Now, let's work on the hairs that extend over onto her back (here, we'll follow part of that same technique from Chapter 4 we used to clean up the edges of her hair). Start by creating a new layer, name it "Hair on Back" (not "Back Hair," which is something else and just sounds so cruel), and then switch to the Healing Brush tool (which works really well and is my go-to tool when hair extends over skin, but other than that, when it comes to removing hair, I use the Clone Stamp tool). There really isn't any trick to this—you just have to be patient, sample clean areas, and heal all the hair away strand by strand. Once you've got those healed away (you may have to switch to the Clone Stamp tool to get the edge of her back), while you've still got the Healing Brush, you might as well get to work on those blemishes and get rid of them, as well. I also got rid of her earring hole.

Step 22:

Just go around and keep healing away those blemishes, until they're all gone. Her skin is a little bit blotchy on her back, so we'll deal with that, but before we get to that, we have two more annoying hair things to work on: (1) those little wisps of hair at the top of the back of her neck, and behind her ear, extending into the rest of her hair (we'll just clone that out), and (2) the hair extending onto her ear.

Step 23:

Normally, when you're working inside the hair area, outside of cloning away some individual crossed hair strands, your best bet is to pick up some existing hair, copy it onto its own layer, and then move that hair over the large piece you want to cover (like you learned back on page 202). If you need to, you can then use Free Transform's Distort feature—just Command-click on a corner point and drag to make it fit perfectly. However, since there's not much detail in this dark area of her hair behind her neck to begin with, we can get away with just cloning over those wisps. So, create a new blank layer (name it "Extra Hair"), then get the Clone Stamp tool, choose a medium-sized, soft-edged brush, and clone over those areas (don't forget to follow the direction of the hair). While you're there, shrink your brush size way down and trim away those little hairs on the back of her neck, as well.

(Continued)

Step 24:
Now, the hair-over-the-ear retouch is one of those pain-in-the-butt retouches that there isn't a great trick for—just a great pair of tools. Use the Healing Brush tool as much as possible, then switch to the Clone Stamp tool when you get to the edges to keep them from smearing. It'll take a few minutes, so be prepared to spend some time here. Create a new blank layer (name it "Hair Over Ear"), zoom in tight, like I did here, use a small Healing Brush, and start just chipping away at each strand of hair, until they're all gone.

Step 25:
Here, the hair's pretty much gone. Again, I only used the Healing Brush and Clone Stamp tools with a *very* small brush size, and I just took the time to painstakingly remove every strand. It wasn't fun, and I wouldn't normally do this for a quickie retouch, but in this case, we're going to go a little farther than I normally would just to show you what can be done with some patience and a small brush size. We still have the issue of that red patch at the top of her ear (that I mentioned in the first step), but you can get rid of that in five seconds using the Healing Brush, so it's really not an issue (go ahead and do that now). She does have a gap in her hair on the left side of her forehead, so let's go fix that next.

Step 26:

To fix that gap, we're going to borrow some hair from somewhere nearby, copy it up onto its own layer, and move it over to cover up the gap (like you learned back on page 204). The piece that looked to me like it might look the best is the one in front with the nice highlight near the top. Before you make your selection in this area, though, get rid of any crossed hairs, spots, specks, or anything else that might repeat itself, in case you have to make more than one copy. Now, create a new merged layer, then get the Lasso tool and make a selection around that perfectly clean nearby area (as shown here). Normally, I would feather this area by 10 pixels, but since the selection is so thin, let's just go for 5 pixels, and then copy this selection up on its own layer.

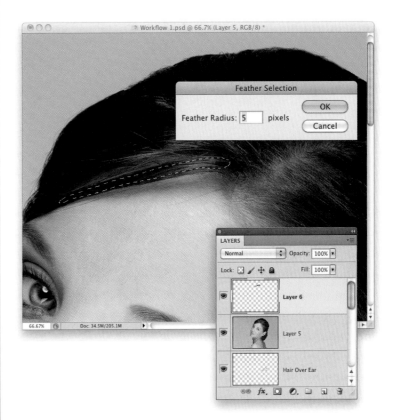

Step 27:

Now, switch to the Move tool and drag that chunk of hair over until it starts to fill in the gap. Moving it straight over leaves a little gap at the bottom, so go to Free Transform and rotate this a little counterclockwise (as shown here) to cover that small gap at the left end.

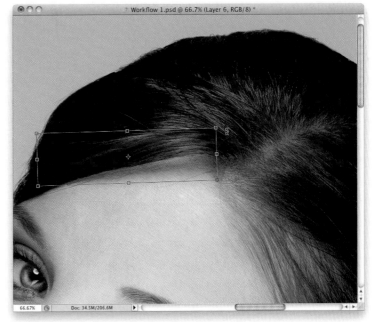

(Continued)

Step 28:

You'll need to do this two more times (make two copies of the selected hair layer, move them over to cover the next part of the gap, and then rotate them as necessary). Once the gap is fully covered (as seen here), zoom in tight and check to see if you have any obvious repeating patterns in the hair (like a speck or crossed hair you see three times in a row—a dead giveaway). If you see something like that, just get the Clone Stamp tool, use a really small brush, and clone those little repeating areas away so it looks natural, like you see here. Now, go to the Layers panel, select all the hair layers, and put them into a group (like you did with the eye layers back in Step 18), and name this group "Hair."

Step 29:

There's not that much left to do on this image, but I would generally either tone down or remove the neck lines, so let's do that. For a beauty shot like this, when it comes to neck lines, less is more, so let's remove the top two lines altogether (and any other little neck muscle twists), and then we'll greatly tone down the bottom one (we'll do this like we removed the wrinkles back on page 119). Create a new blank layer, name it "Neck Lines," and then get to work with the Healing Brush tool. Just sample a nearby area and remove those top two neck lines and any nearby stragglers.

Step 30:

Now, let's create a separate blank layer for the main neck line (name it "Main Neck Line"), so we can remove it completely, then bring it back a little bit by lowering the Opacity a tiny bit (as shown here)—so it's there, but it's really subtle. You can certainly remove the neck line altogether (I've seen it done numerous times in beauty shots), so it's really your call, but I will usually leave a little line there because to me it looks more natural.

Step 31:

I'd finish the retouch of this image off with a skin retouch. But, since the skin on her face is very good, it would just be a matter of getting in tight with a very small Healing Brush, finding any small blemishes or discolorations, and healing them away. There's a little area under her left eye I would probably work on, and a few little blemishes here and there. But what I'm most concerned about is the uneven skin on her back, so for a fairly quick retouch like this, I'd finish off by using the skin smoothing technique found on page 102. Now, while it does use the Surface Blur filter, it brings back the original skin texture on top, so the final result is not blurred-away detail, but nice, clearly visible texture. Lastly, I'd sharpen the entire image by going to the Channels panel, clicking on the Red channel, and then applying the Unsharp Mask filter with settings of Amount: 120, Radius: 1, and Threshold: 3 (you learned this back on page 160).

(Continued)

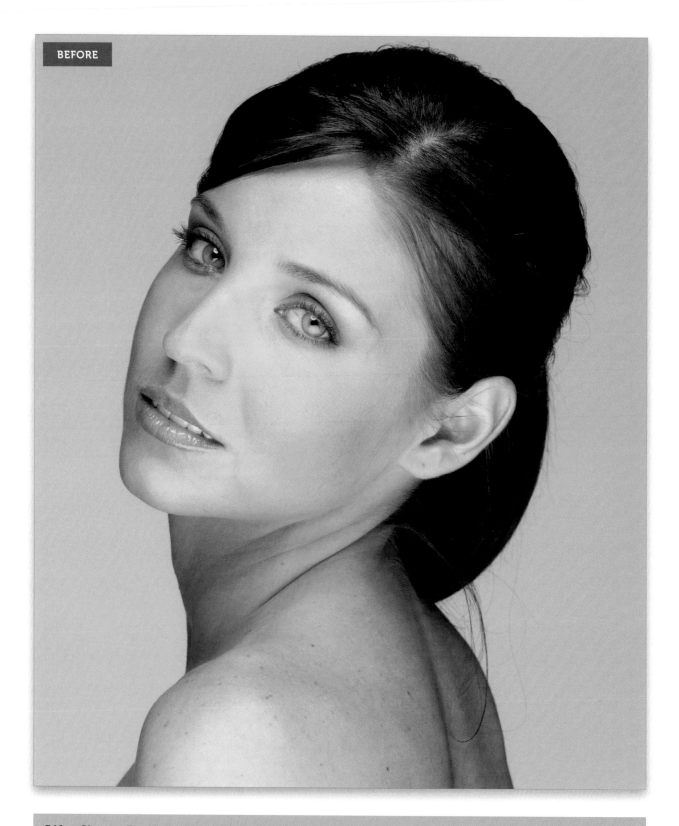

BEFORE

INDEX